THE CANDY BOOK OF TRANSVERSAL CREATIVITY

Rizzoli
NEW YORK

New York · Paris · London · Milan

The Best Of C★NDY *Transversal* Magazine, Allegedly
EDITED BY LUIS VENEGAS

C★NDY *Transversal* 12th Issue, 2019. Pages 48-49. Candy Darling, actress. New York, October 30, 1969 (Contact Print) Photograph by Richard Avedon @ The Richard Avedon Foundation.

Candy Darling, actress. New York, October 30, 1969
(contact print)
All photographs in these pages by Richard Avedon
@ The Richard Avedon Foundation

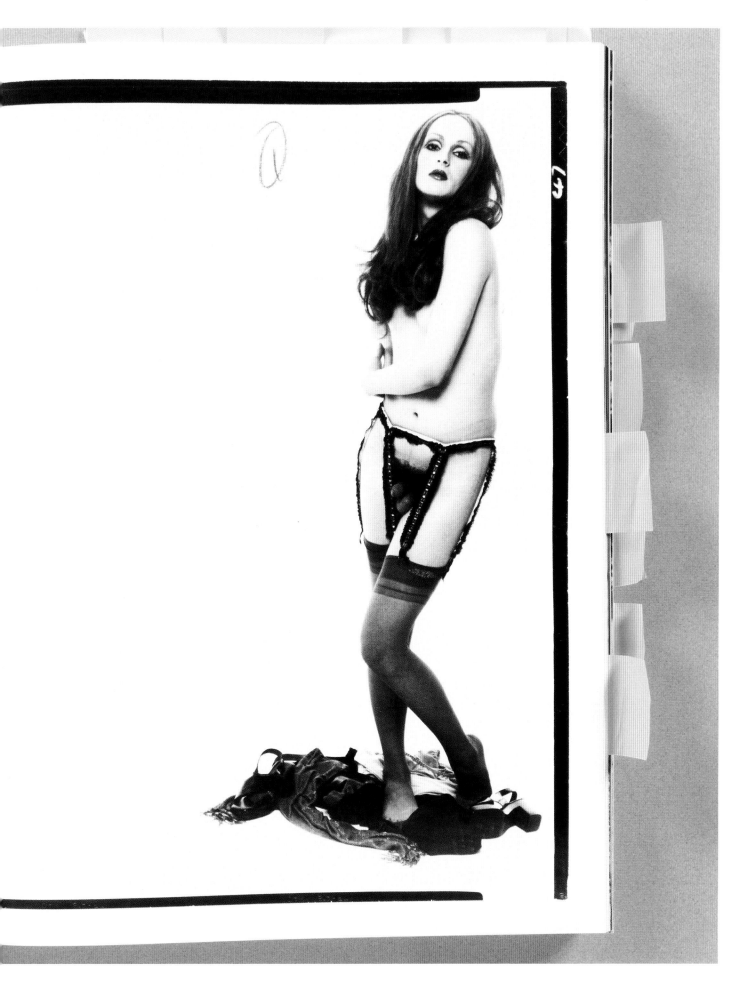

3

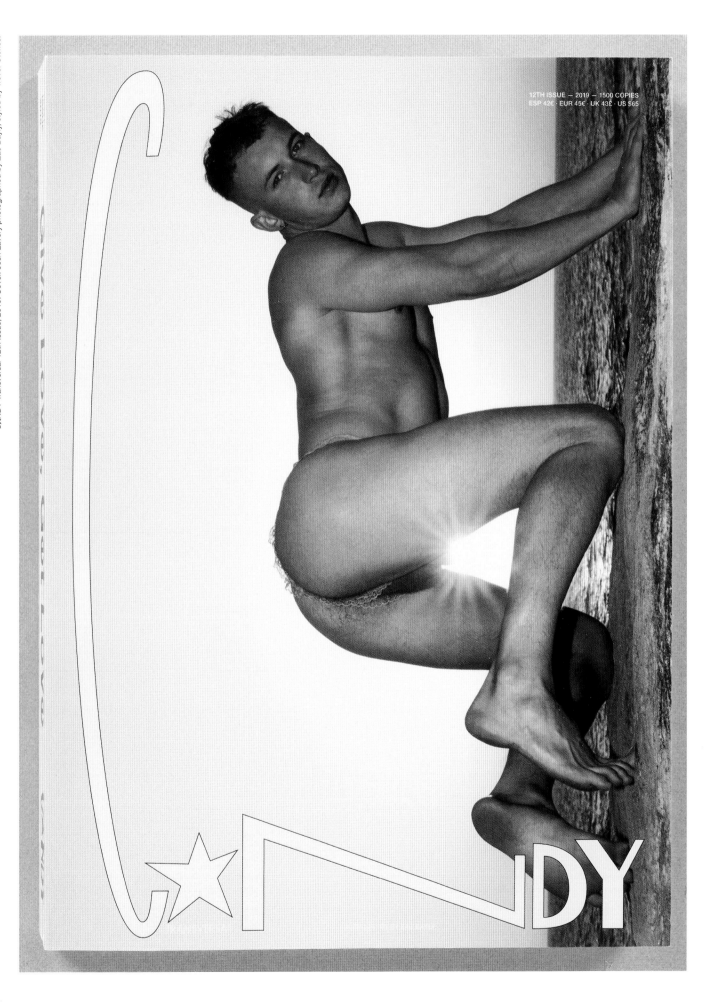

CANDY Transversal 12th Issue, 2019. Cover: Josh Lavery photographed by Zac Bayly, styled by Trevor Stones.

12TH ISSUE — 2019 — 1500 COPIES
ESP 42€ · EUR 45€ · UK 43£ · US $65

TREVOR STONES GAVE LOVE CANDY

C★ANDY

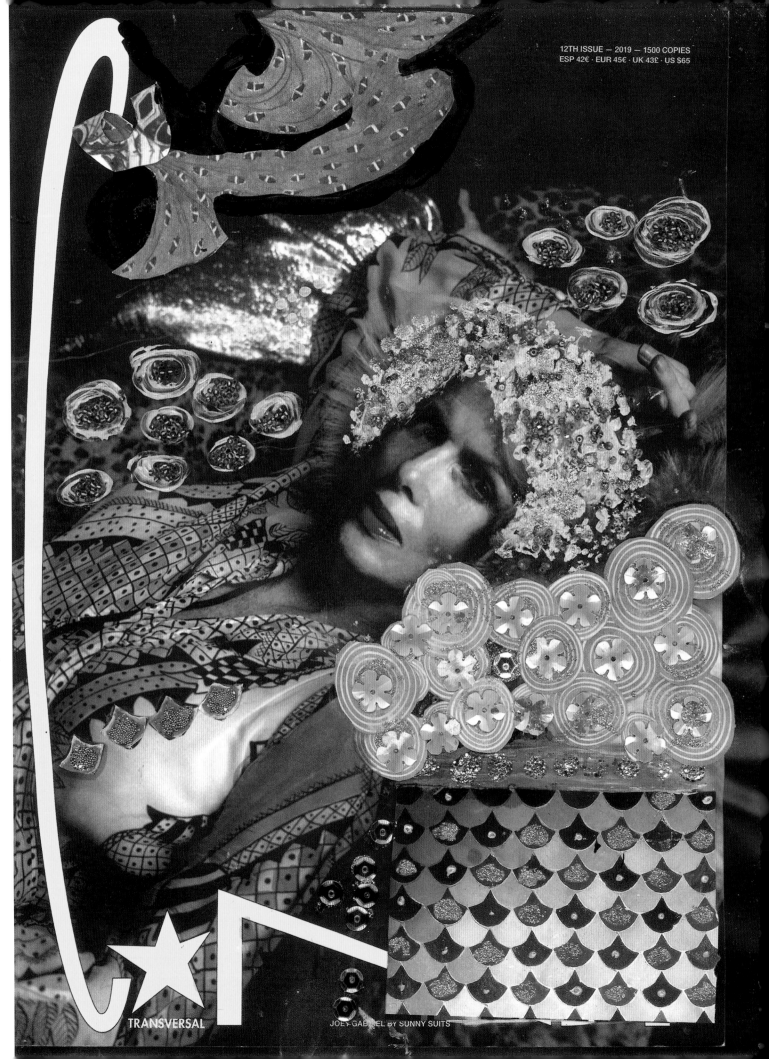

12TH ISSUE — 2019 — 1500 COPIES
ESP 42€ · EUR 45€ · UK 43£ · US $65

TRANSVERSAL

JOE + GABRIEL BY SUNNY SUITS

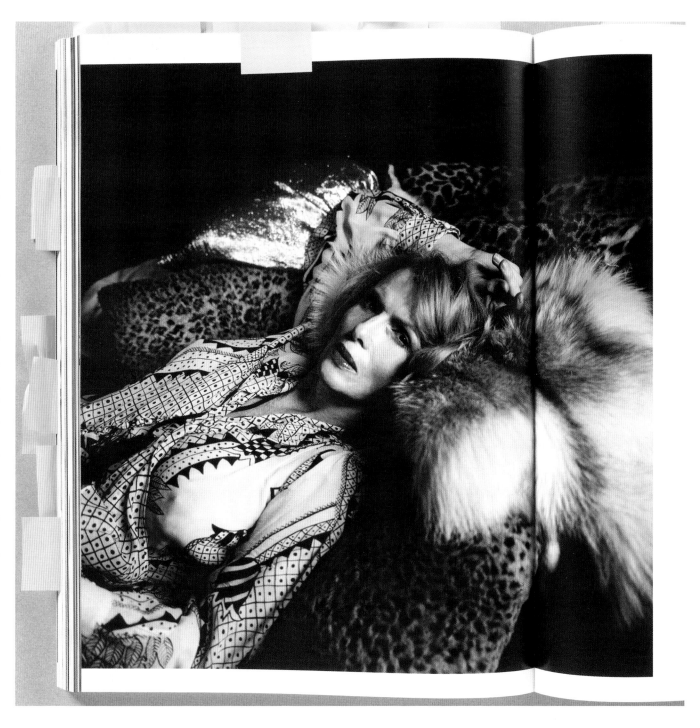

C★NDY Transversal 12th Issue, 2019. Pages 392-393. Joey Gabriel photographed by Sunny Suits. LEFT: Joey Gabriel's artwork inspired by her C★NDY Transversal 12th Issue cover.

I'm not one of those queens without a past. I'm not ashamed. It makes me me.

—
JOEY GABRIEL in conversation with Sunny Suits
C★NDY Transversal 12th Issue, 2019

CANDY *Transversal* 12th Issue, 2019. Pages 420-421. Photographs by Nan Goldin: Joey at my vanity table, NYC, 2000; Joey on my roof, NYC, 1991; Joey and Andrés in Hotel Askanischer Hof, Berlin, 1992; Joey in my mirror, Berlin, 1992.

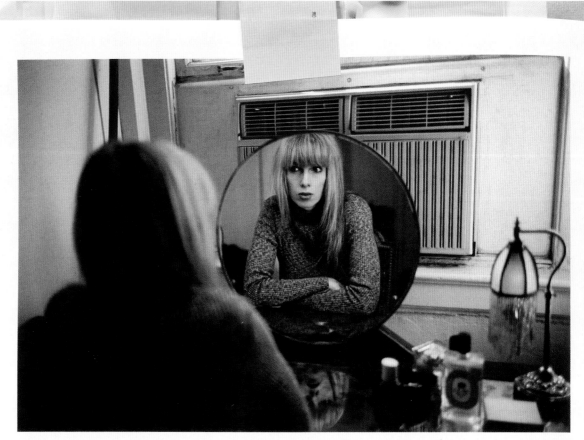

Joey at my vanity table, New York City, 2000.

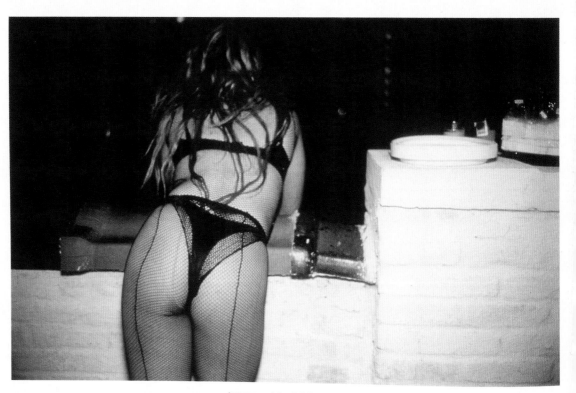

Joey on my roof, New York City, 1991.

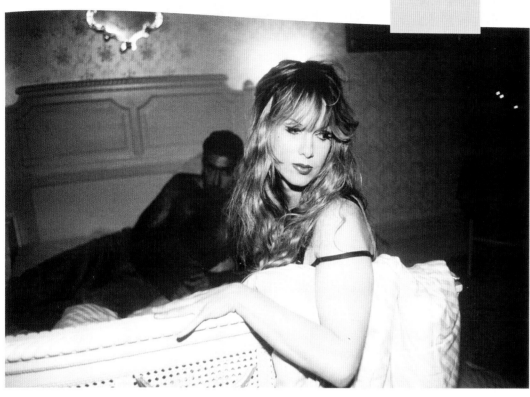

Joey and Andrés in Hotel Askanischer Hof. Berlin, 1992.

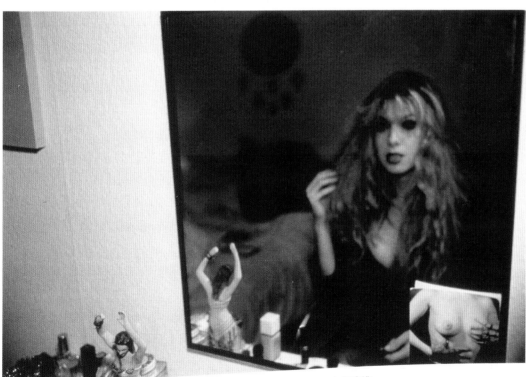

Joey in my mirror, Berlin. 1992. All photographs in these pages by Nan Goldin.

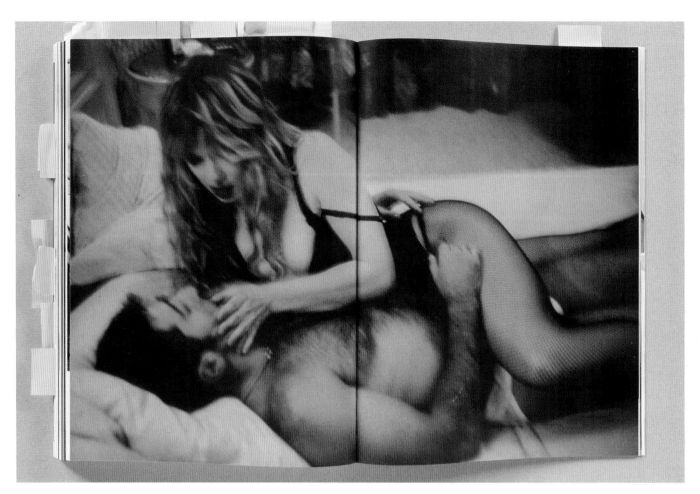

C★NDY Transversal 12th Issue, 2019. Pages 422-423. Photograph by Nan Goldin: Joey and Andrés in bed, Berlin, 1992.

I'm deeply gratified that **C★NDY** exists. I've been waiting since the early'70s
when my dream was to be a fashion photographer and put my friends on
the cover of *Vogue*. I was living then with a few of the most beautiful transsexual
girls who ever appeared on celluloid. Thank you Luis and **C★NDY**
for fulfilling my dreams thirty-five years later.

—
NAN GOLDIN
C★NDY Transversal 10th Issue, 2017

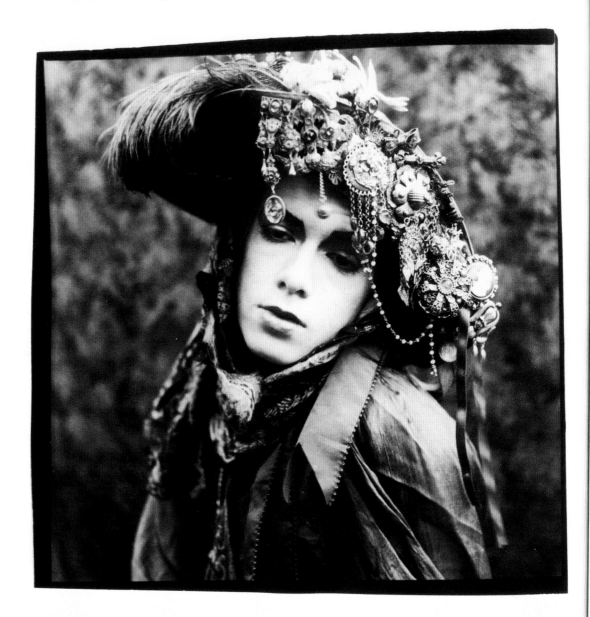

Joey, Cambridge Massachusetts 1984. Opposite Page: Joey as a 1920's Marie Antoinette, New York City, 1989. Photographs by David Armstrong.

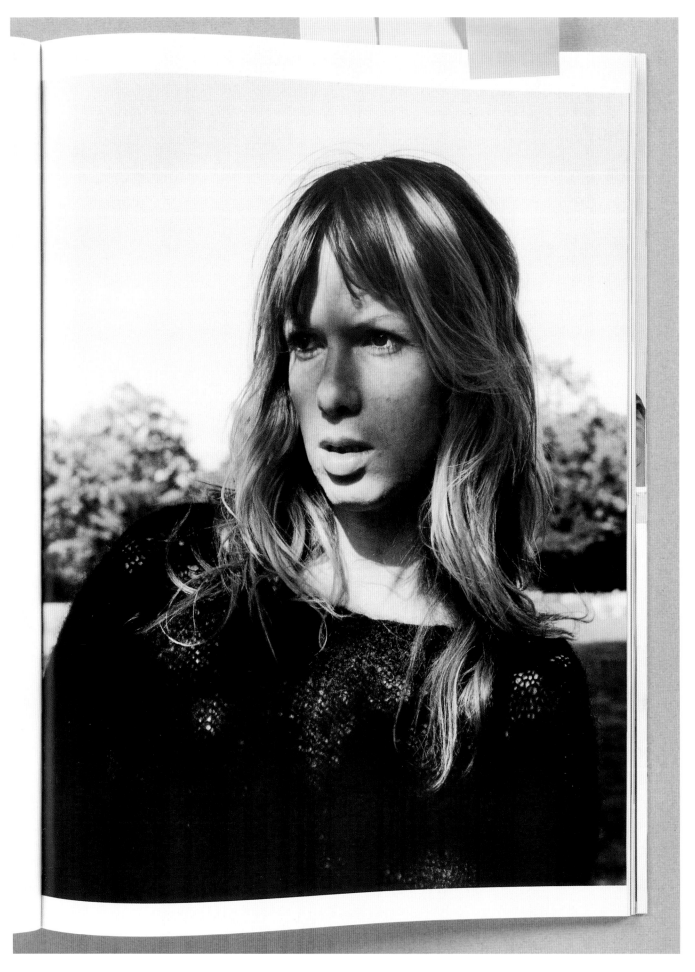

C*NDY *Transversal* 12th Issue, 2019. Page 405. Photograph by David Armstrong: Joey at Kreuzberg Park, Berlin, 1992.

CANDY Transversal 12th Issue, 2019. Page 410. Photograph by Jack Pierson: Joey on Tom's roof, May 1995.

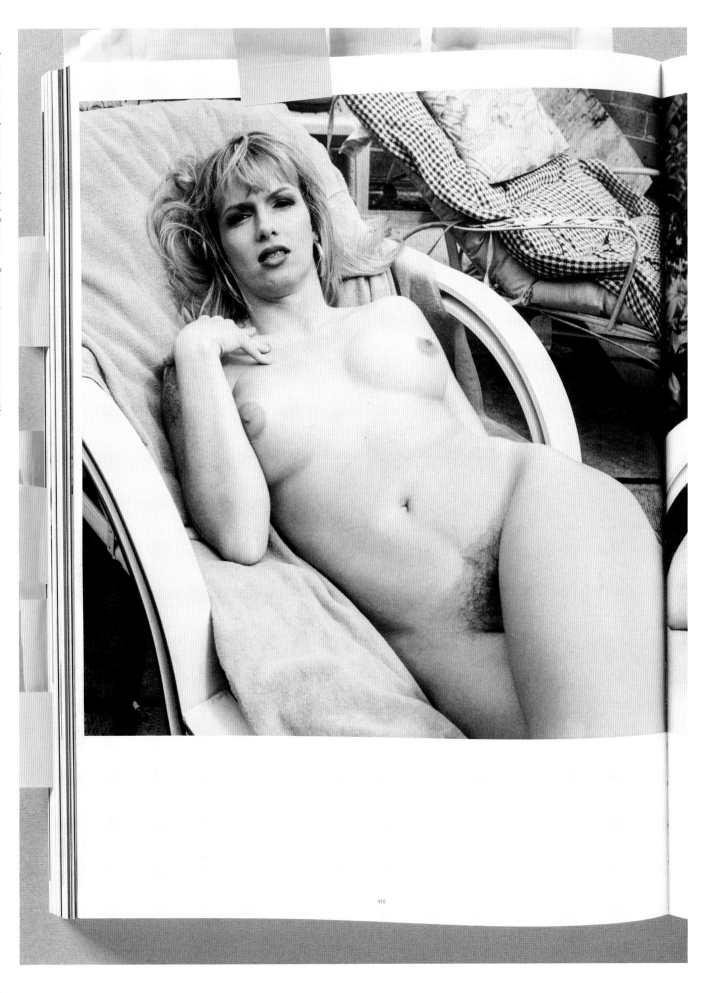

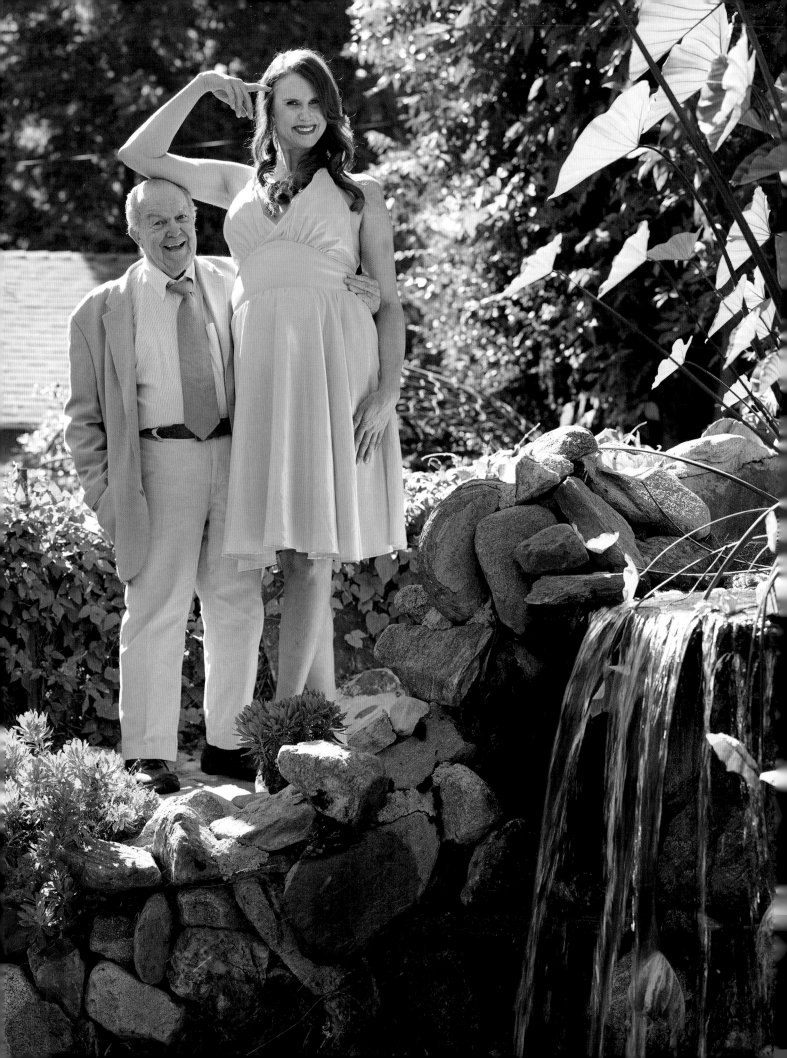

C✴NDY *Transversal* 12th Issue, 2019. Pages 88-89, 92-93. Photographs by Mariette Pathy Allen: Pajama Party, Fantasia Fair, Provincetown, 1984; Maxine, Ariadne, and Virginia, Provincetown, 2000; Virginia Prince at Fantasia Fair, Provincetown, MA, 1992; Vicky with my children; Davida and Diane, Bay Area, 1988. LEFT: Unpublished photograph of Erika Ervin and Don Blocker shot by Torbjørn Rødland for C✴NDY *Transversal* 12th Issue, 2019.

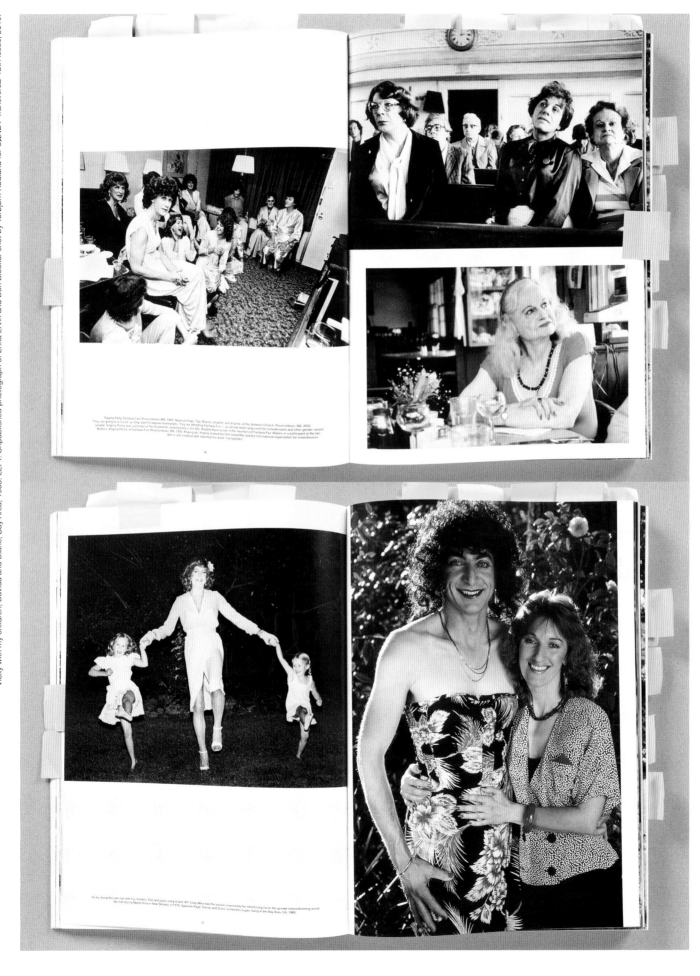

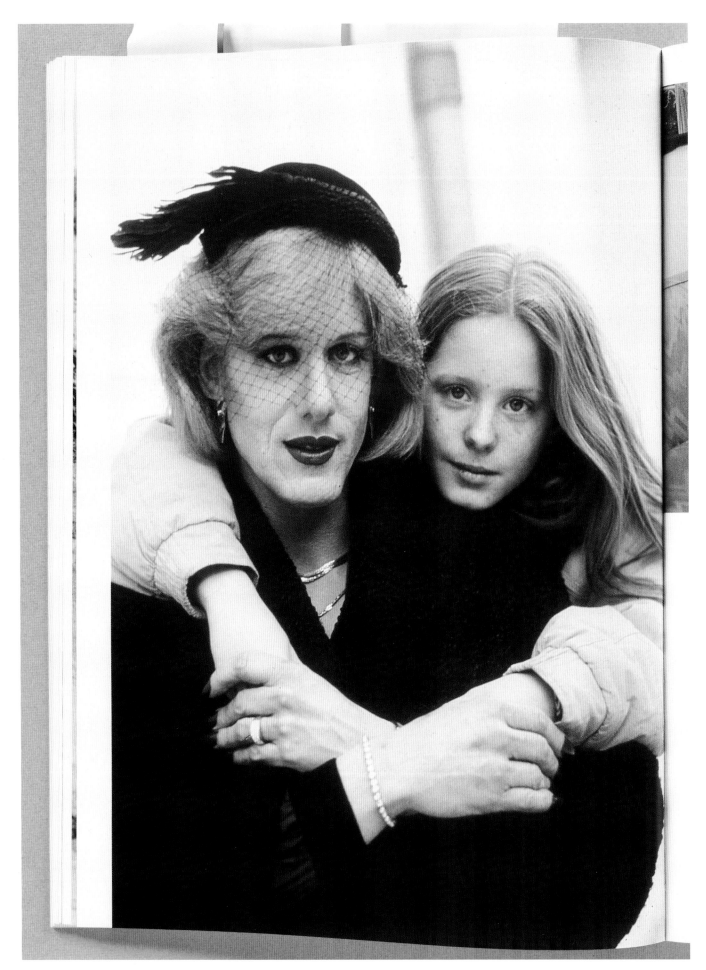

C✭NDY Transversal 12th Issue, 2019. Page 84. Photograph by Mariette Pathy Allen: Paula and her daughter, Rachel, Philadelphia, 1987. RIGHT: Perri White photographed by Luis Venegas for C✭NDY Transversal 12th Issue, 2019.

CANDY Transversal 12th Issue, 2019. Page 51. Marsha P. Johnson, Christopher Street, New York City, 1987. Photograph by Stanley Stellar © Stanley Stellar.

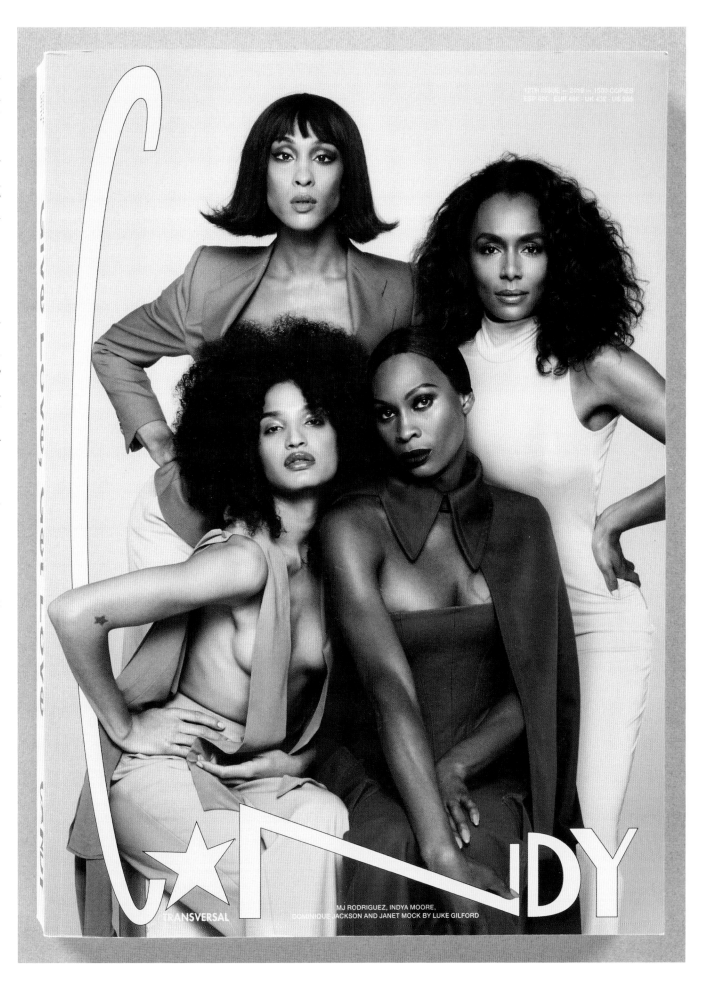

12TH ISSUE — 2019 — 1500 COPIES
ESP $20 EUR 45€ UK 42£ US $86

MJ RODRIGUEZ, INDYA MOORE,
DOMINIQUE JACKSON AND JANET MOCK BY LUKE GILFORD

C★NDY

TRANSVERSAL

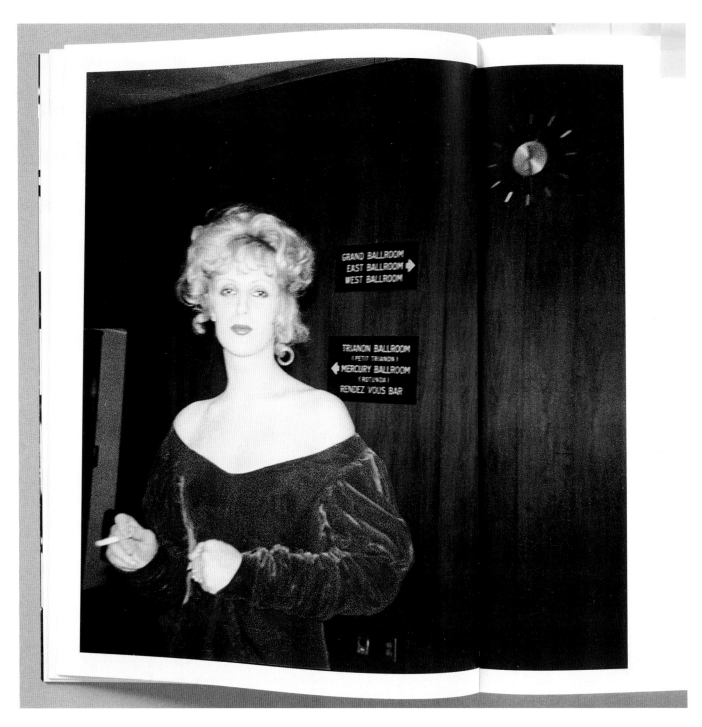

C★NDY *Transversal* 12th Issue, 2019. Pages 38-39. Candy Darling, New York City, early 70s. Photograph by Gary Lee Boas.

The idea of **C★NDY** is like Columbus's egg: nobody thought of it before!!!
As we say, "l'évidence des chefs d'oeuvres": simple, strong, watertight.

—
CHRISTIAN LACROIX
C★NDY Transversal 1st Issue, 2009

G★NDY *Transversal* 12th Issue, 2019. Page 66. Fran Lebowitz photographed by Lia Clay.

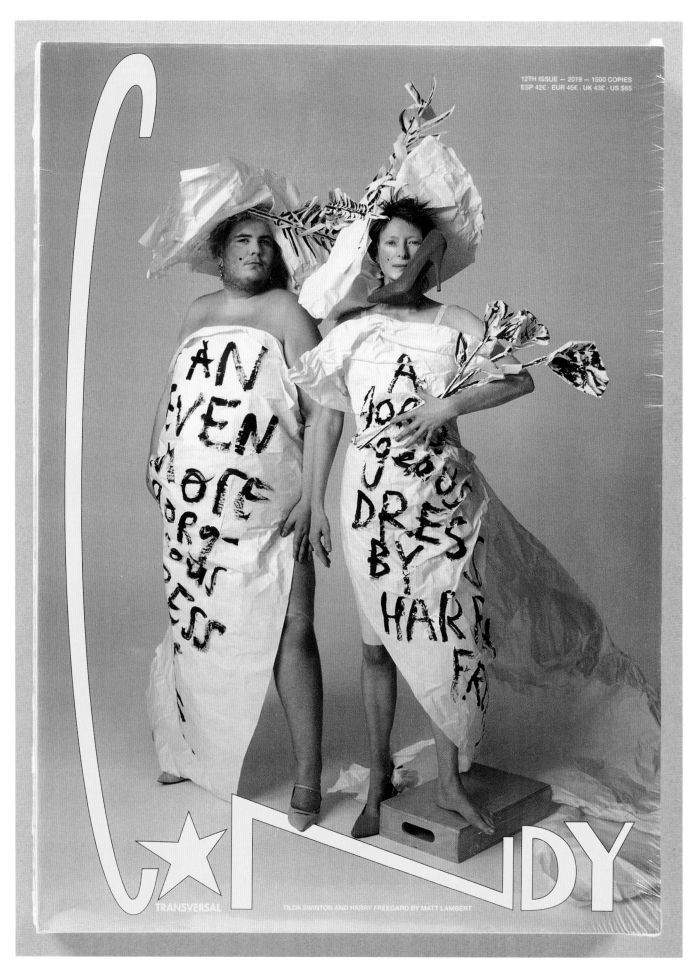

12TH ISSUE — 2019 — 1500 COPIES
ESP 42€ · EUR 45€ · UK 43£ · US $65

C★NDY

TRANSVERSAL

TILDA SWINTON AND HARRY FREEGARD BY MATT LAMBERT

C★NDY *Transversal* 12th Issue, 2019. Cover. Harry Freegard and Tilda Swinton photographed by Matt Lambert, styled by Jerry Stafford.

CANDY *Transversal* 12th Issue, 2019. Page 295. Tilda Swinton photographed by Matt Lambert, styled by Jerry Stafford.

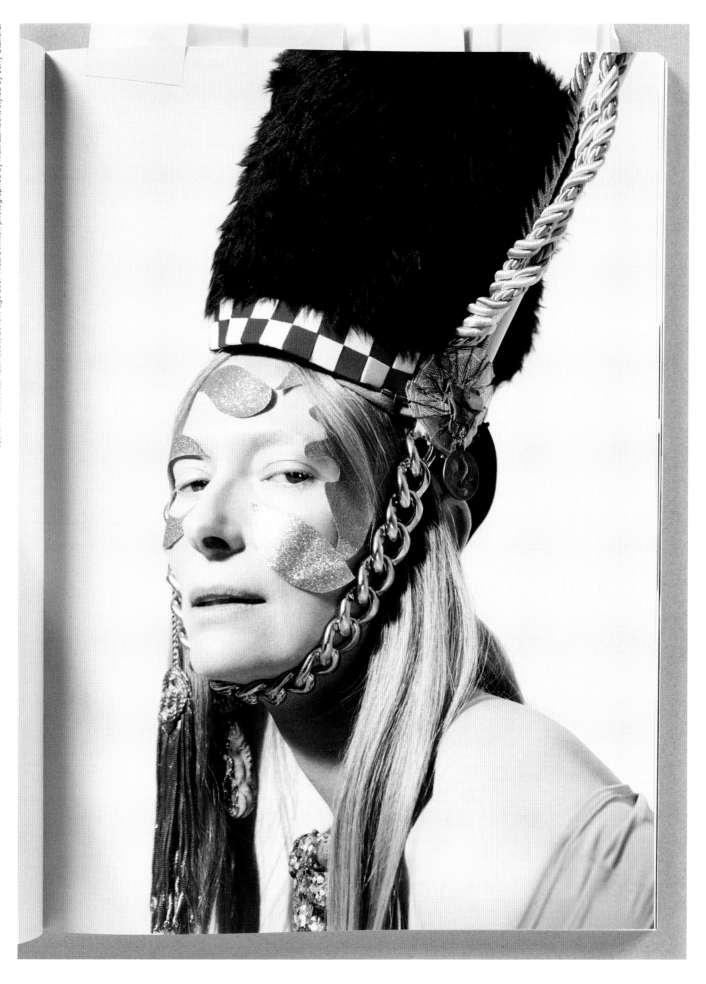

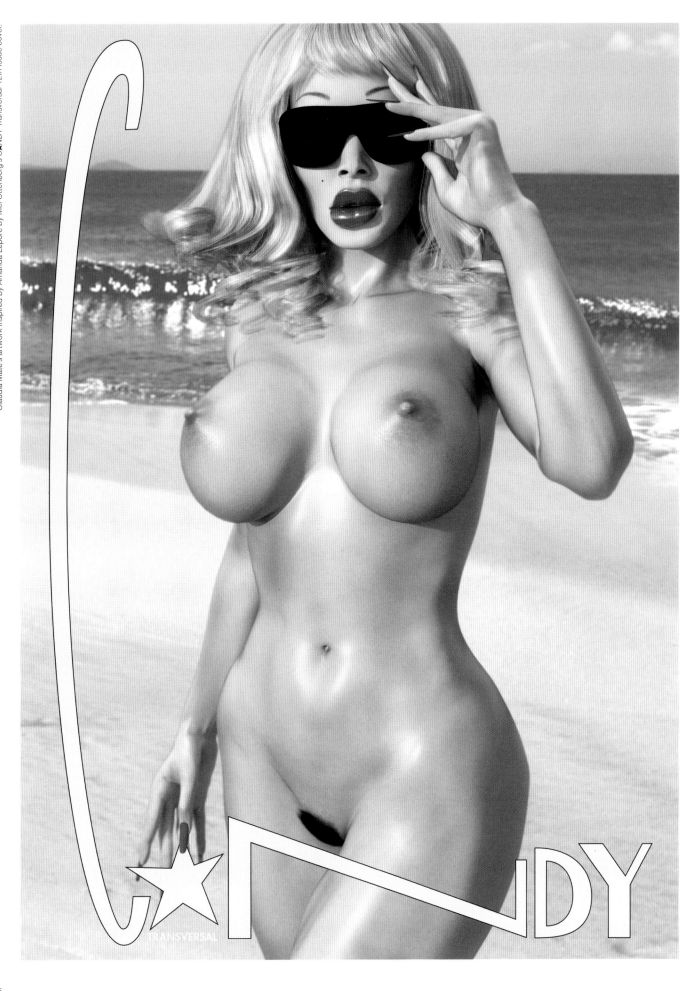

25

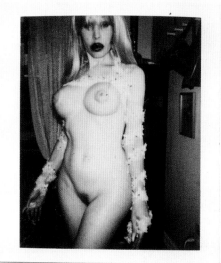

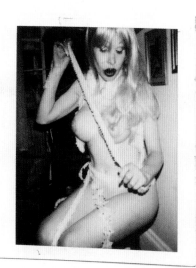

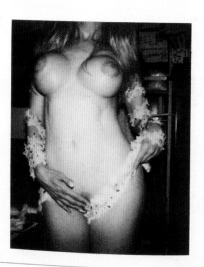

Amanda at home wearing vintage trims from M&J Trimming, Hotel 17, NYC.
Preceding Pages: On Page 84, Top: orange leather dress and bracelets by Maripol; Bottom: jumpsuit by Louis Feraud, Hollywood.
On Page 85: Amanda in Hollywood wearing a hat by Philip Treacy. Opposite Page: Top: Amanda tied up in vintage trim and wearing a white fox hat, NYC;
Bottom: Amanda in her apartment, Hotel 17, NYC, on the night we met.

C★NDY Transversal 12th Issue, 2019. Page 74. Amanda Lepore photographed and styled by Mel Ottenberg, New York City, 2001.

"I DON'T TELL ANYONE THAT THEY'VE GOT TO DO THIS AND THAT, I SIMPLY TELL THE WAY I'VE OVERCOME."

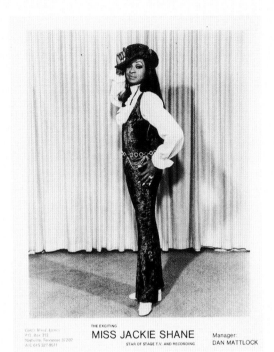

THE EXCITING
MISS JACKIE SHANE
STAR OF STAGE T.V. AND RECORDING

Manager:
DAN MATTLOCK

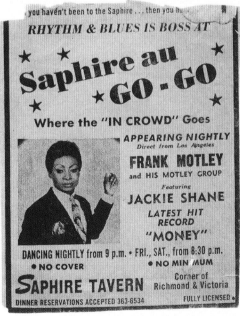

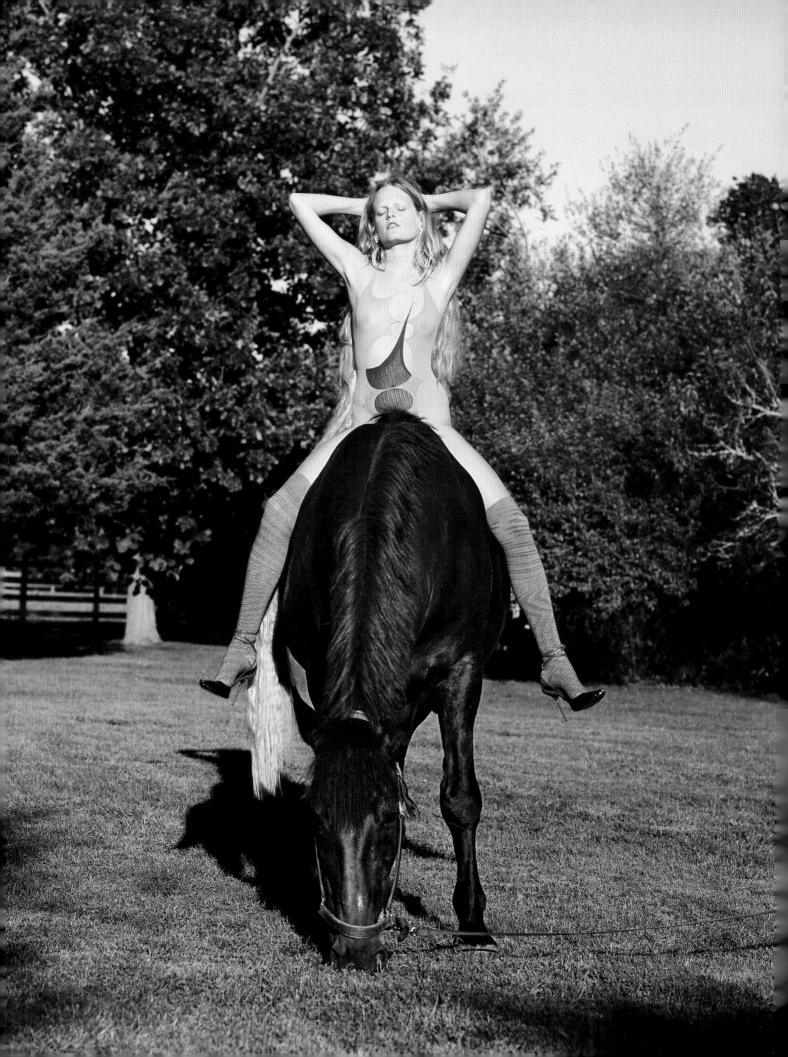

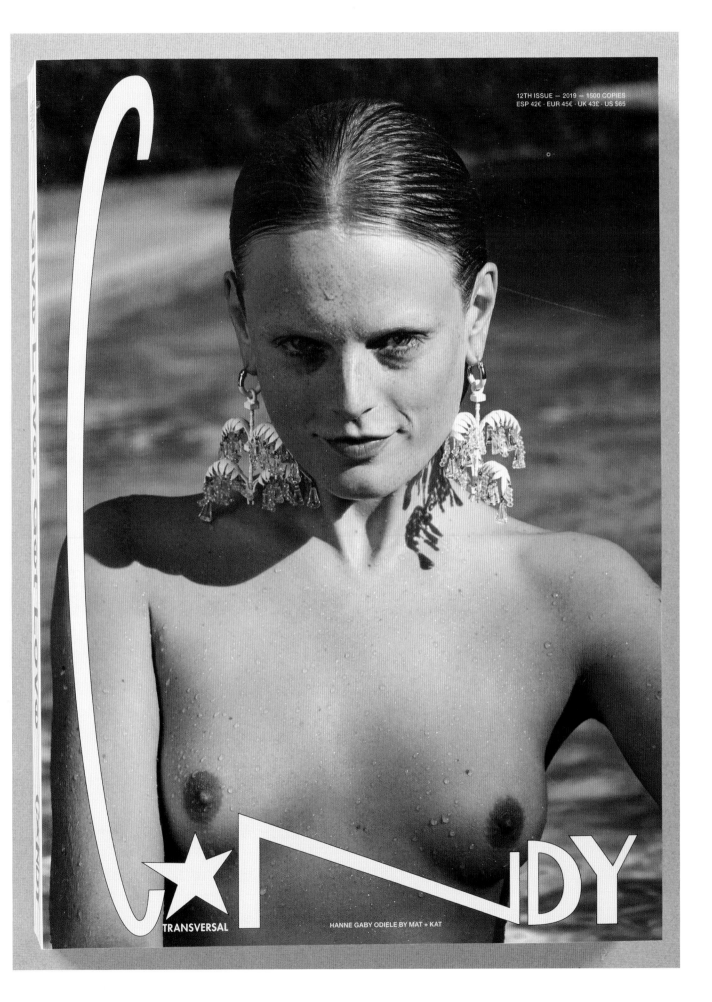

12TH ISSUE — 2019 → 1500 COPIES
ESP 42€ · EUR 45€ · UK 43£ · US $65

TRANSVERSAL

HANNE GABY ODIELE BY MAT + KAT

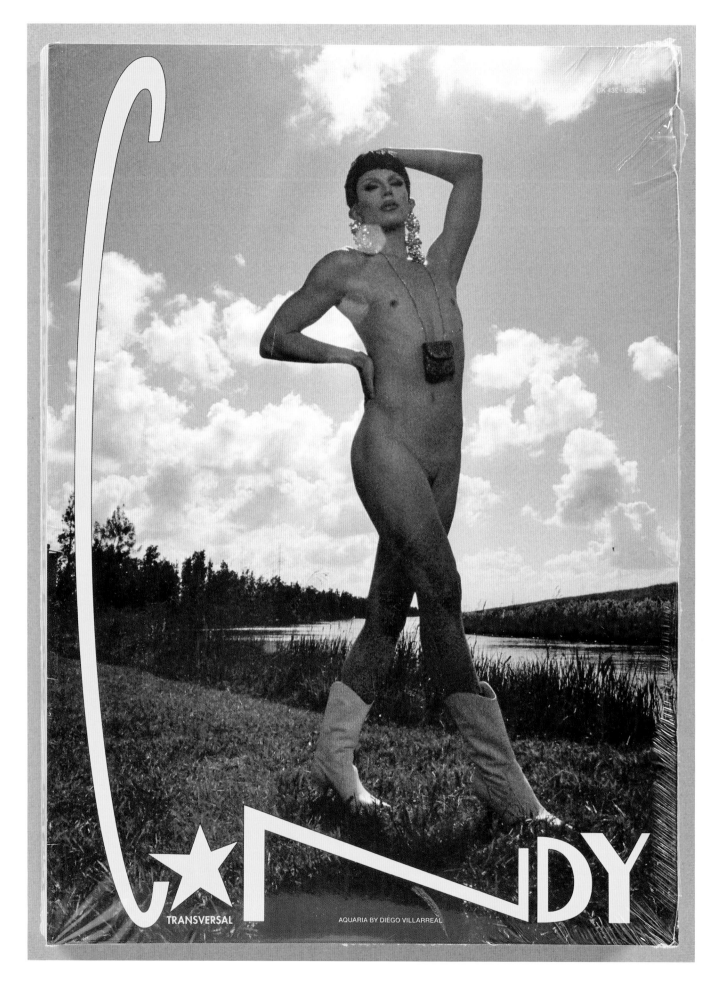

TRANSVERSAL

AQUARIA BY DIEGO VILLARREAL

C★NDY *Transversal* 12th Issue, 2019. Cover. Aquaria photographed by Diego Villarreal, styled by David Martin. RIGHT: Unpublished photograph of Aquaria shot by Diego Villarreal for C★NDY *Transversal* 12th Issue, 2019.

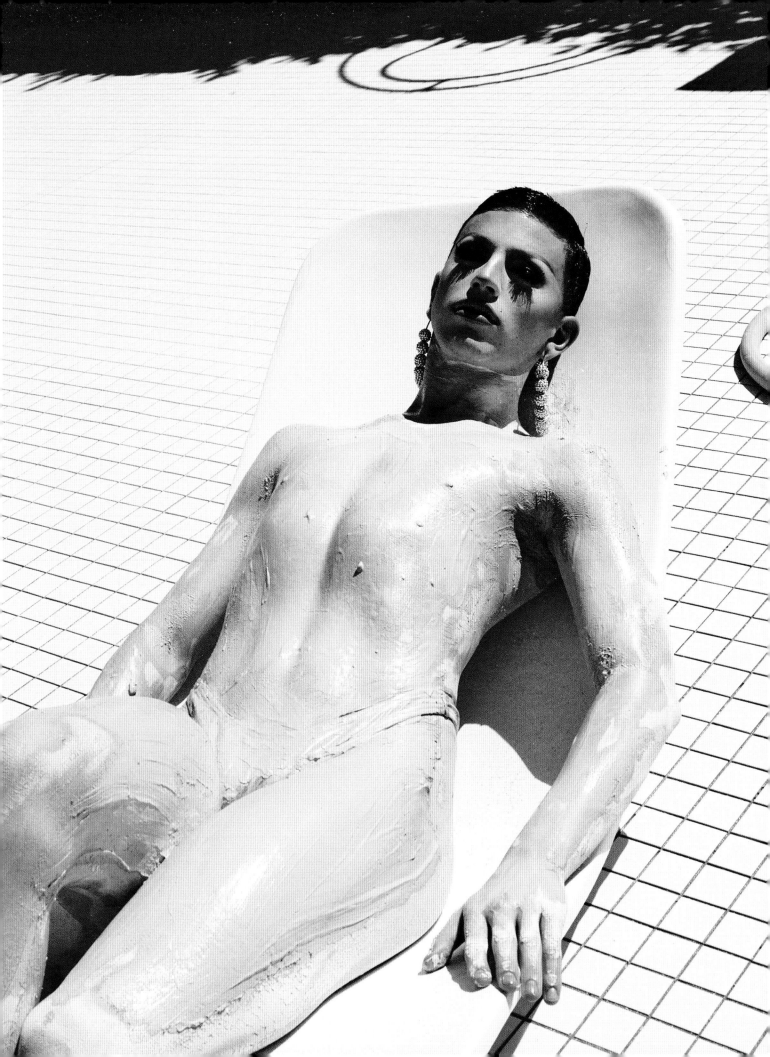

CANDY *Transversal* 12th Issue, 2019. Page 241. Yang Hao photographed by Mark Kean, styled by Andreas Peter Krings.

C✭NDY Transversal 12th Issue, 2019. Page 177. Brax Fleming photographed by Micaiah Carter, styled by Ian Bradley.

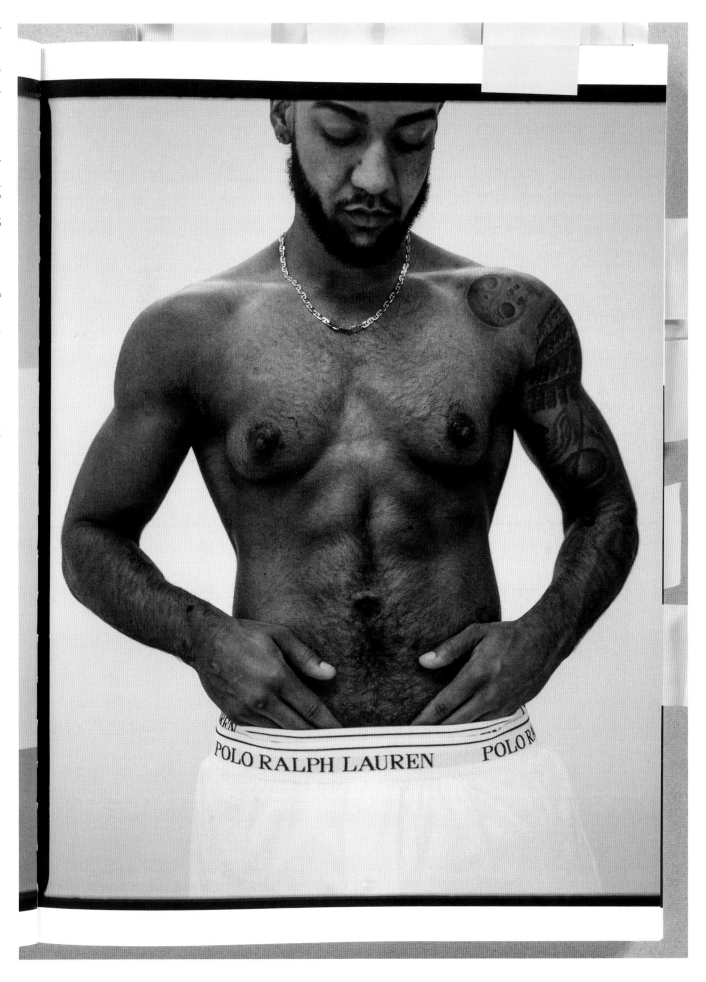

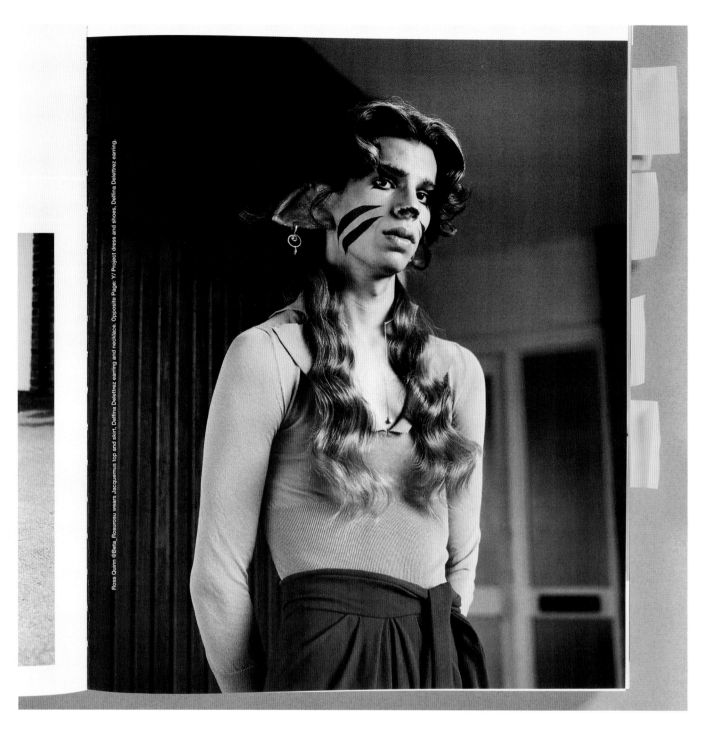

Ross Quinn @Beta, Rosurosu wears Jacquemus top and skirt, Delfina Delettrez earring and necklace. Opposite Page: Y/ Project dress and shoes, Delfina Delettrez earring.

C★NDY *Transversal* 12th Issue, 2019. Page 160. Ross Quinn photographed by Kim Jakobsen To, styled by Hamish Wirgman.

I feel like I can lose myself in the character once I've got the costume on, become someone else and act as them. I suppose the best way to say it is that I just enjoy being someone else for little bit.

—
ROSS QUINN
C★NDY Transversal 12th Issue, 2019

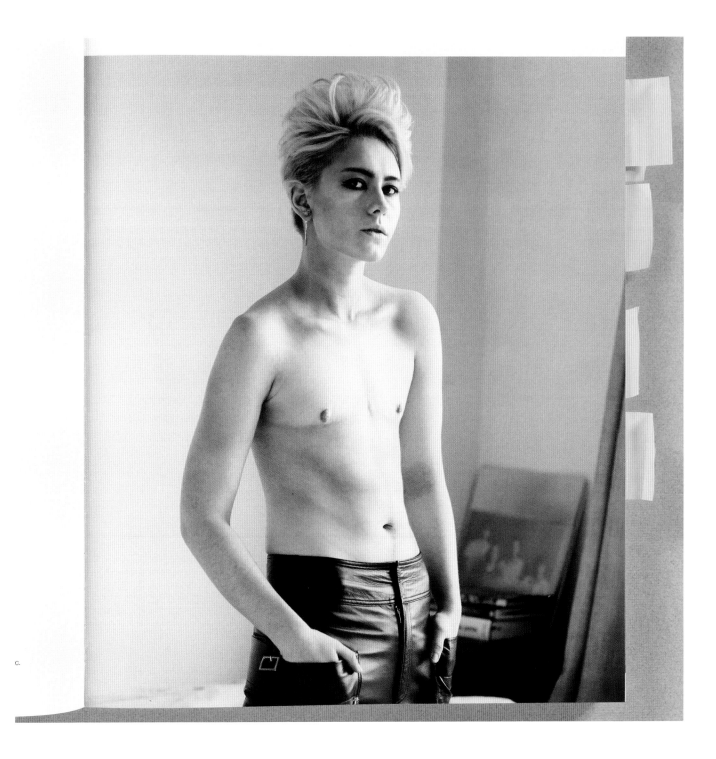

CANDY Transversal / 12th Issue, 2019. Page 169. Phoebe photographed by Kim Jakobsen To, styled by Hamish Wirgman.

C.

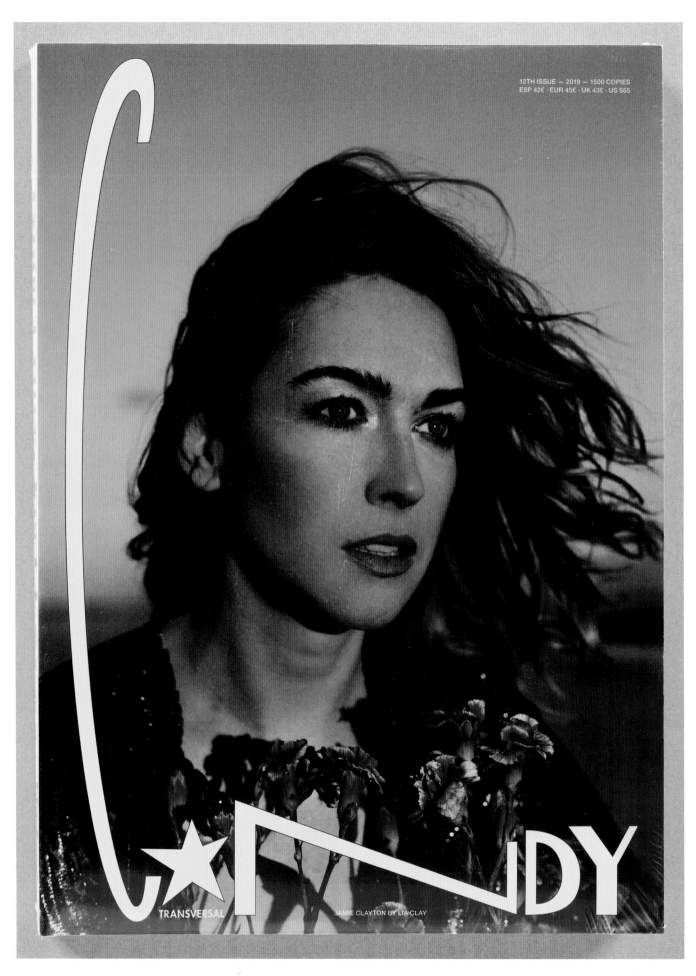

12TH ISSUE — 2019 — 1500 COPIES
ESP 42€ · EUR 45€ · UK 43£ · US $65

TRANSVERSAL

JAMIE CLAYTON BY LIA-CLAY

C★NDY Transversal 12th Issue, 2019. Cover. Jamie Clayton photographed by Lia Clay, styled by Jared Martell.

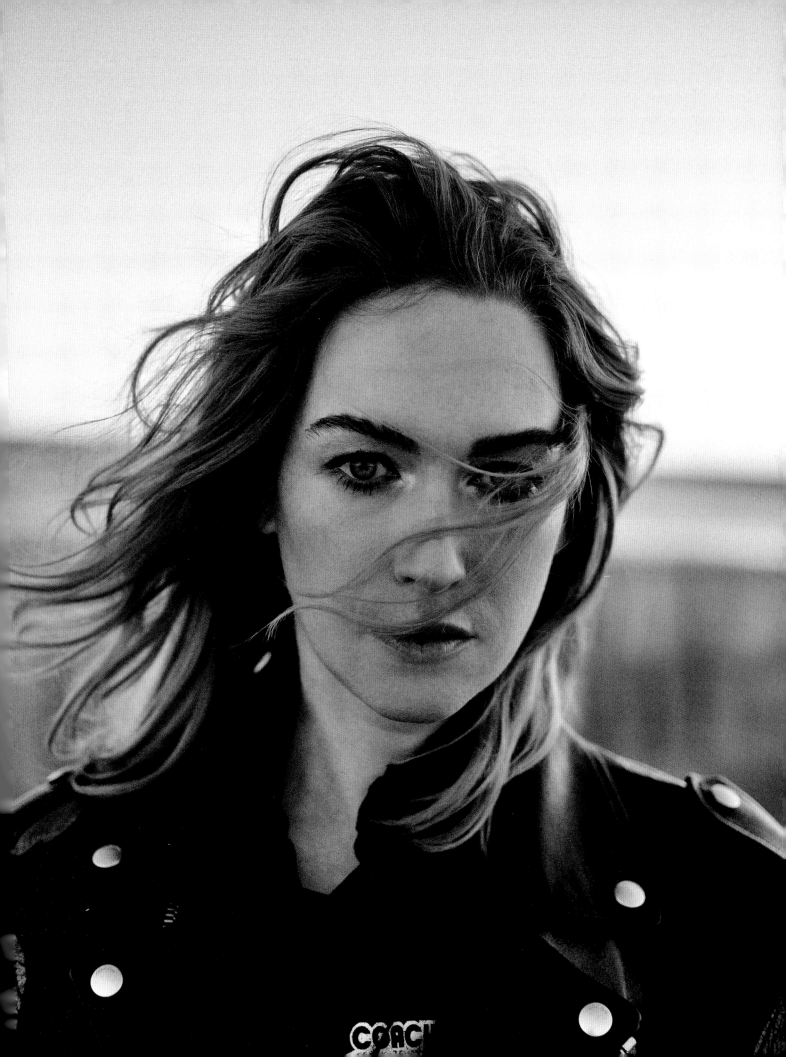

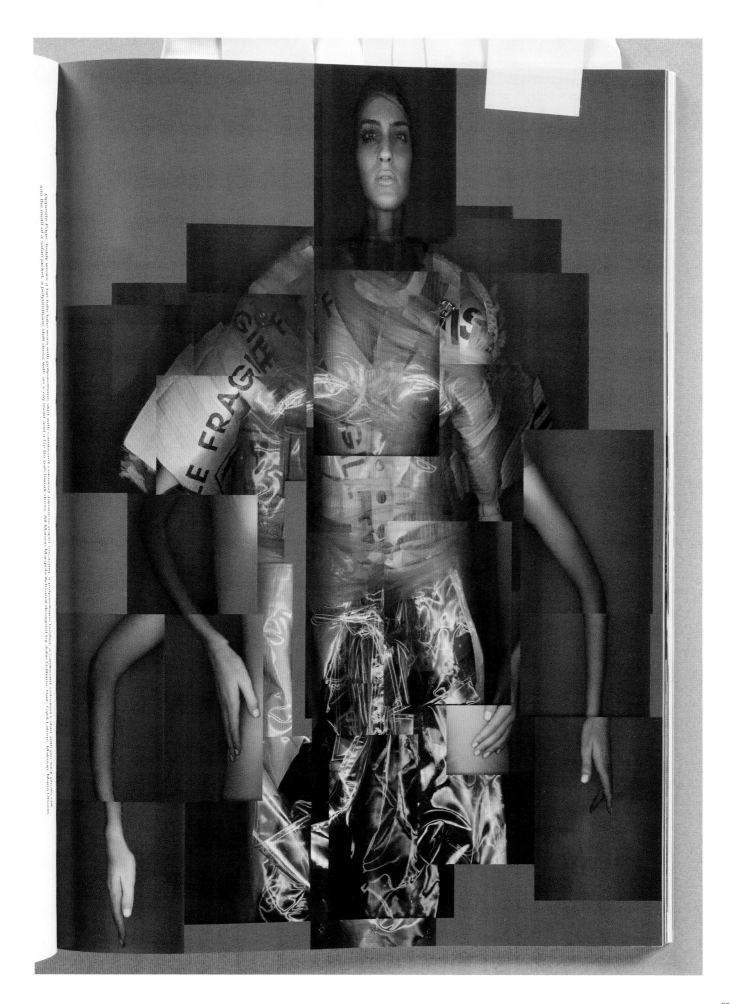

Opposite Page: Teddy wears a tan tulle tube, worn with polyurethane and softly cardboard-coloured Japanese paper encasing a polyurethane bustier, a cardboard-coloured shirt with pin-tuck pleats cut into the motif of a safari jacket, a polyurethane shift dress with an x-ray motif and a Go-Bo patchwork dress. All Maison Margiela Artisanal designed by John Galliano. Hair Cyril Laloue. Makeup Maria Olsson.

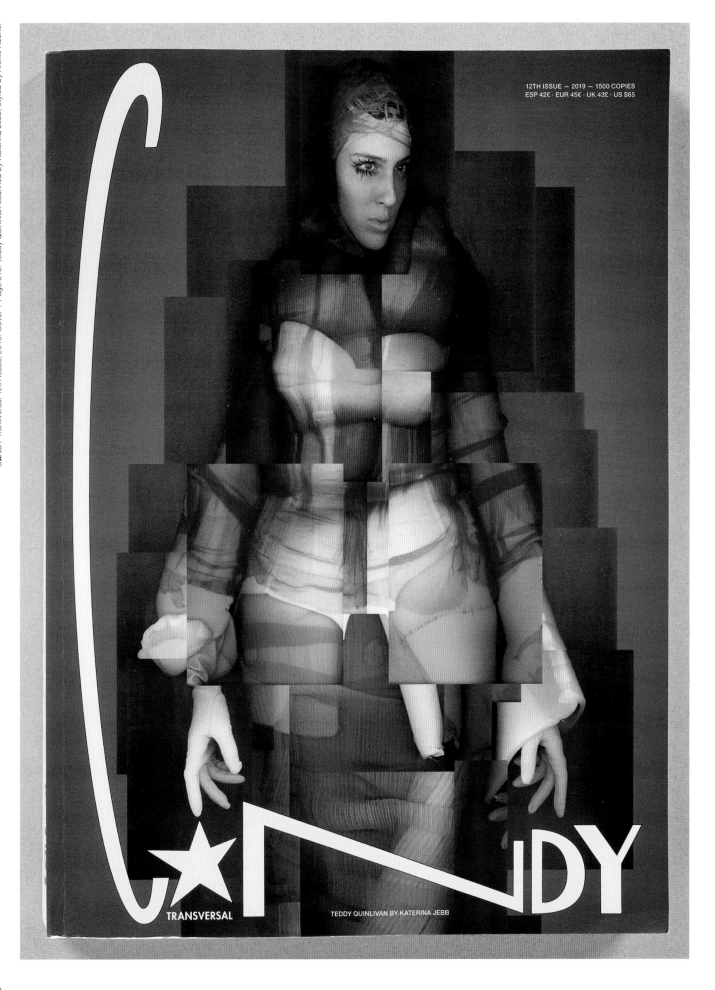

12TH ISSUE — 2019 — 1500 COPIES
ESP 42€ · EUR 45€ · UK 43£ · US $65

C★NDY

TRANSVERSAL

TEDDY QUINLIVAN BY KATERINA JEBB

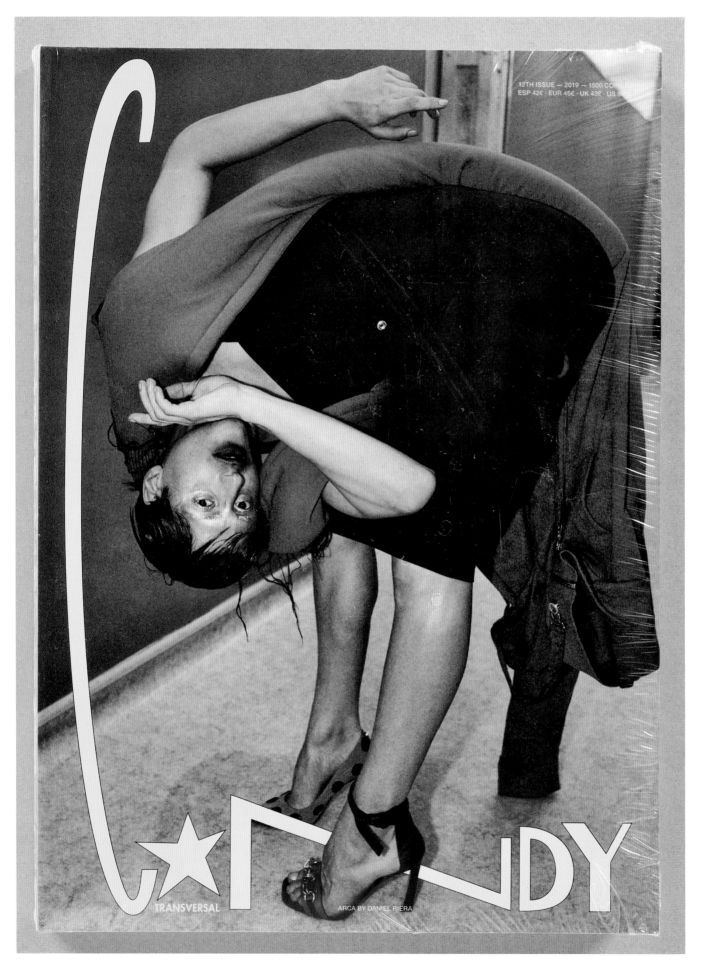

TRANSVERSAL ARCA BY DANIEL RIERA

C★NDY *Transversal* 12th Issue, 2019. Cover + Page 205. Arca photographed by Daniel Riera, styled by Alicia Padrón.

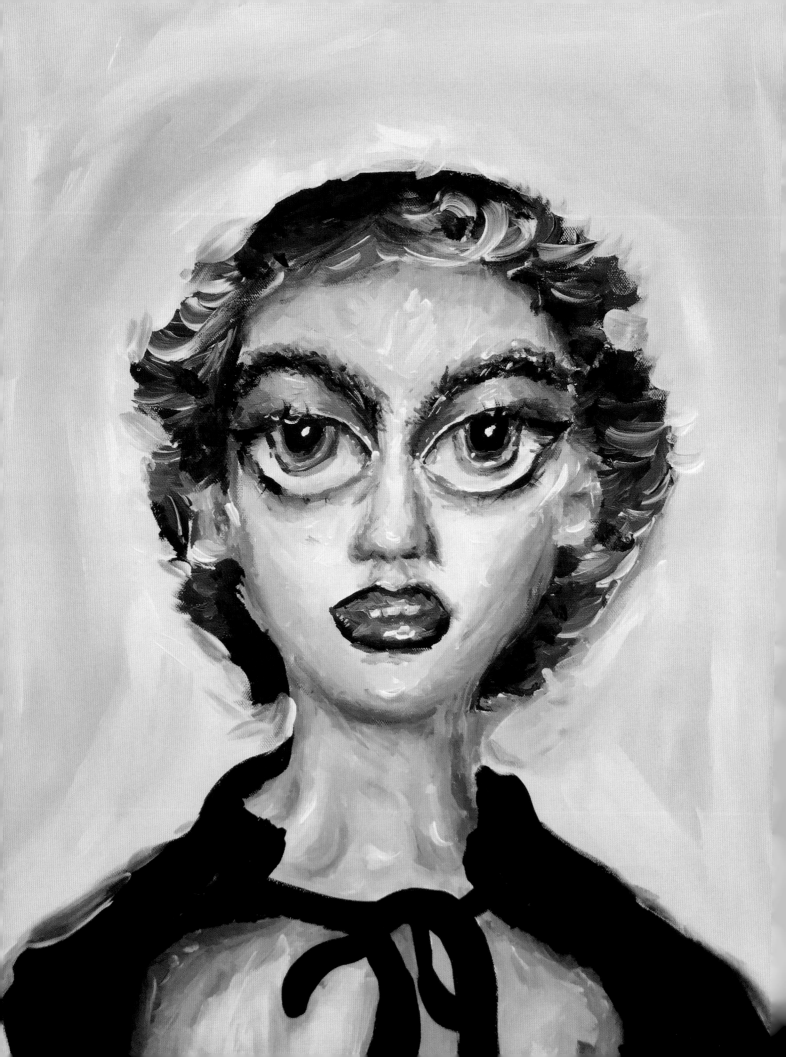

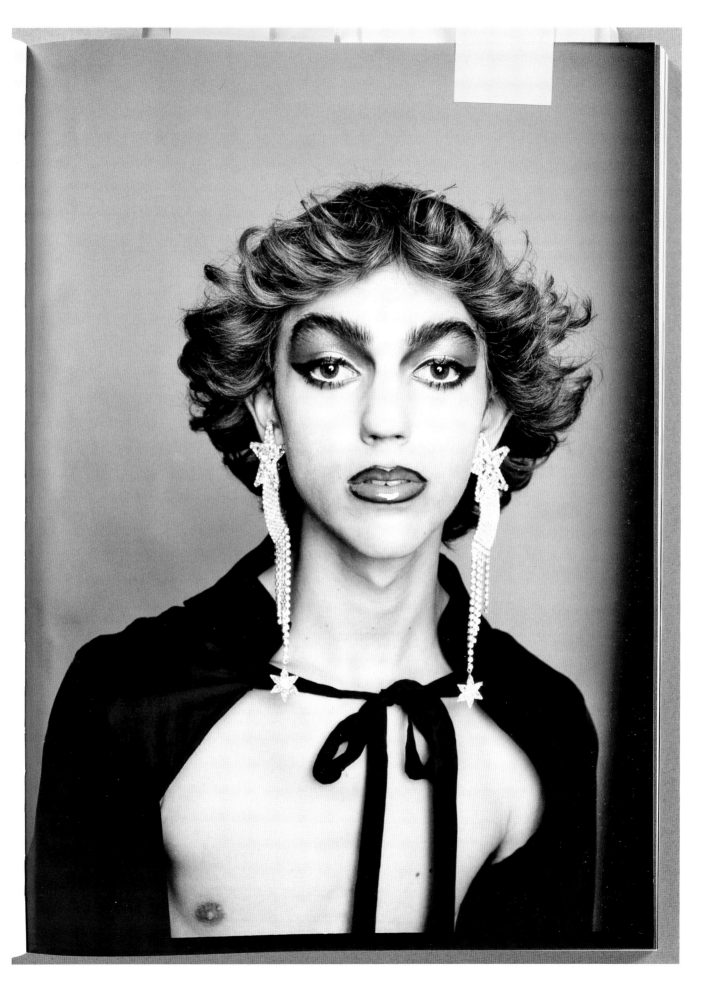

C★NDY Transversal 12th Issue, 2019. Page 289. Bryce Anderson photographed by Michael Bailey-Gates, styled by Djuna Bel. LEFT: Bryce Anderson's artwork inspired by their C★NDY Transversal 12th Issue cover.

What The Hell Does Transversal Mean, Anyway?

The first time I heard about C★NDY Transversal, a friend was scrolling through Facebook, turned to me and asked, "Did you hear about the fancy new trans magazine? Are you jealous?" This was in 2009 when Facebook was *the thing* to use. I immediately found the post on my laptop and clicked it open. Promoting the launch of C★NDY's inaugural issue, the article discussed this groundbreaking, hot-off-the-press "transversal" publication named after Candy Darling and promised extreme transness inside. The cover featured a dragged-up actor and was extra large in stature, expensive, glossy, and filled with exquisite work by famous fashion photographers and texts by celebrities—for the record: *Yes, I was jealous.* But what the hell did "transversal" mean, anyway?

One month earlier, I'd launched the first edition of my own print magazine, *Original Plumbing*. A 5-1/2 x 8 inch quarterly publication inspired by the intersection of zine culture and teen magazines, *OP* was kind of an opposite, funhouse mirror version of C★NDY. A few issues in, the national buzz we received exploded internationally when the *New York Times* featured *OP* in their fashion section, citing the zine's growing popularity in the "once silent" trans-male community. With this new attention, my world felt larger than before, slightly scary, and suddenly very public. I founded the first magazine in the United States of America to focus on trans-male culture and was immediately greeted with love and support— so why did C★NDY magazine, upon first glance, make me nervous and feel invisible?

Before launching *Original Plumbing*, my visual art was super inspired by photos in *BUTT* magazine. Their voyeuristic images were so personal, you felt like you were right there with the models (who were usually artists or non-models, another thing I loved). They celebrated bodies and diversity in the gay male community. And while I appreciated and adored projects like *BUTT*, at the same time, I felt scorned by the lack of trans-male representation in the media from both gay and non-gay periodicals alike. I launched *Original Plumbing* to house the photos I'd been taking of trans men in my San Francisco neighborhood because I wanted to carve out a space for guys like me. When I was behind the camera, my non-models would contort their bodies into teen-magazine positions with brightly colored backdrops showing off their favorite outfit, too-tight underwear, or often shirtless, scarred chests. I'd always pair their photographs with personal interviews. No one else was asking trans guys to share their stories, and I wanted *OP* to be that place by featuring photographs and voices of less-heard members of the LGBTQAI+ community. I didn't have a photo studio or a lighting kit, so I made my lack of professional access seem like an aesthetic choice and went with it. And it worked. My early photos had a raw, unedited quality to them that people gravitated towards. We had a fundraiser to print the first issue, and suddenly I was an "independent publisher." Making an authentic magazine that people cared about was a dream I'd had since I was a kid, back when I was coveting issues of *Sassy*, *huH*, and *Teen Beat*. The first issue of *OP*—an edition of one thousand— sold out in days. We doubled the run. A month later when I read about C★NDY for the first time, the jolt of protectiveness I felt around trans culture caught me by surprise.

Right off the bat, I wondered why a cisgender gentleman in Spain was making a magazine celebrating transness. To find out more about the guy behind C★NDY, I researched Luis Venegas and learned he was this independent-publishing fashion magazine hero in Madrid, around my age, with what looked like my dream career. He was prolific, known for producing periodicals on art, obsessions, and very attractive physiques. I quickly saw Luis wasn't just making a transgender magazine—he was making a project that both championed fashion and fucked with gender binaries. C★NDY was *his* dream like *OP* was mine. He wasn't trying to speak for the trans community, he was creating a project for *all*— especially anyone who felt othered by their freedom of expression. On the pages of C★NDY Transversal, he acknowledged queerness in fashion, highlighted people all-but-forgotten in LGBTQ history, and introduced an audience to up-and-comers who were changing the landscape of art, music, runway, and trans culture—and he did it with a glamorous twist. C★NDY was beautiful.

Luis worked hard. He'd studied with mentors in the print-fashion industry, and his biggest love since childhood was the fashion magazine. My biggest love was the teen magazine (and still is). I saw how different yet similar our paths were and felt silly for assuming someone I didn't even know shouldn't be "allowed" to create a project like C★NDY. I immediately reached out to introduce myself because I felt we should know each other. I wanted to be his friend! At this point, trans representation in printed media was virtually nonexistent. Luis and I had two of the only magazines with trans-leaning content produced on an artistic level during what felt like a turning point in culture. We were at the helm of something.

Not long after Luis and I connected, he asked if I'd like to interview a trans man for the second issue of C★NDY. He found a handsome guy named Scout Rose who he thought perfect for a fashion story he had in mind. I already knew Scout and was elated to conduct the interview and also for the opportunity. Since then, I've gone on to contribute to almost every issue, including an interview with Miley Cyrus and a profile on musician (and now *Grey's Anatomy* actor) Alex Blue Davis. In the 2014–15 edition, I appeared in a fashion story about trans men in New York City that was photographed by Daniel Riera; and in 2017, I photographed actor Elliot Fletcher in the Hollywood Hills. It was a dream come true to see my portraits full-bleed in C★NDY *Transversal*. I respect how Luis continues to find value in having a trans man interview or photograph another transmasculine person, proving he appreciates the nuance this type of relationship can add to an already diverse publication.

When there are so few things in the world that represent an identity or community, it makes the projects that *do* exist extra important. That's a lot of pressure for something that holds a purpose to entertain, inspire, and explore beauty. It can kill a project or negate the mission statement. Scarcity issues, for many trans people, are real and valid. Acknowledging the danger trans people—especially trans women of color—face simply by existing is necessary. These were some of the thoughts I grappled with when I first heard about C★NDY. But at that time, I didn't realize that I was experiencing the same thing when I launched *Original Plumbing*. People were quick to judge, most often those who didn't even bother to pick up the magazine before forming their critique. All I was trying to do was make a fun publication that championed the light, sexy, and truthful parts of being trans. I hoped *OP* would make the world a little more understanding, but things were changing quicker than I realized. There was—and always should have been—room to showcase trans experiences on a glossy, high-fashion pedestal. There was *always* enough space for both of our projects, just as there is space for a million more.

I swiftly came full circle to love and appreciate not only C★NDY *Transversal* but also Luis. We now have a long-working relationship and a supportive friendship that I'm grateful for. And although we have yet to meet in person outside of Skype or email, I see him as my brother in Madrid. He embraced me as an artist and contributor back when our projects were babies. Now we move through the world with snorting, flat-faced dogs by our side and continue to create work as the world evolves. In 2009, we both spearheaded trans-embracing publications, our unique artistic directions splashed across every page. With a desire to tell stories through photographs and essays, we created separate independent magazines, both distinctly different, both out of love. And in a time when print was apparently dying, and it felt like the world was telling us there would never be room for projects like ours, we both succeeded.

AMOS MAC
Artist, writer, founding editor of *Original Plumbing* magazine

C★NDY *Transversal* 11th Issue, 2018. Page 68. Elliot Fletcher photographed by Amos Mac, styled by Love Bailey. RIGHT: Lorena Prain's artwork inspired by Elliot Fletcher by Amos Mac's C★NDY *Transversal* 11th Issue cover.

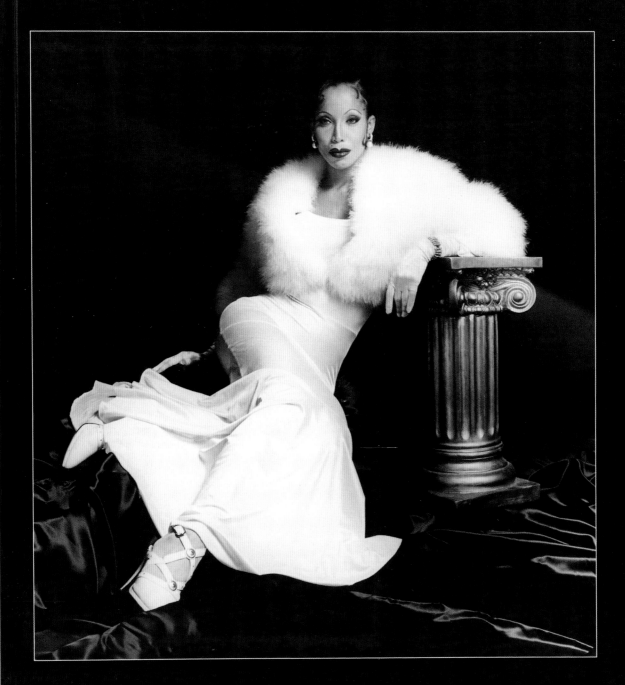

C✩NDY *Transversal* 11th Issue, 2018. Cover. Octavia Saint Laurent photographed by Brian Lantelme, New York City, 1995.

11TH ISSUE — 2018
1500 COPIES
ESP 42€ · EUR 45€ · UK 43£ · US $65

OCTAVIA SAINT LAURENT PHOTOGRAPHED BY BRIAN LANTELME

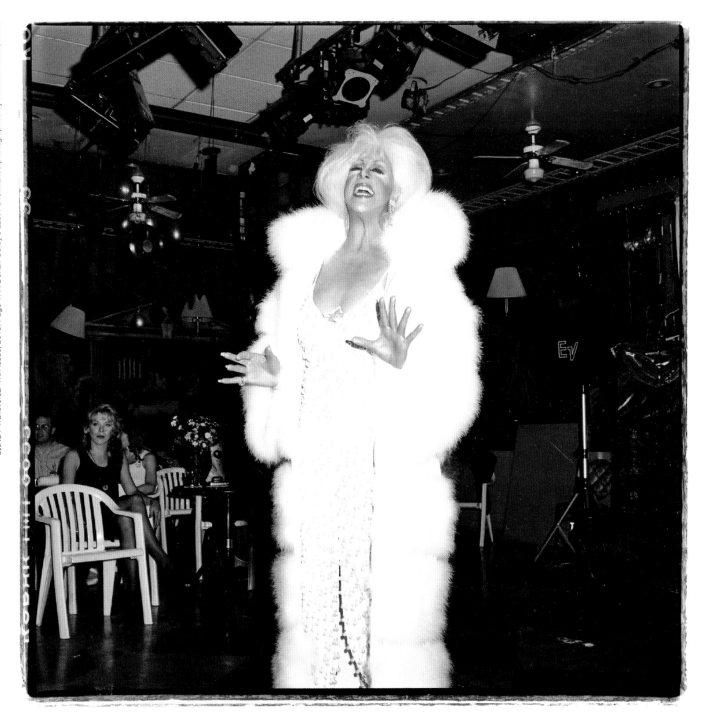

Octavia Saint Laurent and I were very close. She used to say I was
the "Octavia of the photography world," which I took as a great compliment.
Octavia was one of the leading lights of the ball world and one
of the greatest beauties, both inside and out, to ever walk the balls.

—
BRIAN LANTELME in conversation with Sunny Suits
C★NDY Transversal 11th Issue, 2018

Onjenee, 1991

C★NDY Transversal 11th Issue, 2018. Pages 464-465. Onjenae photographed by Brian Lantelme, 1991. RIGHT: Roberta Marrero's artwork inspired by Octavia Saint Laurent by Brian Lantelme's C★NDY Transversal 11th Issue cover.

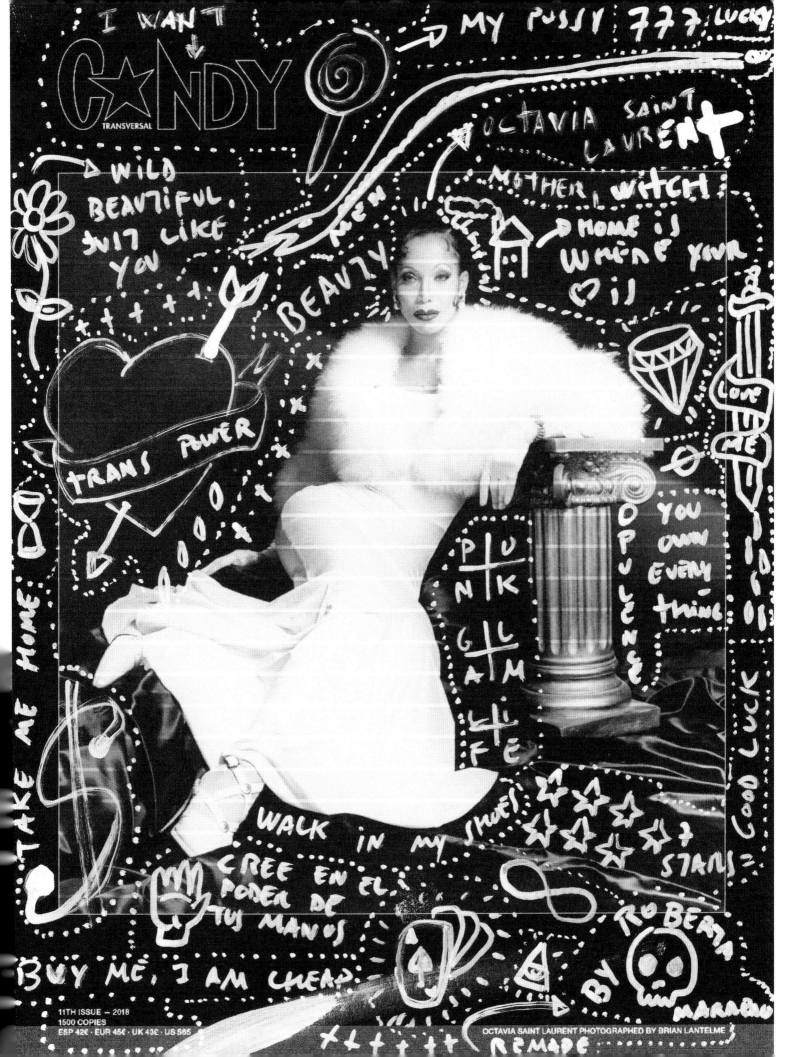

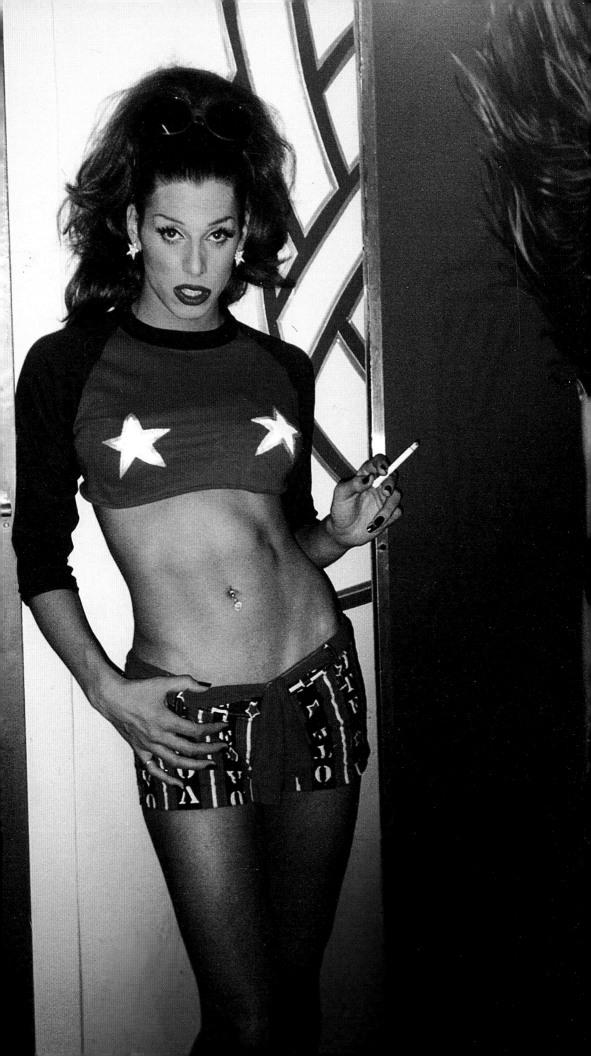

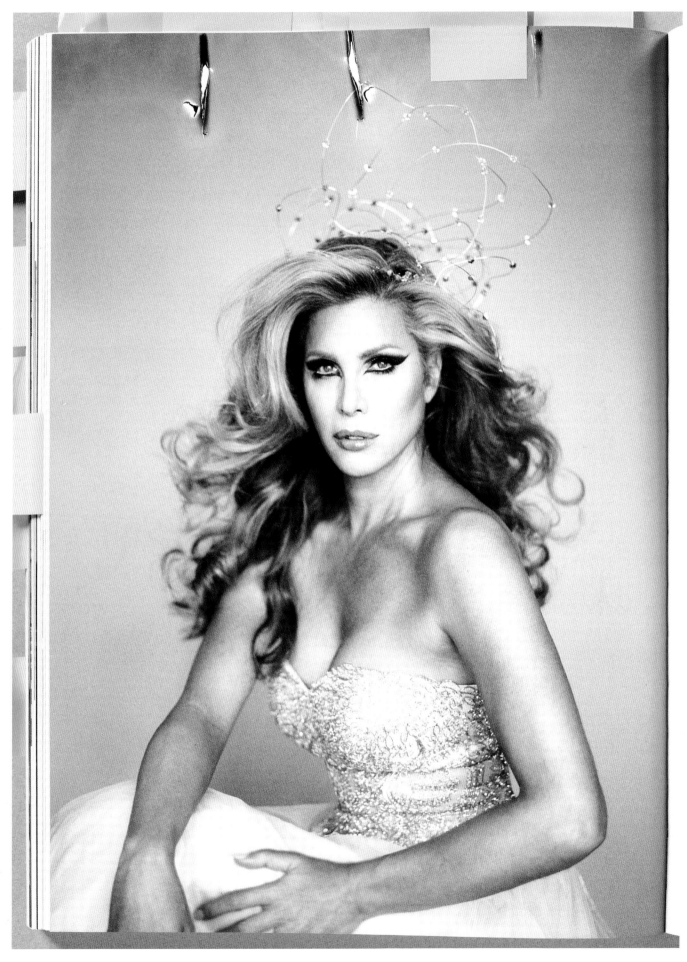

C★NDY *Transversal*/ 11th Issue, 2018. Page 440. Candis Cayne photographed by Michael Bailey-Gates, styled by Djuna Bel. RIGHT: Unpublished photograph of Candis Cayne shot by Linda Simpson, New York City, 1995.

53

G★NDY *Transversal* 11th Issue, 2018. Page 461. Michael Bailey-Gates self-portrait, styled by Djuna Bel.

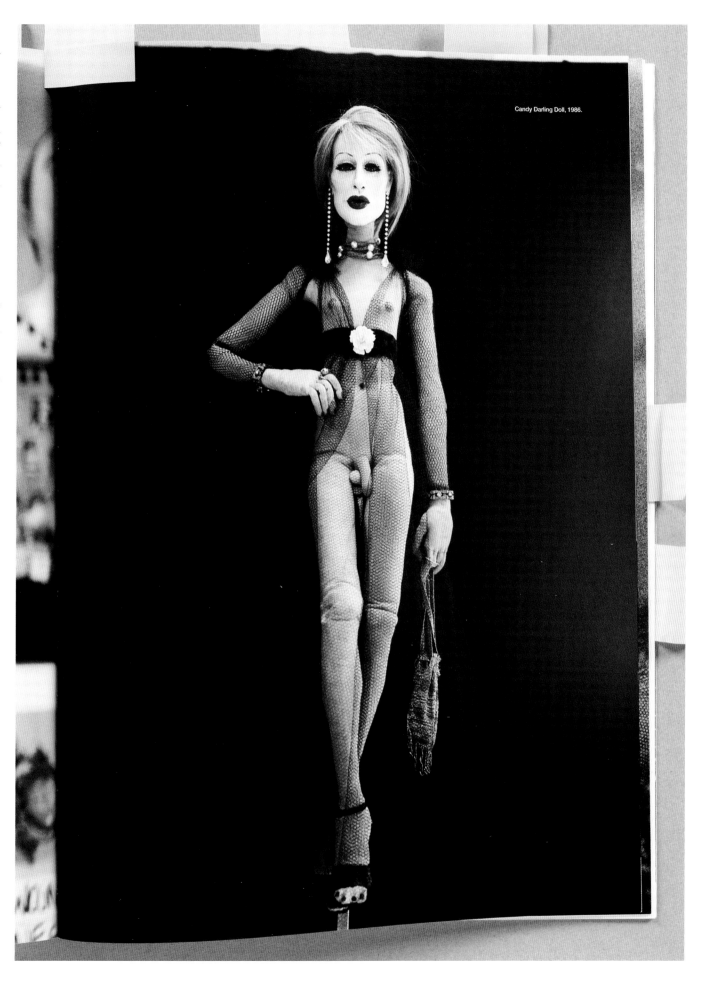

Candy Darling Doll, 1986.

C★NDY *Transversal* 11th Issue, 2018. Page 463. Candy Darling Doll, 1986. Greer Lankton's sculpture photographed by Michael Bailey-Gates.

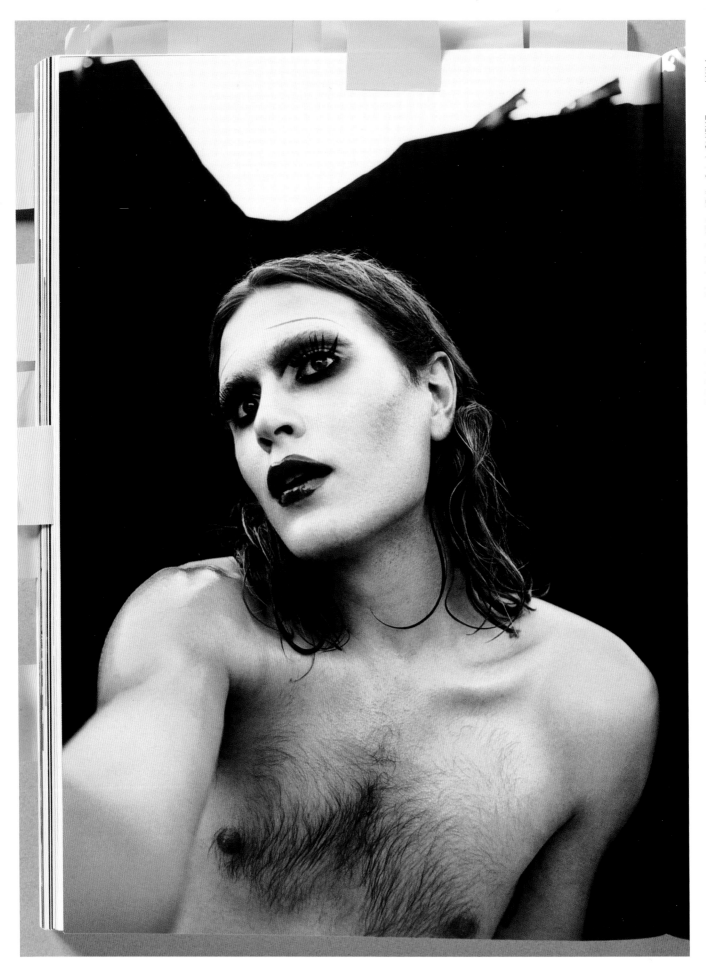

C★NDY *Transversal* 11th Issue, 2018. Page 438. Michael Bailey-Gates self-portrait, styled by Djuna Bel. RIGHT: Christian Lacroix's artwork inspired by the Michael Bailey-Gates's C★NDY *Transversal* 11th Issue cover.

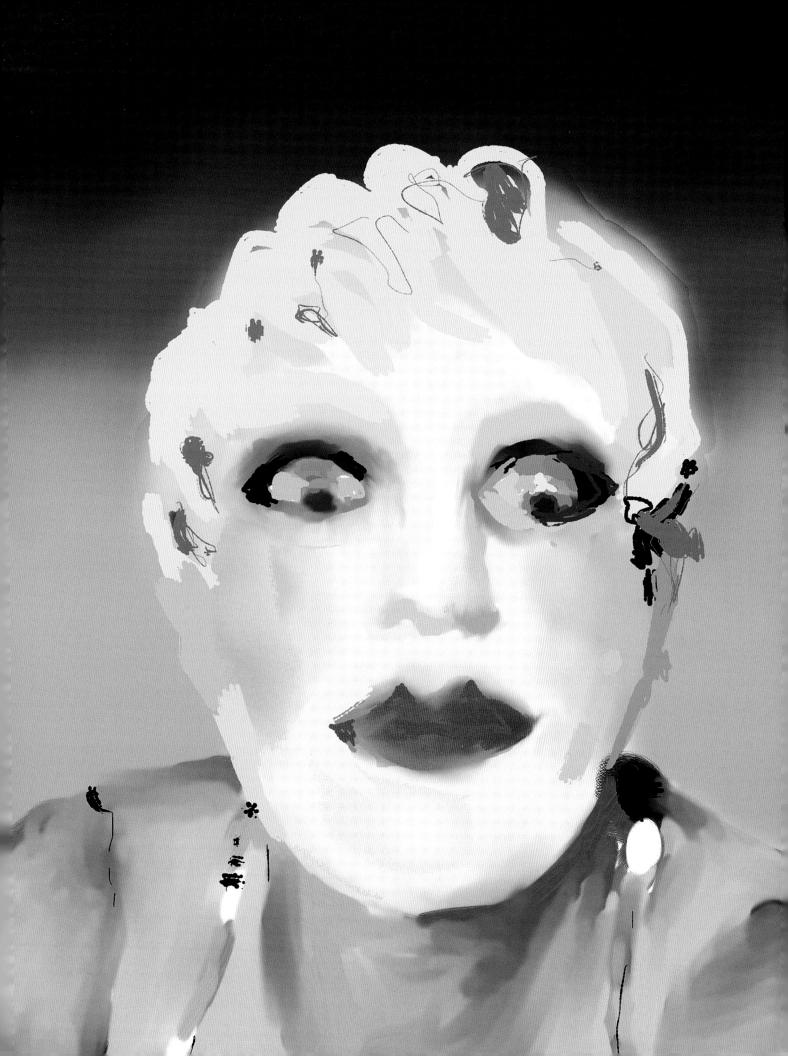

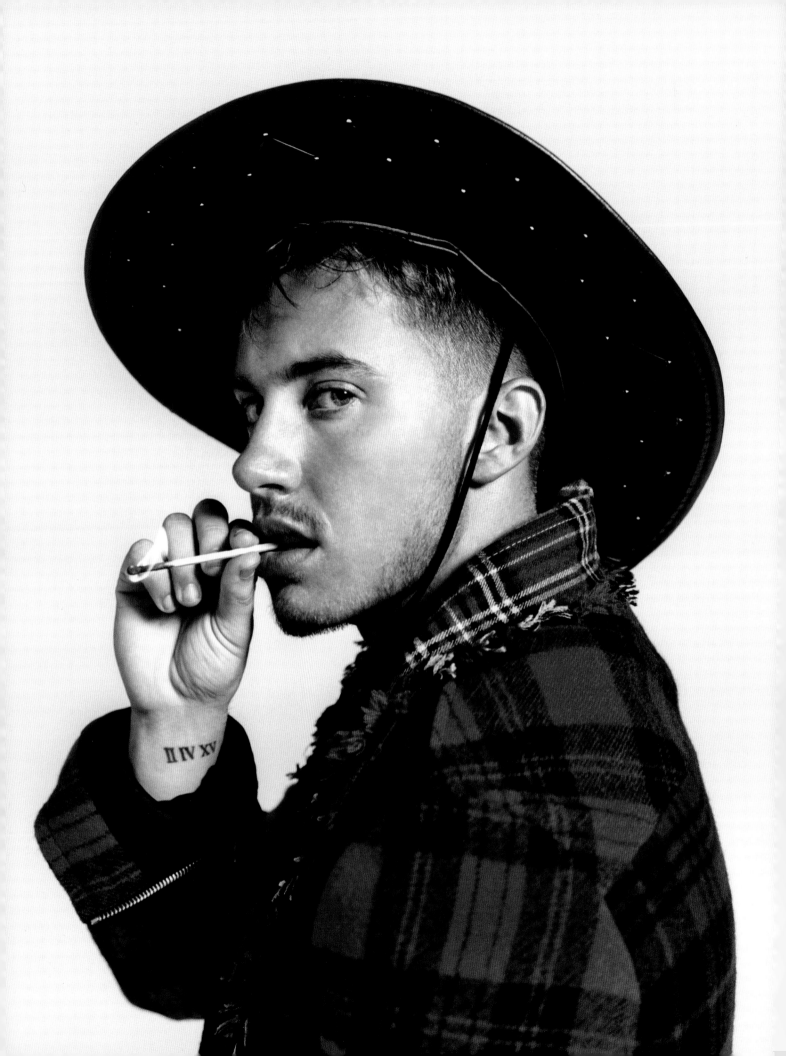

C★NDY Transversal 11th Issue, 2018. Pages 340-341. Adam Eli Werner and Madison Werner photographed by Thomas McCarty, styled by Ian Bradley.
LEFT: Unpublished photograph of Jaimie Wilson shot by Thurstan Redding and styled by Rúben Moreira for C★NDY Transversal 11th Issue, 2018.

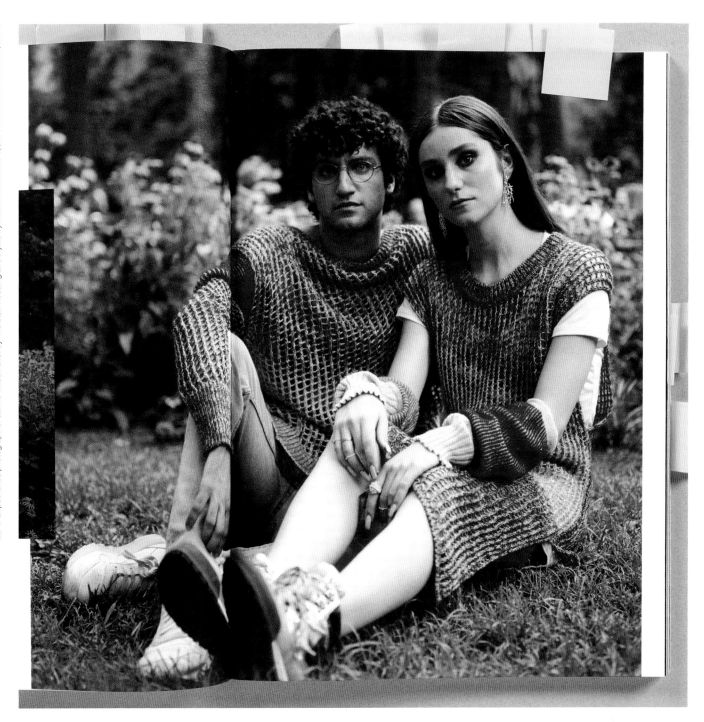

I am proud of how I took what was in my head, my dream life, and made it into a reality. And not just a private reality. A reality that I could share with other people.

—

MADISON WERNER in conversation with Adam Eli Werner
C★NDY Transversal 11th Issue, 2018

CANDY Transversal 11th Issue, 2018. Page 317. Rain Dove photographed by Cole Sprouse, styled by Gro Curtis.

CANDY *Transversal* / 11th Issue, 2018. Page 229. Dora Diamant photographed by Camille Vivier, styled by Leopold Duchemin.

Dora Diamant wears an Issey Miyake Pleats Please top, stylist's own jacket.

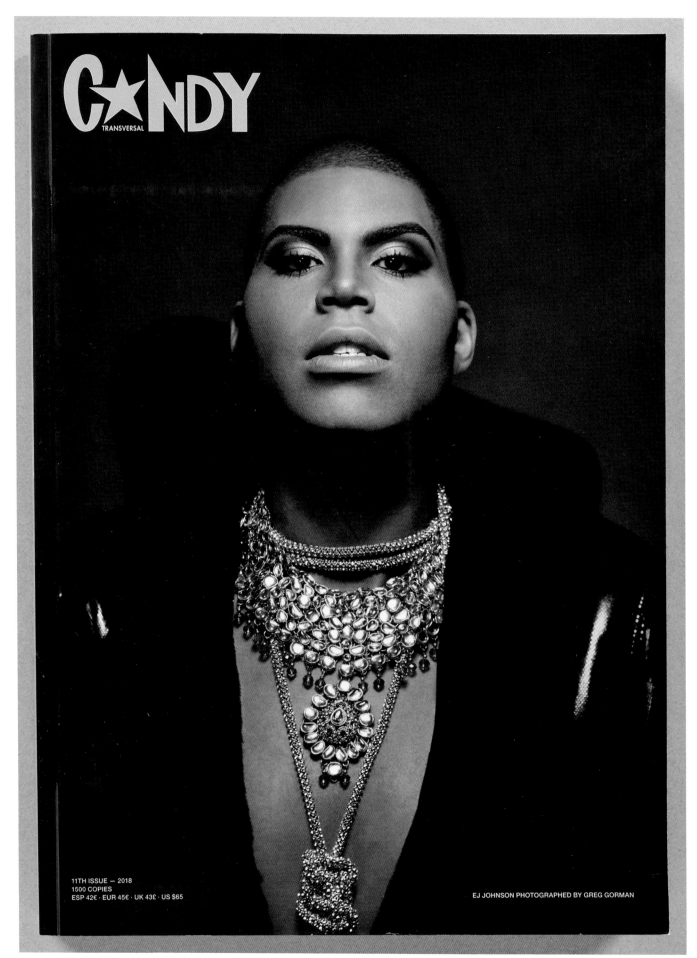

C★NDY *Transversal*/ 11th Issue, 2018. Cover. EJ Johnson photographed by Greg Gorman, styled by Love Bailey.

C★NDY
TRANSVERSAL

11TH ISSUE — 2018
1500 COPIES
ESP 42€ · EUR 45€ · UK 43£ · US $65

EJ JOHNSON PHOTOGRAPHED BY GREG GORMAN

C★NDY Transversal, 11th Issue, 2018. Pages 352–353, 356–357. Luis Mba and Pol Roig photographed by Biel Capllonch, styled by Marc Sebastian Faiella. Text by Dan Thawley.

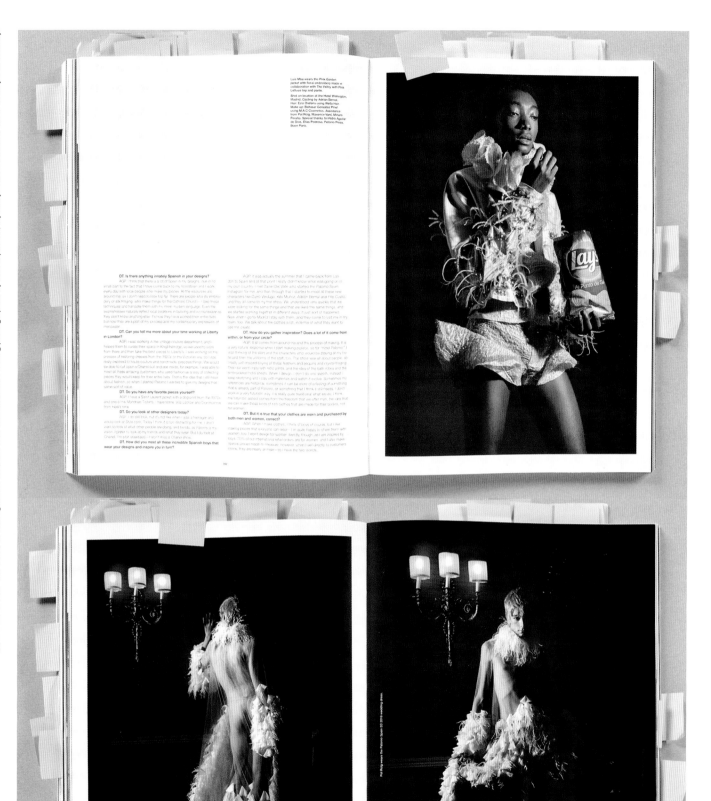

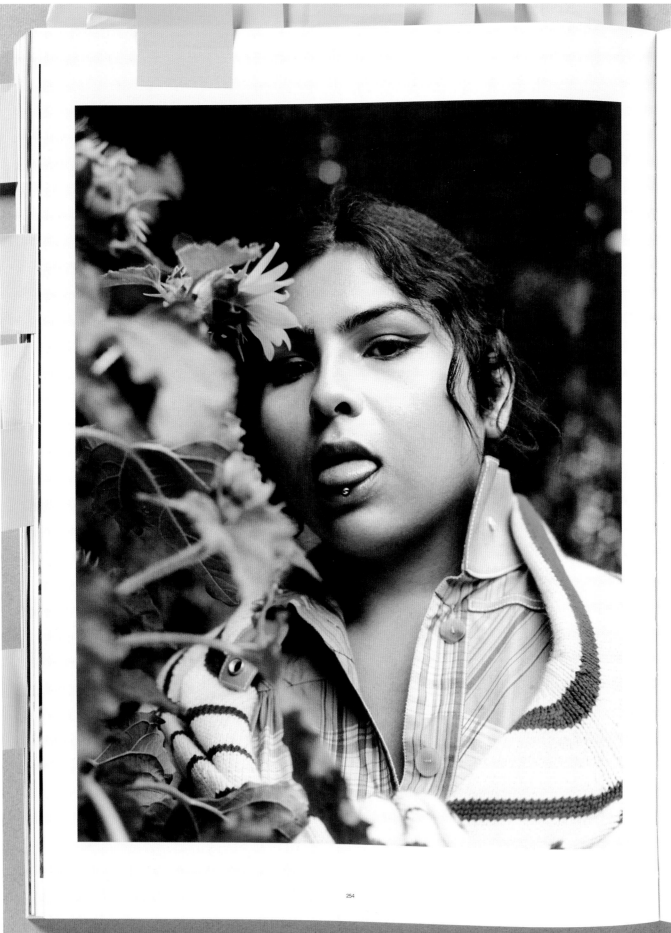

CANDY Transversal 11th Issue, 2018. Page 254. Ser Serpas photographed and styled by Matt Holmes. RIGHT: Kris Knight's artwork inspired by Hari Nef by Matt Holmes's CANDY Transversal 11th Issue cover.

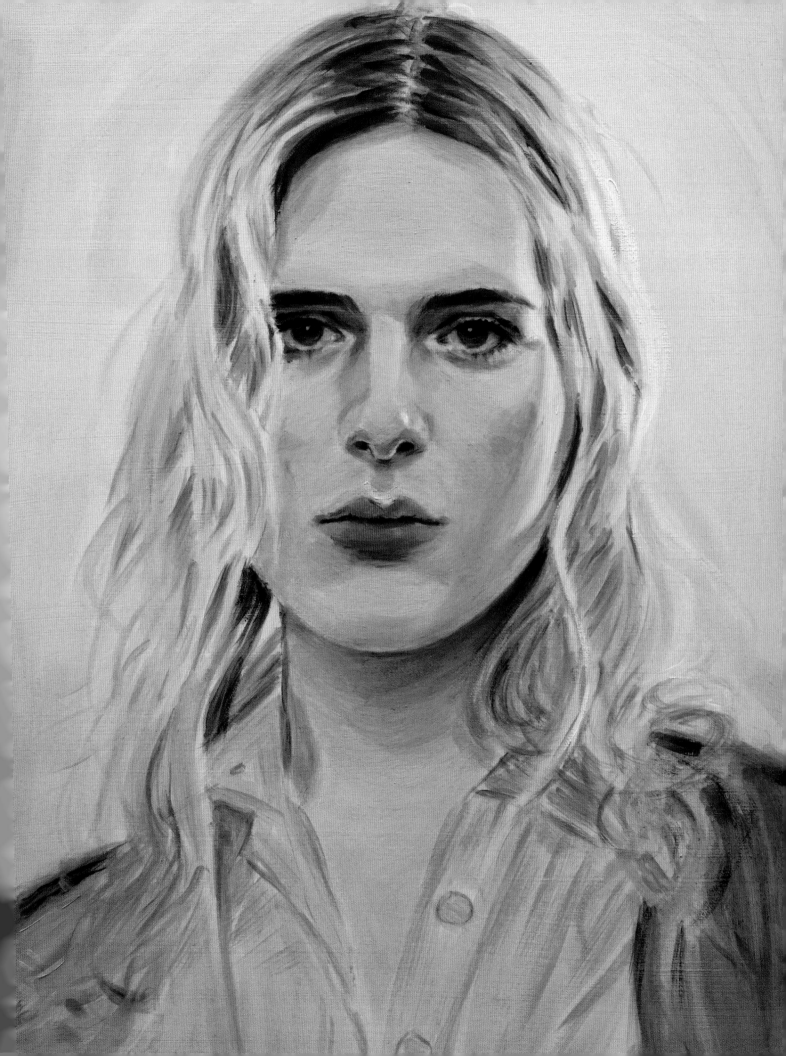

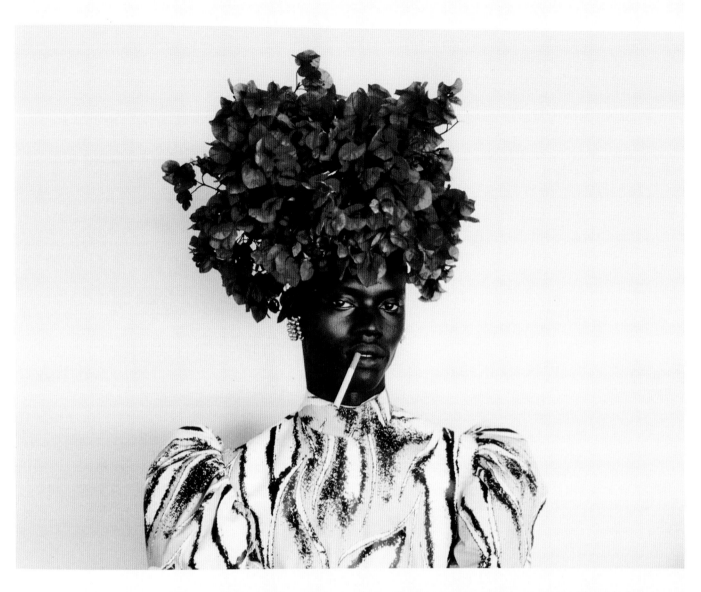

C★NDY *Transversal* 11th Issue, 2018. Page 295. Joseph Ntahilaja photographed by Kristin-Lee Moolman, styled by Ibrahim Kamara.

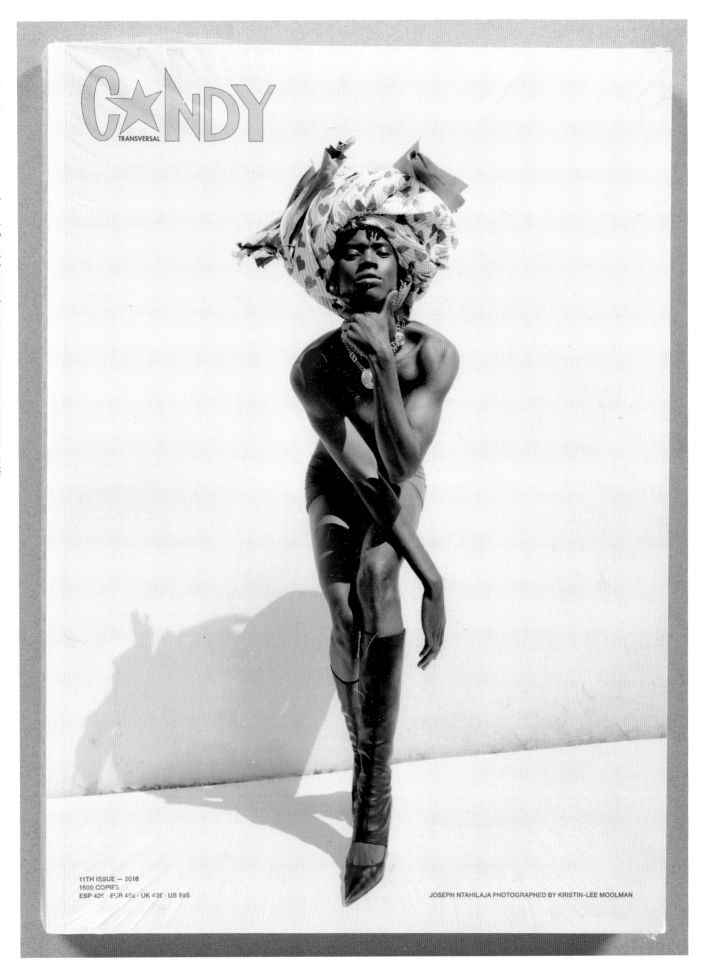

11TH ISSUE — 2018
1500 COPIES
ESP 42€ · EUR 45€ · UK 43£ · US $65

JOSEPH NTAHILAJA PHOTOGRAPHED BY KRISTIN-LEE MOOLMAN

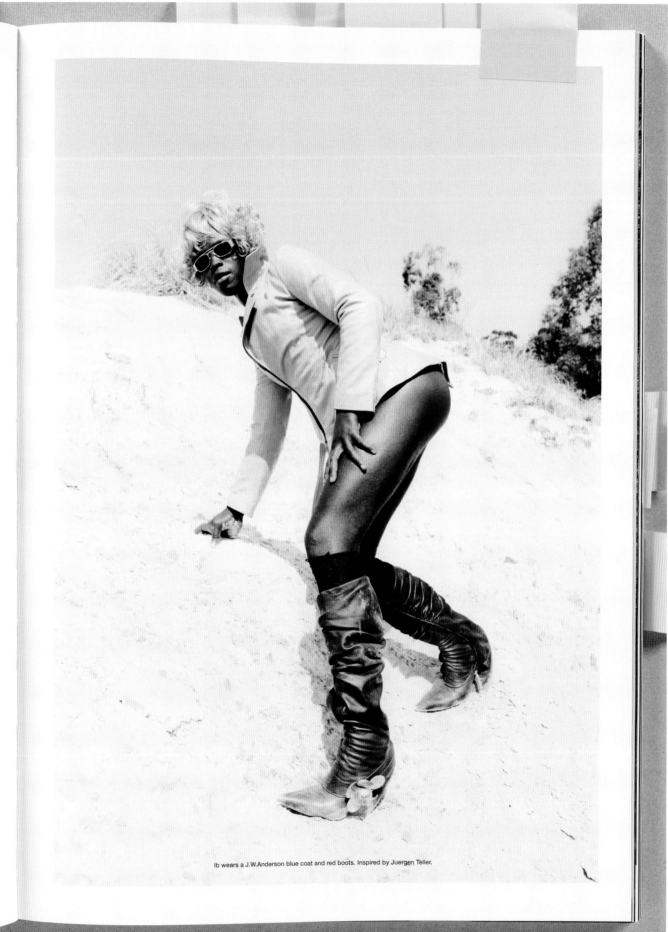

Ib wears a J.W.Anderson blue coat and red boots. Inspired by Juergen Teller.

C★NDY *Transversal* 11th Issue, 2018. Page 303. Ibrahim Kamara photographed by Kristin-Lee Moolman.

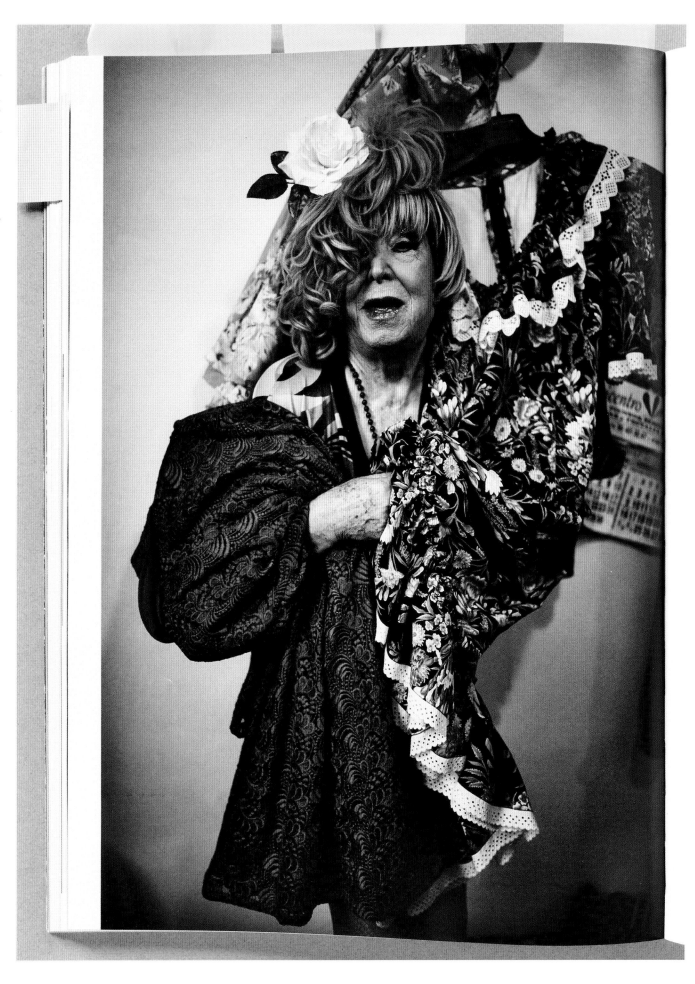

CANDY *Transversal* 11th Issue, 2018. Page 134. Violeta La Burra photographed by Daniel Riera.

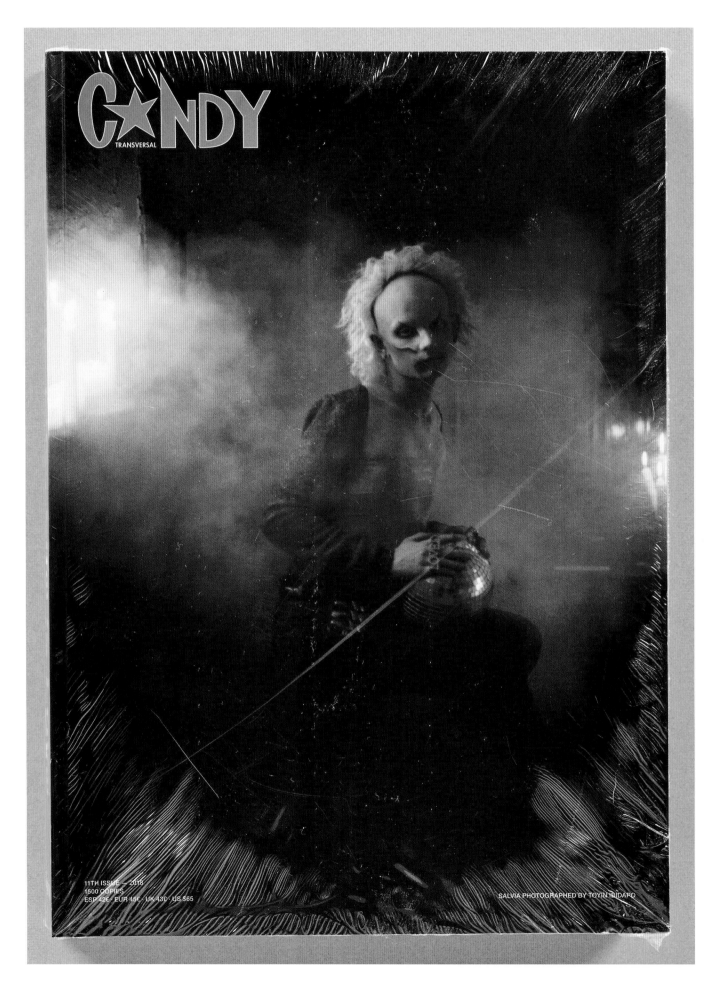

C★NDY

TRANSVERSAL

11TH ISSUE — 2018
1500 COPIES
ESP 42€ · EUR 45€ · UK 43€ · US $65

SALVIA PHOTOGRAPHED BY TOYIN IBIDAPO

C★NDY Transversal 11th Issue, 2018. Cover. Salviia photographed by Toyin Ibidapo, styled by Tara St. Hill.

GANDY Transversal/ 11th Issue, 2018. Page 86. Charles Pierce photographed by Rocky Schenck, late 80s.

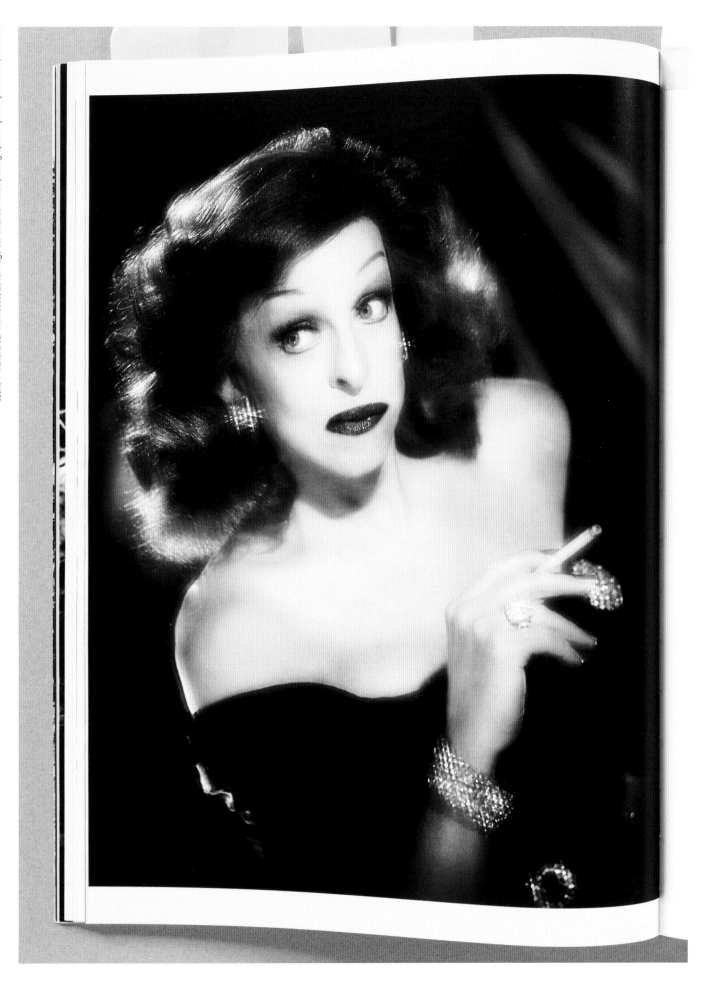

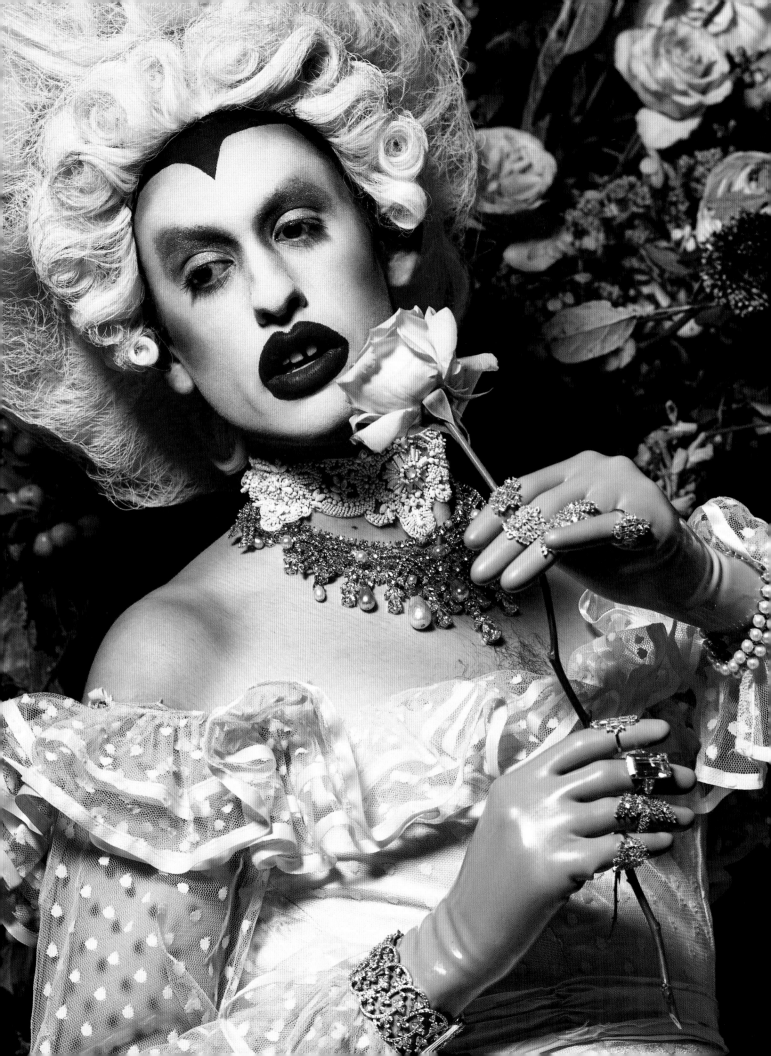

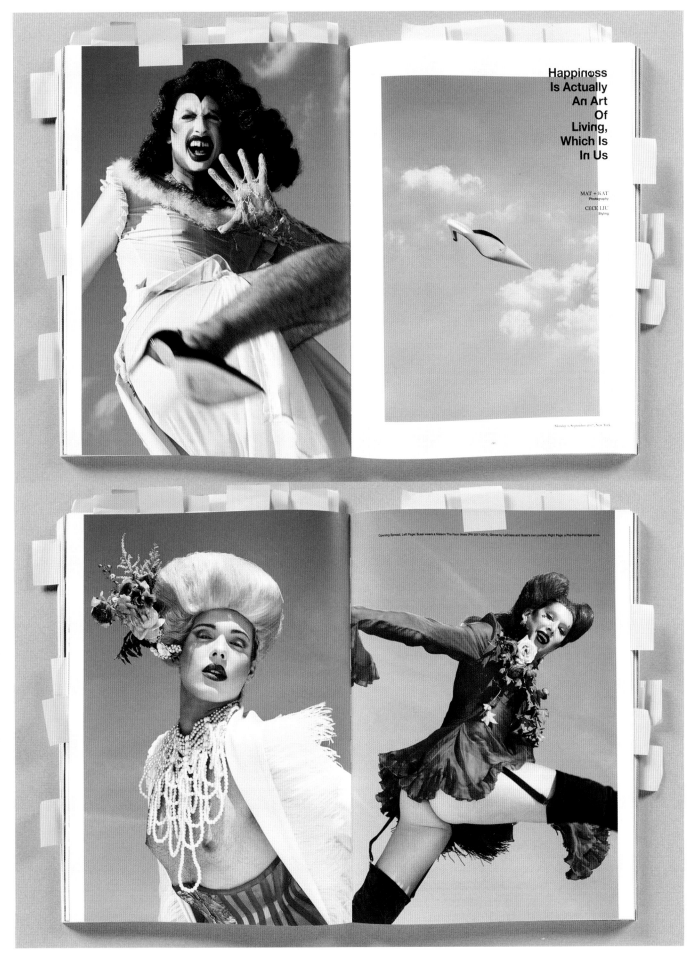

C★NDY Transversal 11th Issue, 2018. Pages 232–235. Sussi, Harry Charlesworth and Love Bailey photographed by Mat + Kat, styled by Cece Liu. LEFT: Unpublished photograph of Sussi shot by Mat + Kat for C★NDY Transversal 11th Issue, 2018.

Happiness
Is Actually
An Art
Of
Living,
Which Is
In Us

MAT + KAT
Photography

CECE LIU
Styling

Opening Spread, Left Page: Sussi wears a Maison The Faux dress (FW 2017-2018), Gloves by LaCrasia and Sussi's own pumps; Right Page: a Pre-Fall Balenciaga shoe.

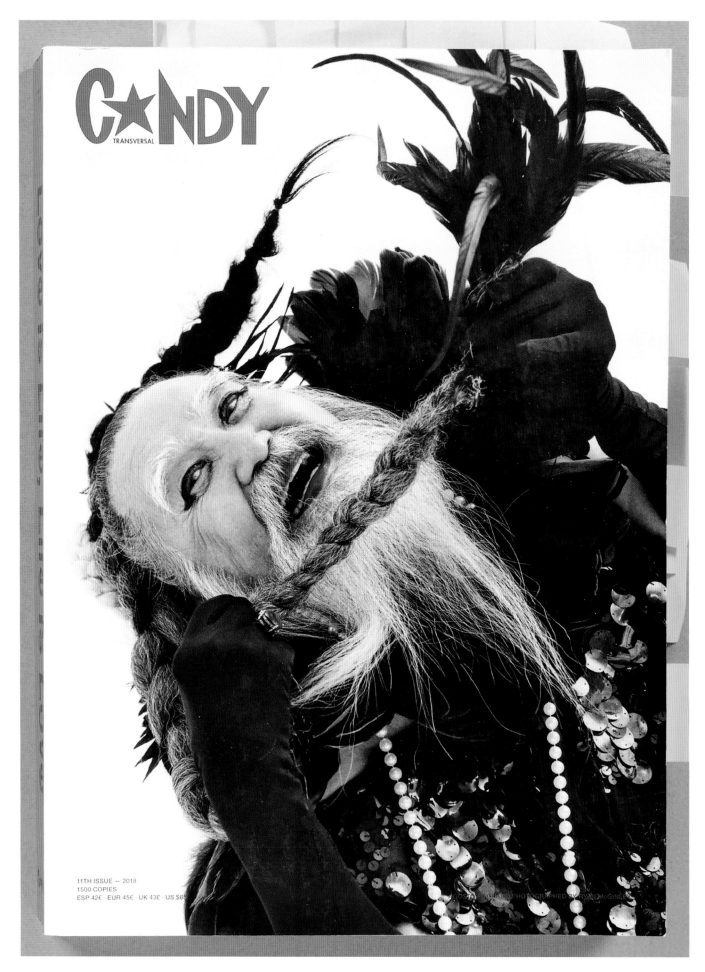

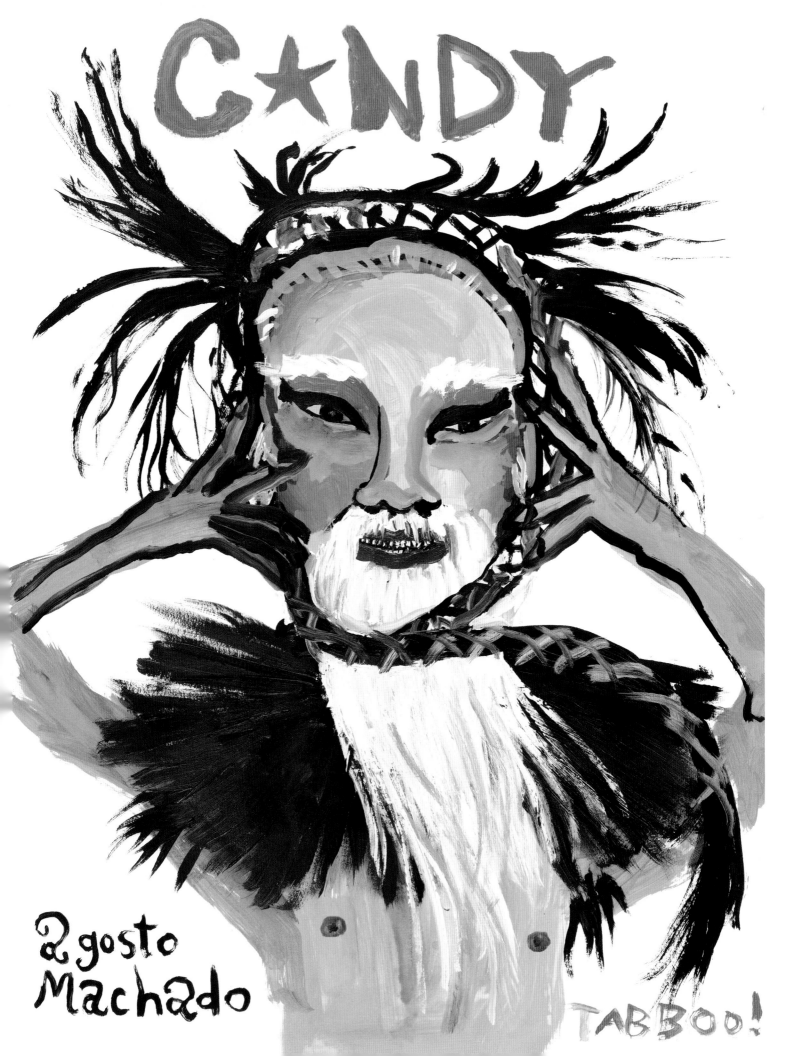

Dear Luis,

Belated Happy New Year 2018.
You deserve much congratulations
and thank you for your talent +
generosity of "Candy", magazine,
which is one of the most important

Wishing You
Peace, Joy, and
Love. by
health continued
successes + happiness

art book in the world. It is a great
honour to be one of the covers and with
great artist sharing the pages.
Gracias adios
Blessings + love, Machado

P.S. King Neptune needs help
in keeping our oceans clean.

Photo and styling by John Hoge and Glen Santiago

AGOSTO MACHADO

SPAIN

00117-0001

CANDY Transversal 11th Issue, 2018. Page 57. Agosto Machado photographed by Ryan McGinley, styled by Tabboo! and Jimmy Paul. LEFT: Letter sent to Luis Venegas by Agosto Machado after his feature in CANDY Transversal 11th Issue, 2018.

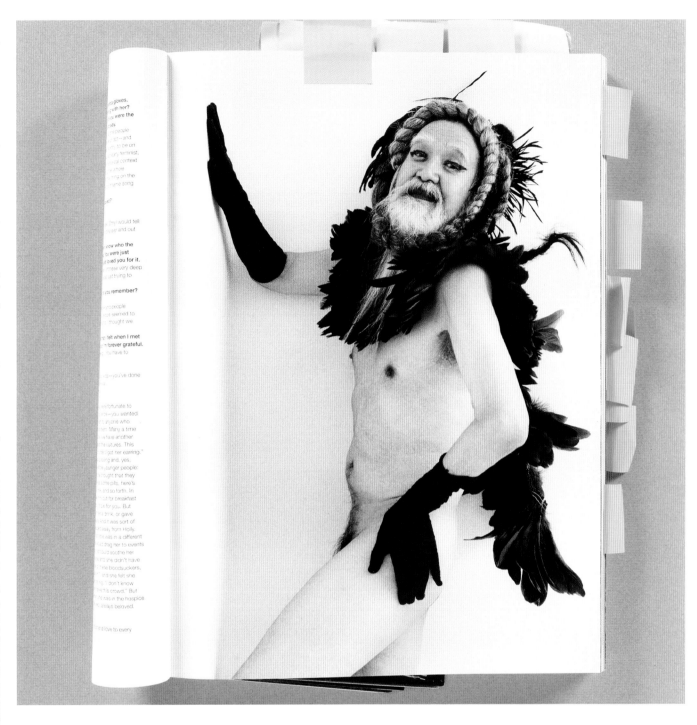

I am so excited, I can't tell you. I really think it was one of the great days of Agosto's life. He said he felt like Veruschka!!!

—
Private email sent by hairstylist JIMMY PAUL
to Luis Venegas on September 6, 2017, after shooting Agosto Machado

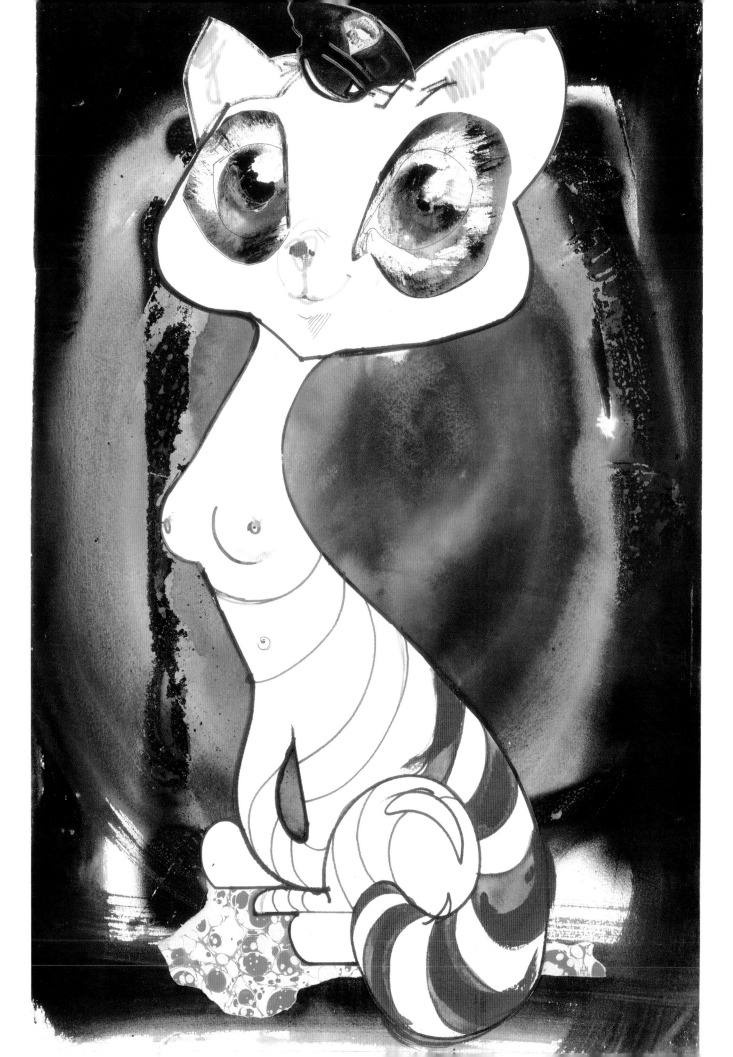

Hari Nef by Nan Goldin

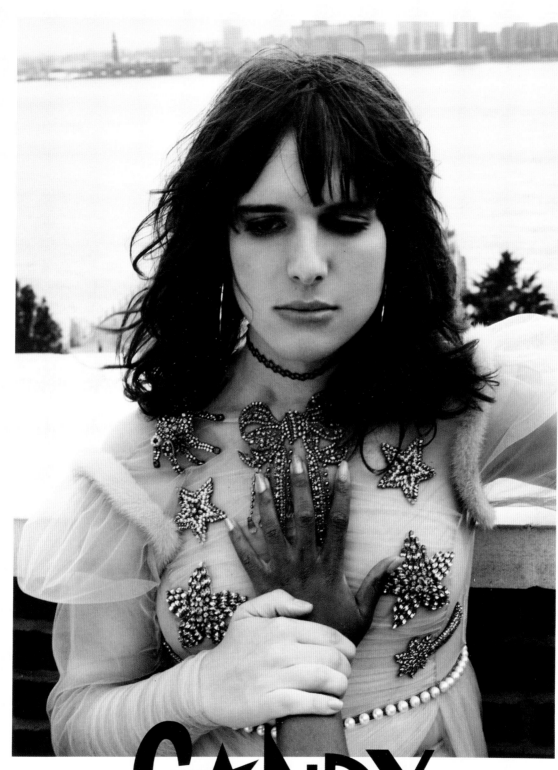

C☆NDY
TRANSVERSAL

ESP 42€ · EUR 45€
UK 43£ · US $65

10TH ISSUE
2017
1500 COPIES
LIMITED EDITION

**HARI NEF
GUEST EDITOR**

Searching For Magic Hour

NAN GOLDIN
Photography

MATT HOLMES
Styling

Tuesday 28 and Wednesday 29, June 2016, New York City

All clothes Gucci Pre-Fall 2016 and FW 2016-2017
(unless specified)

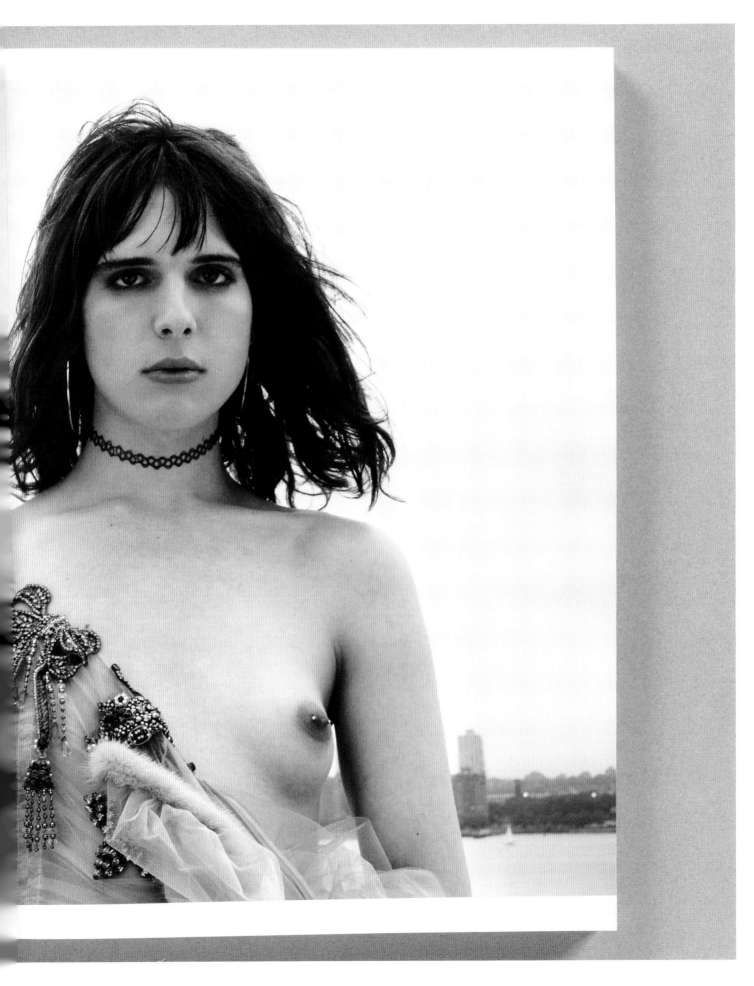

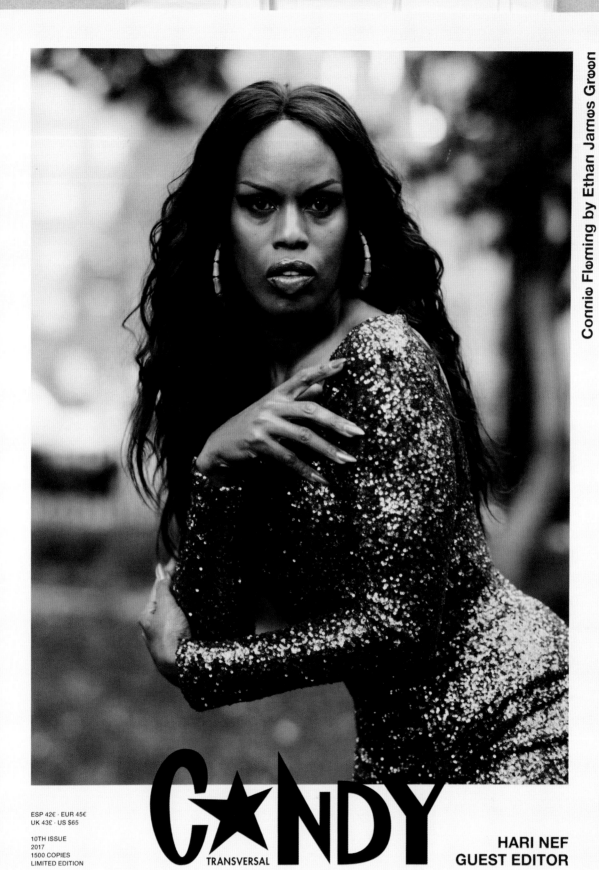

Connie Fleming by Ethan James Green

C★NDY *Transversal*/ 10th Issue, 2017. Cover. Connie Fleming photographed by Ethan James Green, styled by Matt Holmes.

ESP 42€ · EUR 45€
UK 43£ · US $65

10TH ISSUE
2017
1500 COPIES
LIMITED EDITION

C★NDY
TRANSVERSAL

**HARI NEF
GUEST EDITOR**

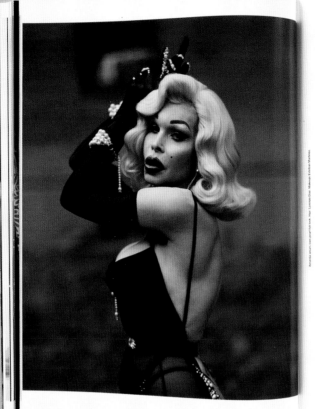

Pioneers

ETHAN JAMES GREEN
Photography

MATT HOLMES
Styling

Texts written by
DEVAN DIAZ
and edited by
JAMIE BERROUT

Thursday 20, Tuesday 21 and Wednesday 22, June 2016, New York City

AMANDA LEPORE

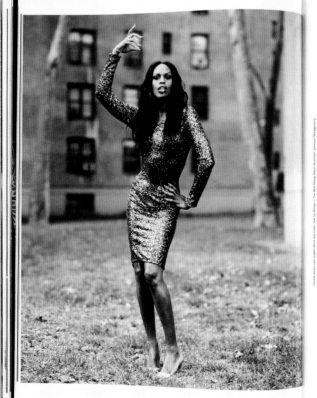

CONNIE FLEMING

To Luis
xoxoxoxo

Honey Dijon :)

HONEY DIJON

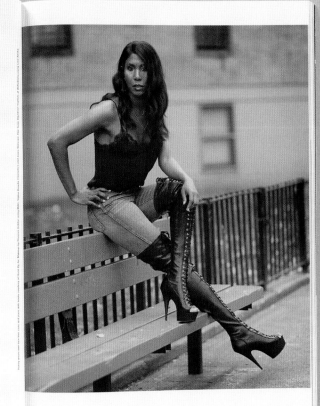

LAUREN FOSTER

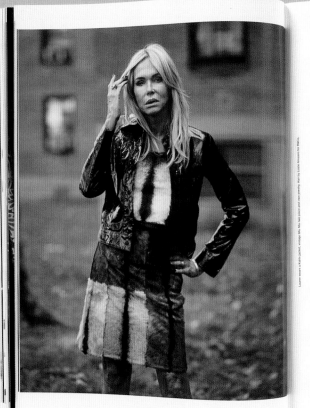

C★NDY Transversal/ 10th Issue, 2017. Pages 114–117. Honey Dijon and Lauren Foster photographed by Ethan James Green, styled by Matt Holmes. Texts by Devan Diaz.

C★NDY Transversal 10th Issue, 2017. Pages 120-123. Geena Rocero and Dina Marie photographed by Ethan James Green, styled by Matt Holmes. Texts by Devan Díaz.

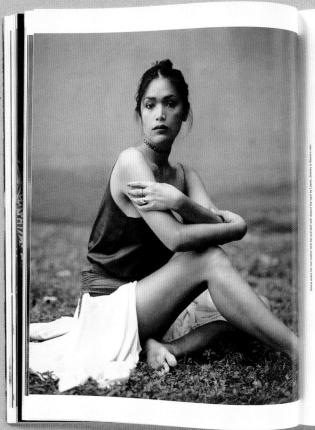

GEENA ROCERO

DINA MARIE

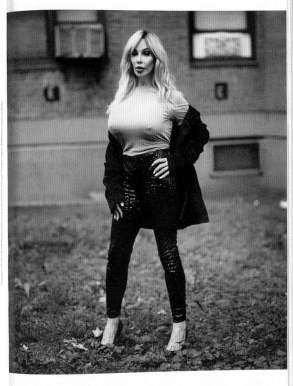

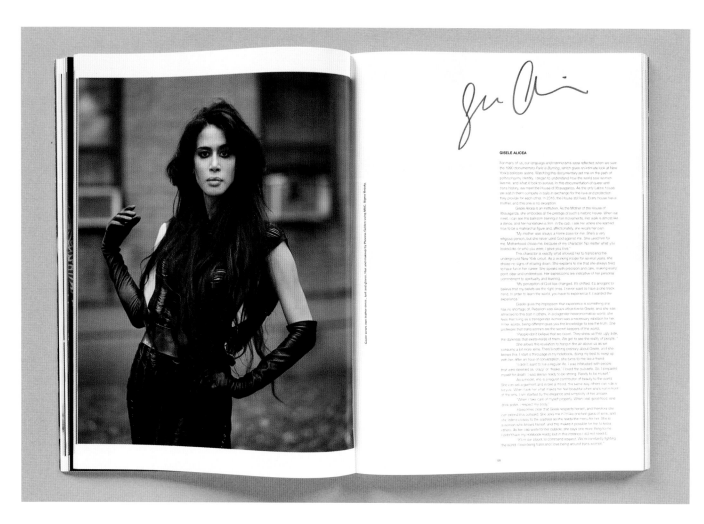

C★NDY *Transversal* 10th Issue, 2017. Pages 124-125. Gisele Alicea photographed by Ethan James Green, styled by Matt Holmes. Text by Devan Diaz.

GISELE ALICEA

For many of us, our language and mannerisms were reflected when we saw the 1990 documentary *Paris is Burning*, which gives an intimate look at New York's ballroom scene. Watching this documentary set me on the path of performing my identity. I began to understand how the world saw women like me, and what it took to survive. In this documentation of queer and trans history, we meet the House of Xtravaganza. As the only Latino house we watch them compete in balls in exchange for the love and protection they provide for each other. In 2016, the House still lives. Every house has a mother, and this one is no exception.

Gisele Alicea is an institution. As the Mother of the House of Xtravaganza, she embodies all the prestige of such a historic house. When we meet, I can see the ballroom training in her movements. Her walk is almost like a dance, and her handshake a firm. In the cab, I ask her where she learned how to be a matriarchal figure and, affectionately, she recalls her own.

"My mother was always a home base for me. She's a very religious person, but she never used God against me. She used him for me. Motherhood chose me, because of my character. No matter what you looked like or who you were, I gave you love."

This character is exactly what allowed her to transcend the underground New York circuit. As a working model for several years, she showed no signs of slowing down. She explains to me that she always tried to have fun in her career. She speaks with precision and care, making every point clear and understood. Her expressions are indicative of her personal commitment to spirituality and learning.

"My perception of God has changed. It's shifted. It's arrogant to believe that my beliefs are the right ones. I never want to have a one-track mind. In order to learn the world, you have to experience it. I wanted the experience."

Gisele gives the impression that experience is something she has no shortage of. Rebellion was always attractive to Gisele, and she was attracted to the bad in others. In a cisgender heteronormative world, she feels that living as a transgender woman was a necessary rebellion for her. In her words, being different gives you the knowledge to see the truth. She professes that trans women are the secret keepers of the world.

"People don't believe that we count. They show us their ugly side, the darkness that exists inside of them. We get to see the reality of people."

She allows this revelation to hang in the air above us as we consume a lot more wine. There's nothing ordinary about Gisele, and she knows this. I start a third page in my notebook, doing my best to keep up with her. After an hour of conversation, she turns to me like a friend.

"I didn't want to live a regular life. I was infatuated with people that were deemed as 'crazy' or 'freaks.' I loved the outsiders. So, I prepared myself for death. I was always ready to be strong. Ready to be myself."

As a model, she is a regular contributor of beauty to the world. She can set a garment and create a mood. The same way others can ruin a picture. When I ask her what makes her feel beautiful when she's not in front of the wins, I am startled by the elegance and simplicity of her answer. "When I take care of myself properly. When I eat good food, and drink water. I respect my body."

It becomes clear that Gisele respects herself, and therefore she can extend this outward. She asks me if I'm like one last glass of wine, and she listens closely to the waitress as she reads the menu for her. She is a woman who knows herself, and this makes it possible for her to know others. As her cab waits for her outside, she says one more thing to me. I didn't have my notebook ready, but in this instance I did not need it.

"It's in our blood, to command respect. We're constantly fighting the world. I love being trans and I love being around trans women."

Working with this magazine is always special to me because it's a transversal, high-end magazine and it is very important to have for our community to show the world who we are from a different perspective. This kind of magazine gives us a voice, and tells the stories of many people that would not have a voice otherwise. It's more than a magazine. It's a revolution.

—
GISELE ALICEA
C★NDY Transversal 10th Issue, 2017

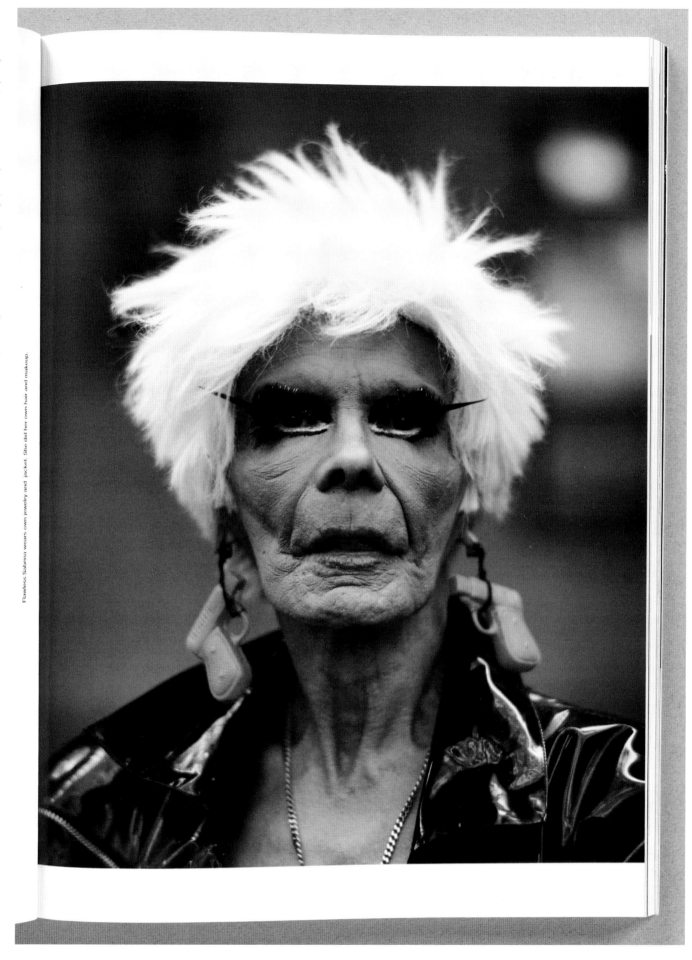

C★NDY Transversal 10th Issue, 2017. Page 131. Flawless Sabrina photographed by Ethan James Green, styled by Matt Holmes.

Flawless Sabrina wears own jewelry and jacket. She did her own hair and makeup.

CANDY Transversal/ 10th Issue, 2017. Pages 260-261, 268-269. Torraine Futurum, Stevie, Dara and Cruz Valdez photographed by Lia Clay, styled by Matt Holmes.

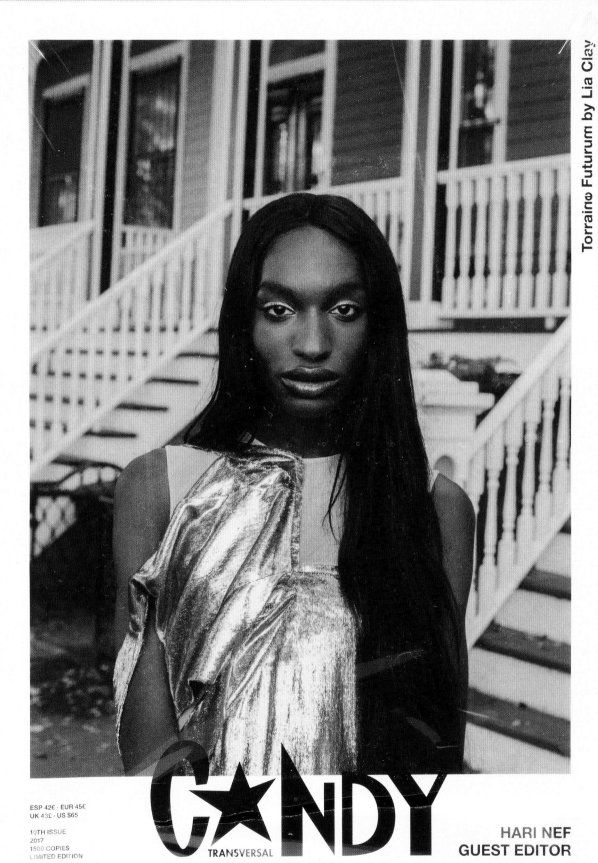

Torraine Futurum by Lia Clay

C★NDY

ESP 42€ · EUR 45€
UK 43£ · US $65

10TH ISSUE
2017
1500 COPIES
LIMITED EDITION

TRANSVERSAL

HARI NEF
GUEST EDITOR

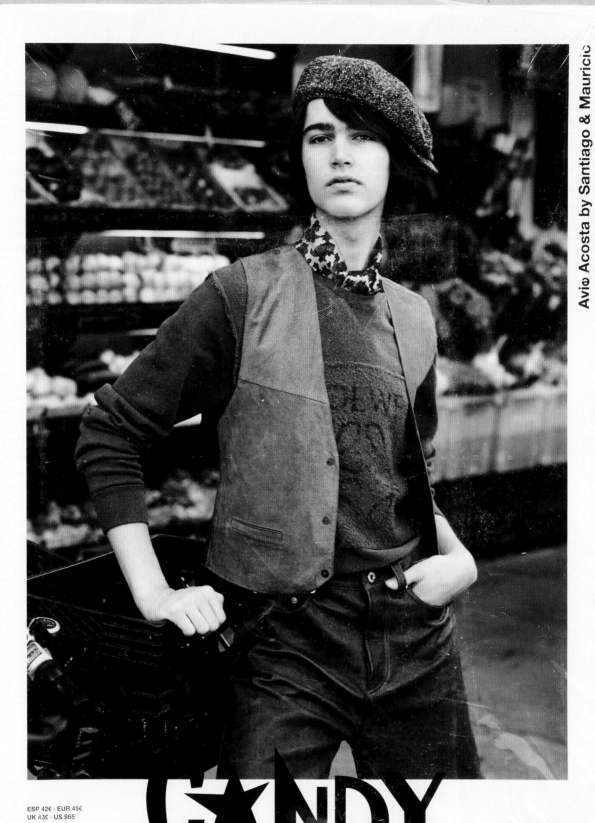

CANDY

TRANSVERSAL

ESP 42€ · EUR 45€
UK 43£ · US $65

10TH ISSUE
2017
1500 COPIES
LIMITED EDITION

HARI NEF
GUEST EDITOR

CANDY Transversal/ 10th Issue, 2017. Cover: Avie Acosta photographed by Santiago & Mauricio, styled by Simon Rasmussen.

Avie Acosta by Santiago & Mauricio

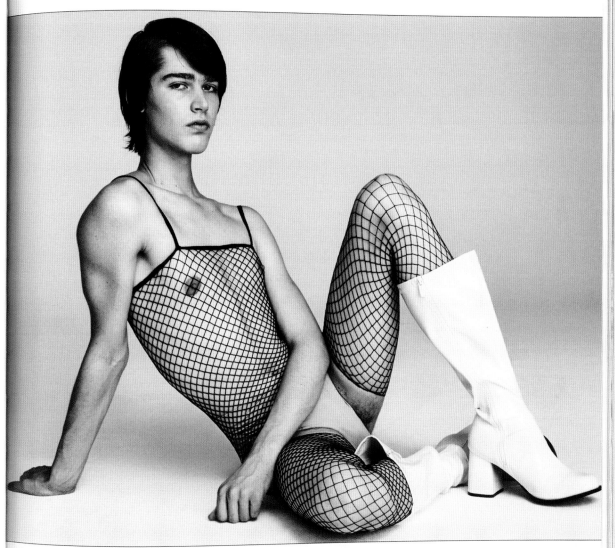

C★NDY *Transversal* 10th Issue, 2017. · Page 201. Avie Acosta photographed by Santiago & Mauricio, styled by Simon Rasmussen.

AFTER PARTY

Avie Acosta wears a Pink Lipstick fishnet bodysuit, Ellie boots and own underwear.

This fashion story has been inspired by Hal Fischer's iconic book *Gay Semiotics* (1977), a photographic study of visual coding among homosexual men.

201

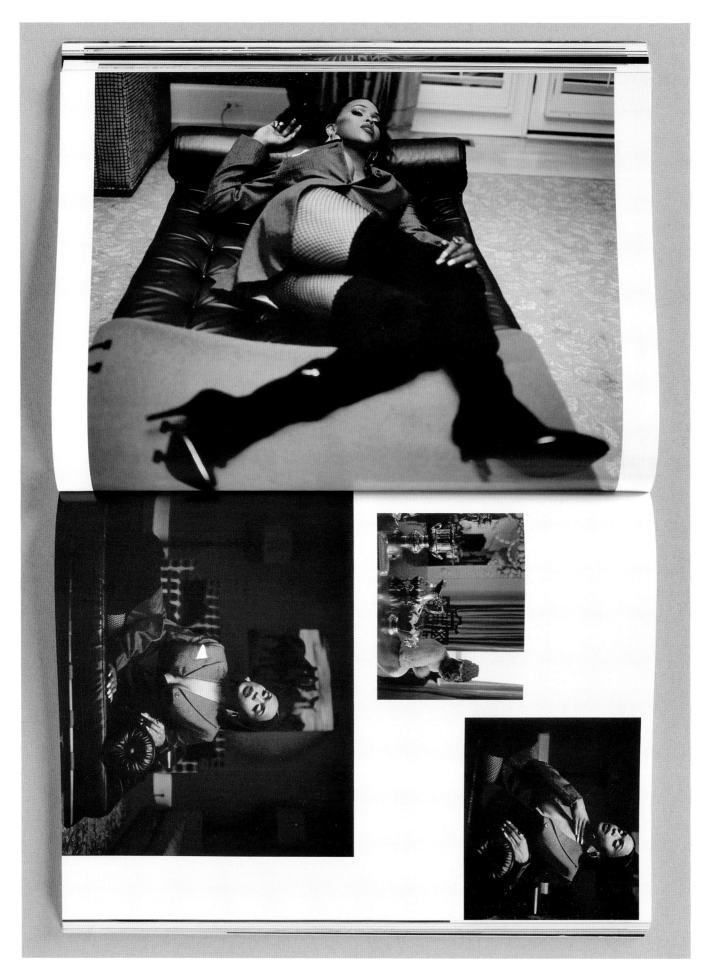

C★NDY *Transversal* 10th Issue, 2017. Pages 144-145. Amiyah Scott photographed by Thomas McCarty, styled by Ian Bradley.

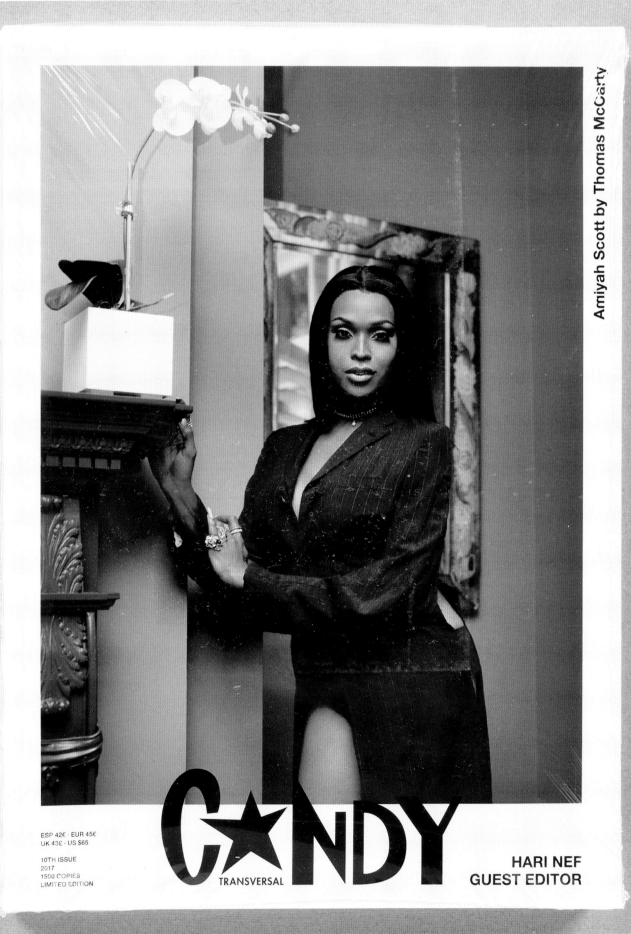

Amiyah Scott by Thomas McCarty

C★NDY
TRANSVERSAL

ESP 42€ · EUR 45€
UK 43£ · US $65

10TH ISSUE
2017
1500 COPIES
LIMITED EDITION

**HARI NEF
GUEST EDITOR**

Triana Seville by Pierre-Ange Carlotti

ESP 42€ · EUR 45€
UK 43£ · US $65

10TH ISSUE
2017
1500 COPIES
LIMITED EDITION

C★NDY
TRANSVERSAL

HARI NEF
GUEST EDITOR

C★NDY Transversal 10th Issue, 2017. Cover. Triana Seville photographed by Pierre-Ange Carlotti; styled by Bárbara Martelo. RIGHT: Unpublished photograph of Triana Seville shot by Pierre-Ange Carlotti for C★NDY Transversal 10th Issue, 2017.

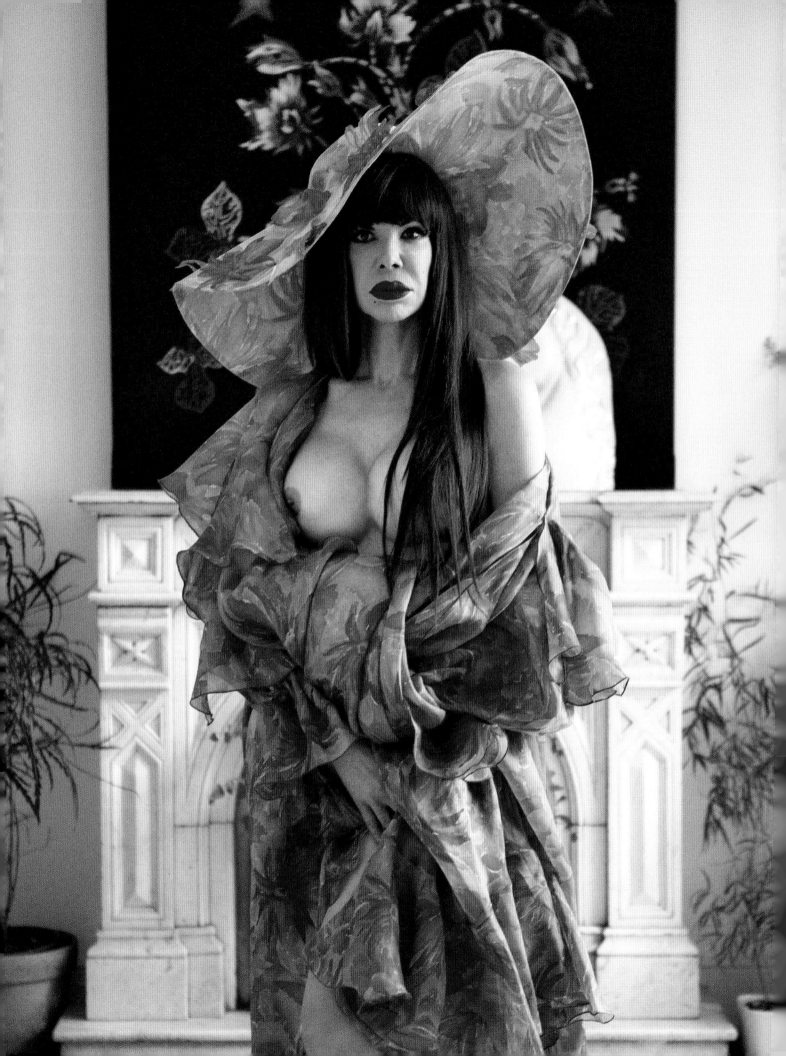

C★NDY Transversal 10th Issue, 2017. Page 109. Jackie Curtis photographed by Timothy Greenfield-Sanders, New York City, 1979. Text by Morgan M Page. LEFT: Unpublished photograph of Cristina La Veneno shot by Matías Uris and styled by Alicia Padrón for C★NDY Transversal 10th Issue, 2017.

For Luis !

Behind the gender-defying aesthetics and genre-defying theatrical productions, Jackie Curtis was a person deeply conflicted about her place in the world. Growing up split between her father's Baptist family in Tennessee and her mother's Catholic family in the legendary Lower East Side of Manhattan, she had trouble working out whether she was coming or going — something she would later credit for her life-long movement back and forth between genders, both on and off the stage. Raised primarily by her grandmother, a former speakeasy manager and long-time proprietor of storied LES bar Slugger Ann's, Jackie escaped into the world of cinema to avoid her somewhat turbulent and lonely childhood.

Jackie would later say, "When I was an adolescent and went to the movie, I realized that I identified with the female characters. And then the lights would come up and I was attracted to people of the same sex. I don't think of myself as gay, although I do sleep exclusively with men. But sex is not my main goal either."

Fixated on movies and theatre, teenage Jackie marched around Manhattan in a peacoat and Beatles haircut carrying a plastic shopping bag full of plays and records, talking her way into her first stage role — opposite Bette Midler (also Midler's first role) in Tom Eyen's *Miss Nefertiti Regrets* at La MaMa. Despite being so young, Jackie wormed her way quickly into the underground scene and within just a few years would make her film debut in Andy Warhol's *Flesh* (1968). She would go on to star in Warhol's *Women in Revolt* (1971), appear in numerous theatre productions and become a critically acclaimed cabaret performer alongside her friend Holly Woodlawn. Her own plays and musicals would feature the likes of such legends as Patti Smith, Jayne County, Harvey Fierstein and Robert De Niro.

Though Jackie would never find the breakout success she craved — as either a man or a woman, despite her many attempts at both — her defiant style and memorable performance antics helped give birth to modern queer theatre and film. Jackie Curtis was a true original. Decades before genderqueer as an identity came into vogue, Jackie was pushing the boundaries of gender fluidity even within the drag and trans worlds. Eschewing all identity labels, she summed up her existence simply: "I'm not a boy, not a girl, not a faggot, not a drag queen, not a transsexual — I'm just me, Jackie."

love

Jackie Curtis, East Village, New York, October 28, 1979. Photographs by Timothy Greenfield-Sanders.

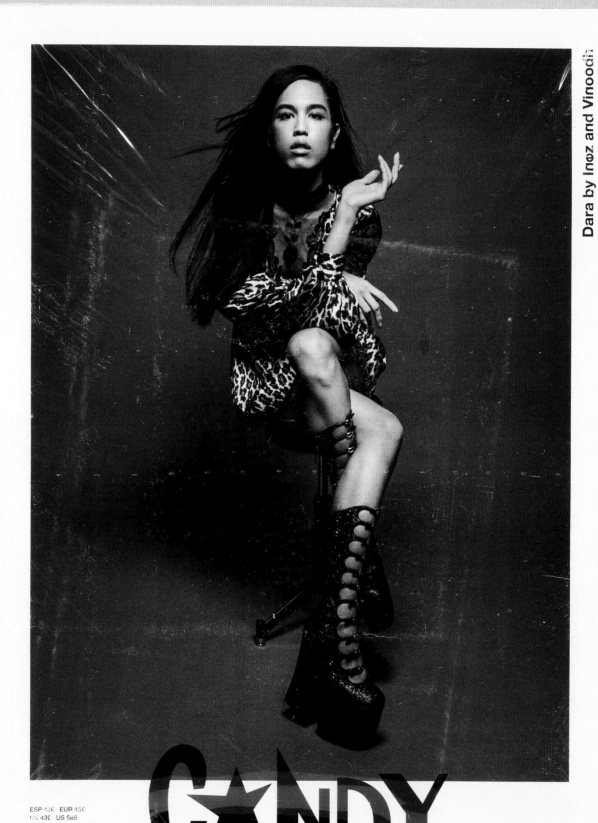

C★NDY

ESP 42€ · EUR 45€
UK 43£ · US $65

10TH ISSUE
2017
1500 COPIES
LIMITED EDITION

TRANSVERSAL

HARI NEF
GUEST EDITOR

C★NDY *Transversal* 10th Issue, 2017. Cover: Dara photographed by Inez & Vinoodh.

Dara by Inez and Vinoodh

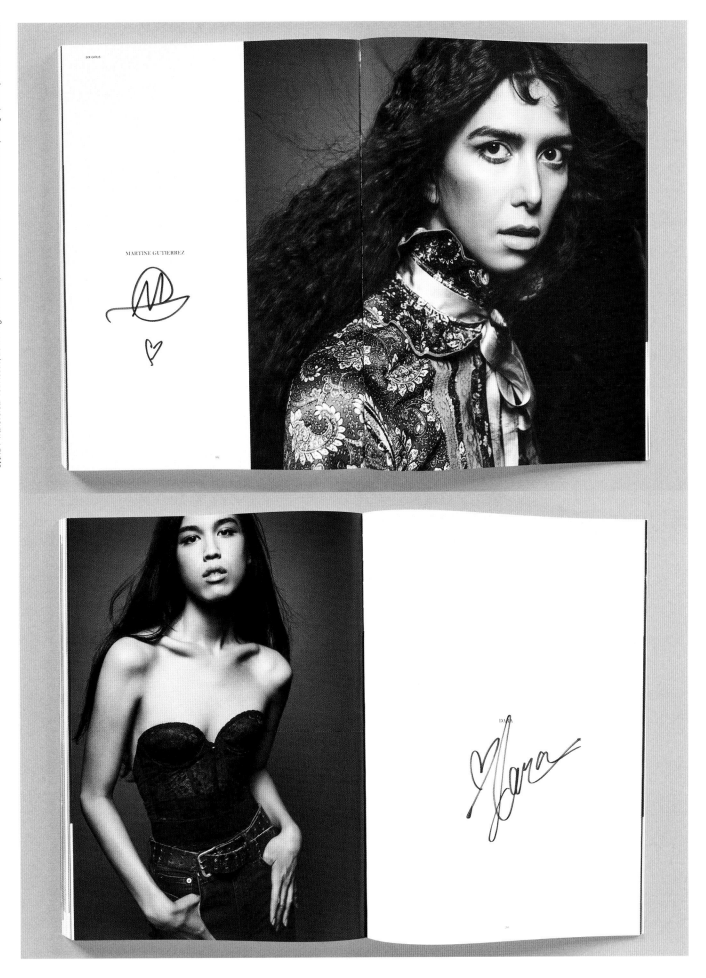

C★NDY Transversal 10th Issue, 2017. Pages 292-293, 306-307. Martine Gutierrez and Dara photographed by Inez & Vinoodh.

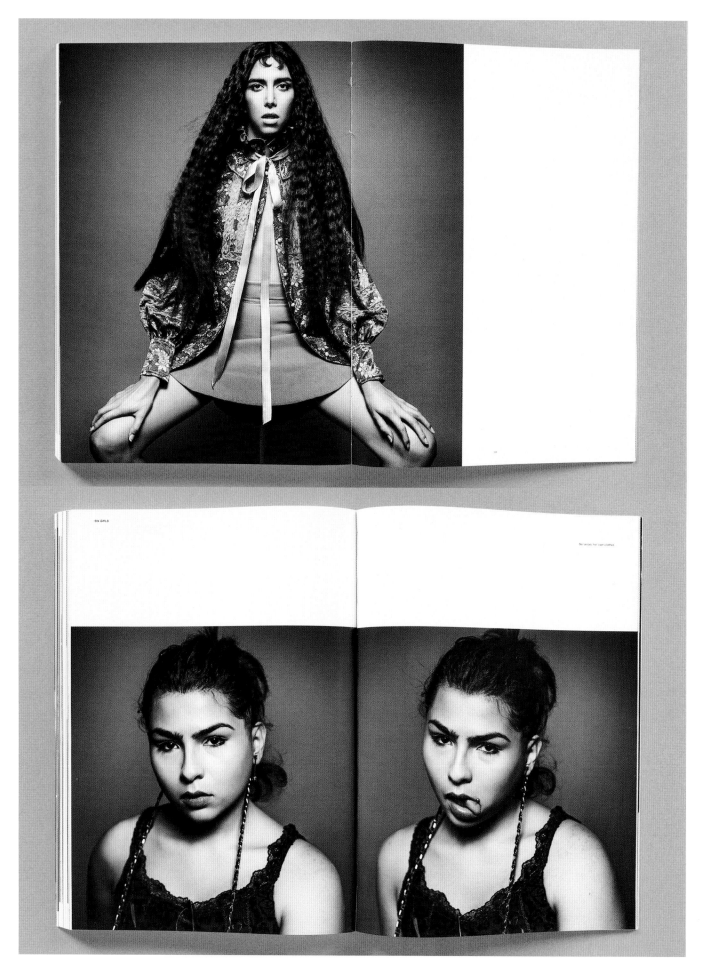

CANDY Transversal 10th Issue, 2017 . Pages 278-279, 310-311. Martine Gutierrez and Ser Serpas photographed by Inez & Vinoodh.

G★NDY *Transversal* 10th Issue, 2017. Pages 284-285, 312-313. M Zavos and Hari Nef photographed by Inez & Vinoodh.

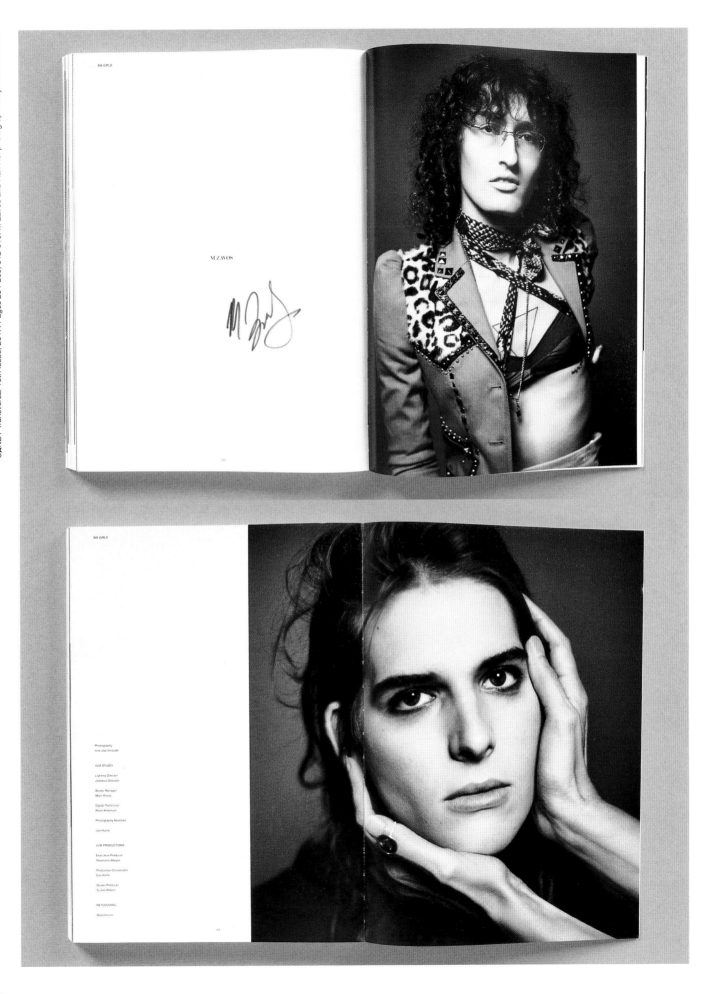

SIX GIRLS

M ZAVOS

SIX GIRLS

Photography
Inez and Vinoodh

VLM STUDIO

Lighting Director
Jodokus Driessen

Studio Manager
Marc Kroop

Digital Technician
Brian Anderson

Photography Assistant
Joe Hume

VLM PRODUCTIONS

Executive Producer
Stephanie Bargas

Production Coordinator
Eva Harte

Studio Producer
Tucker Birbilis

RETOUCHING

Stereohorse

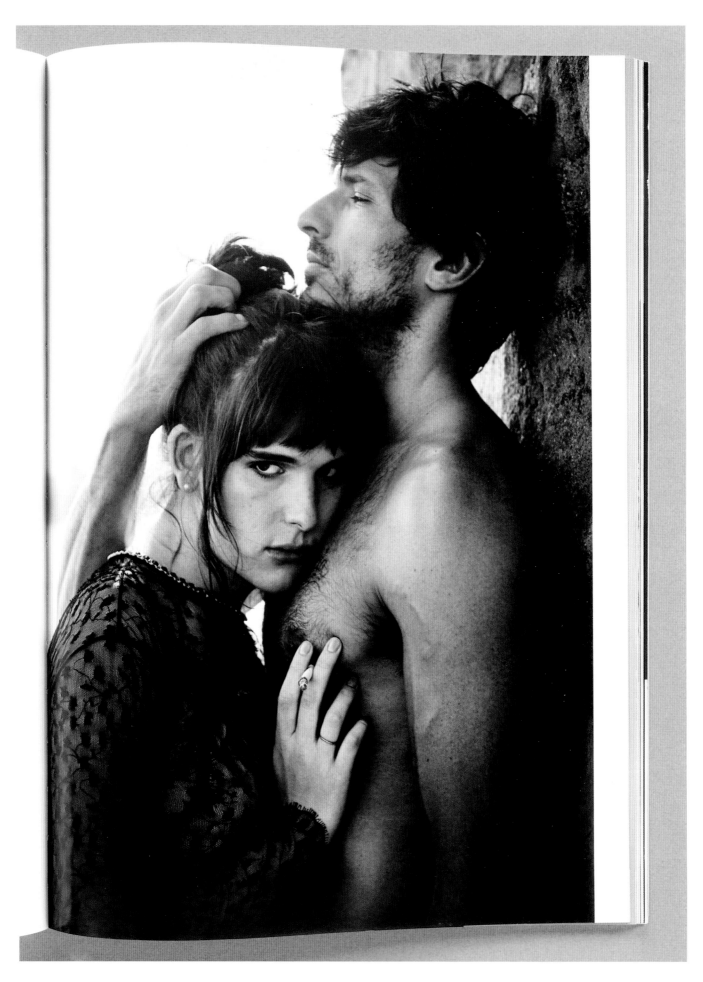

C★NDY *Transversal*/ 10th Issue, 2017. Page 237. Hari Nef and Andrés Velencoso photographed by Sebastián Faena, styled by Sofía Achaval.

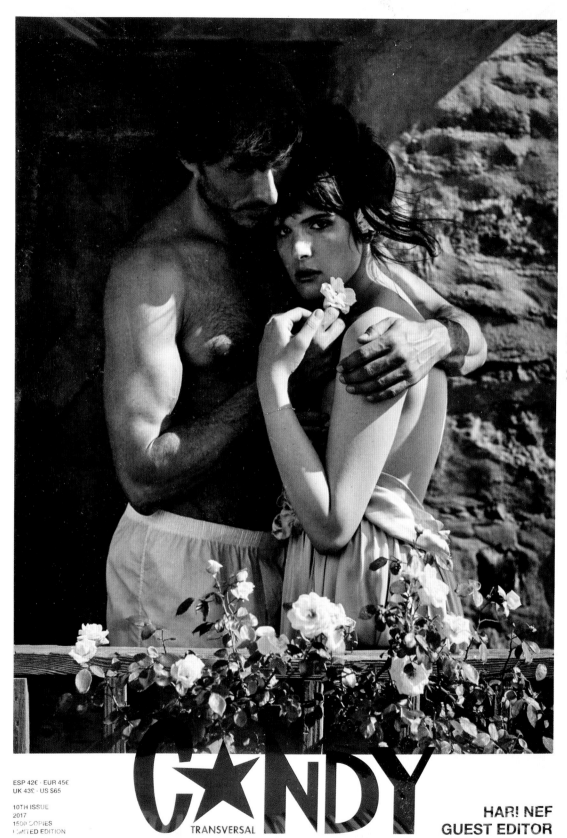

Hari Nef + Andrés Velencoso by Sebastián Faena

C★NDY

TRANSVERSAL

ESP 42€ · EUR 45€
UK 43£ · US $65

10TH ISSUE
2017
1500 COPIES
LIMITED EDITION

HARI NEF
GUEST EDITOR

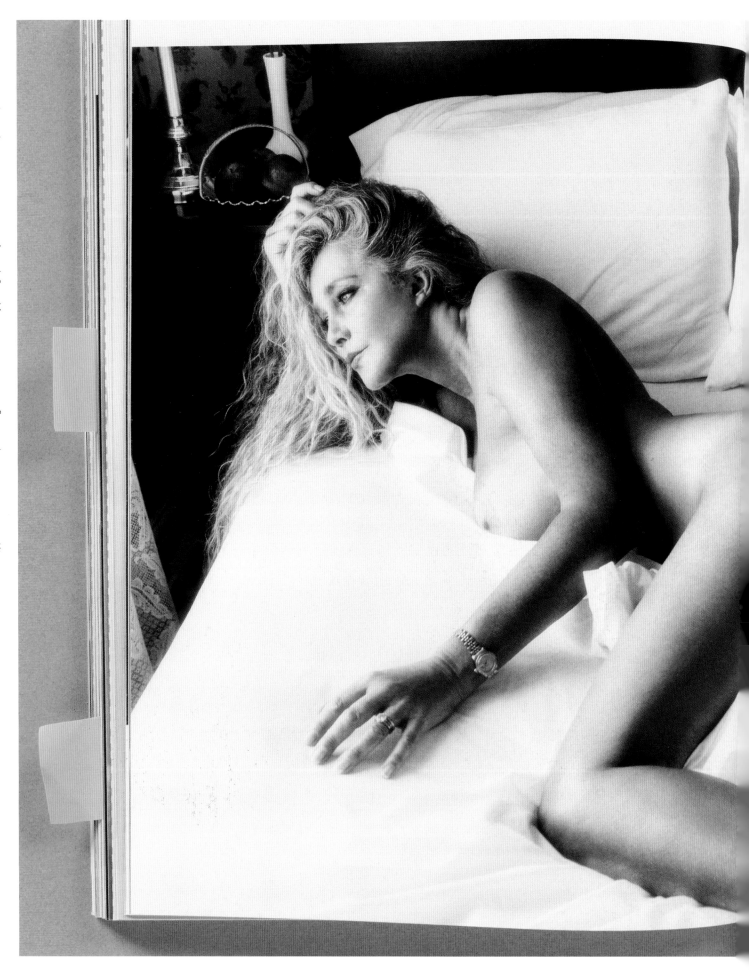

C★NDY Transversal 9th Issue, 2016. Pages 230-231. Caroline Cossey photographed by Sofía Sánchez & Mauro Mongiello, styled by Samuel François.

Caroline Cossey photographed in Atlanta, Wednesday 9th September 2015.

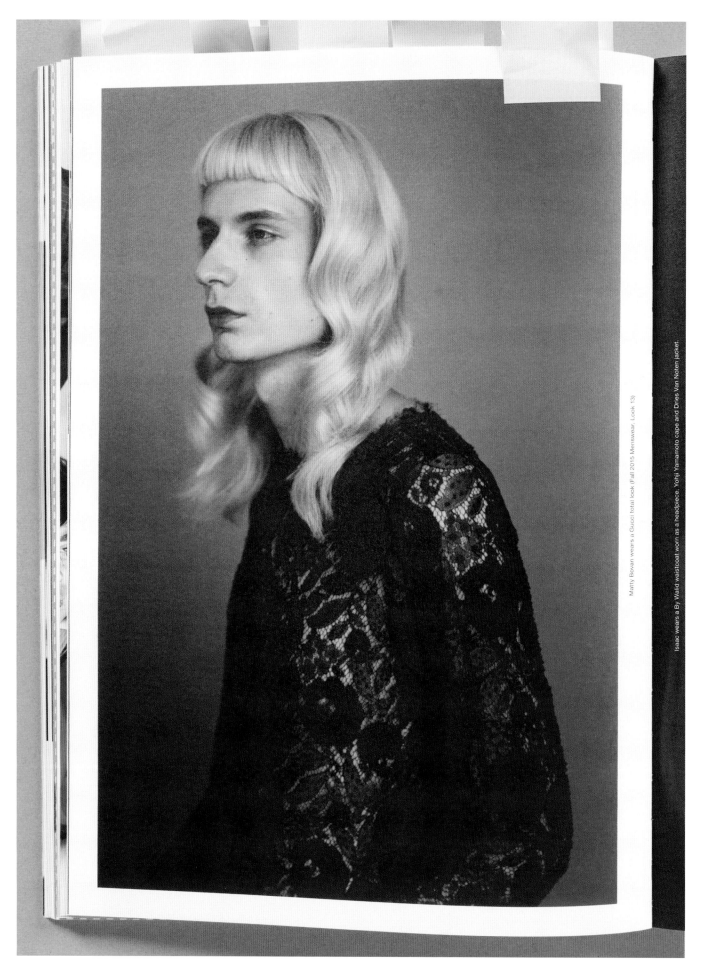

C★NDY *Transversal* 9th Issue, 2016. Page 126. Matty Bovan photographed by Leon Mark, styled by Benjamin Kirchhoff.

Matty Bovan wears a Gucci total look (Fall 2015 Menswear, Look 13)

Isaac wears a By Walid waistcoat worn as a headpiece, Yohji Yamamoto cape and Dries Van Noten jacket.

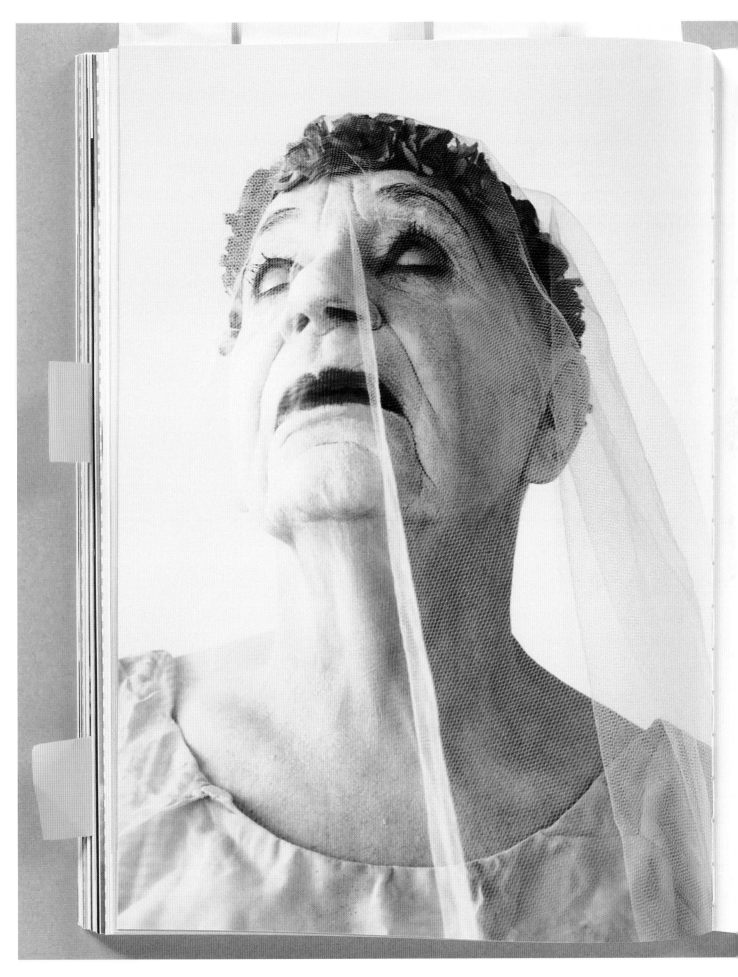

C★NDY Transversal/ 9th Issue, 2016. Page 210. Lindsay Kemp photographed by Tim Walker.

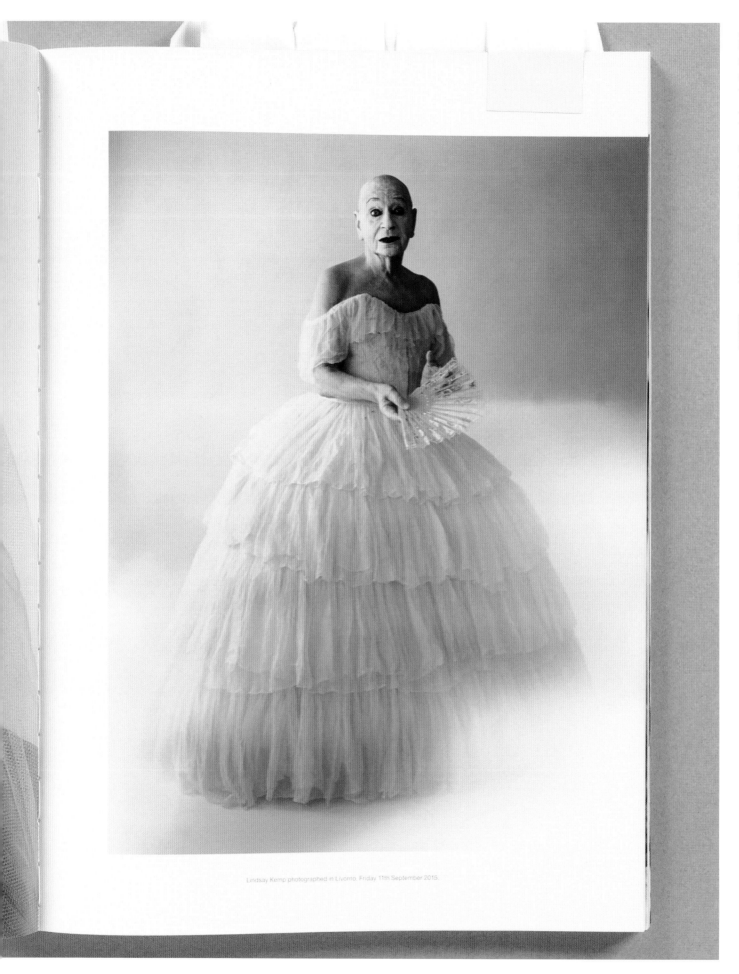

Lindsay Kemp photographed in Livorno. Friday 11th September 2015.

CANDY *Transversal*/ 9th Issue, 2016. Page 211. Lindsay Kemp photographed by Tim Walker.

CANDY Transversal/ 1st Issue. 2009. Pages 108-109. *Dressed To Kiss* fashion story photographed by David Armstrong.

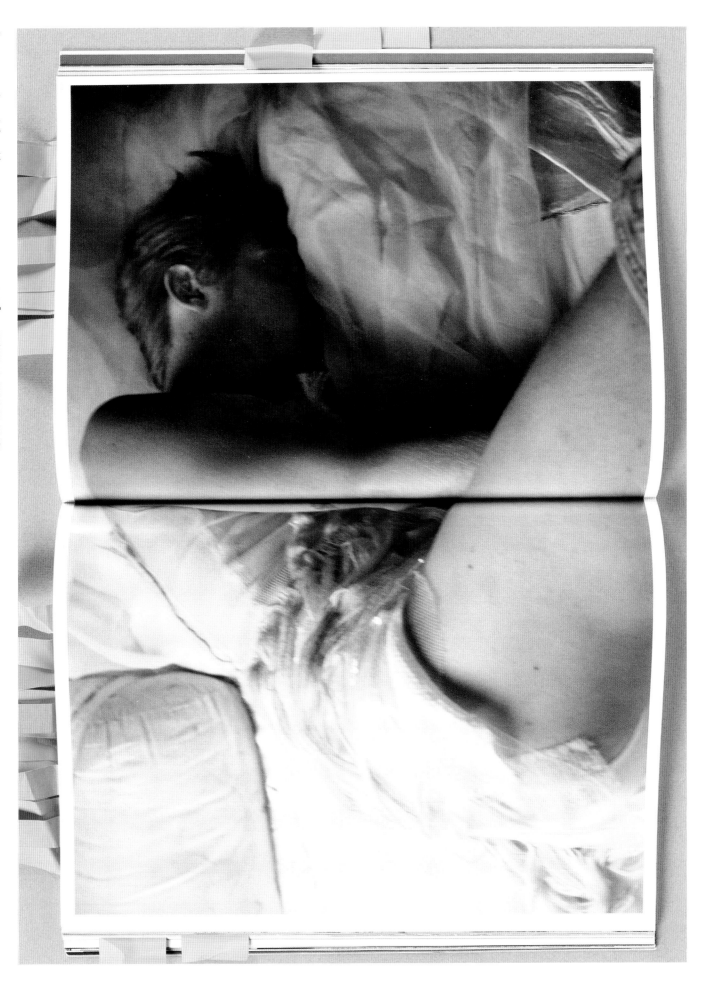

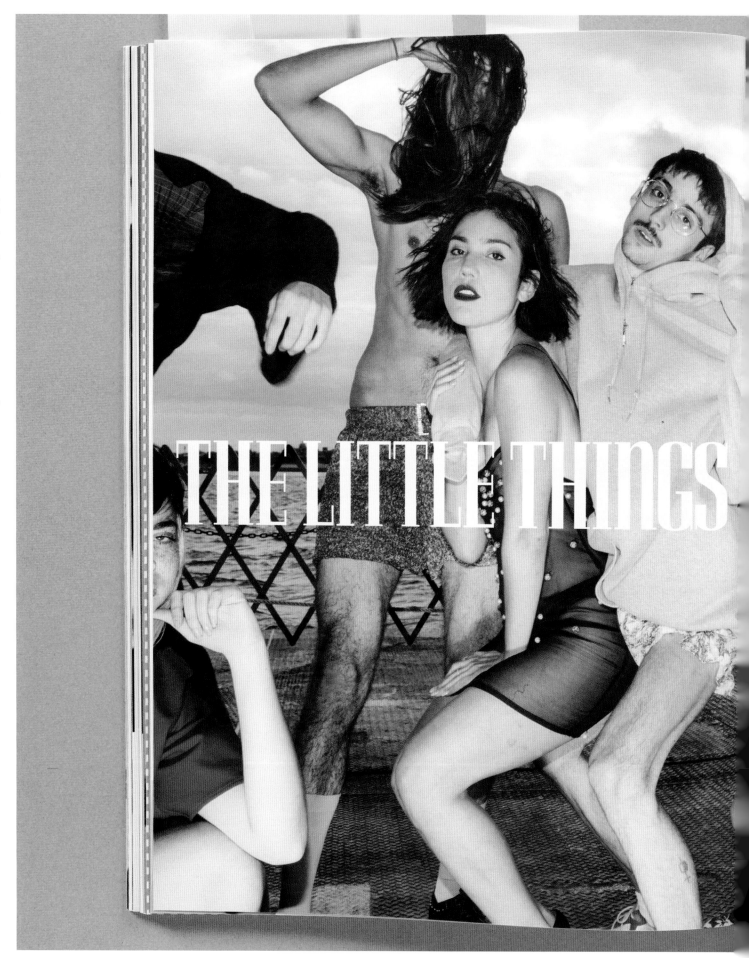

THE LITTLE THINGS

CANDY *Transversal* 9th Issue, 2016. Pages 114-115. The Moses Gauntlett Cheng crew photographed by Thomas McCarty, styled by Patric DiCaprio.

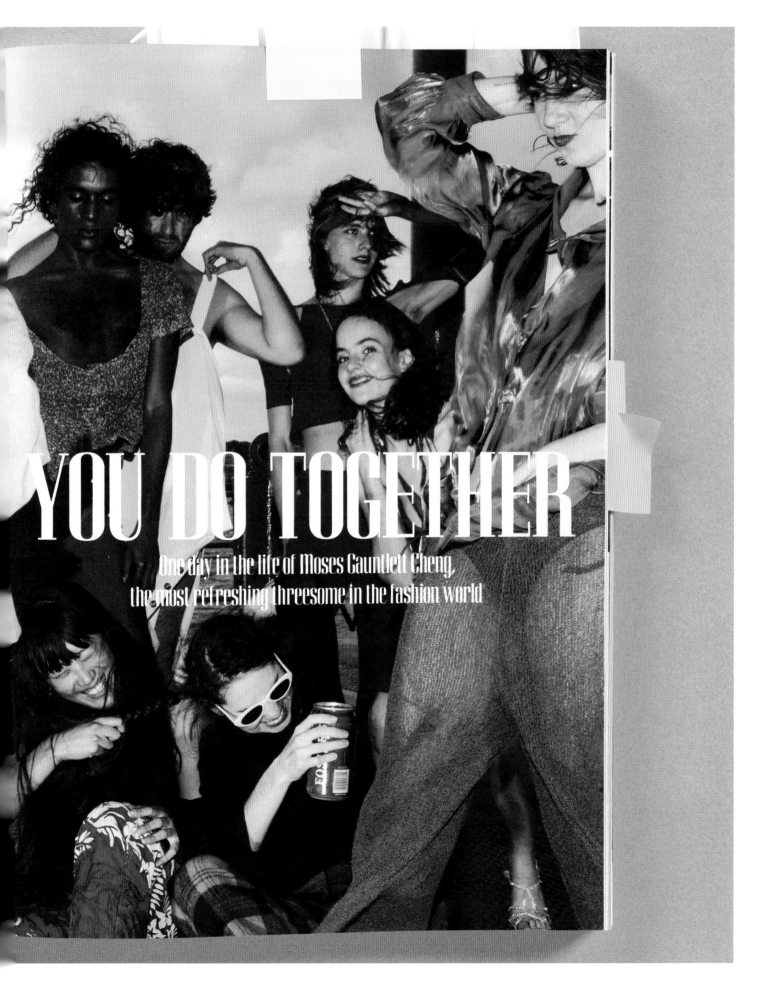

YOU DO TOGETHER

One day in the life of Moses Gauntlett Cheng,
the most refreshing threesome in the fashion world

C★NDY Transversal 9th Issue, 2016. Page 117. Matt Holmes, Richie Shazam and Marcs Goldberg photographed by Thomas McCarty, styled by Patric DiCaprio.

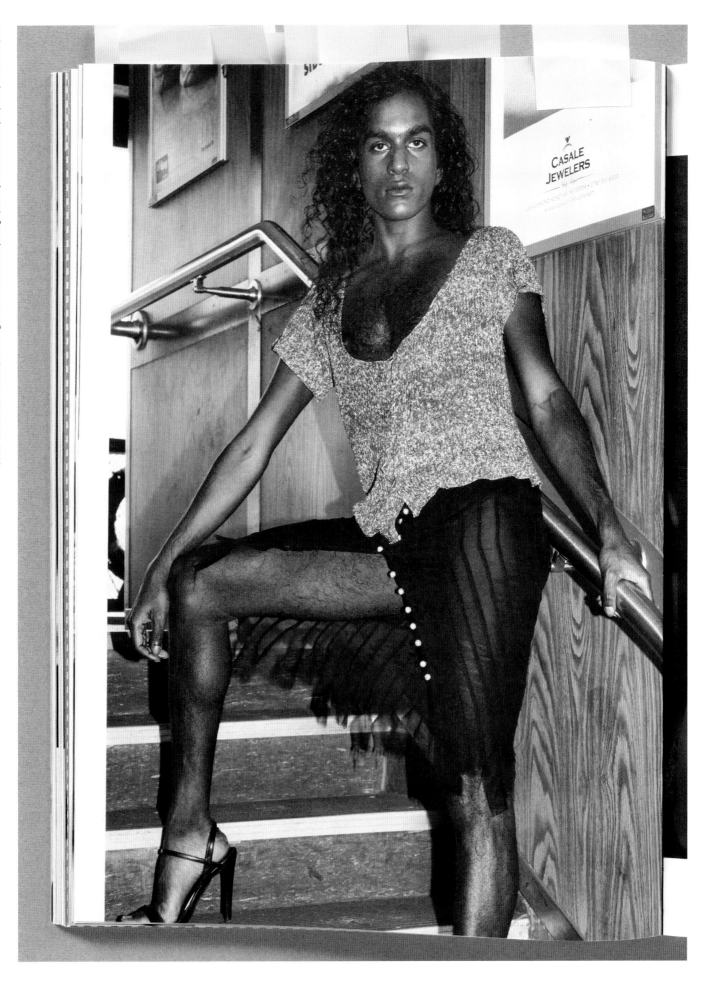

CANDY Transversal/ 9th Issue, 2016. Page 120. Richie Shazam photographed by Thomas McCarty, styled by Patric DiCaprio.

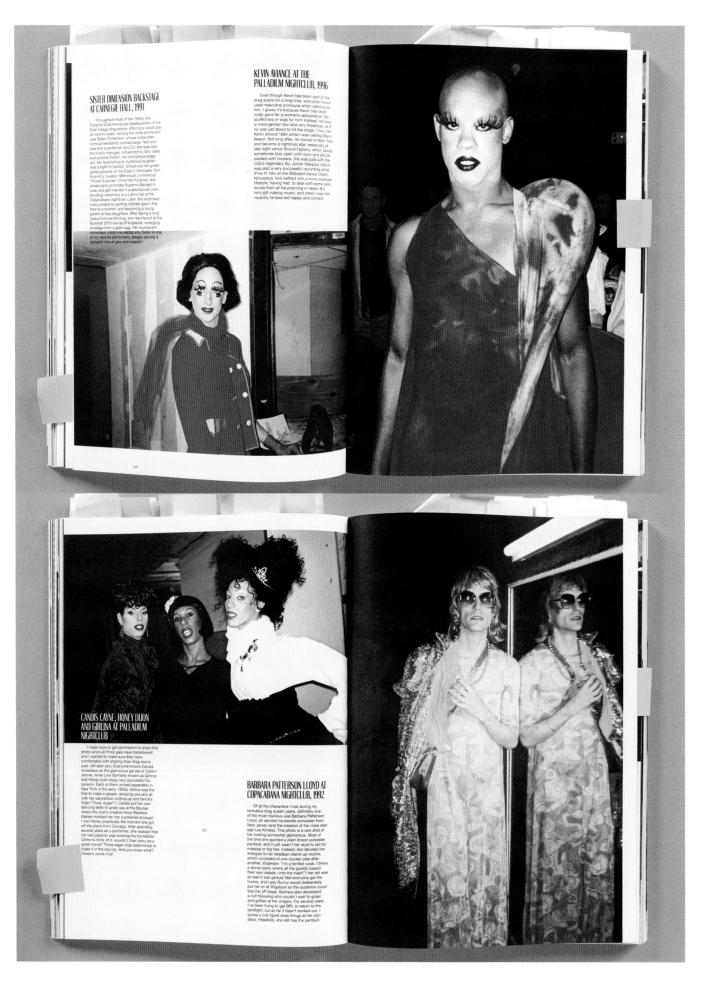

SISTER DIMENSION BACKSTAGE AT CARNEGIE HALL, 1991

Throughout most of the 1980s, the Pyramid Club thrived as headquarters of the East Village drag scene, offering a cavalcade of colorful stars. Among the most prominent was Sister Dimension, whose outlandish, comical sensibility loomed large. Not only was she a performer and DJ, she was also the club's manager. Influenced by fairy tales and science fiction, her conceptual stage act, like hip-synching to hysterical laughter, was a sight to behold. (Check out her green genie persona on YouTube in filmmaker Tom Rubnitz's twisted 1989 snack commercial "Pickle Surprise.") From the Pyramid, she joined party promoter Susanne Bartsch's crew and got married in a spectacular (non-bonding) ceremony to a Latino lad at the Copacabana nightclub. Later, she surprised many people by getting hitched again, this time to a woman, and becoming a loving parent to two daughters. After taking a long hiatus from performing, she resurfaced at the Summer 2015 revival of Wigstock, emerging on stage from a giant egg. Her triumphant comeback made me realize why Sister is one of my favorite performers, always serving a fantastic mix of glee and insanity!

KEVIN AVIANCE AT THE PALLADIUM NIGHTCLUB, 1996

Even though Kevin has been part of the drag scene for a long time, everyone I know uses masculine pronouns when referring to him. I guess it's because Kevin has never really gone for a womanly appearance. No stuffed bra or wigs for him! Instead, his look is more gender blur and very theatrical, as if he was just about to hit the stage. I first met Kevin around 1994 while I was visiting Miami Beach. Not long after, he moved to New York and became a nightclub star, especially at late night venue Sound Factory, which would sometimes stay open until noon and still be packed with revelers. (He was pals with the club's legendary DJ, Junior Vasquez.) Kevin was also a very successful recording artist. (Five #1 hits on the Billboard dance chart!) Nowadays, he's settled into a more subdued lifestyle, having had to deal with some sore bones from all his prancing in heels. But he's still making music, and when I saw him recently he seemed happy and content.

CANDIS CAYNE, HONEY DIJON AND GIRLINA AT PALLADIUM NIGHTCLUB

I made sure to get permission to share this photo since all three gals have transitioned and I wanted to make sure they were comfortable with sharing their drag scene past. (All said yes.) Everyone knows Candis nowadays as the glamorous gal pal of Caitlyn Jenner, while Lina (formerly known as Girlina) and Honey both enjoy very successful DJ careers. Each of them arrived separately in New York in the early 1990s. Girlina was the first to make a splash, amazing one and all with her dancefloor cutting-up and fanciful lingo ("Trust, sugar!"). Candis put her own dancing skills to great use at the Boybar, where the club's creative force Matthew Kasten molded her into a polished showgirl. I met Honey practically the moment she got off the plane from Chicago. After spending several years as a performer, she realized that her real passion was working the turntables. Come to think of it, wouldn't their story be a great movie? Three eager kids determined to make it in the big city. And you know what? Dreams come true!

BARBARA PATTERSON LLOYD AT COPACABANA NIGHTCLUB, 1992

Of all the characters I met during my formative drag queen years, definitely one of the most hilarious was Barbara Patterson Lloyd, an earnest housewife comedian from New Jersey (and the creation of her male alter ego Lee Kimble). This photo is a rare shot of her looking somewhat glamorous. Most of the time she sported a plain brown polyester pantsuit, and it just wasn't her style to opt for makeup or big hair. Instead, she devoted her energies to her deadpan stand-up routine, which consisted of one clunker joke after another. (Example: "I'm a terrible cook. I threw a dinner party where all the guests tossed their own salads—into the trash!") Her act was so bad it was genius! Not everyone got the humor, and Lady Bunny would deliberately put her on at Wigstock so the audience could boo her off stage. Barbara also developed a cult following who couldn't wait to groan and guffaw at her zingers. For several years I've been trying to get BPL to return to the spotlight, but so far it hasn't worked out. I guess a cult figure does things at her own pace. Hopefully, she still has the pantsuit.

G★NDY *Transversal* 9th Issue, 2016. Pages 142-143, 146-147, 146-147. Sister Dimension, Kevin Aviance, Candis Cayne, Honey Dijon, Girlina and Barbara Patterson Lloyd photographed by Linda Simpson. Texts by Linda Simpson.

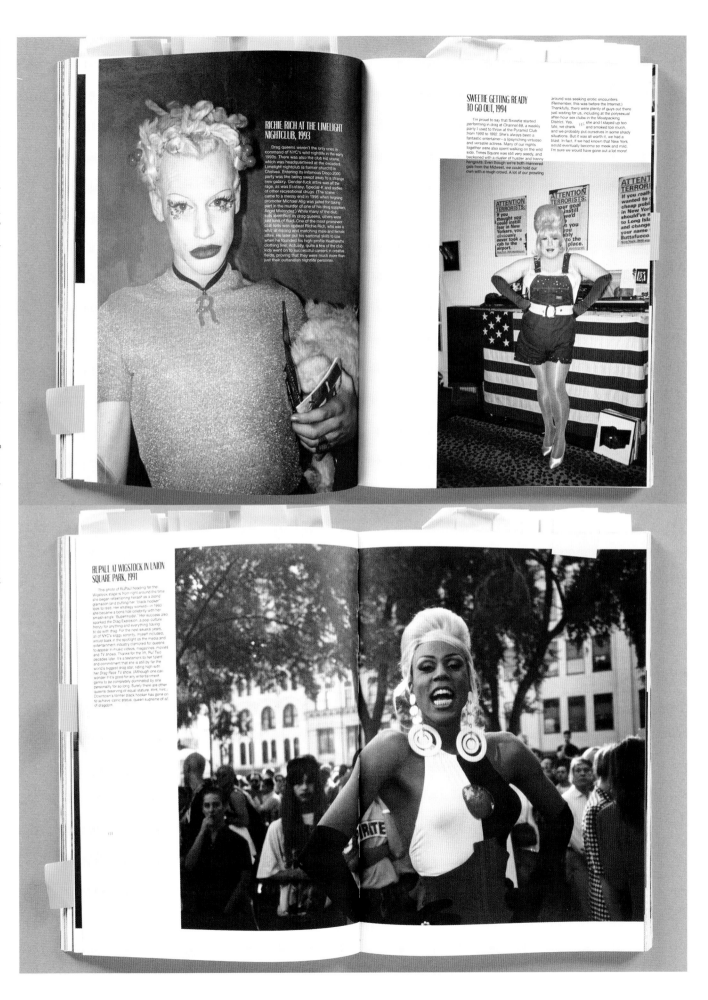

C★NDY Transversal 9th Issue, 2016. Pages 144-145, 154-155. Richie Rich, Sweetie and RuPaul photographed by Linda Simpson. Texts by Linda Simpson.

C★NDY Transversal 9th Issue, 2016. Page 284. Divine photographed by Robyn Beeche, 1985.

ROBYN BEECHE

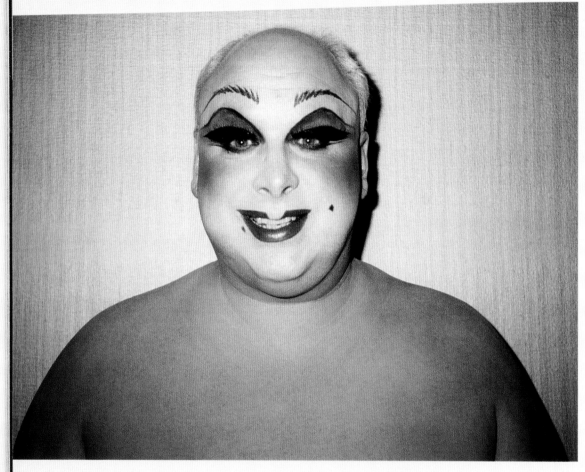

Divine Faceblot, 1985. Photo by Robyn Beeche, Black Eye Gallery. Courtesy of Jack Beeche.

In 1977, Beeche was invited by Divine to make her first trip to New York. And although

makeup can provide a mask to provide an alternate identity.

G★NDY *Transversal* 9th Issue, 2016. Page 289. Divine with twin sisters Jennifer and Amanda Quinn and friends, photographed by Joan Agajanian Quinn, 80s. Quote by Amanda Quinn Olivar.

289

JOAN AGAJANIAN QUINN

Divine with twin sisters Jennifer and Amanda Quinn, daughters of Jack Quinn and Joan Agajanian Quinn

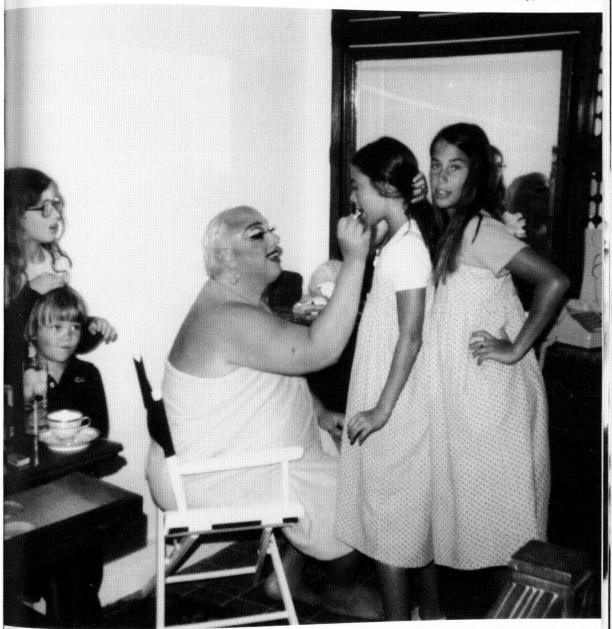

I remember the first time seeing Divvy...we were young, maybe seven? My father opened our huge front door to Divvy in drag. Jennifer and I ran into my mother's closet asking how that huge woman could get into the front door. Divvy quickly became a member of our family... kind and so much fun. Divine would sleep—always sitting up—on the sofa downstairs, snoring like thunder.

AMANDA QUINN OLIVAR

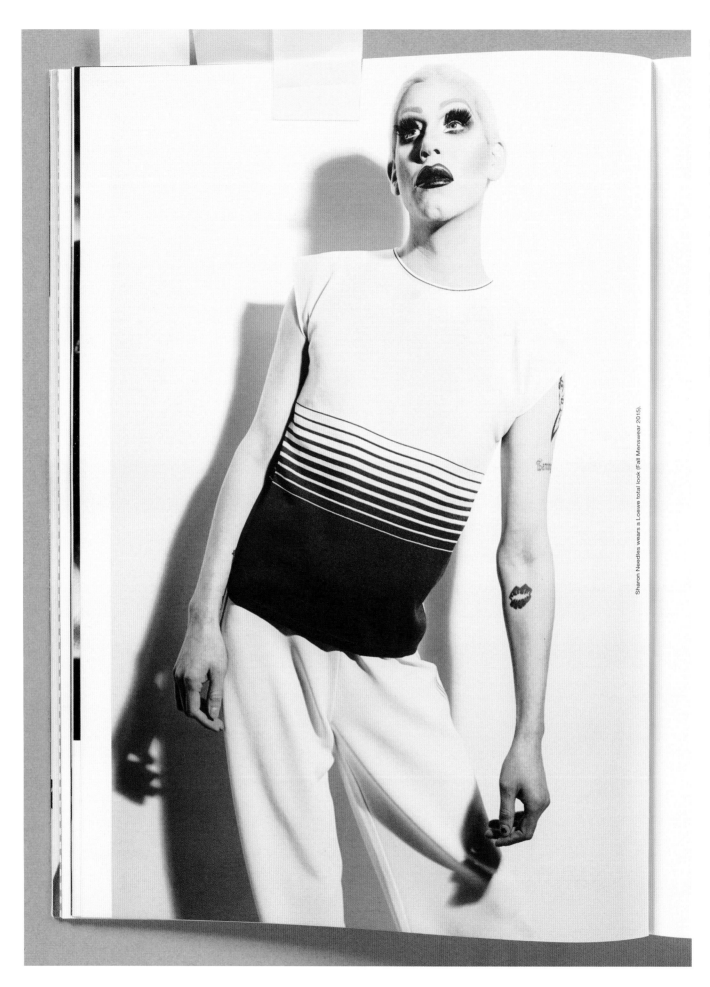

C★NDY *Transversal* 9th Issue, 2016. Page 50. Sharon Needles photographed by Daniel Riera, styled by Ana Murillas.

Sharon Needles wears a Loewe total look (Fall Menswear 2015).

C★NDY *Transversal* 9th Issue, 2016. Page 76. Bobby photographed by Chris von Wangenheim, 1975.

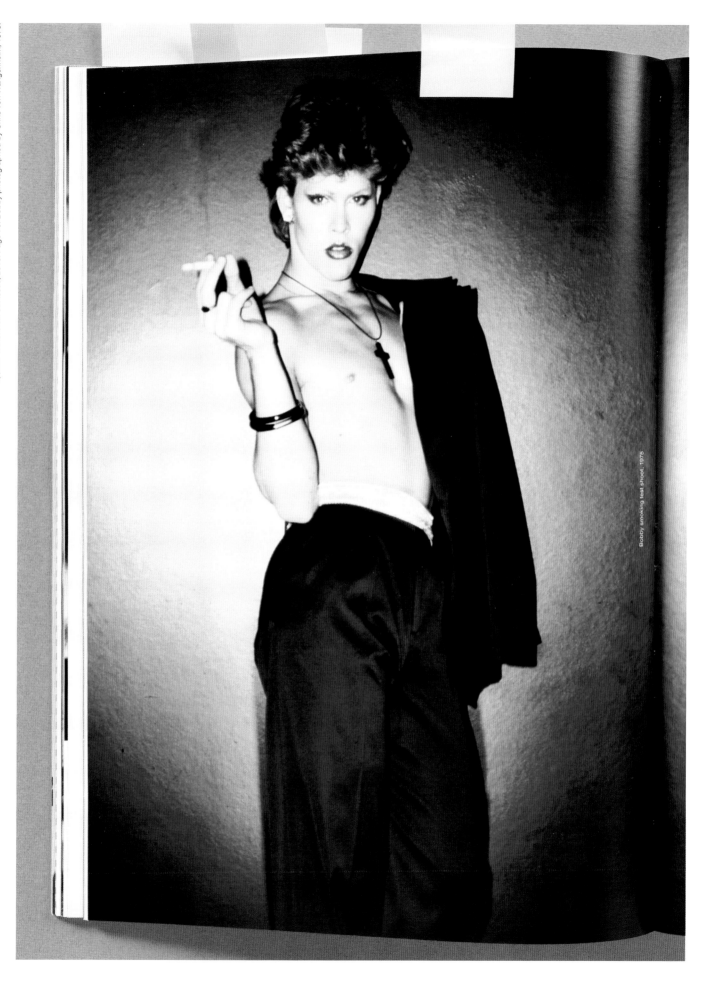

Bobby smoking test shoot, 1975

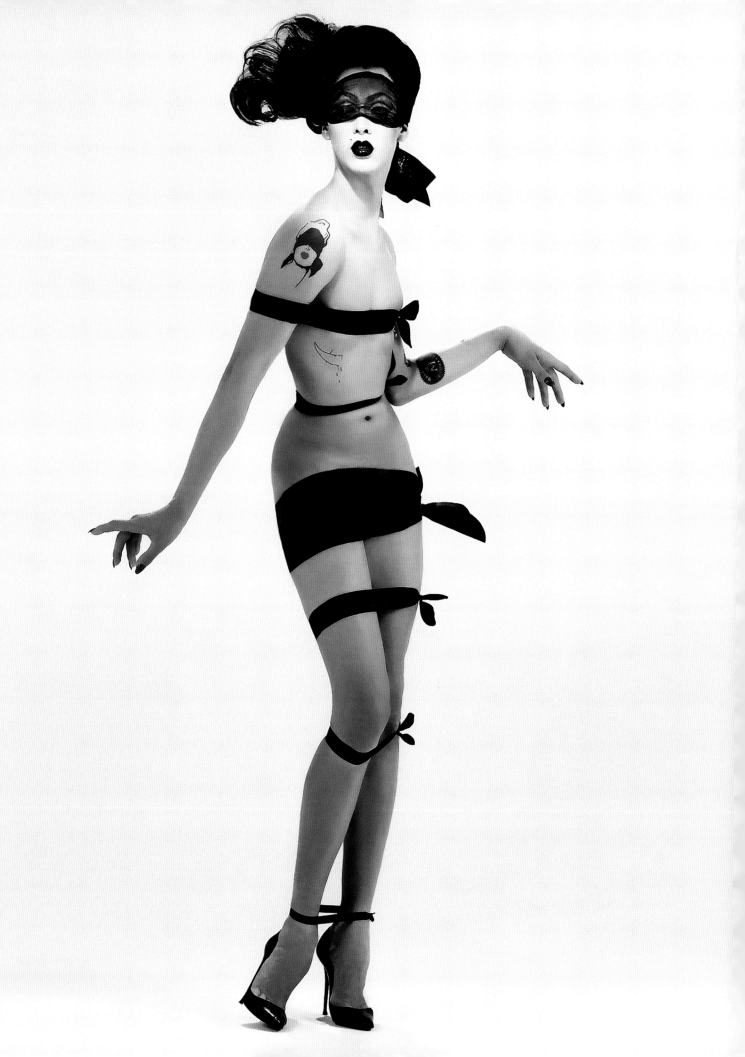

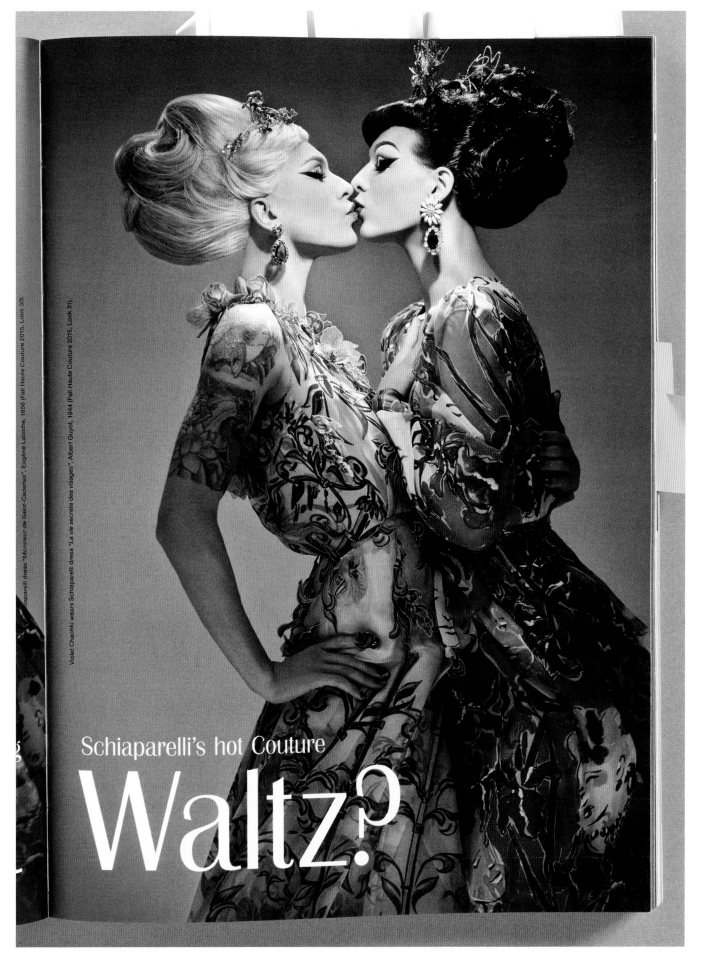

C★NDY *Transversal*/ 9th Issue, 2016. Page 89. Miss Fame and Violet Chachki photographed by Ali Mahdavi, styled by Catherine Baba. LEFT: Unpublished photograph of Violet Chachki shot by Ali Mahdavi, styled by Laurent Mercier.

...hiaparelli dress *"Monsieur de Saint-Cadenas"*, Eugène Labiche, 1856 (Fall Haute Couture 2015, Look 30).

Violet Chachki wears Schiaparelli dress *"La vie secrète des visages"*, Albert Guyot, 1944 (Fall Haute Couture 2015, Look 31).

Schiaparelli's hot Couture

Waltz?

WEST SIDE STORY

- Prologue
- Jet Song
- Something's Coming
- Dance at the Gym
- Maria
- Tonight
- America
- Cool
- One Hand, One Heart
- Tonight (Quintet)
- The Rumble
- I Feel Pretty
- Somewhere (Dream Ballet)
- Gee, Officer Krupke
- A Boy Like That
- I Have a Love
- Finale

SWEENEY TODD

The Ballad of Sweeney Todd
No Place Like London
The Barber and His Wife
The Worst Pies in London
Poor Thing
My Friends
Green Finch and Linnet Bird
Ah, Miss
Johanna
Pirelli's Miracle Elixir
The Contest
Wait
Kiss Me
Ladies in Their Sensitivities
Kiss Me/Ladies in Their Sensitivities
Pretty Women
Epiphany
A Little Priest
God, That's Good
Johanna
By the Sea
Wigmaker Sequence
The Letter
Not While I'm Around
Parlor Songs
City on Fire!
Searching
Final Sequence
The Ballad of Sweeney Todd

SUNDAY IN THE PARK WITH GEORGE 3

Sunday in the Park with George
No Life
Color and Light
Gossip
The Day Off
Everybody Loves Louis
Finishing the Hat
We Do Not Belong Together
Beautiful
Sunday
It's Hot Up Here
Chromolume #7
Putting It Together
Children and Art
Lesson #8
Move On
Sunday

A LITTLE NIGHT MUSIC 3

Vocal Overture
Night Waltz
Now
Later

Soon
The Glamorous Life
Remember?
You Must Meet My Wife
Liaisons
In Praise of Women
Every Day a Little Death
A Weekend in the Country
The Sun Won't Set
It Would Have Been Wonderful
Perpetual Anticipation
Send in the Clowns
The Miller's Son
Finale
Cut Songs
Bang!
Silly People

INTO THE WOODS 3

Prologue: Into the Woods
Cinderella at the Grave
Hello, Little Girl
Guess This Is Goodbye
Maybe They're Magic
I Know Things Now
A Very Nice Prince
First Midnight
Giants in the Sky
Agony
It Takes Two
Stay With Me
On the Steps of the Palace
Ever After
Prologue: So Happy
Agony
Lament
Any Moment
Moments in the Woods
Your Fault
Last Midnight

GYPSY 2

Overture
May We Entertain You
Some People
Small World
Baby June and Her Newsboys
Mr. Goldstone, I Love You
Little Lamb
You'll Never Get Away From Me
Dainty June and Her Farmboys
If Momma Was Married
All I Need Is the Girl
Everything's Coming Up Roses
Madame Rose's Toreadorables
Together, Wherever We Go
You Gotta Get a Gimmick
Let Me Entertain You
Rose's Turn

FOLLIES 4

Prologue
Beautiful Girls
Don't Look at Me
Waiting for the Girls Upstairs
Rain on the Roof
Ah, Paris!
Broadway Baby
The Road You Didn't Take
In Buddy's Eyes
Bolero d'Amour
Who's That Woman?
I'm Still Here
Too Many Mornings
The Right Girl
One More Kiss

Could I Leave You?
Loveland
You're Gonna Love Tomorrow
Love Will See Us Through
The God-Why-Don't-You-Love-Me
Blues (Buddy's Blues)
Losing My Mind
The Story of Lucy and Jessie
Live, Laugh, Love

DO I HEAR A WALTZ? 2

Overture
Someone Woke Up
This Week Americans
What Do We Do? We Fly!
Someone Like You
Bargaining
Here We Are Again
Thinking
No Understand
Take the Moment
Moon in My Window
We're Gonna Be All Right
Do I Hear a Waltz?
Stay
Perfectly Lovely Couple
Thank You So Much
Finale

COMPANY 3

Company
The Little Things You Do Together
Sorry-Grateful
You Could Drive a Person Crazy
Have I Got a Girl for You
Someone Is Waiting
Another Hundred People
Getting Married Today
Side by Side by Side
What Would We Do Without You?
Poor Baby
Tick Tock
Barcelona
The Ladies Who Lunch
Being Alive
Finale

ANYONE CAN WHISTLE 1

Overture
I'm Like the Bluebird
Me and My Town
Miracle Song
Simple
A-1 March
Come Play Wiz Me
Anyone Can Whistle
A Parade in Town
Everybody Says Don't
I've Got You to Lean On
See What It Gets You
The Cookie Chase
With So Little to Be Sure Of
Finale

The Role Models Cover

In May 2014, only a month had passed since my viral "coming out" TED Talk. I knew that my message resonated with a global audience, but little did I know that 2014 was the year when transgender stories in pop culture would enter the mainstream *zeitgeist*.

When you have a message that you truly believe in and want to share, the next step is to find your collaborators—people who will help you take your message to the next level. I started reaching out to friends after the TED Talk had come out. I wanted to use art in telling my story *and* to tell a bigger story, so my friend Miguel Figueroa connected me to Luis Venegas.

My email to Luis was a link to my TED Talk and paragraph after paragraph of my vision about the things I wanted to do to the world, the speeches that I wanted to give, of the truth that I wanted to speak in the biggest platforms that I could think of. I wanted to share the bigger story of the trans community and the beauty in all of our journeys to the whole world. I wanted to amplify my trans sisters' stories by collaborating to create something visual.

Coincidentally, Luis' reply to me was a vision of what he wanted for C★NDY. He shared that, for 2014, he was only going to do one issue, and he was thinking about the idea of the role models and icons. He was hoping to get all the greatest working trans models in fashion industry to come together and create a big magazine cover, with the vision of us looking powerful and beautiful, the embodiment of truth and beauty.

I replied: "It will be my pleasure to collaborate with you and be part of the next issue of C★NDY Transversal… just let me know about next steps… this makes me smile." Luis Skyped me just a few minutes later, and after about an hour into our conversation—which involved the repeated words "Yaaas!" and "Yes!" and "Amazing!"—we were sharing stories of the many trans trailblazers that came before us, the arts, my journey from the Philippines to New York, and his story of why he started C★NDY—it was full of excitement for what would happen next.

I then forwarded an email to Laverne Cox, Janet Mock, and Carmen Carrera, sharing the vision for this C★NDY magazine project and ended up writing, "The cover will be a gatefold cover with a large group of trans role models in a studio, a bit like those special *Vanity Fair* Hollywood Issue covers, you know? I feel it'd be unforgettable and an immediate collector's item! Everybody featured on the cover will also have individual portraits inside and an interview. Would you be interested to be part of this? I hope so! Superphotographer Mariano Vivanco and his team is shooting the cover and portraits for this very special issue." Our shoot was ON!!! Walking into a big warehouse location in Brooklyn felt like a Hollywood studio production. There was a total of fourteen of us scheduled to be photographed, so the group shot was divided up to different times and groupings. On set, I met Isis King, Nina Poon, and Niki M'nray for the first time. There was a BTS video that Laverne posted on social media of us laughing the moment we finished shooting the cover. Just looking at that video oozes so much love.

I met Leyna Bloom in person for the first time even though we've been following each other on Instagram. (Honestly, I didn't know her *tea* when I first followed her on social). Leyna shared with me that just a few weeks prior, she saw my Marriott Hotels campaign advertisement. She knew that I'm Filipina, but she didn't know my *tea* either. She shared with me that this C★NDY magazine shoot would be her "coming out." It was as if this magazine cover was revealing the deepest truths that we'd all been wanting to share with the world. What better way to share this than with your power trans sisters! Us all being in that space, sharing our power, seeing each other laughing, kissing, serving, and loving each other was a moment that I'll never forget.

Laverne Cox, Janet Mock, Carmen Carrera, Geena Rocero, Isis King, Leyna Bloom, Nina Poon, Gisele Alicea, Dina Marie, Juliana Huxtable, Niki M'nray, Pêche Di, Carmen Xtravaganza, and Yasmine Petty—the names of my powerful sisters! There are many more names of the ones who came before us and the future trans babies whose names I will proudly celebrate. Seeing ourselves reflected in that magazine cover was not just a dream, it was a vision of the future that we all share. This magazine cover is the image I wished I had seen when I was a young trans girl growing up in the Philippines—I can only imagine how huge a difference it would've made. This cover is a literal dream come true. To see ourselves reflected in culture, the arts, politics, and all media is a powerful statement that says we belong, that we deserve to be in all spaces in all the glory and nuance of humanity. For so long, we fought (and still fight) for the just recognition of our humanity. This year—2019—is the fiftieth anniversary of Stonewall, and how fittingly powerful that this is the year I'm writing a tribute about our magazine cover. Five years ago, we looked glamorous and powerful in that C★NDY Transversal magazine cover! We need more of that… the fight and the glam continues.

Muchas gracias, Luis, for your vision!

GEENA ROCERO
Model, producer, activist

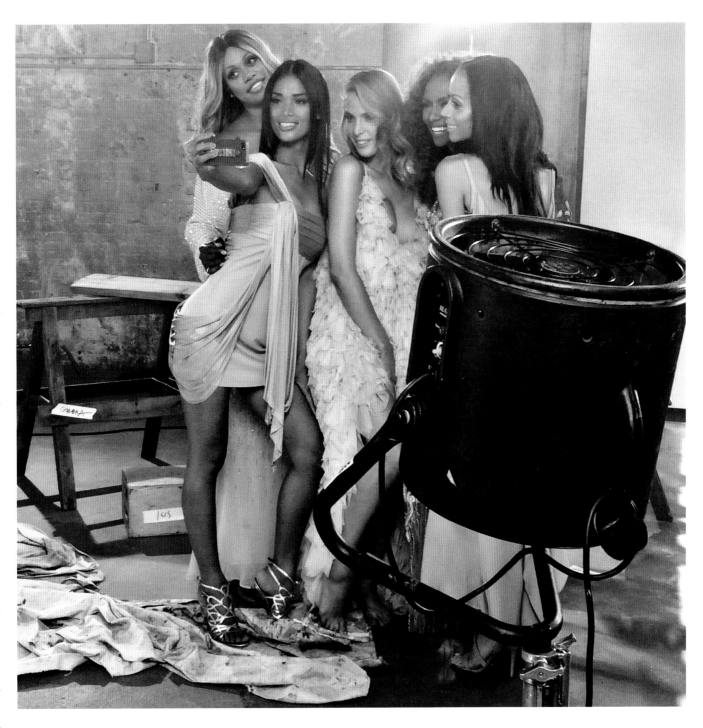

Unpublished photo of Laverne Cox, Geena Rocero, Carmen Carrera, Janet Mock and Isis King behind the scenes during *The Role Models* shoot for the C★NDY Transversal 8th Issue, 2015. Cover story.

The first time I became aware of *C★NDY* magazine was when they printed their Trans Role Models issue. It was a real defining media moment for visibility, and it made me feel extremely empowered to see such beautiful, aspirational, incredible women come together in the relatively early days of my transition.

—
MUNROE BERGDORF
C★NDY Transversal 12th Issue, 2019

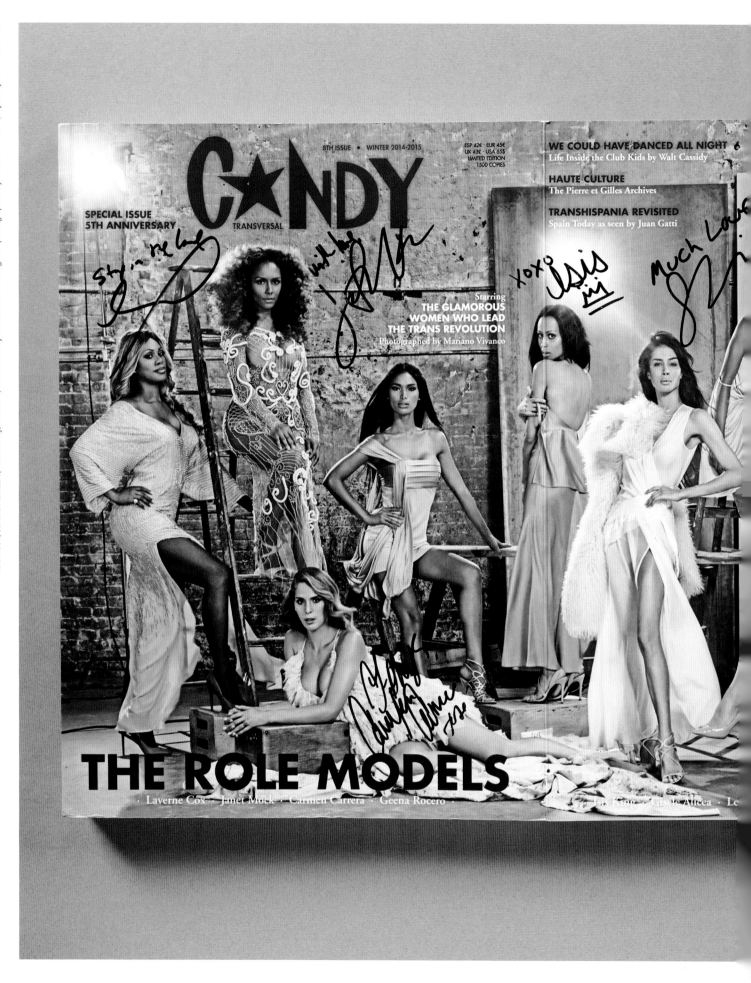

CANDY *Transversal* 8th Issue, 2015. Cover: Laverne Cox, Janet Mock, Carmen Carrera, Geena Rocero, Isis King, Gisele Alicea, Leyna Bloom, Dina Marie, Nina Poon, Juliana Huxtable, Niki M'nray, Pêche Di; Yasmine Petty and Carmen Xtravaganza photographed by Mariano Vivanco, styled by Yasmine Sterea.

8TH ISSUE • WINTER 2014-2015

ESP 42€ • EUR 45€
UK 43£ • USA 65$
LIMITED EDITION
1500 COPIES

C★NDY
TRANSVERSAL

SPECIAL ISSUE
5TH ANNIVERSARY

WE COULD HAVE DANCED ALL NIGHT
Life Inside the Club Kids by Walt Cassidy

HAUTE CULTURE
The Pierre et Gilles Archives

TRANSHISPANIA REVISITED
Spain Today as seen by Juan Gatti

Starring
THE GLAMOROUS
WOMEN WHO LEAD
THE TRANS REVOLUTION
Photographed by Mariano Vivanco

THE ROLE MODELS

• Laverne Cox • Janet Mock • Carmen Carrera • Geena Rocero • Isis King • Gisele Alicea • Le

126

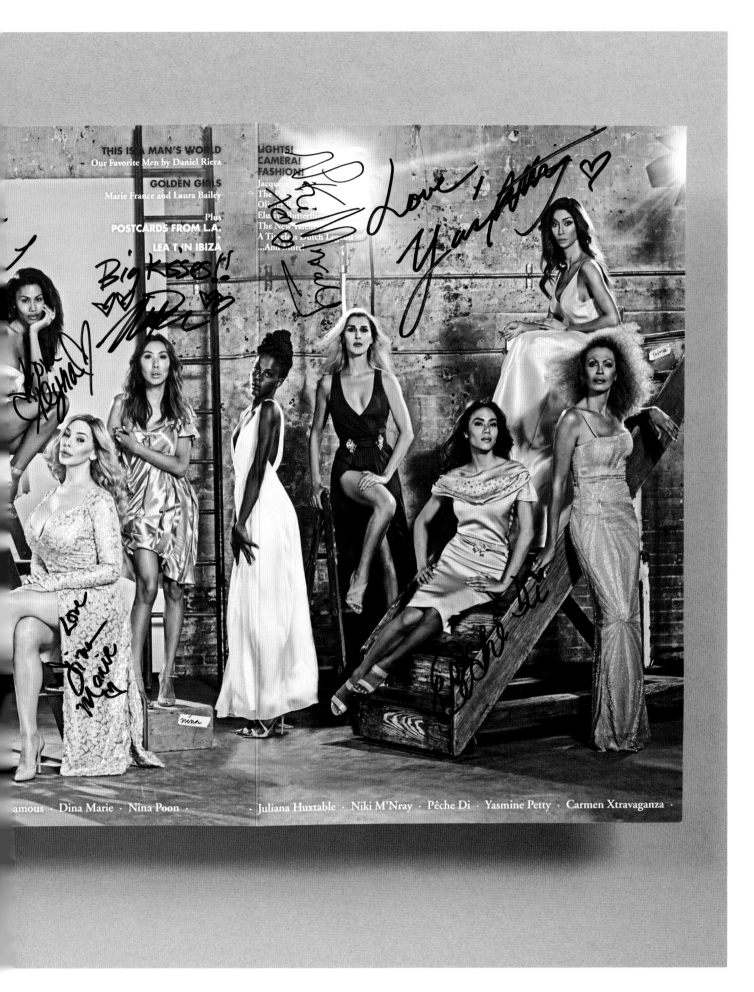

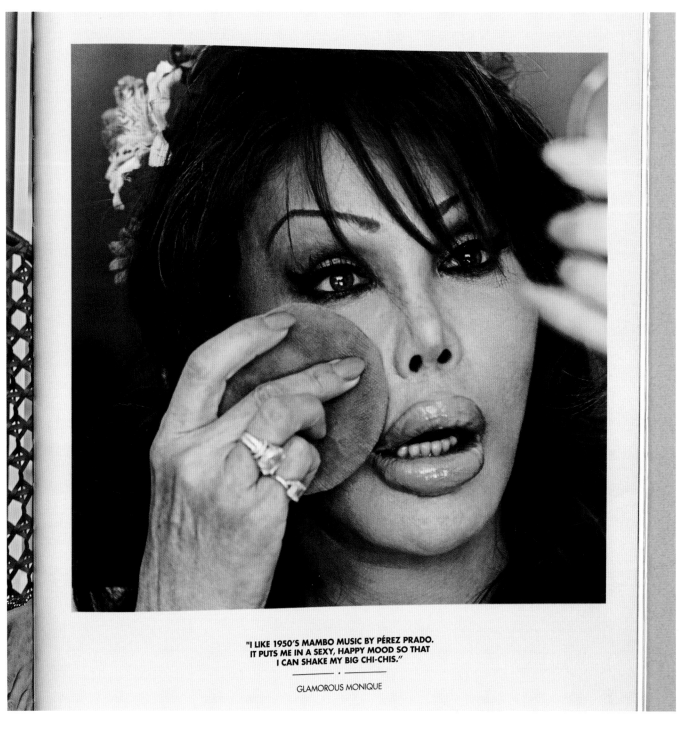

"I LIKE 1950'S MAMBO MUSIC BY PÉREZ PRADO.
IT PUTS ME IN A SEXY, HAPPY MOOD SO THAT
I CAN SHAKE MY BIG CHI-CHIS."

GLAMOROUS MONIQUE

C★NDY Transversal 8th Issue, 2015. Page 311. Glamorous Monique photographed by Mariano Vivanco. RIGHT: Unpublished photograph of Laura Bailey shot by Daniel Riera for C★NDY Transversal 8th Issue, 2015.

I love C★NDY magazine. I wish it had been around when I was a kid.
The pictures are fantastic. It's an art book. I really look forward to seeing it.
Luis Venegas calls it "transversal," which I think is a wonderful word. It would have been
unimaginable for me growing up to think that this would ever happen.
He's the one that made it happen. It's sort of cool to be trans. I think he's made
an impact on the fashion world with this magazine. It's wonderful.

—
LAURA BAILEY in conversation with Timothy Young
C★NDY Transversal 8th Issue, 2015

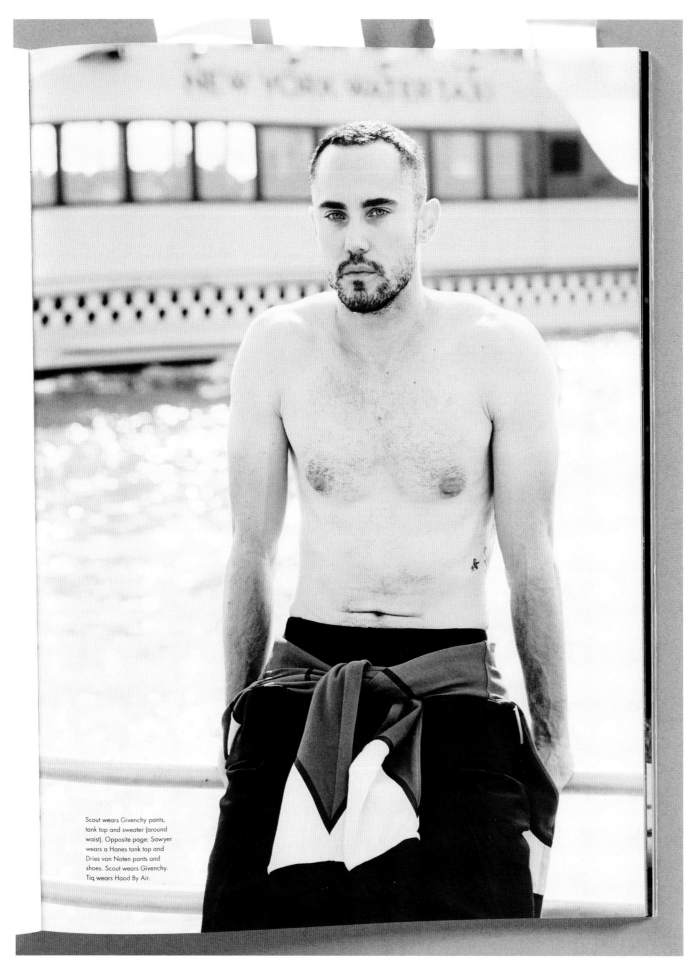

Scout wears Givenchy pants,
tank top and sweater (around
waist). Opposite page: Sawyer
wears a Hanes tank top and
Dries van Noten pants and
shoes. Scout wears Givenchy.
Tiq wears Hood By Air.

C★NDY *Transversal* 8th Issue, 2015. Page 261. Scout Rose photographed by Daniel Riera, styled by Grant Woolhead.

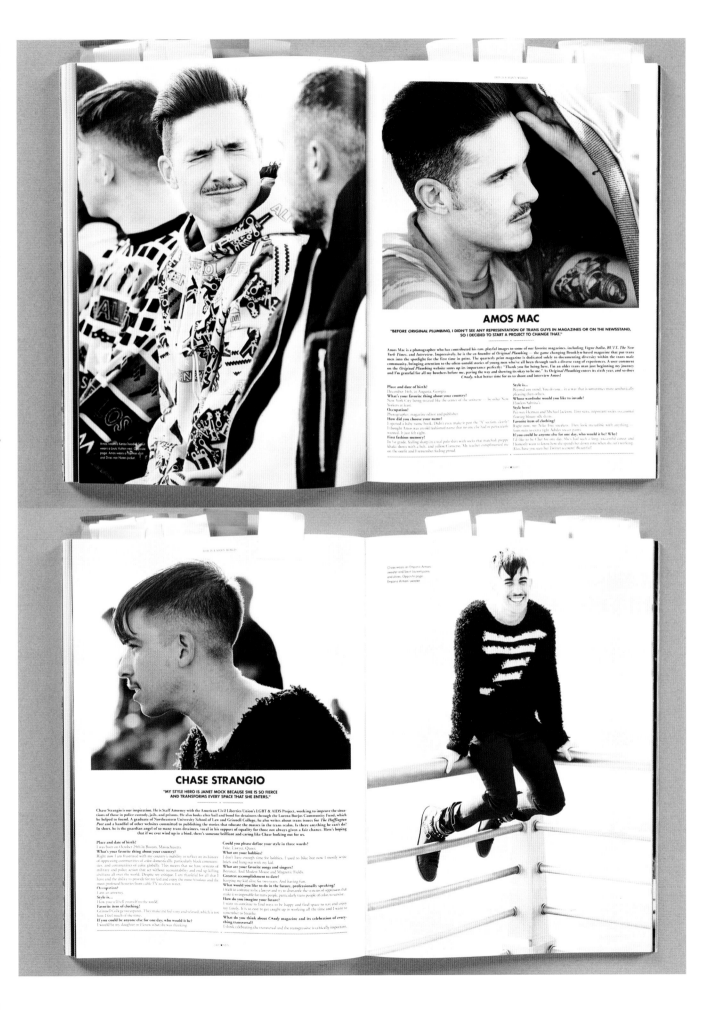

AMOS MAC

"BEFORE *ORIGINAL PLUMBING*, I DIDN'T SEE ANY REPRESENTATION OF TRANS GUYS IN MAGAZINES OR ON THE NEWSSTAND, SO I DECIDED TO START A PROJECT TO CHANGE THAT."

Amos Mac is a photographer who has contributed his raw, playful images to some of our favorite magazines, including *Vogue Italia*, *BUTT*, *The New York Times*, and *Interview*. Impressively, he is the co-founder of *Original Plumbing* — the game changing Brooklyn-based magazine that put trans men into the spotlight for the first time in print. The quarterly print magazine is dedicated solely to documenting diversity within the trans male community, bringing attention to the often-untold stories of young men who've all been through such a diverse range of experiences. A user comment on the *Original Plumbing* website sums up its importance perfectly: "Thank you for being here. I'm an older trans man just beginning my journey and I'm grateful for all my brothers before me, paving the way and showing its okay to be me." As *Original Plumbing* enters its sixth year, and so does *Candy*, what better time for us to shoot and interview Amos!

Place and date of birth?
December 16th, in Augusta, Georgia.
What's your favorite thing about your country?
New York City being treated like the center of the universe — by other New Yorkers at least.
Occupation?
Photographer, magazine editor and publisher.
How did you choose your name?
I opened a baby name book. Didn't even make it past the "A" section, in truth. I thought Amos was an old fashioned name that no one else had in particular I wanted. It just felt right.
First fashion memory?
In 1st grade, feeling sharp in a teal polo shirt with socks that matched, preppy khaki shorts with a belt, and yellow Converse. My teacher complimented me on the outfit and I remember feeling proud.

Style is....
Beyond, yes trend. You do you... it's a way that is sometimes more aesthetically pleasing than others.
Whose wardrobe would you like to invade?
Hanley Sabrina's.
Style hero?
Pee-wee Herman and Michael Jackson. Their suits, important socks, occasional floating blouse with shorts.
Favorite item of clothing?
Right now, my Nike free sneakers. They look incredible with anything, from suits to extra tight Adidas soccer pants.
If you could be anyone else for one day, who would it be? Why?
I'd like to be Cher for one day. She's had such a long, successful career, and I honestly want to know how she spends her down time when she isn't working. Also, have you seen her Twitter account? Beautiful!

Amos wears a Kenzo hoodie, Saint wears a Louis Vuitton vest. Opposite page: Amos wears a fashion shirt and Dries van Noten jacket.

CHASE STRANGIO

"MY STYLE HERO IS JANET MOCK BECAUSE SHE IS SO FIERCE AND TRANSFORMS EVERY SPACE THAT SHE ENTERS."

Chase Strangio is our inspiration. He is Staff Attorney with the American Civil Liberties Union's LGBT & AIDS Project, working to improve the situations of those in police custody, jails, and prisons. He also looks after bail and bond for detainees through the Lorena Borjas Community Fund, which he helped to found. A graduate of Northeastern University School of Law and Grinnell College, he also writes about trans issues for *The Huffington Post* and a handful of other websites committed to publishing the stories that educate the masses in the trans realm. In short, he is the guardian angel of so many trans detainees, vocal in his support of equality for those not always given a fair chance. Here's hoping that if we ever wind up in a bind, there's someone brilliant and caring like Chase looking out for us.

Place and date of birth?
I was born on October 29th in Boston, Massachusetts.
What's your favorite thing about your country?
Right now I am frustrated with my country's inability to reflect on its history of oppressing communities of color domestically, particularly black communities, and communities of color globally. This means that we have systems of military and police action that act without accountability and end up killing civilians all over the world. Despite my critique, I am thankful for all that I have and the ability to provide for my kid and enjoy the most frivolous of the most profound luxuries from cable TV to clean water.
Occupation?
I am an attorney.
Style is...
How you sell/tell yourself to the world.
Favorite item of clothing?
Grinnell College sweatpants. They make me feel cozy and relaxed, which is too how I feel back if the time.
If you could be anyone else for one day, who would it be?
I would be my daughter so I knew what she was thinking

Could you please define your style in three words?
Fake. Lawyer. Queer.
What are your hobbies?
I don't have enough time for hobbies. I used to bike but now I mostly write briefs and hang out with my kid.
What are your favorite songs and singers?
Beyoncé. And Modest Mouse and Magnetic Fields.
Greatest accomplishment to date?
Keeping my kid alive for two years. And having fun.
What would you like to do in the future, professionally speaking?
I want to continue to be a lawyer and try to dismantle the systems of oppression that make it so impossible for trans people, particularly trans people of color, to survive.
How do you imagine your future?
I want to continue to find ways to be happy and find space to rest and enjoy my family. It is so easy to get caught up in working all the time and I want to remember to breathe.
What do you think about *Candy* magazine and its celebration of everything transversal?
I think celebrating the transversal and the transgressive is critically important.

Chase wears an Emporio Armani sweater and Saint Laurent pants and shoes. Opposite page: Emporio Armani sweater.

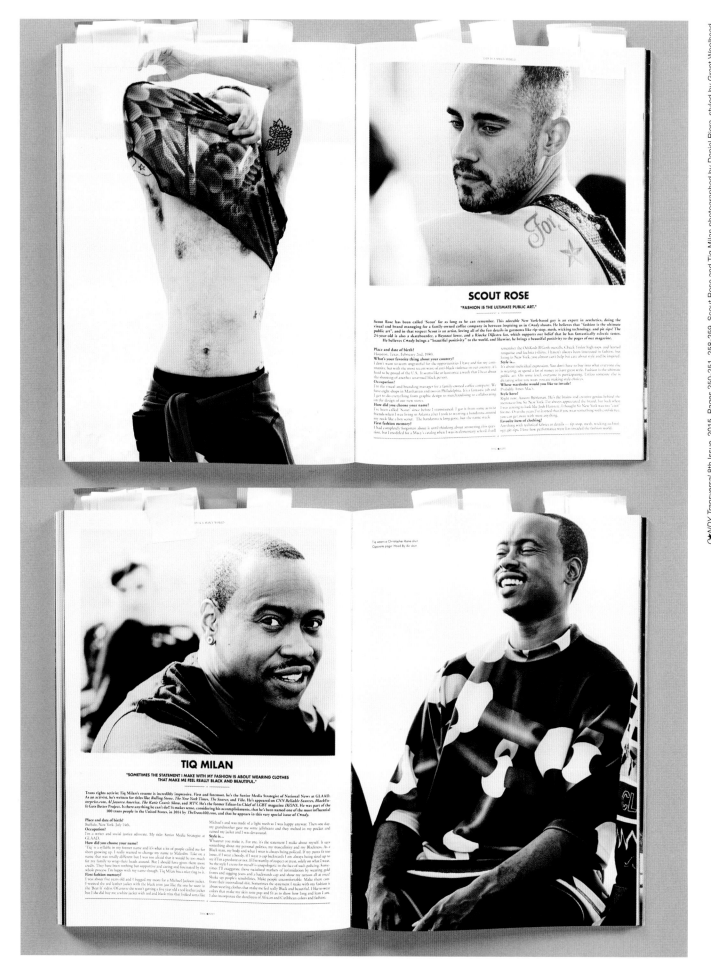

SCOUT ROSE

"FASHION IS THE ULTIMATE PUBLIC ART."

Scout Rose has been called 'Scout' for as long as he can remember. This adorable New York-based guy is an expert in aesthetics, doing the visual and brand managing for a family-owned coffee company in between inspiring us in *Candy* shoots. He believes that "fashion is the ultimate public art", and in that respect Scout is an artist, loving all of the fun details in garments like rip-stop, mesh, wicking technology, and pit zips! The 24-year-old is also a skateboarder, a Beyoncé lover, and a Rineke Dijkstra fan, which supports our belief that he has fantastically eclectic tastes. He believes *Candy* brings a "beautiful positivity" to the world, and likewise, he brings a beautiful positivity to the pages of our magazine.

Place and date of birth!
Houston, Texas. February 2nd, 1980.
What's your favorite thing about your country?
I don't want to seem ungrateful for the opportunities I have and for my community, but with the most recent wave of anti-black violence in our country, it's hard to be proud of the U.S. It seems like at least once a week that I hear about the shooting of another unarmed black person.
Occupation!
I'm the visual and branding manager for a family-owned coffee company. We have eight shops in Manhattan and two in Philadelphia. It's a fantastic job and I get to do everything from graphic design to merchandising to collaborating on the design of our new stores.
How did you choose your name?
I've been called 'Scout' since before I transitioned. I got it from some activist friends when I was living in Atlanta after I took to wearing a bandana around my neck like a boy scout. The bandana is long gone, but the name stuck.
First fashion memory!
I had completely forgotten about it until thinking about answering this question, but I modeled for a Macy's catalog when I was in elementary school. I still

remember the OshKosh B'Gosh overalls, Chuck Taylor high tops and layered turquoise and fuchsia t-shirts. I haven't always been interested in fashion, but living in New York, you almost can't help but care about style and be inspired.
Style is...
It's about individual expression. You don't have to buy into what everyone else is wearing, or spend a lot of money to have great style. Fashion is the ultimate public art. On some level, everyone is participating. Unless someone else is dictating what you wear, you are making style choices.
Whose wardrobe would you like to invade?
Probably Annie Mac's.
Style hero!
Right now, Aurora Brökeman. He's the brains and creative genius behind the menswear line So New York. I've always appreciated the brand, but back when I was aiming to look like Josh Hartnett, I thought So New York was too 'cool' for me. Over the years I've learned that if you wear something with confidence, you can get away with most anything.
Favorite item of clothing!
Anything with technical fabrics or details — rip-stop, mesh, wicking technology, pit zips. I love how performance wear has invaded the fashion world.

TIQ MILAN

"SOMETIMES THE STATEMENT I MAKE WITH MY FASHION IS ABOUT WEARING CLOTHES
THAT MAKE ME FEEL REALLY BLACK AND BEAUTIFUL."

Trans rights activist Tiq Milan's resume is incredibly impressive. First and foremost, he's the Senior Media Strategist of National News at GLAAD. As an activist, he's written for titles like *Rolling Stone, The New York Times, The Source,* and *Vibe.* He's appeared on *CNN Reliable Sources, BlackEnterprise.com, Al Jazeera America, The Katie Couric Show,* and *MTV.* He's the former Editor-In-Chief of LGBT magazine *IKONS.* He was part of the It Gets Better Project. Is there anything he can't do?! It makes sense, considering his accomplishments, that he's been named one of the most influential 100 trans people in the United States, in 2014 by *TheTrans100.com,* and that he appears in this very special issue of *Candy.*

Place and date of birth!
Buffalo, New York. July 16th.
Occupation!
I'm a writer and social justice advocate. My title: Senior Media Strategist at GLAAD.
How did you choose your name?
Tiq is a syllable in my former name and it's what a lot of people called me for short growing up. I really wanted to change my name to Malcolm. Tiq or a name that was totally different but I was too afraid that it would be too much for my family to wrap their heads around. But I should have given them more credit. They have been nothing but supportive and caring and fascinated by the whole process. I'm happy with my name though. Tiq Milan has a nice ring to it.
First fashion memory!
I was about five years old and I bugged my mom for a Michael Jackson jacket. I wanted the red leather jacket with the black trim just like the one he wore in the Beat It video. Of course she wasn't getting a five year old a red leather jacket but I she did buy my a white jacket with red and black trim that looked sorta like

Michael's and was made of a light mesh so I was happy anyway. Then one day my grandmother gave me some leftovers and they melted in my pocket and ruined my jacket and I was devastated.
Style is...
Whatever you make it. For me, it's the statement I make about myself. It says something about my personal politics, my masculinity and my Blackness. As a Black man, my body and what I wear is always being policed. If my pants fit too loose, if I wear a hoody, if I wear a cap backwards I am always being sized up to see if I'm a predator or not. If I'm worthy of respect or trust, solely on what I wear. So the style I create for myself is unapologetic in the face of such policing. Sometimes I'll exaggerate those racialized markers of intimidation by wearing gold fronts and sagging jeans and a backwards cap and show my tattoos all at once! Shake up people's sensibilities. Make people uncomfortable. Make them confront their internalized shit. Sometimes the statement I make with my fashion is about wearing clothes that make me feel really Black and beautiful. I like to wear colors that make my skin tone pop and fit as to show how long and lean I am. I also incorporate the cloudiness of African and Caribbean colors and fashion.

Tiq wears a Christopher Kane shirt
Opposite page: Hood By Air shirt

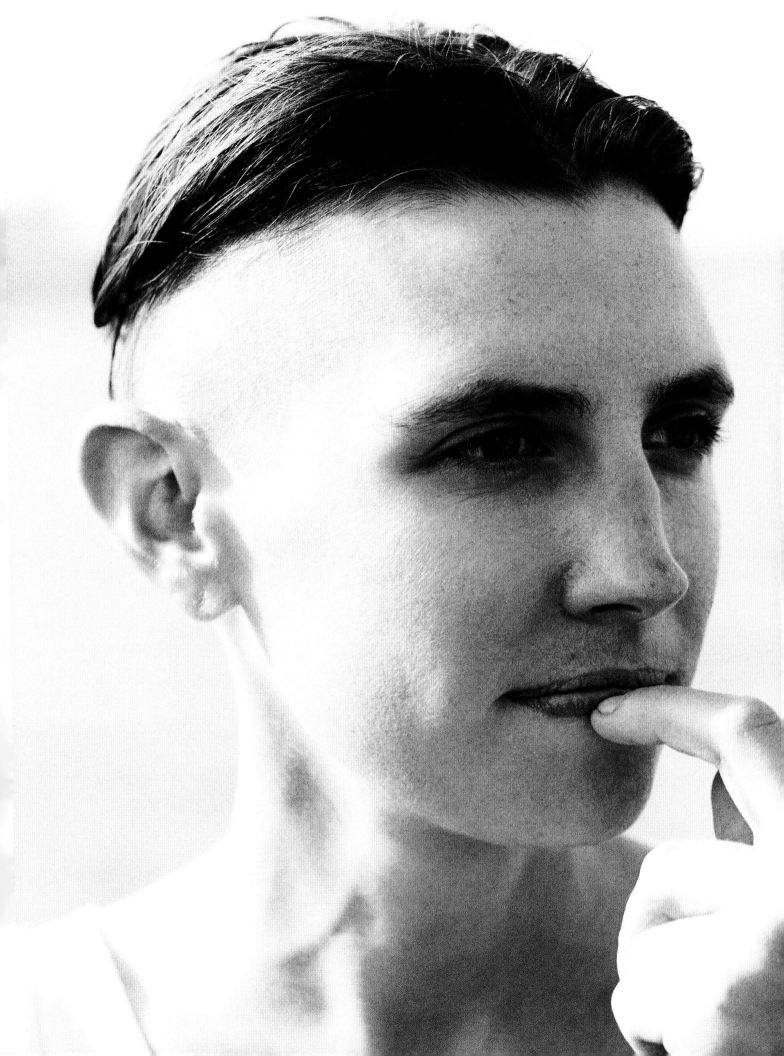

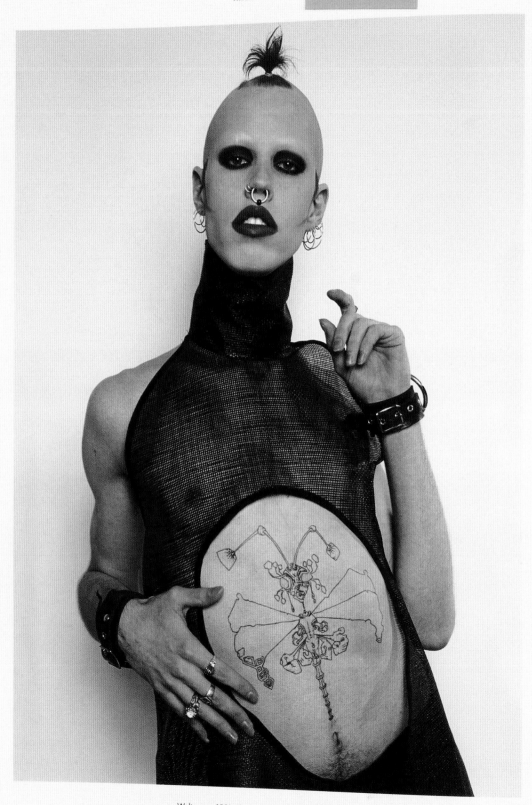

C✱NDY *Transversal* 8th Issue, 2015. Page 38. Waltpaper, 1991, photographed by Michael Fazakerley.

Waltpaper, 1991. Photograph by Michael Fazakerley.

C★NDY *Transversal* 8th Issue, 2015. Page 65. Waltpaper at Roxy, 1994, photographed by Misa Martin.

Waltpaper at Roxy, 1994.
Photographs by Misa Martin.

We were a group of children growing up, discovering our voices,
our bodies and identities, finding our balance and purpose.
New York City was our mother and we honored her with sound,
costume, movement, and ritual.

—
WALT CASSIDY / WALTPAPER about the early 90s Club Kids scene
C★NDY *Transversal* 8th Issue, 2015

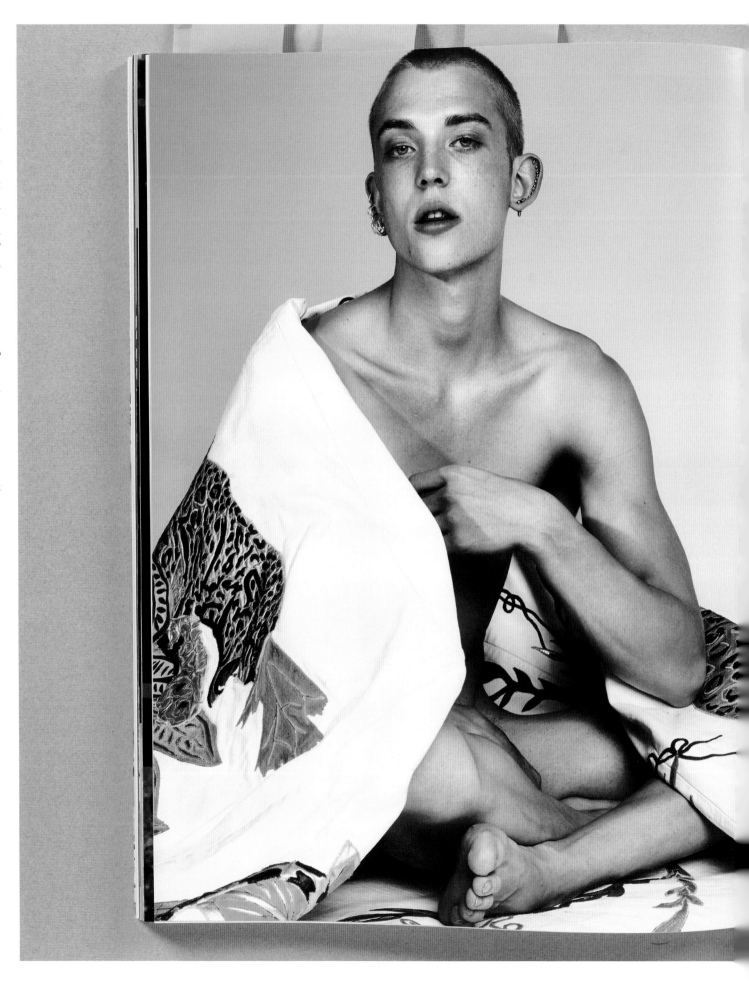

C★NDY *Transversal* 8th Issue, 2015. Pages 148-149. Jelle Haen photographed by Philippe Vogelenzang, styled by Ferry van der Nat.

THE
DUTCH HOUSE

JE MAINTIENDRAI

OF
EXTRAVAGANZA

THE LEGACY OF FASHION DESIGNER FONG LENG

———— • ————

PHILIPPE VOGELENZANG
PHOTOGRAPHY

FERRY VAN DER NAT
STYLING

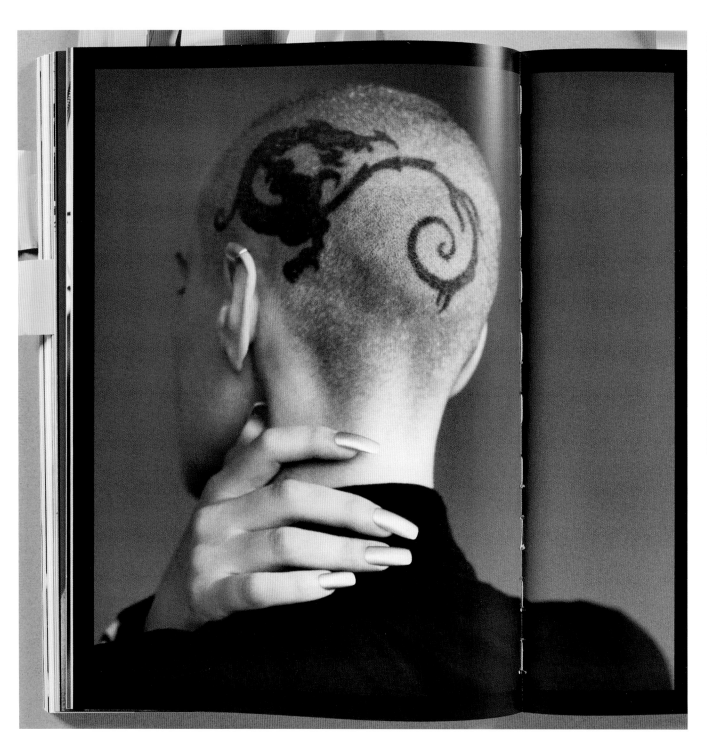

CANDY *Transversal* 5th Issue, 2012. Pages 234-235. Eve Salvail photographed by Bruno Staub, styled by Julian Jesus.

C★NDY Transversal 7th Issue, 2014. Pages 300-301. James Jeanette photographed by Benjamin A Huseby.

R HUSEBY

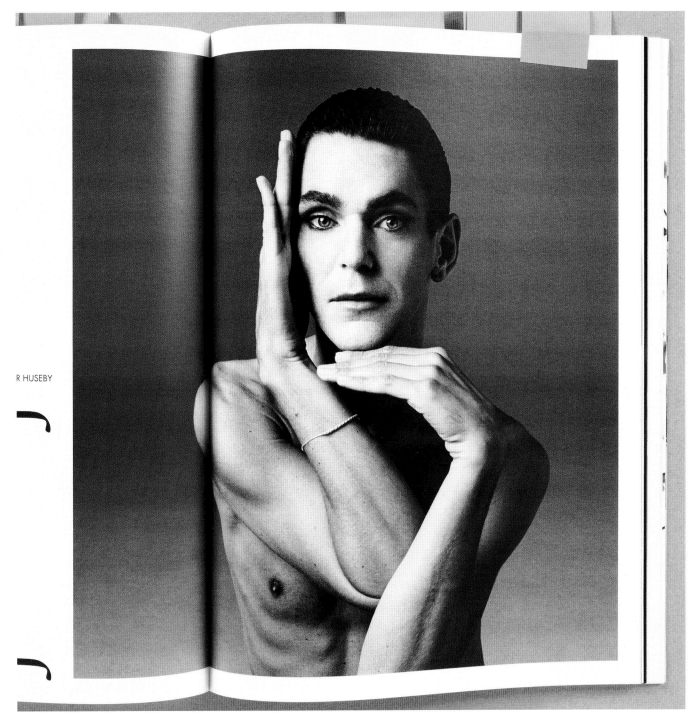

I'd pretend I was Alexis Colby, wear my dressing gown back-to-front,
my head in a towel turban. My dad caught me talking to Blake in the mirror.

—
JAMES JEANETTE in conversation with Tim Blanks
C★NDY Transversal 7th Issue, 2014

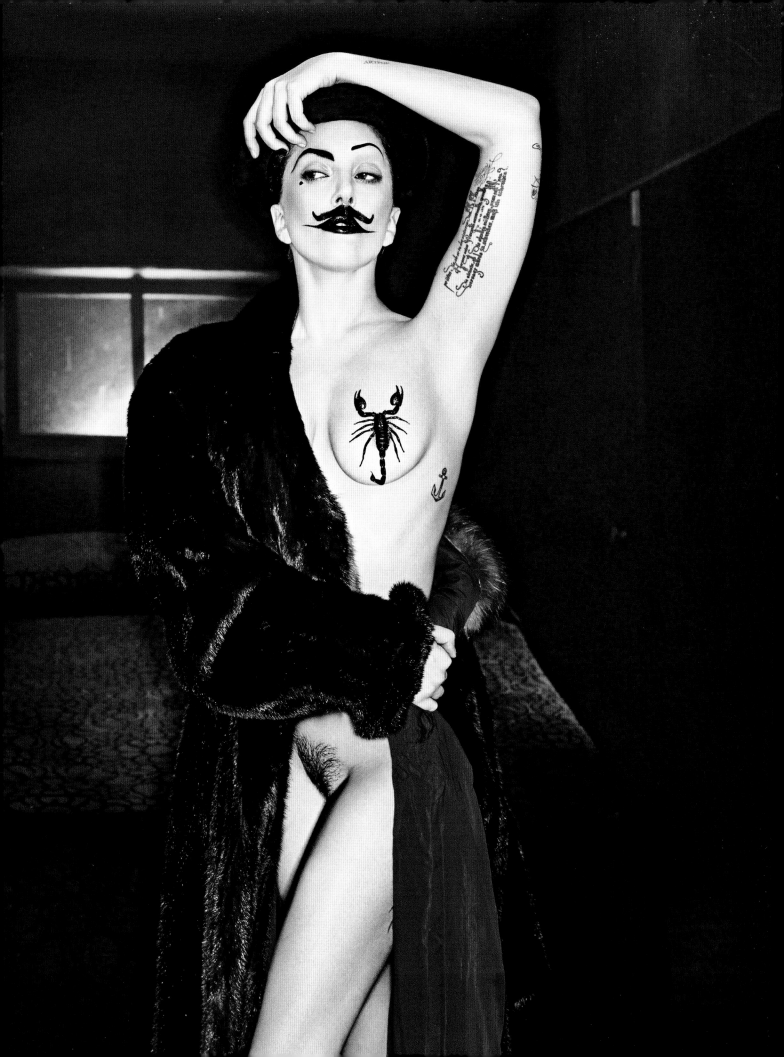

C★NDY Transversal 7th Issue, 2014. Cover: Lady Gaga photographed by Steven Klein, styled by Panos Yiapanis.

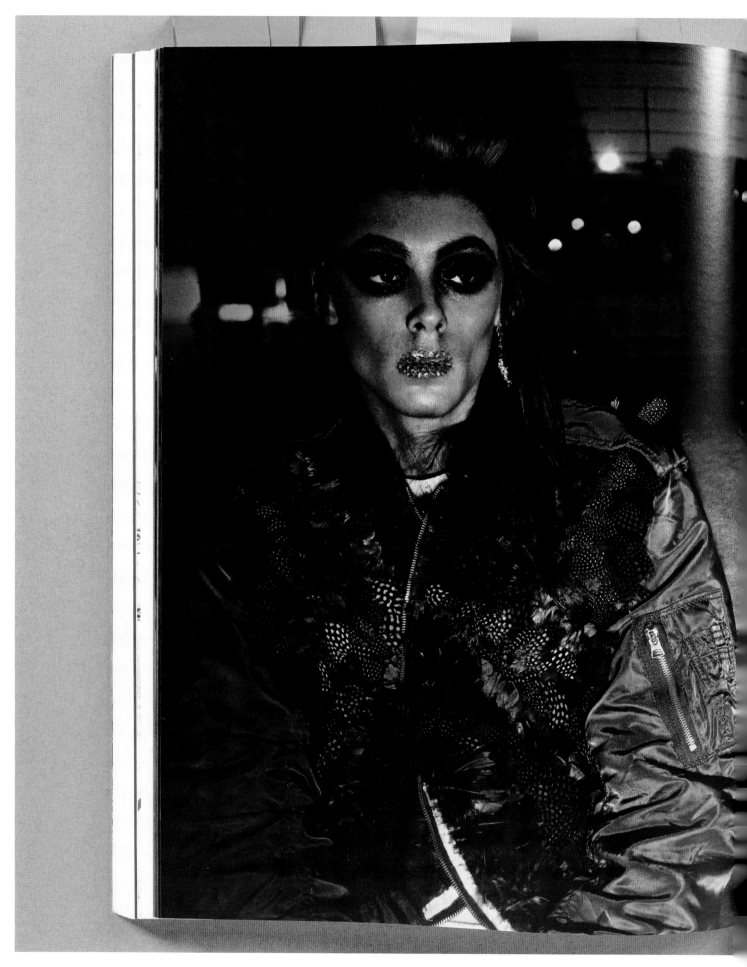

C★NDY Transversal 7th Issue, 2014. Pages 212-213. Marley Chapman and Hannelore Knuts photographed by Steven Klein, styled by Panos Yiapanis.

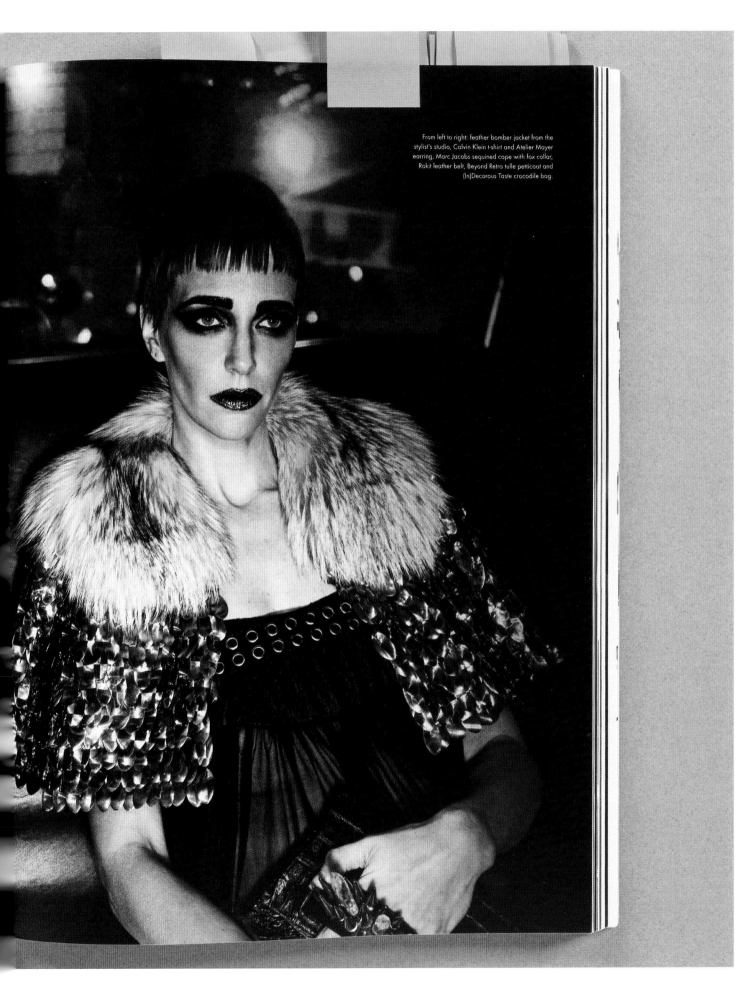

From left to right: feather bomber jacket from the stylist's studio, Calvin Klein t-shirt and Atelier Mayer earring, Marc Jacobs sequined cape with fox collar, Rokit leather belt, Beyond Retro tulle petticoat and (In)Decorous Taste crocodile bag.

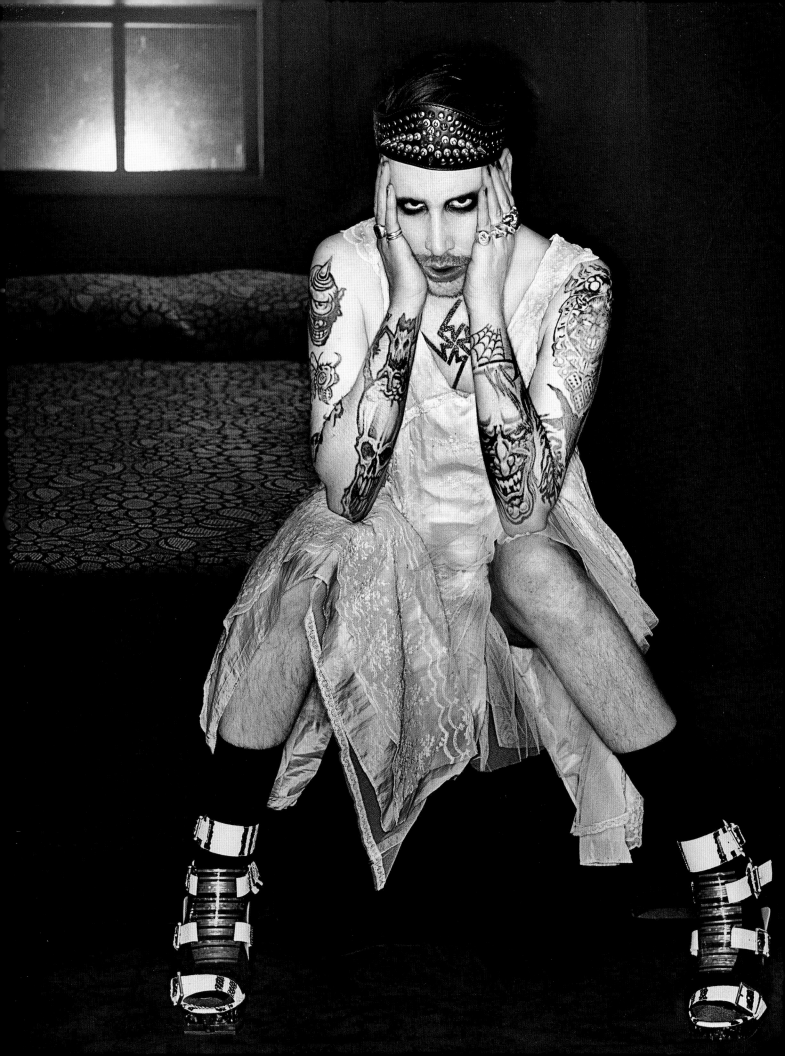

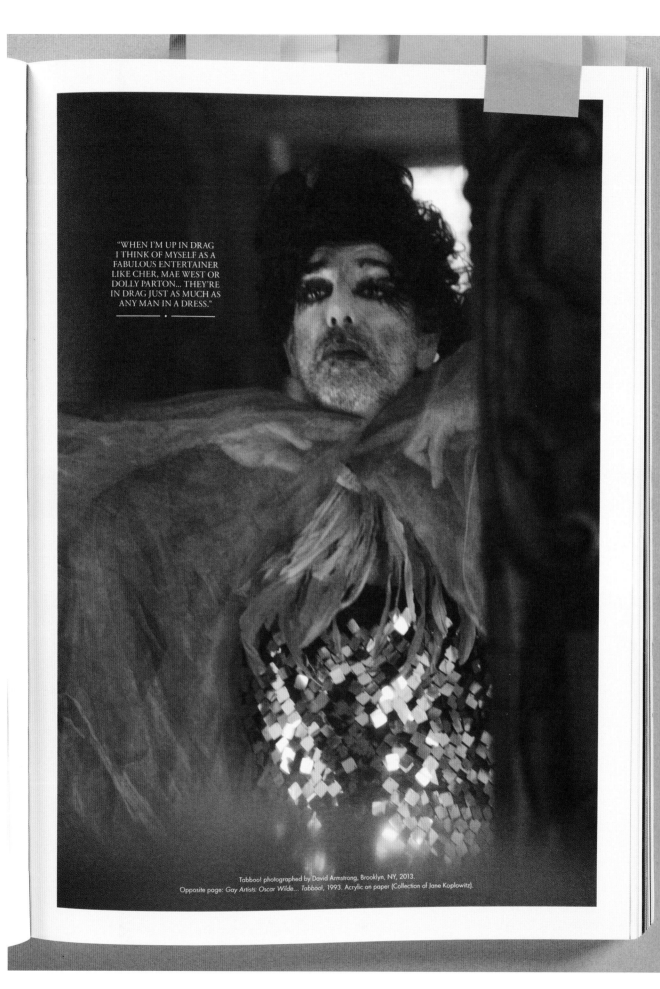

"WHEN I'M UP IN DRAG
I THINK OF MYSELF AS A
FABULOUS ENTERTAINER
LIKE CHER, MAE WEST OR
DOLLY PARTON... THEY'RE
IN DRAG JUST AS MUCH AS
ANY MAN IN A DRESS."
————— • —————

Tabboo! photographed by David Armstrong, Brooklyn, NY, 2013.
Opposite page: *Gay Artists: Oscar Wilde... Tabboo!*, 1993. Acrylic on paper (Collection of Jane Koplowitz).

C✷NDY *Transversal* 7th Issue, 2014. Page 113. Tabboo! photographed by David Armstrong.

C★NDY Transversal 7th Issue, 2014. Pages 100–101. Tabboo! photographed by David Armstrong, New York City, 1983.

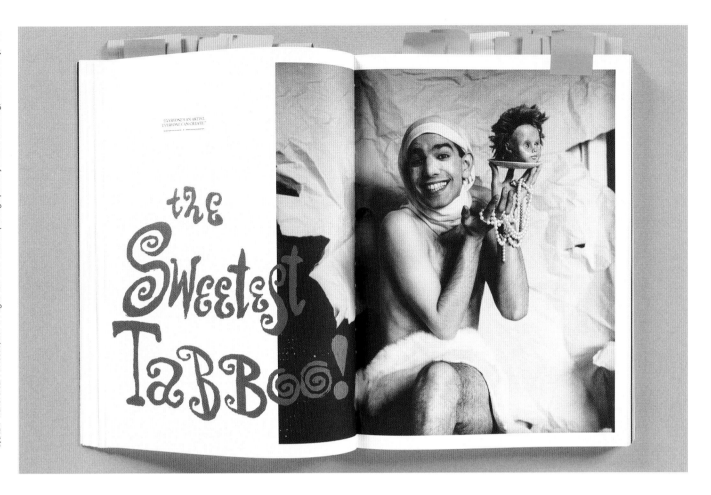

Can you believe I was performing in drag under my real name?
Wendy Wild came up to me and said, "Girl,
you gotta have a drag's name." So I came up with Tabboo!
I thought it sounded exotic, Polynesian maybe!

—
TABBOO! in conversation with Josiah Howard
C★NDY Transversal 7th Issue, 2014

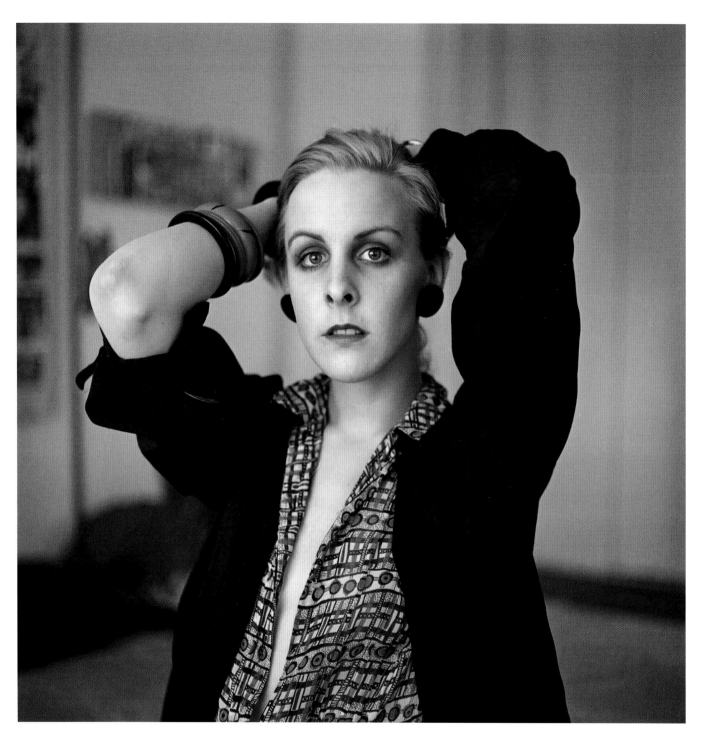

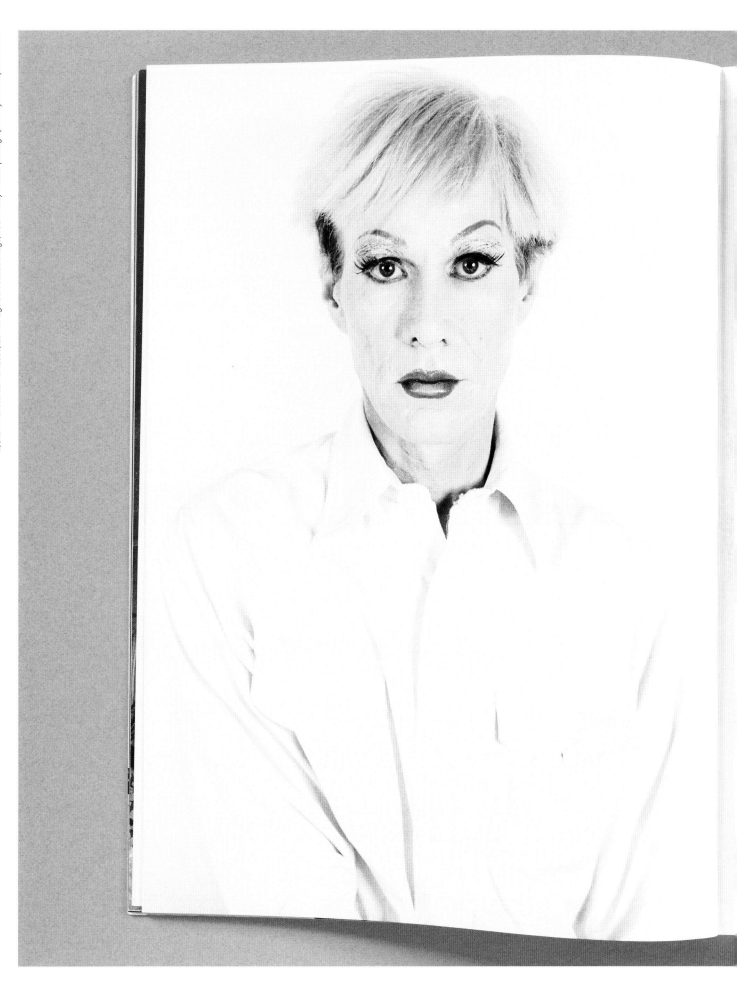

C✷NDY *Transversal* 7th Issue, 2014. Page 30. Altered Image, 1981. Andy Warhol photographed by Christopher Makos.

CANDY *Transversal* 7th Issue, 2014. Page 31. Altered Image, 1981. Andy Warhol photographed by Christopher Makos.

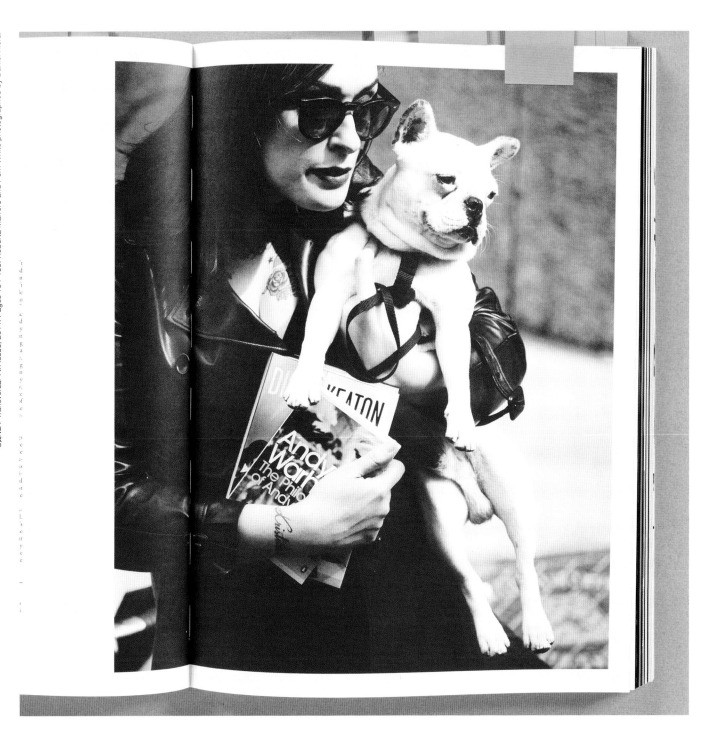

C★NDY Transversal/ 7th Issue, 2014. Pages 154-155. Roberta Marrero and Perri White photographed by Daniel Riera.

I usually say that *C★NDY* is our *Vogue*,
but my statement is not quite enough:
Vogue never reached this level of opulence,
and Anna Wintour is super cool,
but not half as much as Luis Venegas.

—
ROBERTA MARRERO about *C★NDY Transversal* in her book *We Can Be Heroes*, 2018

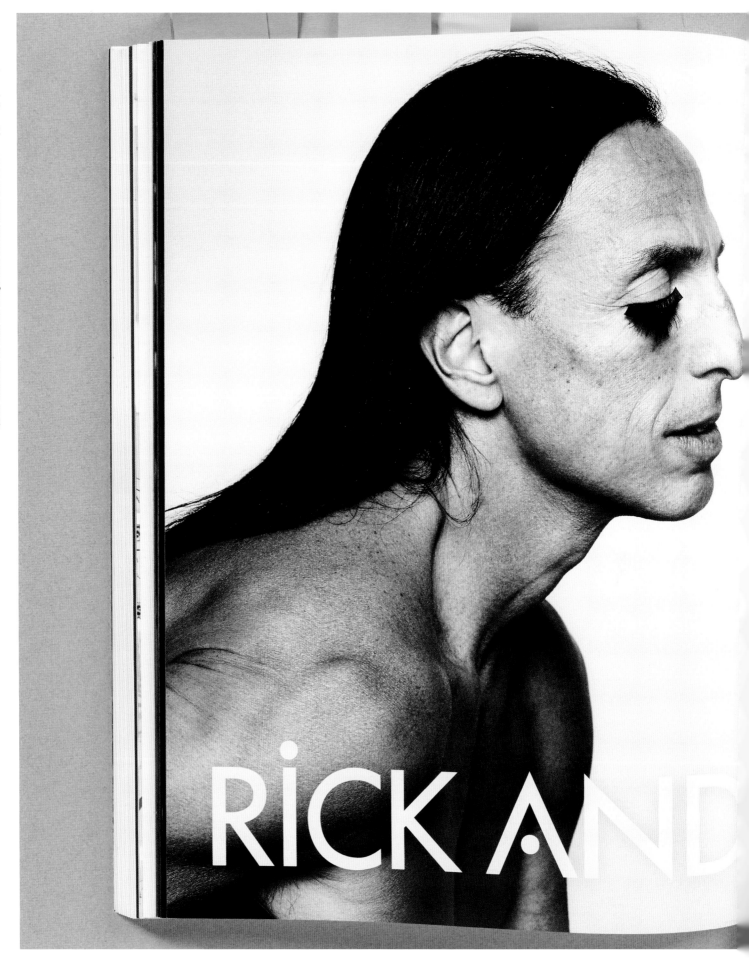

C★NDY Transversal 7th Issue, 2014. Pages 218-219. Rick Owens and Michele Lamy photographed by Danielle Levitt.

RICK AND

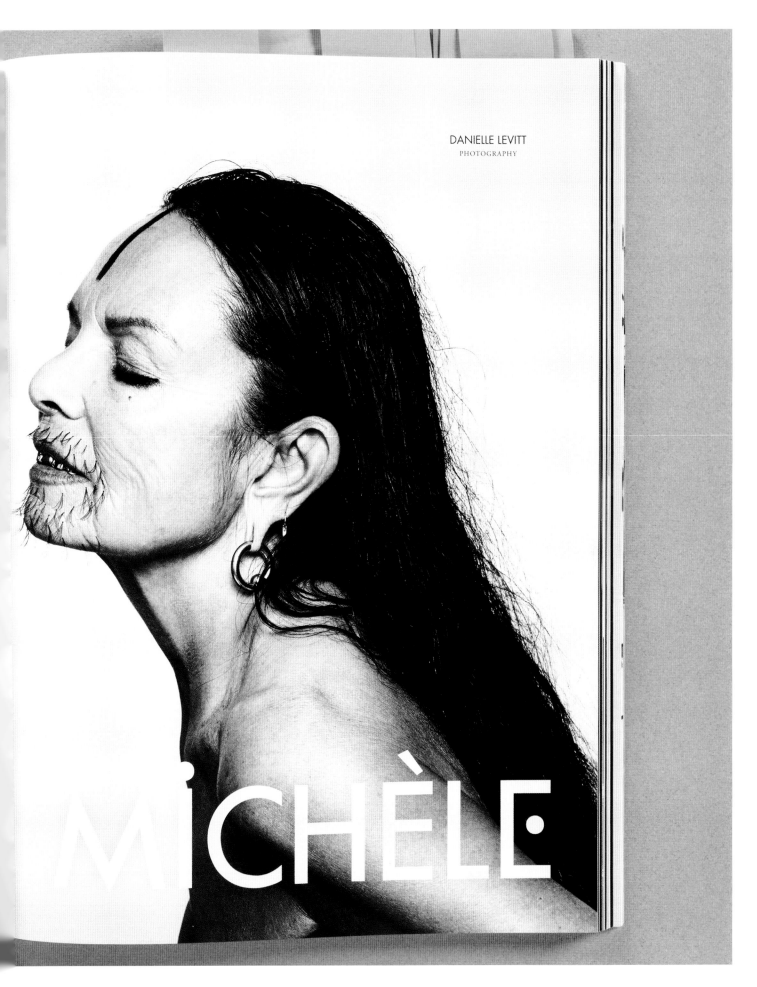

MICHÈLE·

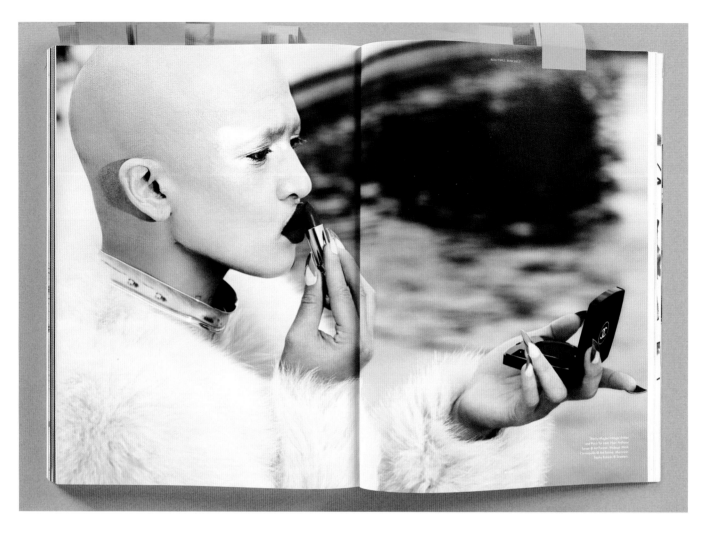

C★NDY *Transversal* 7th Issue, 2014. Pages 344-345. Boychild photographed by Mikael Jansson, styled by George Cortina.

Life is a funny thing… I think we're allowed to have as many lives as we want.

—
BOYCHILD in conversation with Zac Bayly
C★NDY *Transversal* 7th Issue, 2014

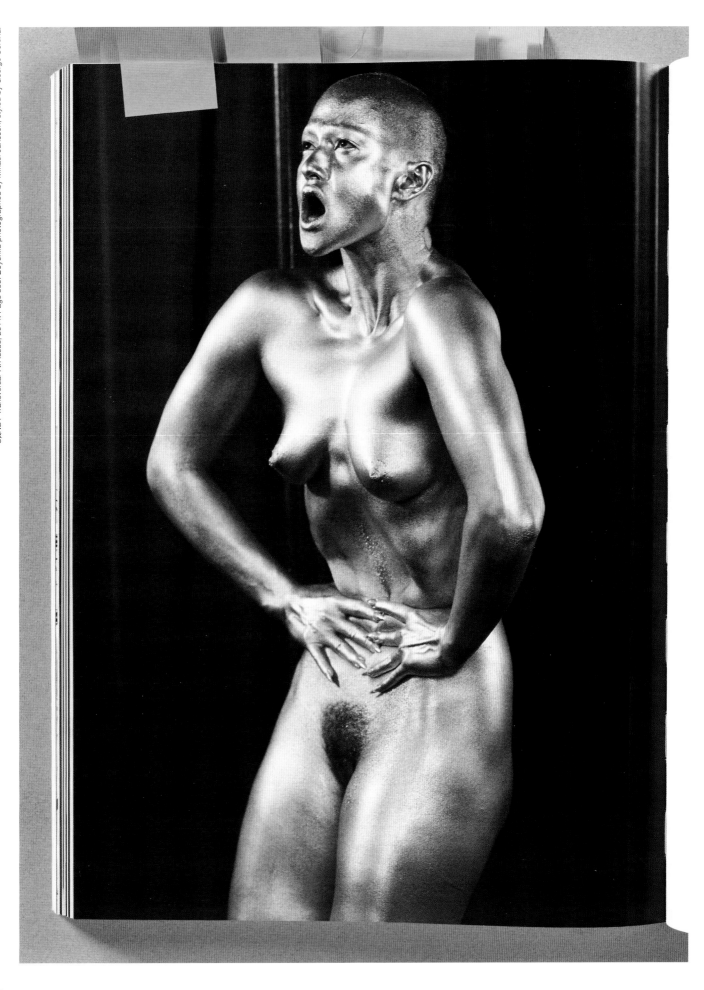

CANDY Transversal 7th Issue, 2014. Page 338. Boychild photographed by Mikael Jansson, styled by George Cortina.

CANDY *Transversal* / 7th Issue, 2014. Pages 280-281. Artwork by Jordi Labanda after Inès Rau photographed by Xevi Muntané, styled by Guillaume Boulez.

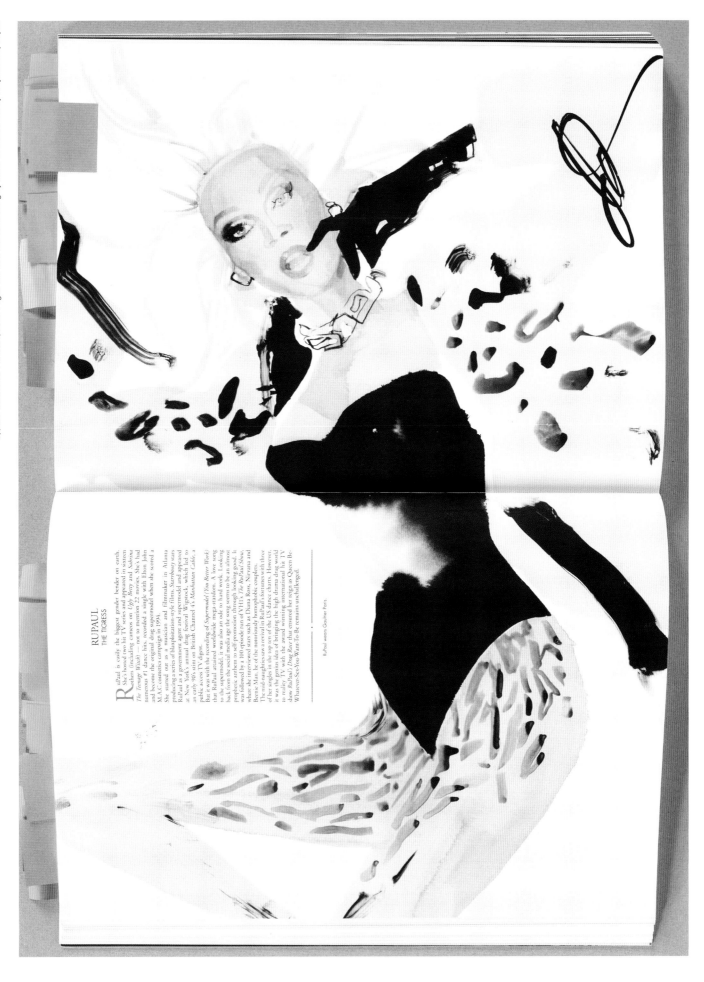

G★NDY *Transversal* 7th Issue, 2014. Pages 120–121. RuPaul drawing by David Downton. Text by Daryoush Haj-Najafi.

RUPAUL
THE TIGRESS

RuPaul is easily the biggest gender bender on earth. She's hosted two hit TV series and appeared in sixteen movies (including cameos on *Ugly Betty* and *Sabrina The Teenage Witch*) — not to mention 22 movies. She's had numerous #1 dance hits, recorded a single with Elton John and become the original drag supermodel when she scored a M.A.C cosmetics campaign in 1994.

She started out as a musician and filmmaker in Atlanta producing a series of blaxploitation-style films. *Starrbooty* stars RuPaul as a government agent and supermodel and appeared at New York's annual drag festival Wigstock, which led to an early 90's stint on British Channel 4's *Manhattan Cable*, a public access TV digest.

But it was with the recording of *Supermodel (You Better Work)* that RuPaul attained worldwide mega-stardom. A love song to the supermodel, it was also an ode to hard work. Looking back from the social media age the song seems to be an almost prophetic anthem to self-promotion through looking good. It was followed by a 100 episode run of VH1's *The RuPaul Show*, where she interviewed stars such as Diana Ross, Nirvana and Beenie Man, he of the notoriously homophobic couplets.

The mid-naughties saw a revival in RuPaul's fortunes with three of her singles in the top ten of the US dance charts. However, it was the genius idea of bringing the high drama drag world to reality TV with the award winning international hit TV show *RuPaul's Drag Race* that ensured her reign as Queen Be-Whatever-Sex-You-Want-To-Be remains unchallenged.

RuPaul wears Gaultier Paris.

CANDY *Transversal*/ 6th Issue, 2013. Page 179. Gilda Love photographed by Daniel Riera.

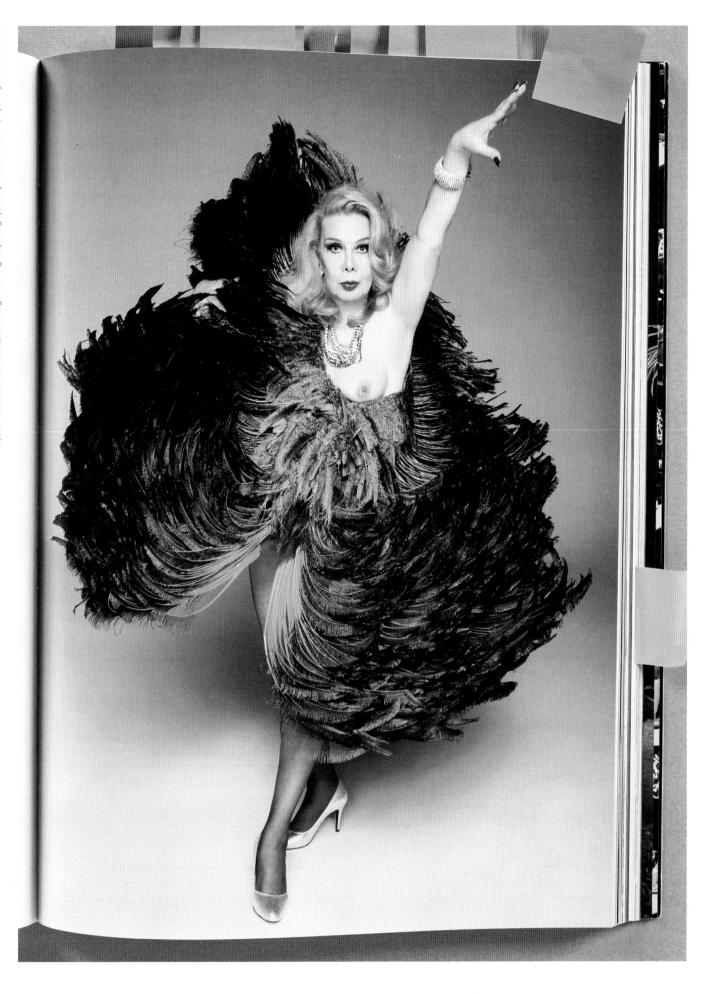

C★NDY *Transversal* 6th Issue, 2013. Page 157. Rogéria photographed by Marcelo Krasilcic, styled by Dudu Bertholini.

Trojan in Tokyo. 1985.

C★NDY *Transversal* 6th Issue, 2013. Page 53. Trojan photographed by Michael Costiff in Tokyo, 1985.

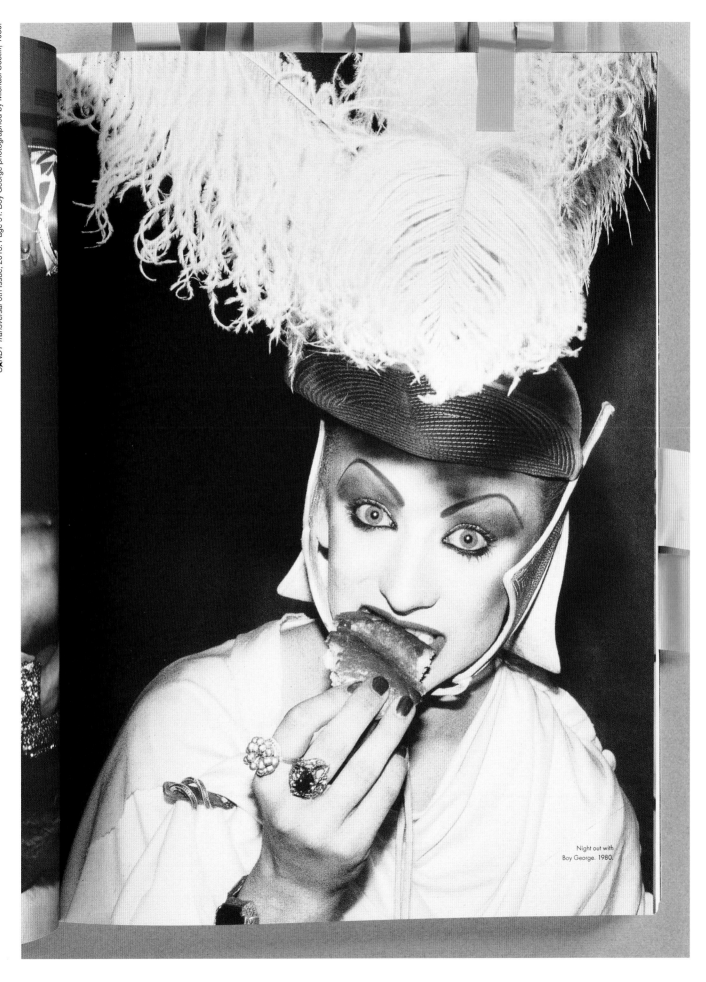

G★NDY *Transversal* 6th Issue, 2013. Page 51. Boy George photographed by Michael Costiff, 1980.

Night out with
Boy George. 1980.

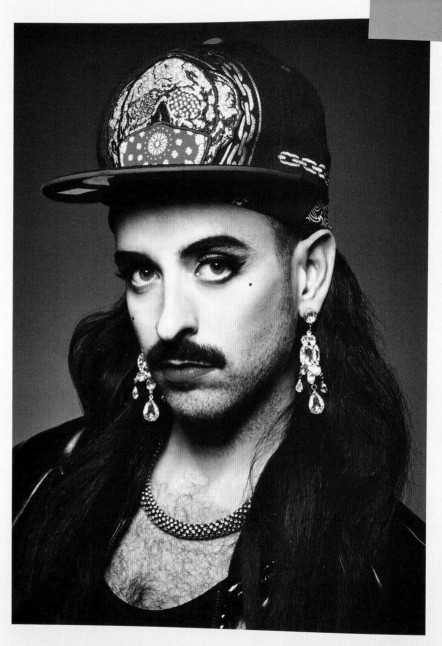

CODY CRÍTCHELOE
SINGER

Only a handful of men can pull off a full face of women's makeup and still look so damn handsome, Cody Critcheloe is one of them. The lead singer of Ssion moved to New York from Kansas over two years ago. His birthday is February 19, "a day before Yoko Ono, a day after Kurt Cobain." He shares his special day with Cindy Crawford, Seal and his good friend, the bodacious Beth Ditto, who he told me was born just a few hours apart from him. Like many other Pisces, Cody is obsessed with the horoscope and reads a few different astrologers each month. We bonded gushing over Susan Miller and ABBA, whose greatest hits played non-stop throughout the shoot. I have to admit, I have a big, big platonic crush on Cody Critcheloe. But after trying to date, now known in this city as "hanging out", a few other fishies before, I know it just won't work.

———— • ————

Cody Critcheloe wears a Maison Martin Margiela jacket, New Era Hat and Noir jewelry.
Opposite page: Julianna Huxtable wears an Atsuko Sudo top and an Alexis Bittar necklace.
Opening spread: Alexis Blair Penny wears an Irina Marinescu dress.

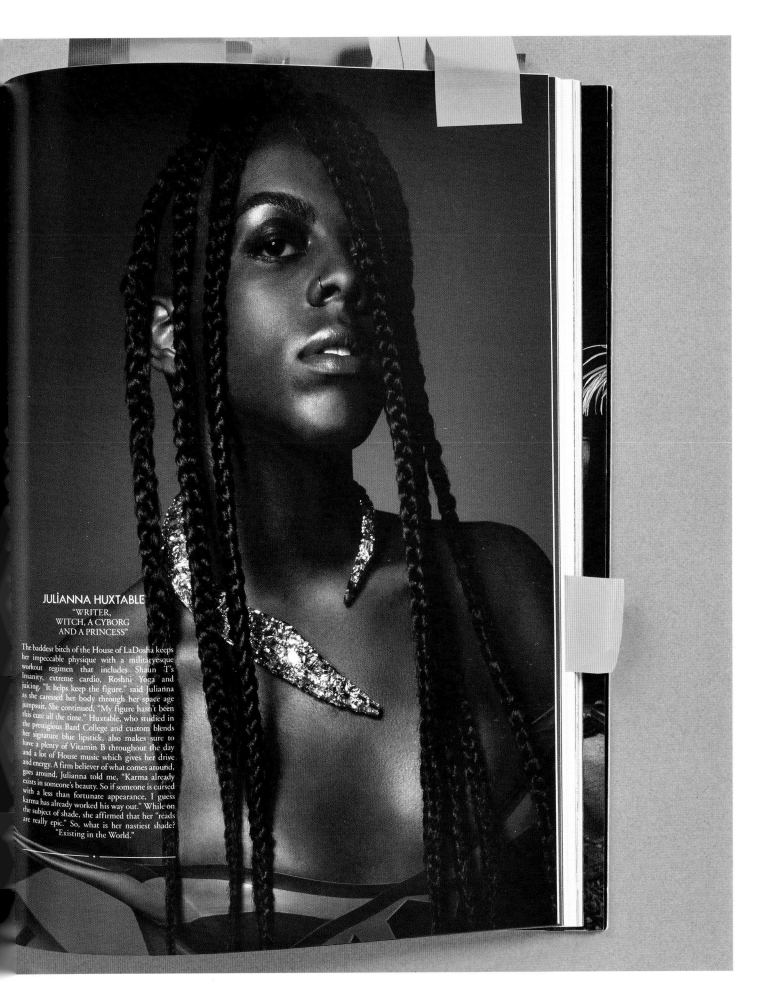

JULIANNA HUXTABLE

"WRITER,
WITCH, A CYBORG
AND A PRINCESS"

The baddest bitch of the House of LaDosha keeps her impeccable physique with a militaryesque workout regimen that includes Shaun T's Insanity, extreme cardio, Roshni Yoga and juicing. "It helps keep the figure." said Julianna as she caressed her body through her space age jumpsuit. She continued, "My figure hasn't been this cute all the time." Huxtable, who studied in the prestigious Bard College and custom blends her signature blue lipstick, also makes sure to have a plenty of Vitamin B throughout the day and a lot of House music which gives her drive and energy. A firm believer of what comes around, goes around, Julianna told me, "Karma already exists in someone's beauty. So if someone is cursed with a less than fortunate appearance, I guess karma has already worked his way out." While on the subject of shade, she affirmed that her "reads are really epic." So, what is her nastiest shade? "Existing in the World."

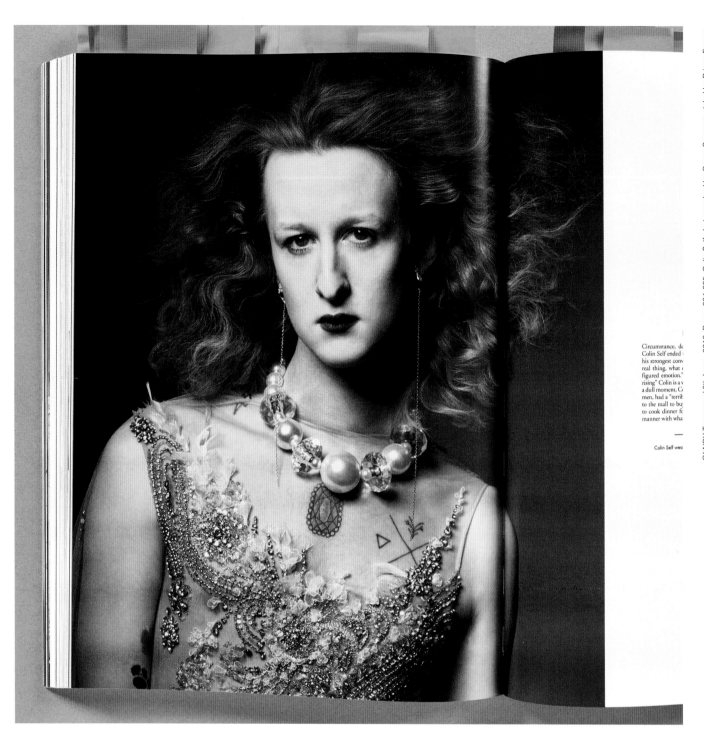

C★NDY Transversal 6th Issue, 2013. Pages 234-235. Colin Self photographed by Casey Spooner, styled by Prince Franco.

RIGHT: Unpublished photograph of Tammie Brown shot by Sofia Sánchez & Mauro Mongiello, styled by Samuel François for C★NDY Transversal 6th Issue, 2013.

Circumstance, de
Colin Self ended
his strongest conv
real thing, what
figured emotion."
rising" Colin is a v
a dull moment, C
men, had a "terrib
to the mall to buy
to cook dinner fo
manner with wha

—

Colin Self wea

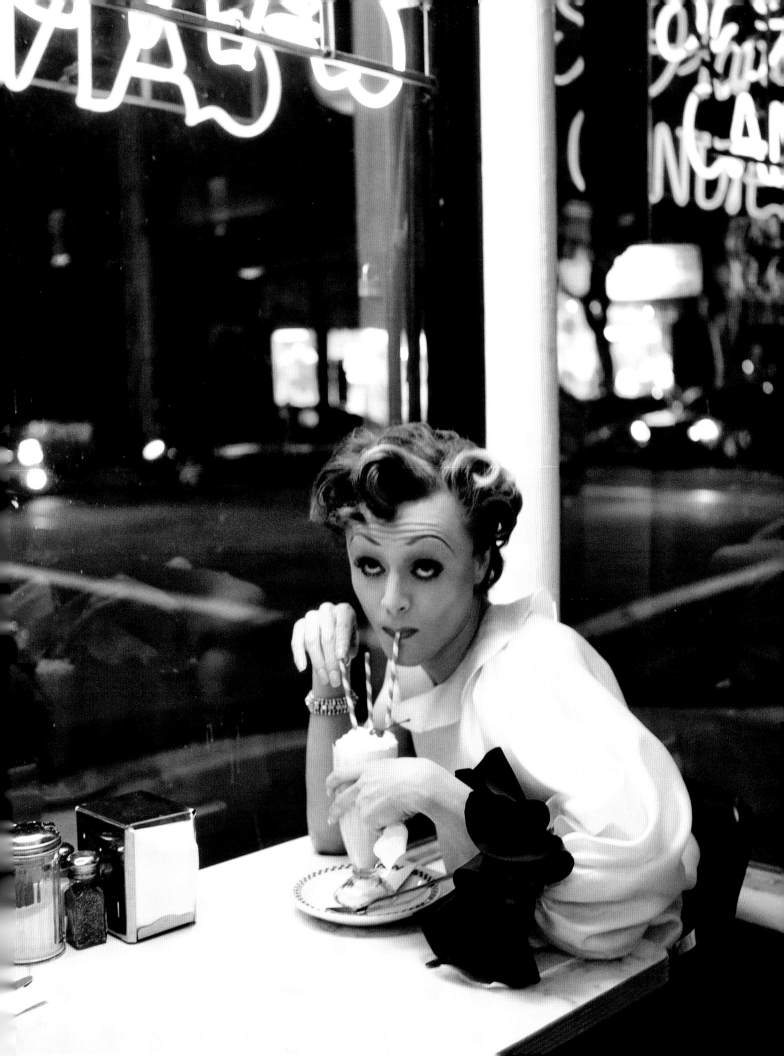

Why should I spend 70 thousand on a cock, when I can buy a new truck?
Everyone else wants me to have one to complete their picture of me as a man.
It is more empowering to me to have a vagina than a penis.

—
BUCK ANGEL in conversation with Greg Garry
C★NDY Transversal 6th Issue, 2013

C✭NDY Transversal 6th Issue, 2013. Pages 86-87. Jodie Foster photographed by Terry O'Neill, 1976 © Iconic Images.

PAUL MORRISSEY. Right. So, the magazine is called *C✭NDY*?

HOLLY WOODLAWN. Yeah.

PM. Because of Candy Darling?

HW. No, no, no, it's just, it's this glossy, um, magazine, all the magazine's stars are all transsexuals and they're all beautiful, they're, you know. (…)

PM. And why do they call the magazine *C✭NDY*?

HW. Why don't they call it Holly? God damn!

PM. Yes! Why wouldn't they call it Holly?

—

HOLLY WOODLAWN in conversation with PAUL MORRISSEY
C✭NDY Transversal 6th Issue, 2013

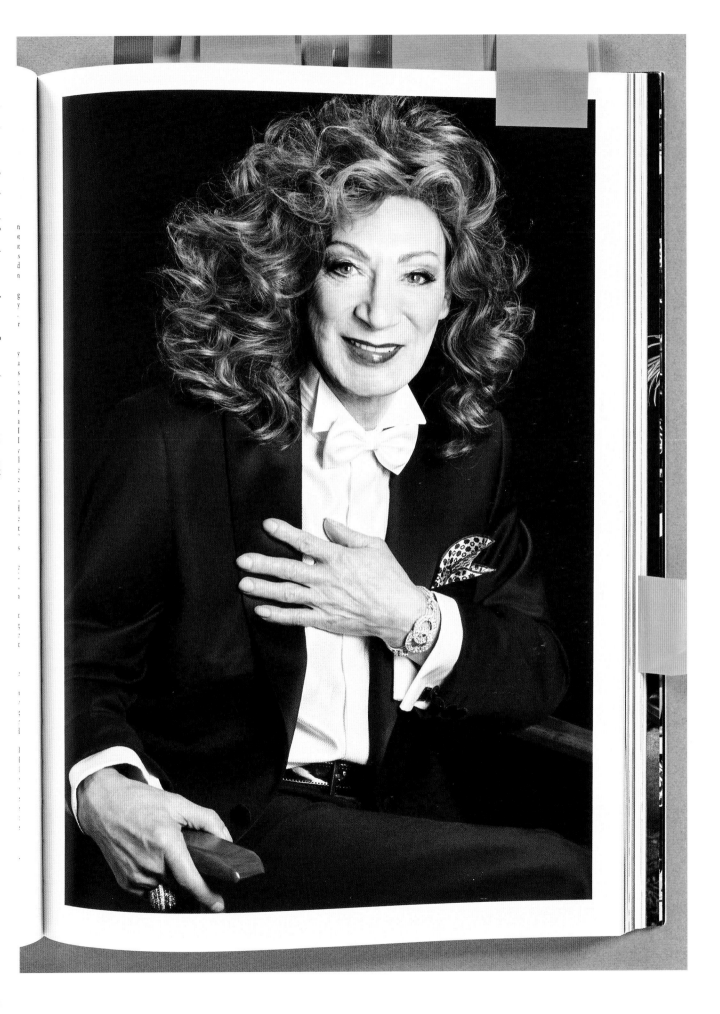

CANDY *Transversal* 6th Issue, 2013. Page 153. Holly Woodlawn photographed by Greg Gorman, styled by Elisabeth Watson.

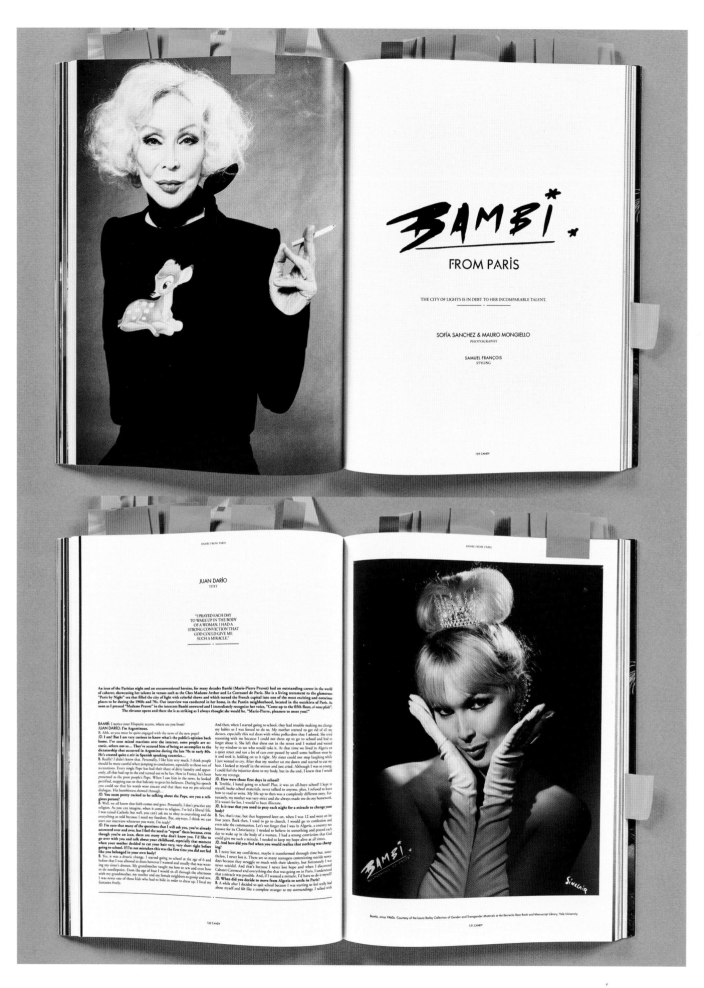

CANDY Transversal 6th Issue, 2013. Pages 128-131. Bambi photographed by Sofía Sánchez & Mauro Mongiello, styled by Samuel François. Archive photography, courtesy of the Laura Bailey Collection of Gender and Transgender Materials at the Beinecke Rare Book and Manuscript Library, Yale University. RIGHT: Unpublished photograph of Bambi shot by Sofía Sánchez & Mauro Mongiello for CANDY Transversal 6th Issue, 2013.

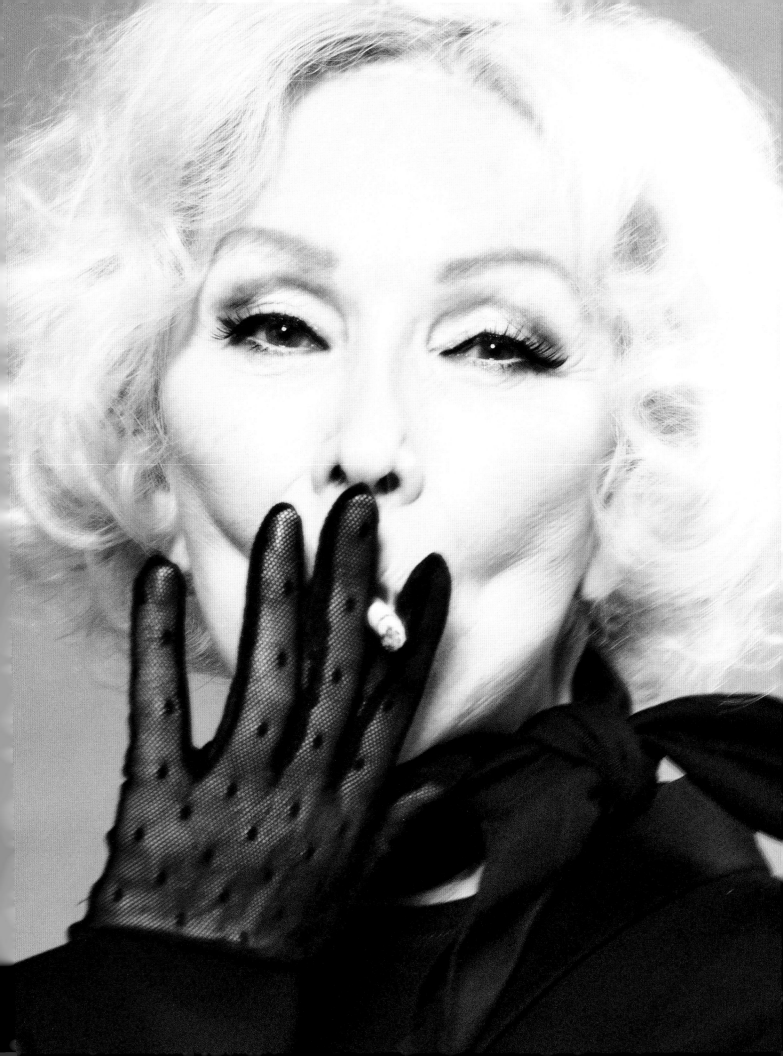

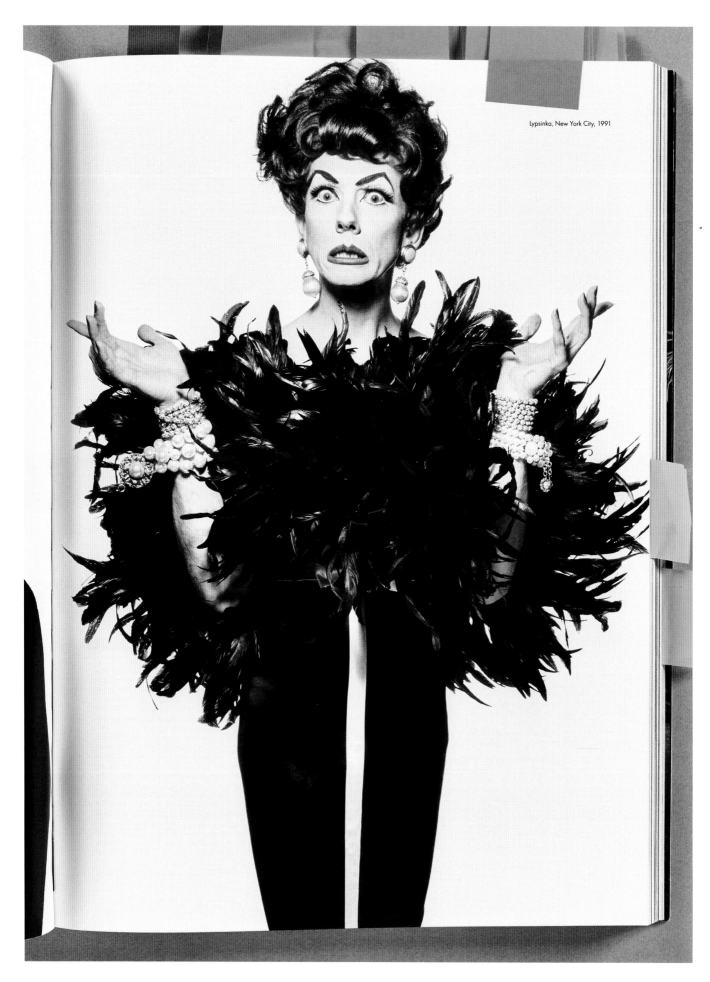

Lypsinka, New York City, 1991

C★NDY Transversal 6th Issue, 2013. Page 95. Lypsinka photographed by Albert Watson, New York City, 1991.

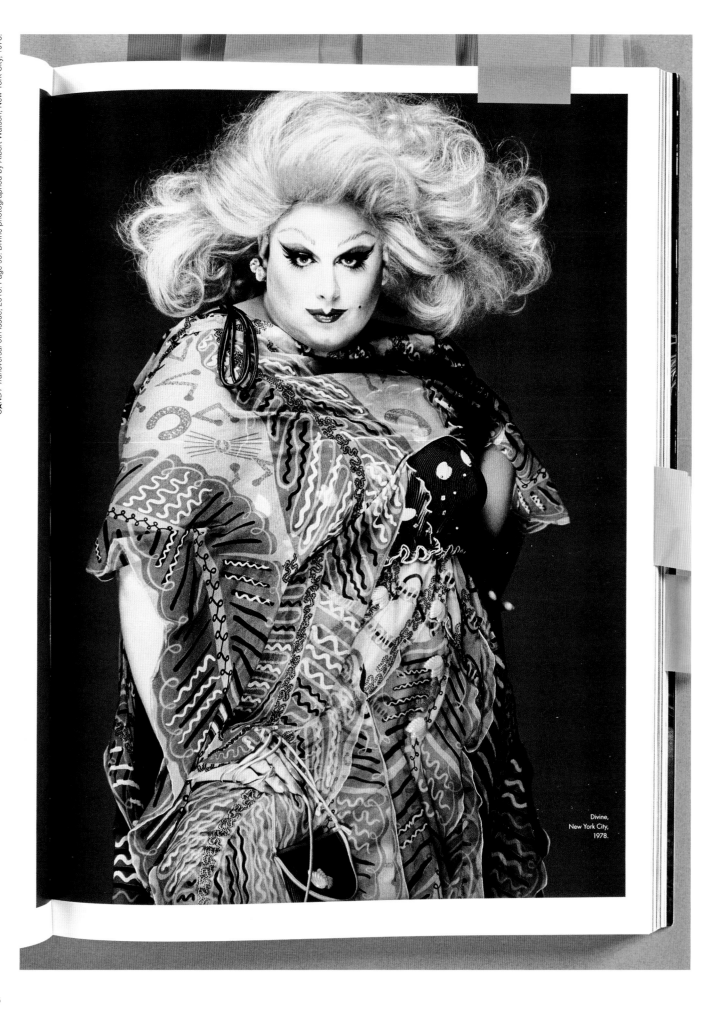

C★NDY *Transversal* 6th Issue, 2013. Page 93. Divine photographed by Albert Watson, New York City, 1978.

Divine,
New York City,
1978.

C★NDY Transversal 6th Issue, 2013. Page 68-69. Artwork by Ignasi Monreal.

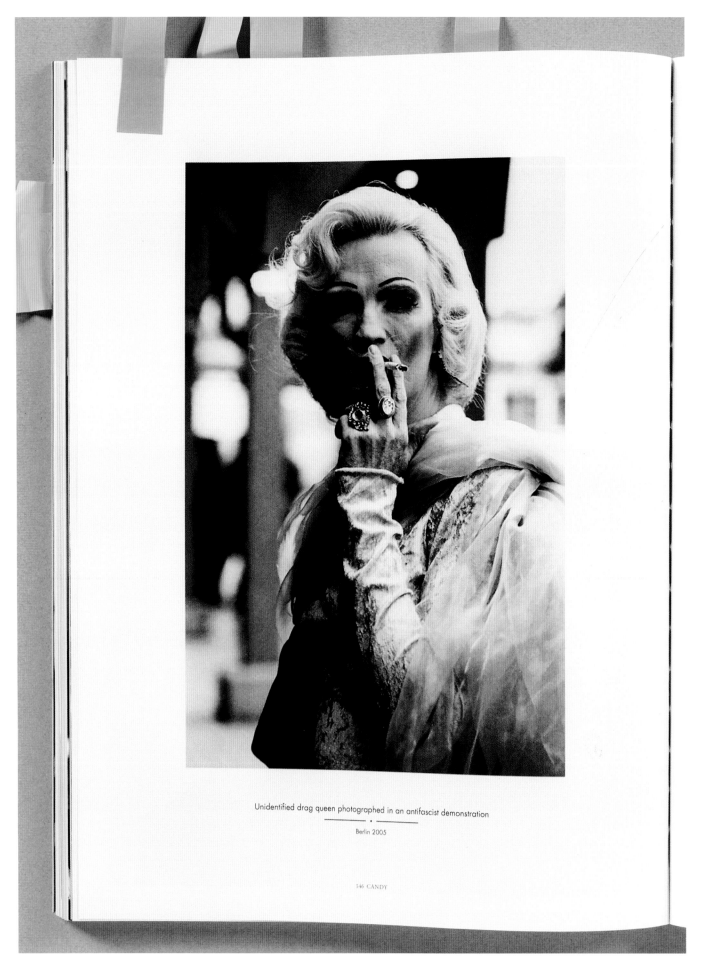

Unidentified drag queen photographed in an antifascist demonstration

———— • ————

Berlin 2005

C✱NDY *Transversal* 5th Issue, 2012. Page 146. Unidentified drag queen in an antifascist demonstration, photographed by Benjamin A Huseby, Berlin, 2005. RIGHT: Björk photographed by Herb Ritts, 1990, included in C✱NDY *Transversal* 6th Issue, 2013.

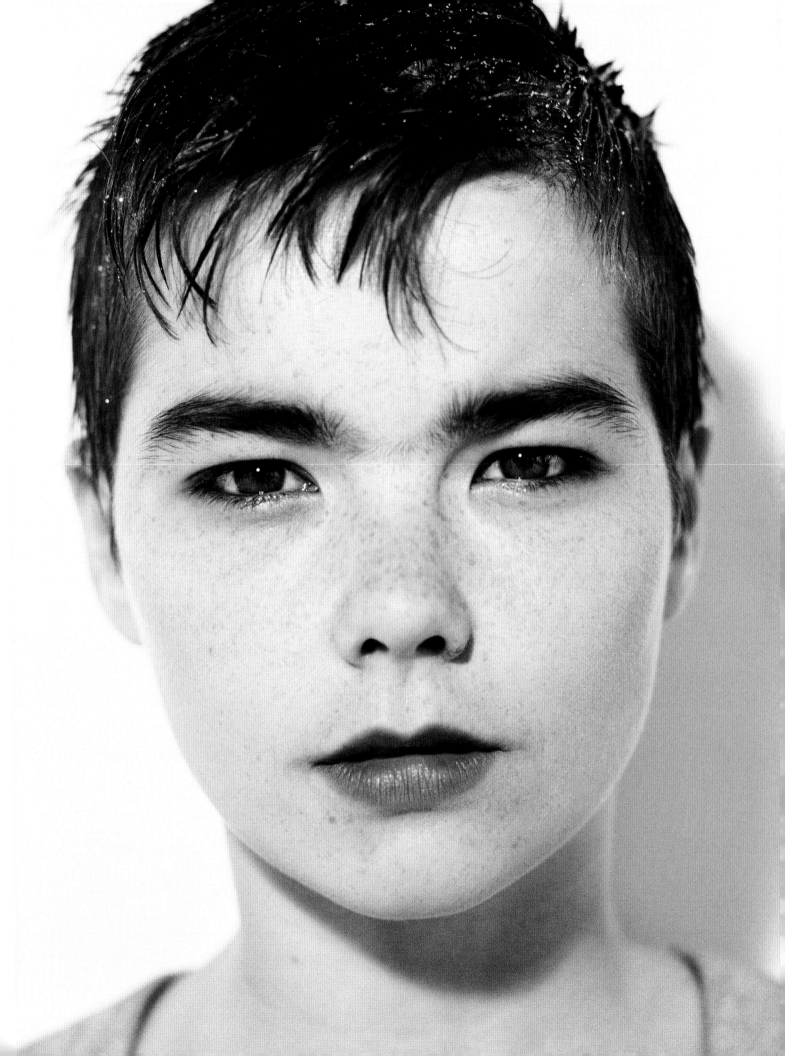

CANDY Transversal 5th Issue, 2012. Pages 270-271. Dani Shay photographed by Marcelo Krasilcic, styled by Guillaume Boulez.

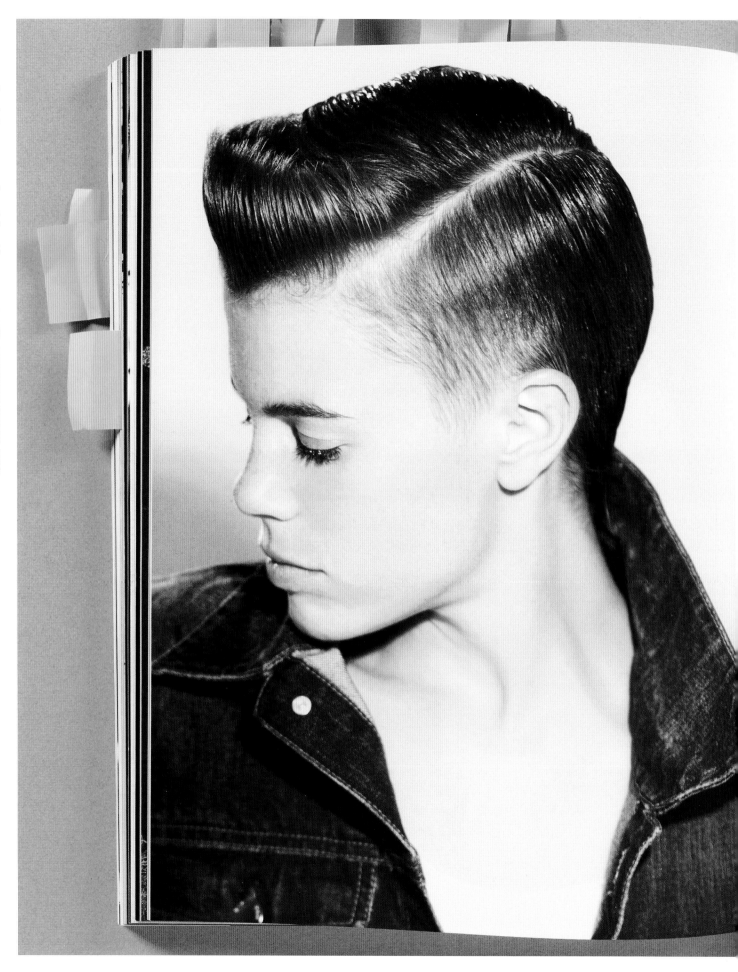

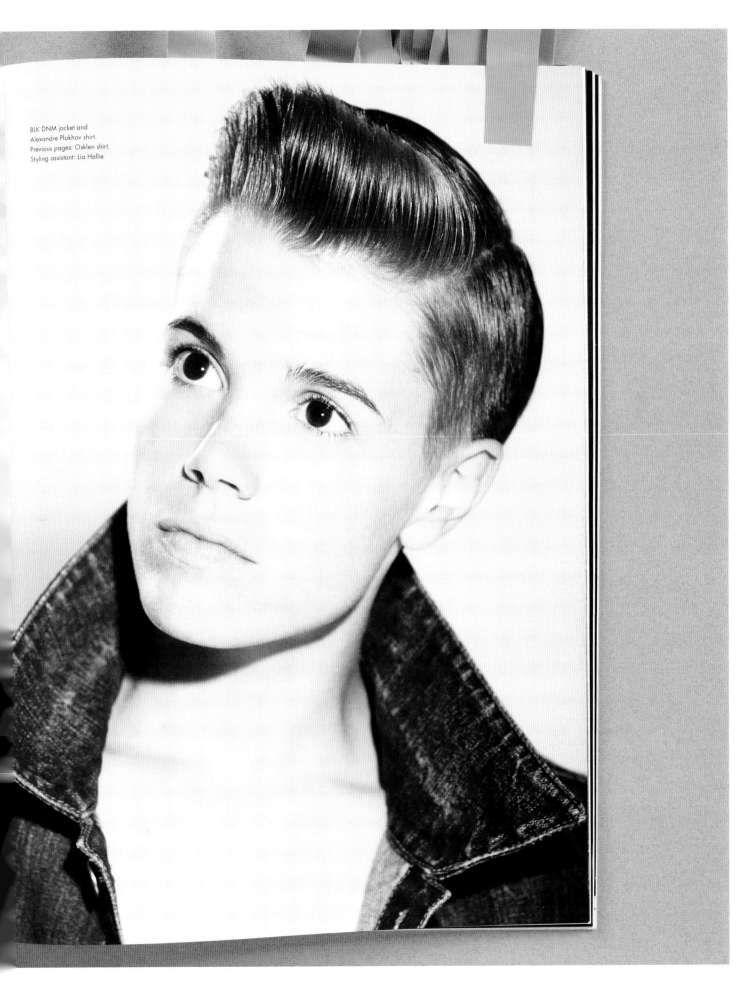

BLK DNM jacket and
Alexandre Plokhov shirt.
Previous pages: Osklen shirt.
Styling assistant: Lia Hallie

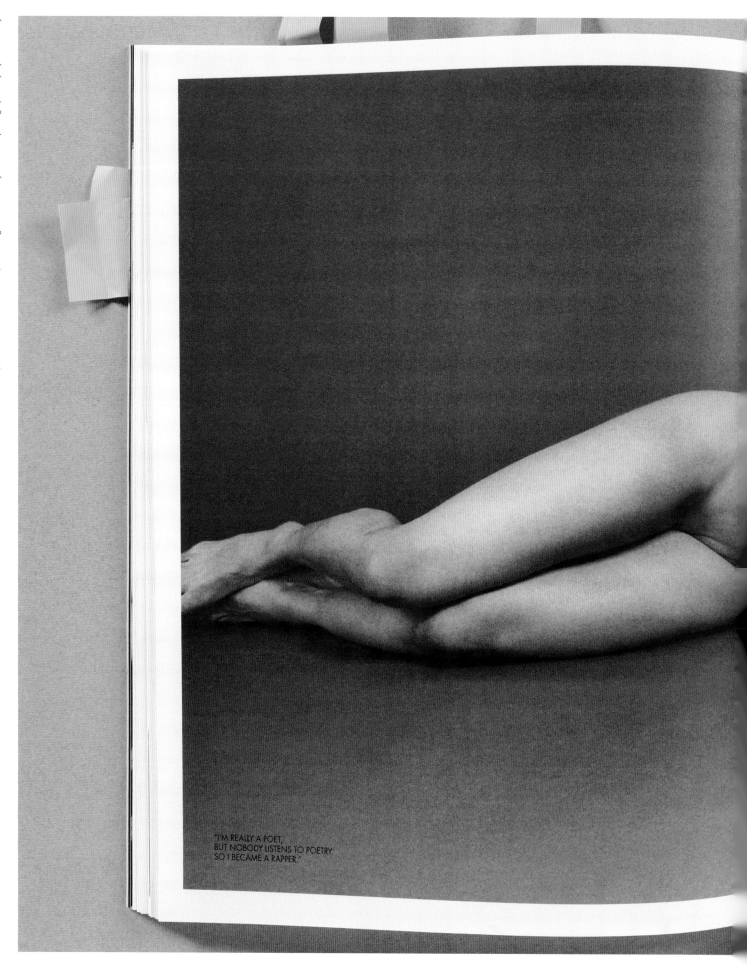

CANDY *Transversal* 5th Issue, 2012. Pages 112–113. Mykki Blanco photographed by Ryan McGinley.

"I'M REALLY A POET,
BUT NOBODY LISTENS TO POETRY
SO I BECAME A RAPPER."

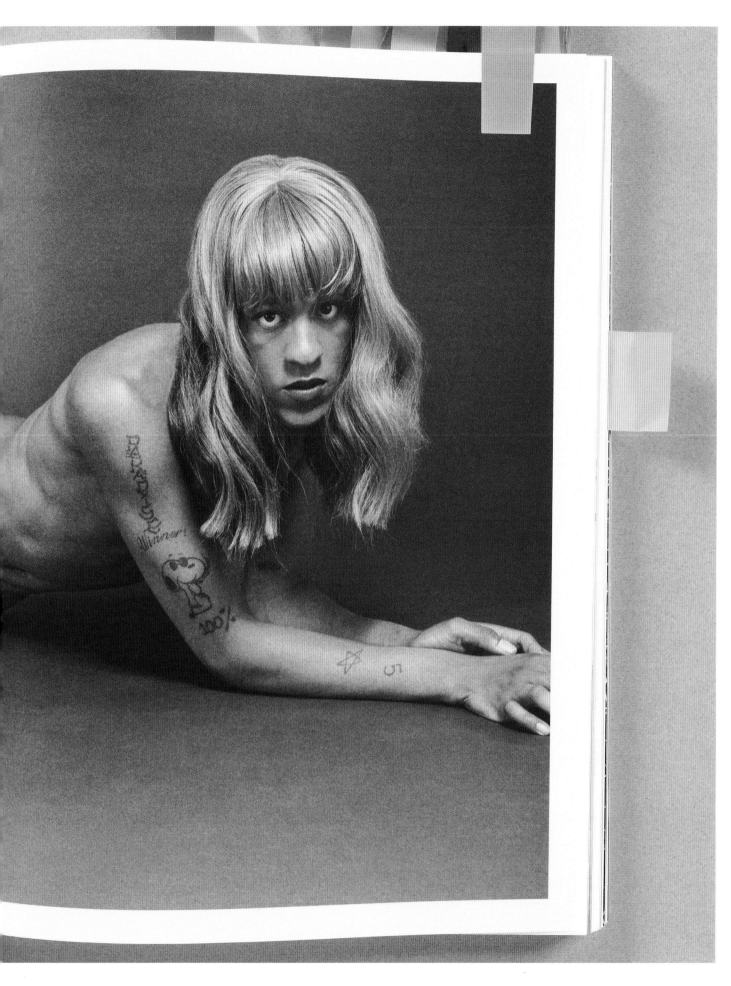

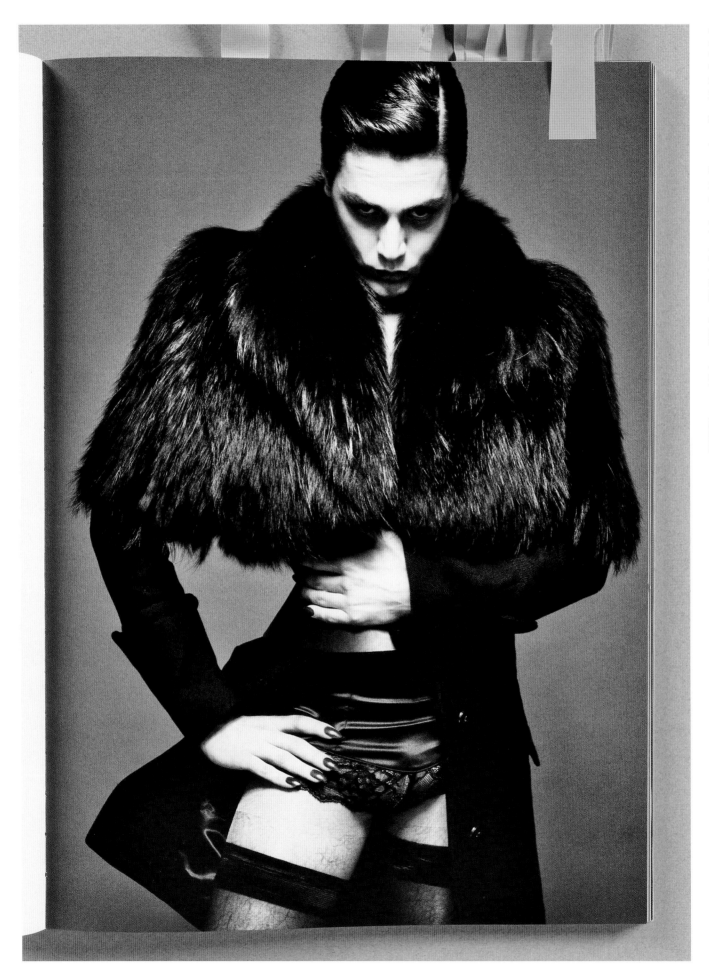

CANDY *Transversal* 5th Issue, 2012. Page 233. Xavier Dolan photographed by Shayne Laverdière, styled by Annie Horth.

CANDY Transversal 5th Issue, 2012. Page 170. Opening page for Lady Bunny feature.

THAT'S
WHY
THE
LADY
IS
A
DRAG!

THE LADY BUNNY
BY LADYFAG

ELLEN VON UNWERTH
PHOTOGRAPHY

C★NDY *Transversal*/ 5th Issue, 2012. Page 171. Lady Bunny photographed by Ellen von Unwerth.

C★NDY Transversal 5th Issue, 2012. Page 299. Andreas Larsson and Stephane Carcy photographed by Andreas Larsson, styled by Thomas Persson.

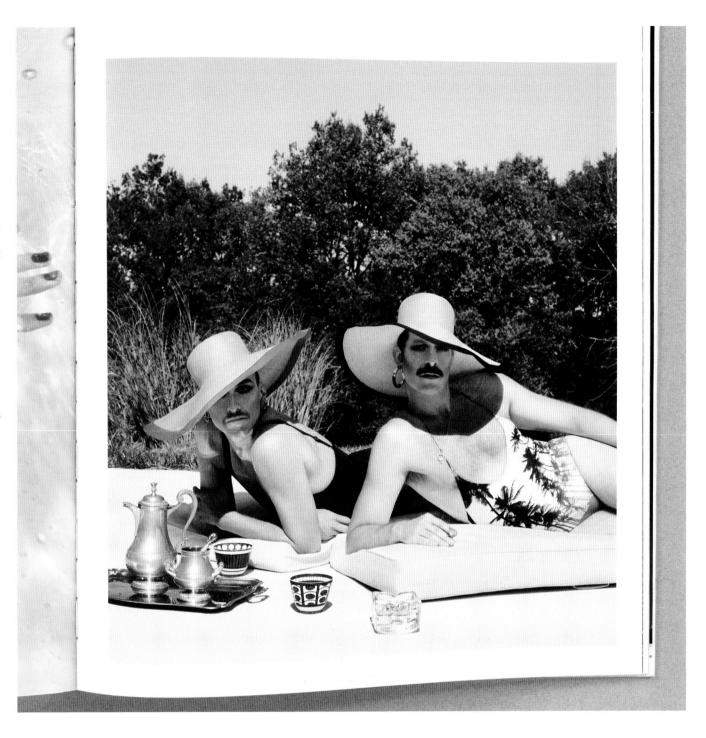

**People that know me say I don't change with or without the wig.
The wig just gives me an excuse to behave more outrageously.**

—
LADY BUNNY in conversation with Ladyfag
C★NDY Transversal 5th Issue, 2012

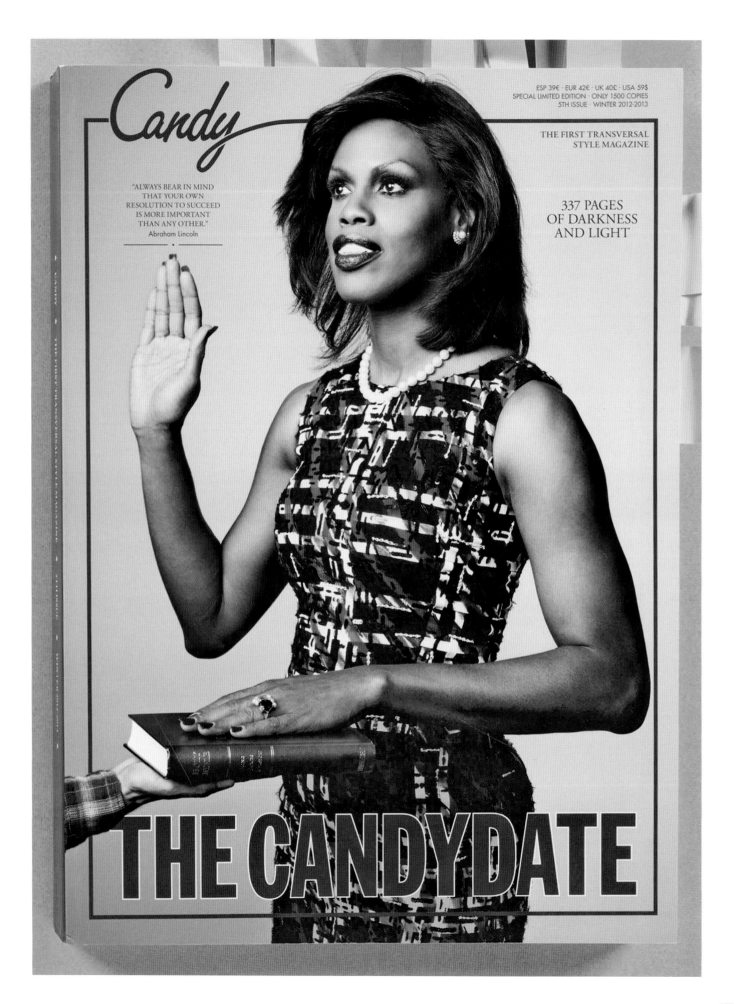

188

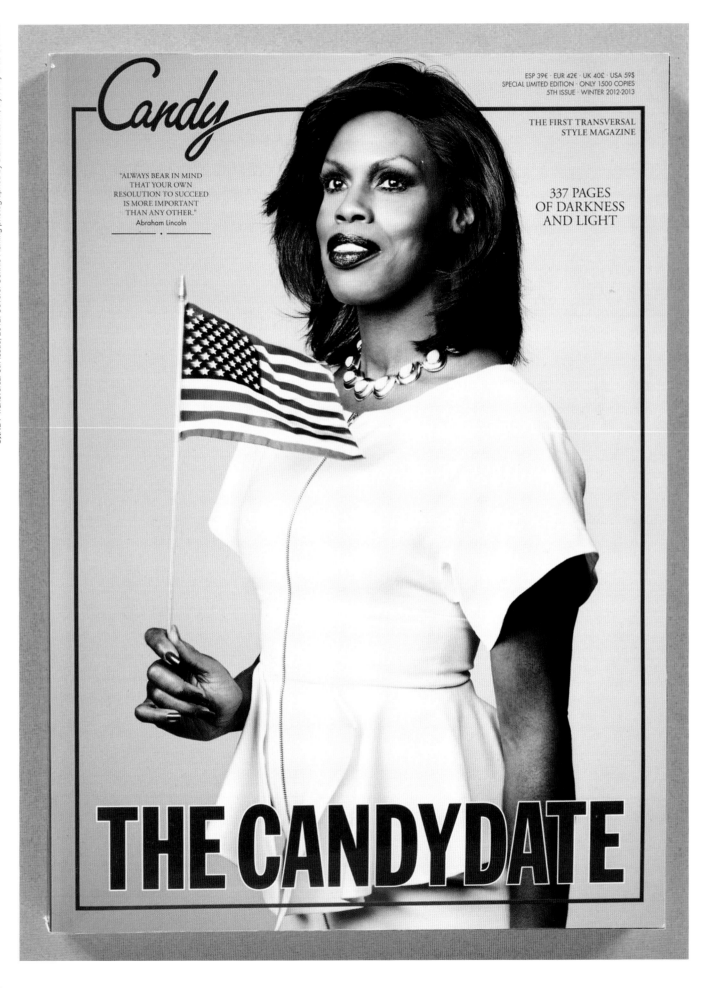

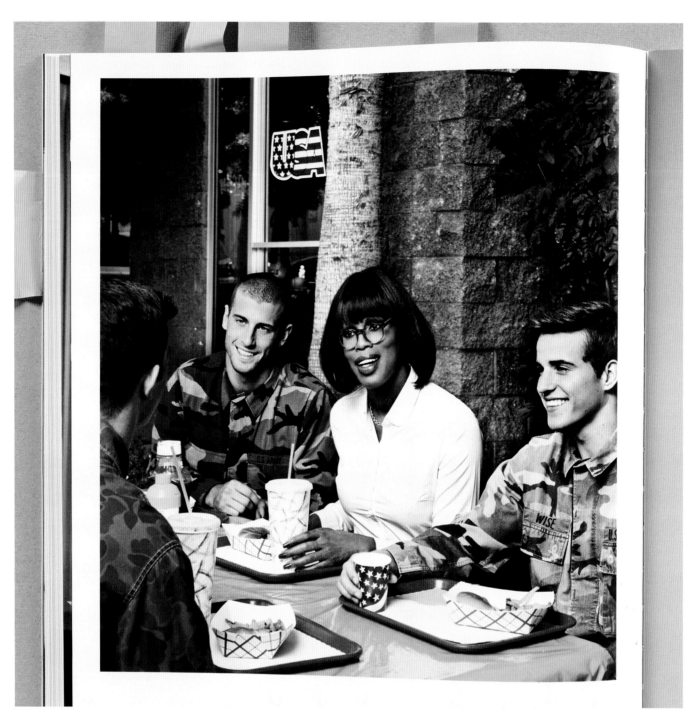

C★NDY Transversal 5th Issue, 2012. Page 132. Connie Fleming and models photographed by Danielle Levitt, styled by Brad Goreski.

The first **C★NDY** I saw was the issue where the legend Connie Fleming posed as First Lady Michelle Obama. It sent chills up my spine to see the meeting of two black icons in an empowering space. Powerful!

—
JANET MOCK
C★NDY Transversal 12th Issue, 2019

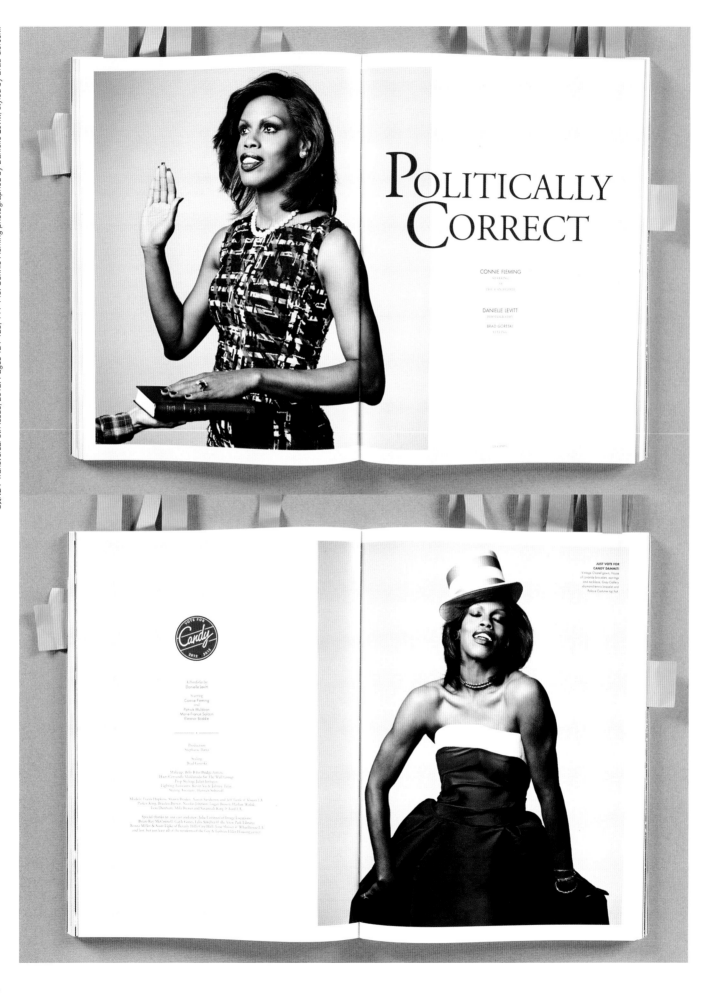

G★NDY *Transversal* 5th Issue, 2012. Pages 124-125, 144-145. Connie Fleming photographed by Danielle Levitt, styled by Brad Goreski.

POLITICALLY CORRECT

CONNIE FLEMING

DANIELLE LEVITT

BRAD GORESKI

JUST VOTE FOR CANDY DAMMIT!

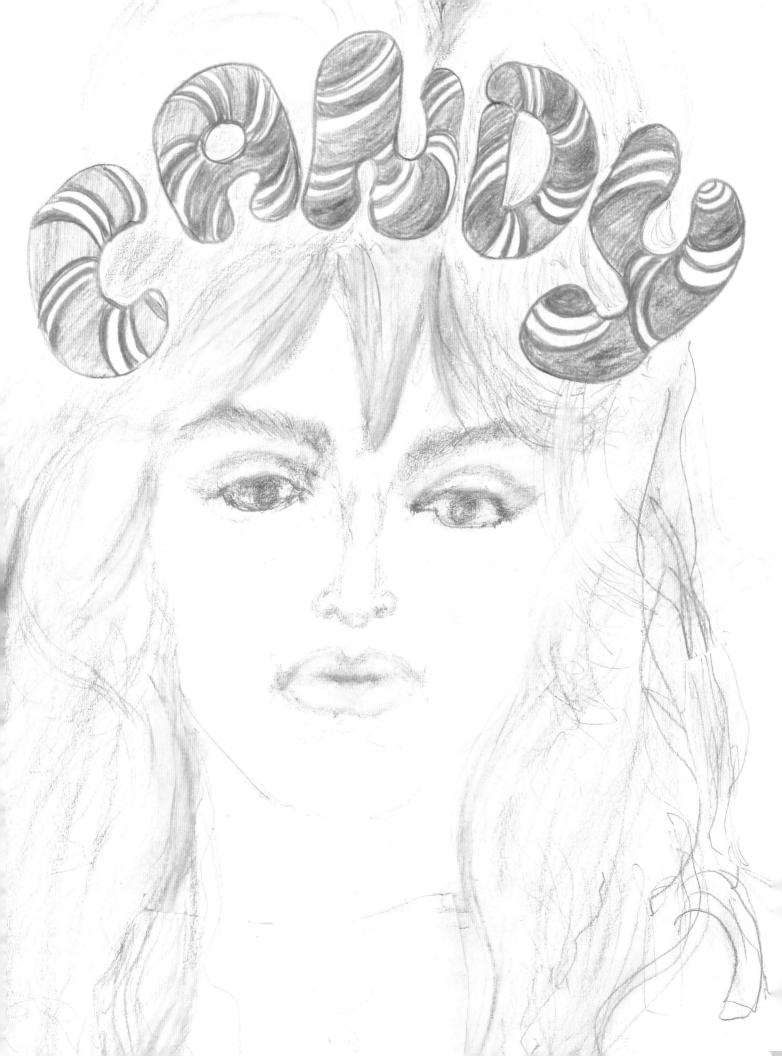

Spanish candies photographed by Walter Pfeiffer for C★NDY Transversal 4th Issue, 2012. LEFTT: Jimmy Paul's artwork inspired by C★NDY Transversal.

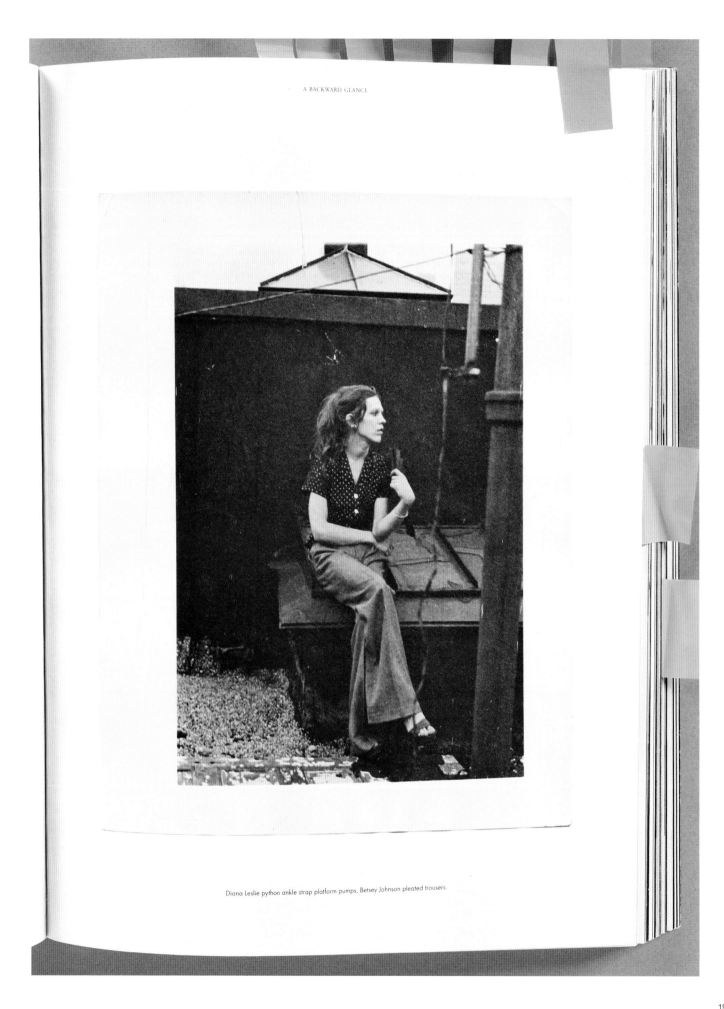

Diana Leslie python ankle strap platform pumps, Betsey Johnson pleated trousers.

C★NDY *Transversal*/ 4th Issue, 2012. Pages 147 and 159. David Armstrong photographed by Nan Goldin, early 70s.

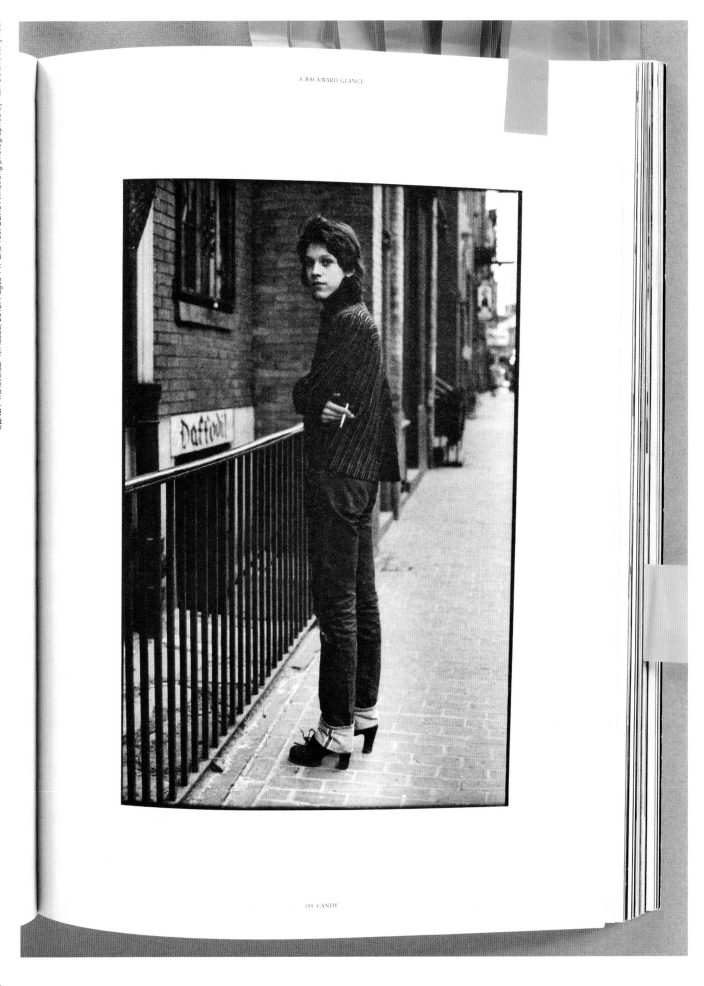

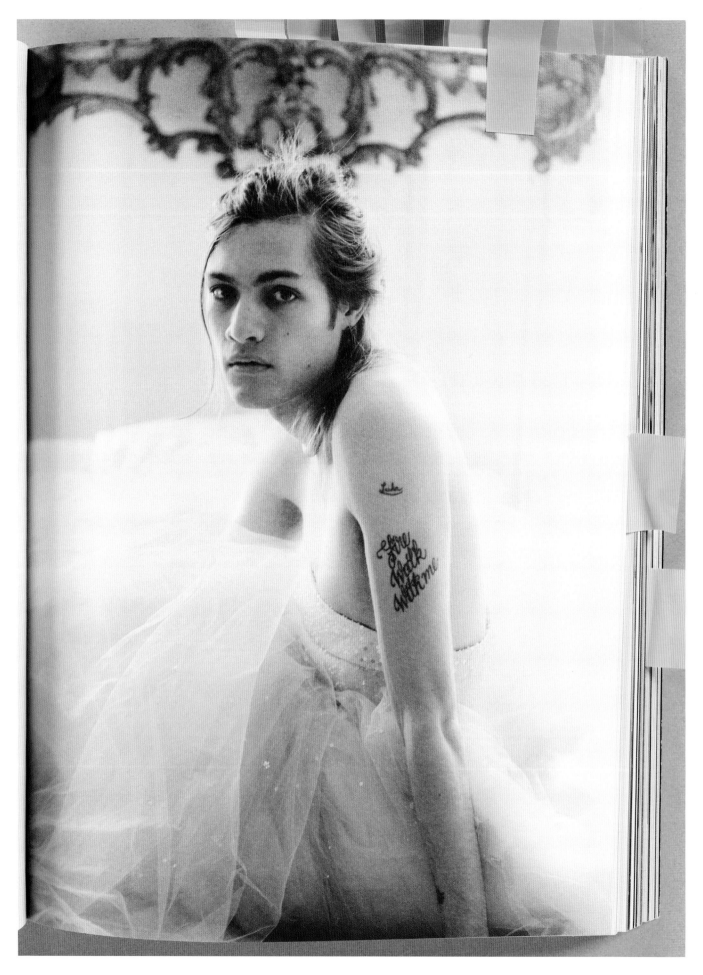

C★NDY *Transversal* 4th Issue, 2012. Page 145. Marcel Castenmiller photographed by David Armstrong.

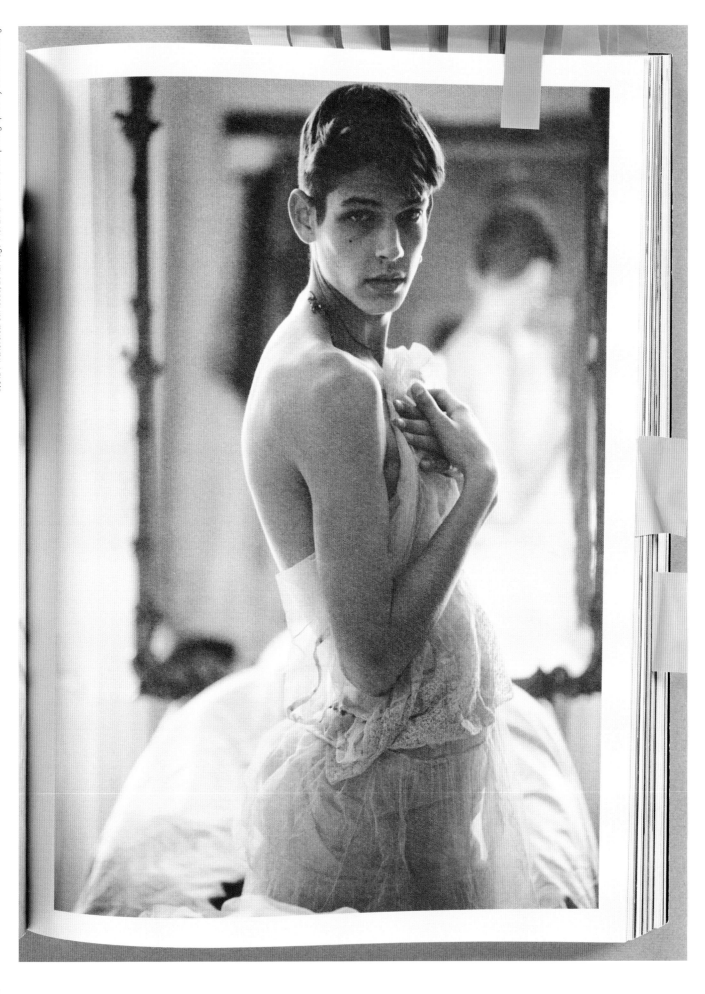

CANDY *Transversal* 5th Issue. 2012. Page 149. Ethan James Green photographed by David Armstrong.

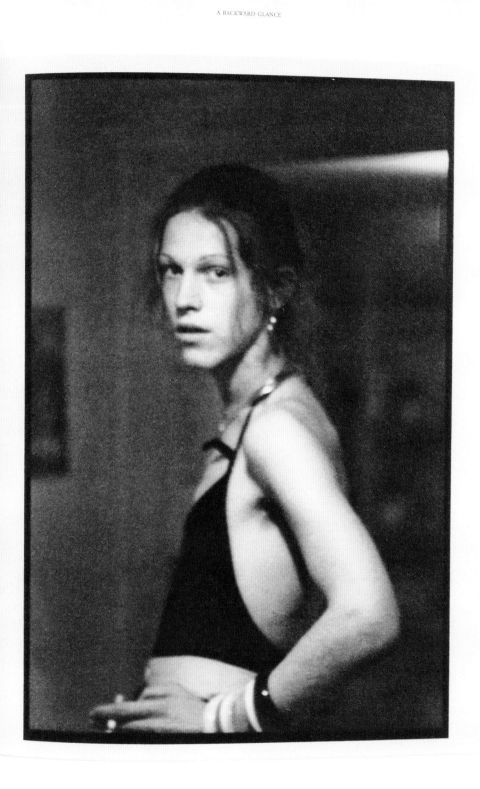

A younger David Armstrong -photographed by Nan Goldin- wearing a strap halter Capezio body suit, pleated Betsey Johnson pants and vintage 1930s bakelite bangles.
Left page: the younger Nan Goldin -photographed by David Armstrong in Myrtle Street, Boston, 1972- wearing a necklace and earrings made by Armstrong from vintage beads.

CANDY Transversal 4th Issue, 2012. Page 137. David Armstrong photographed by Nan Goldin in Myrtle Street, Boston, 1972.

C★NDY Transversal 5th Issue, 2012. Page 55. Breck Girl (AXL Rose from Guns N' Roses) 1988, artwork by Mel Odom.

Breck Girl (AXL Rose from Red Hot Chili Peppers), 1988

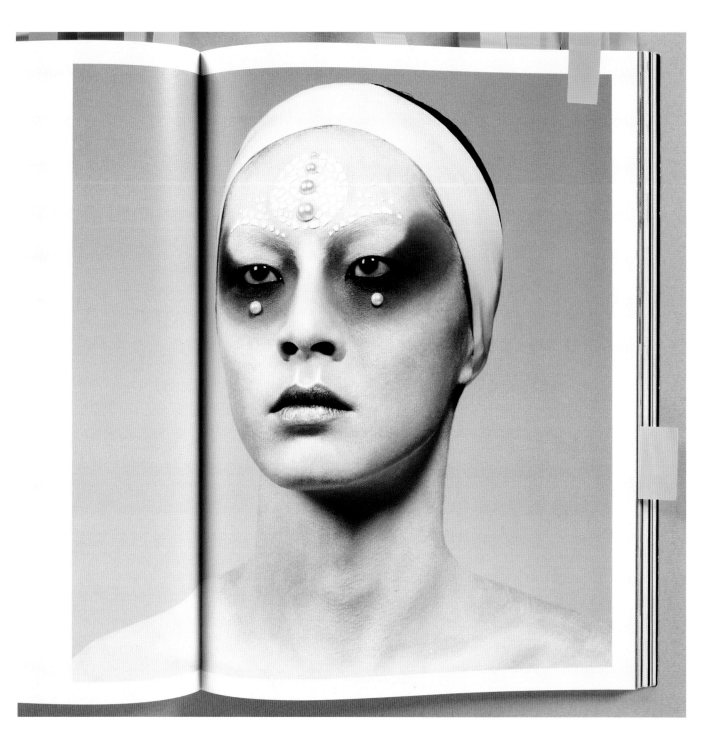

C★NDY *Transversal*/ 5th Issue, 2012. Pages 244-245. David Chiang photographed by Daniel King, styled by Christopher Niquet.

C★NDY Transversal 9th Issue, 2016. Page 285. Divine photographed by Robyn Beeche, 1980.

...eeche.

...provide an

...38, Divine
...zine: "I can't
...conceptions
...g one of my
...e a loud
...Divine's quiet
...ographed by
...liquéd kimono.
...ono have a
...n mask, a
..." painted on his
...created a void,
...r. "One of the
...Divvy was that
...ven when he
...eche.

...ples, who
...also fondly
...most subjetcs
...he lay back on
...ainted him and
...e of hours. He
...an to doze off,"
...vine's case, as I
...started to snore
...d up having
...lull between
...dy stopped

...t. 2009)

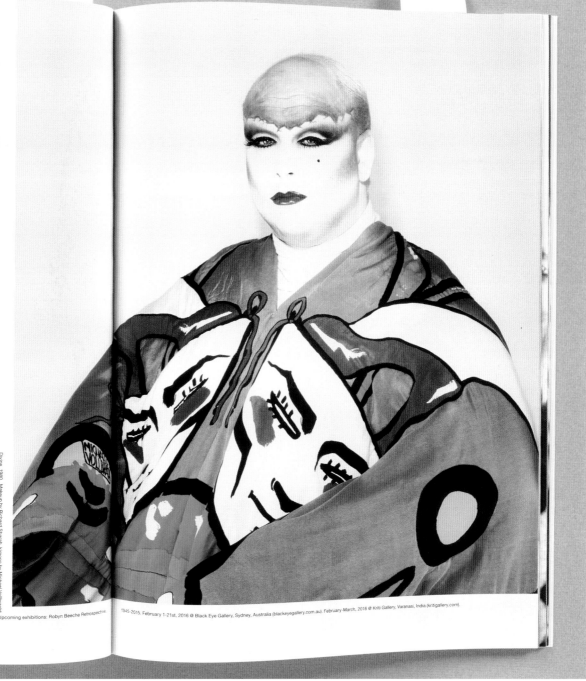

Divine, 1980. Makeup by Richard Sharah, kimono by Michael Vollbracht.

Upcoming exhibitions: Robyn Beeche Retrospective. 1945-2015. February 1-21st, 2016 @ Black Eye Gallery, Sydney, Australia (blackeyegallery.com.au). February-March, 2016 @ Kriti Gallery, Varanasi, India (kritigallery.com).

As much as Divine resisted the labels the press created for him, I don't think he would have argued with the first line of the *People* magazine obituary: "He was the Drag Queen of the Century." Period.

—
JOHN WATERS about Divine
C★NDY Transversal 2nd Issue, 2010

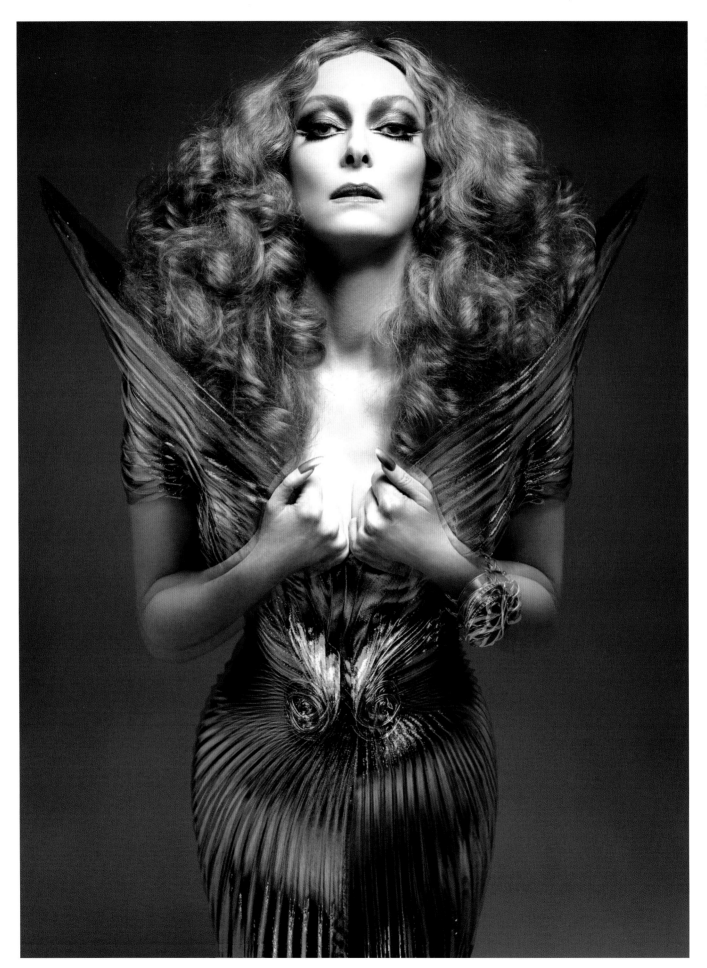

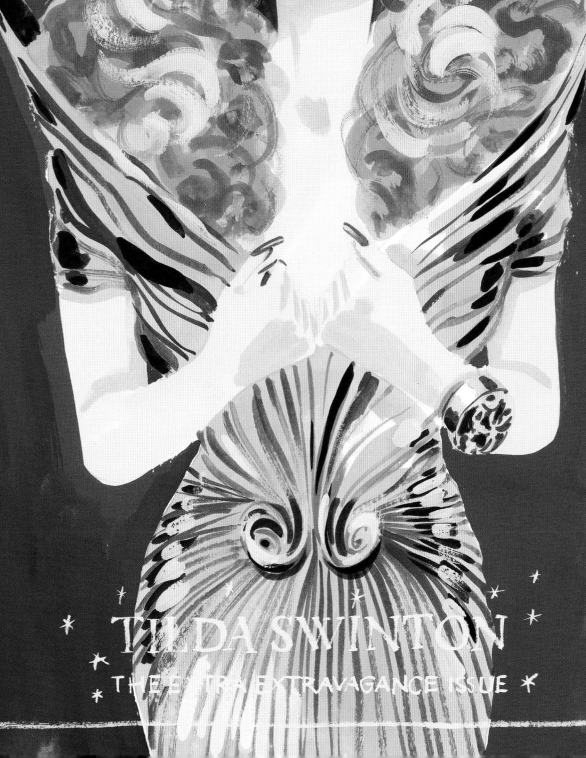

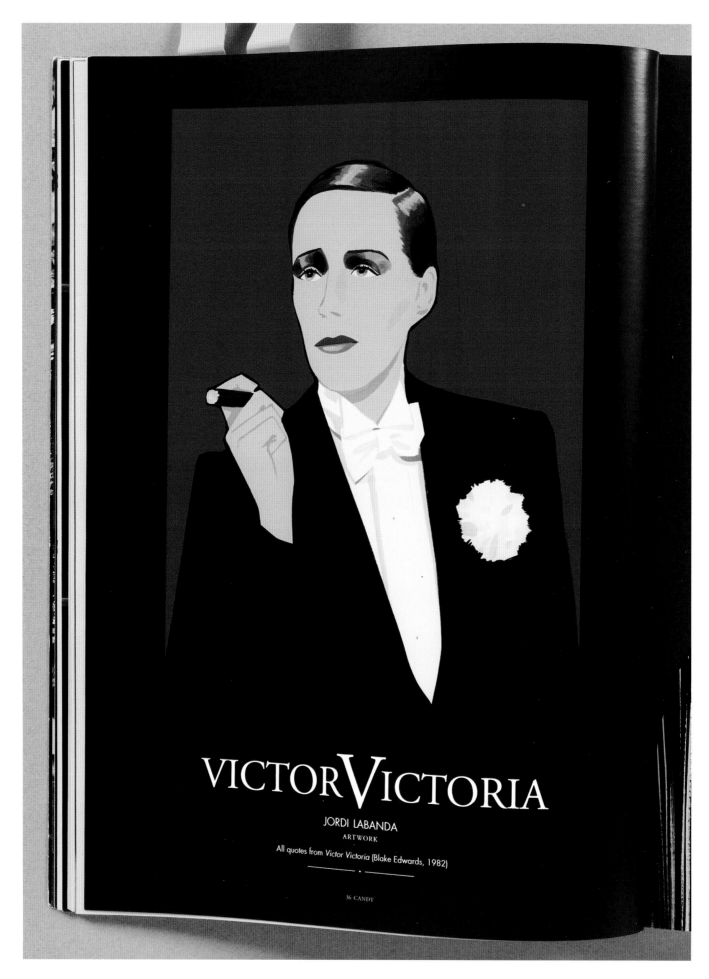

VICTORVICTORIA

JORDI LABANDA
ARTWORK

All quotes from *Victor Victoria* (Blake Edwards, 1982)

36 CANDY

CANDY *Transversal* 4th Issue, 2012. Page 36. Artwork by Jordi Labanda.

204

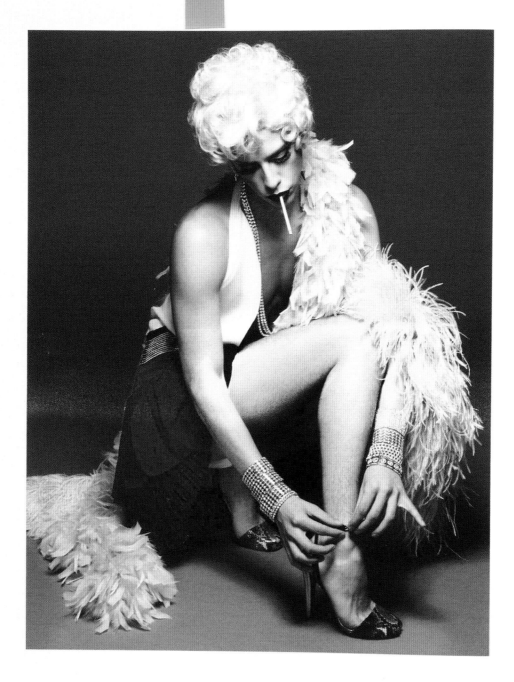

THE (Not So) INGENUE

Eduardo Casanova

———————— • ————————

Gucci dress and shoes.

CANDY *Transversal* 8th Issue, 2015. Pages 344-345. Didi Maquiaveli photographed by Juan Gatti, styled by Paola Torres.

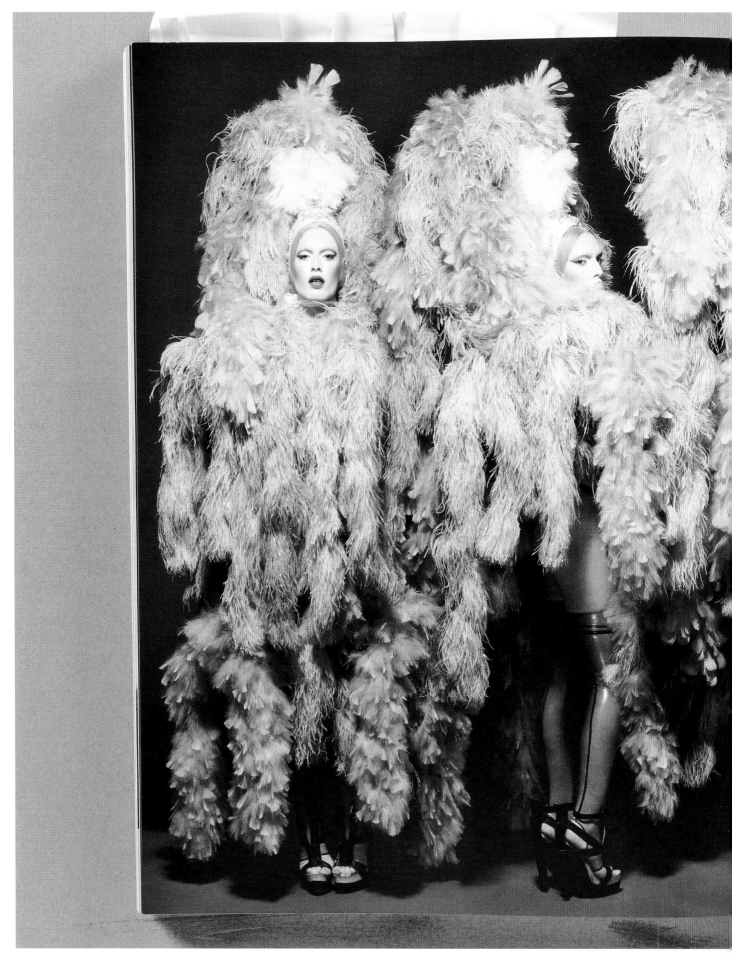

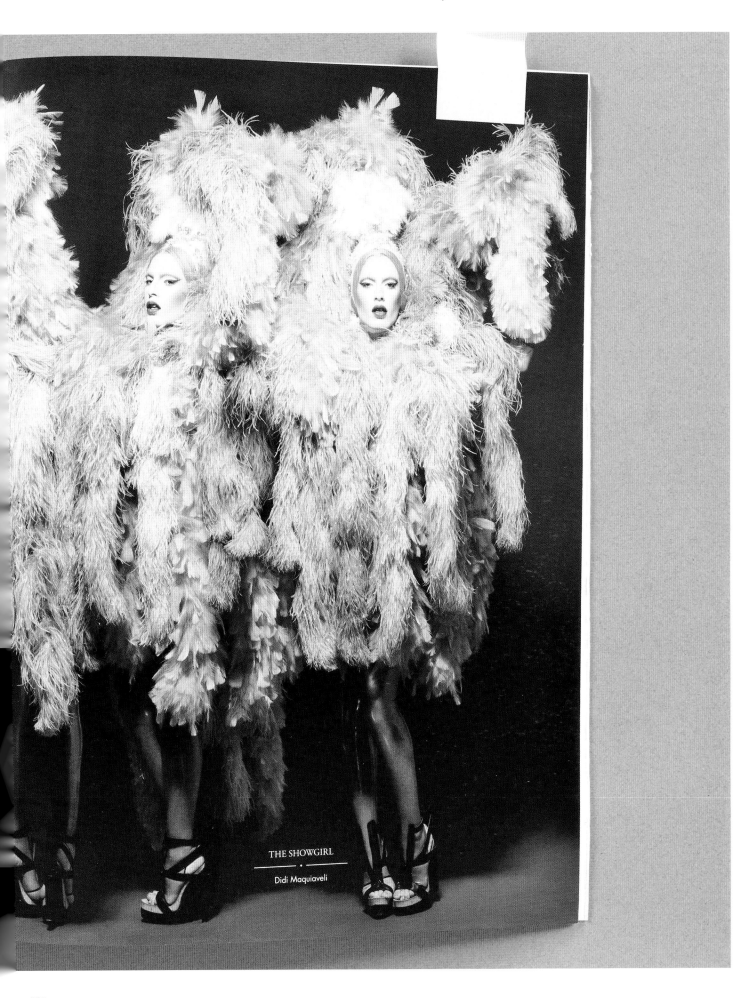

THE SHOWGIRL

·

Didi Maquiaveli

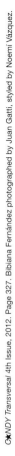

C★NDY Transversal/ 4th Issue, 2012. Page 327. Bibiana Fernández photographed by Juan Gatti, styled by Noemí Vázquez.

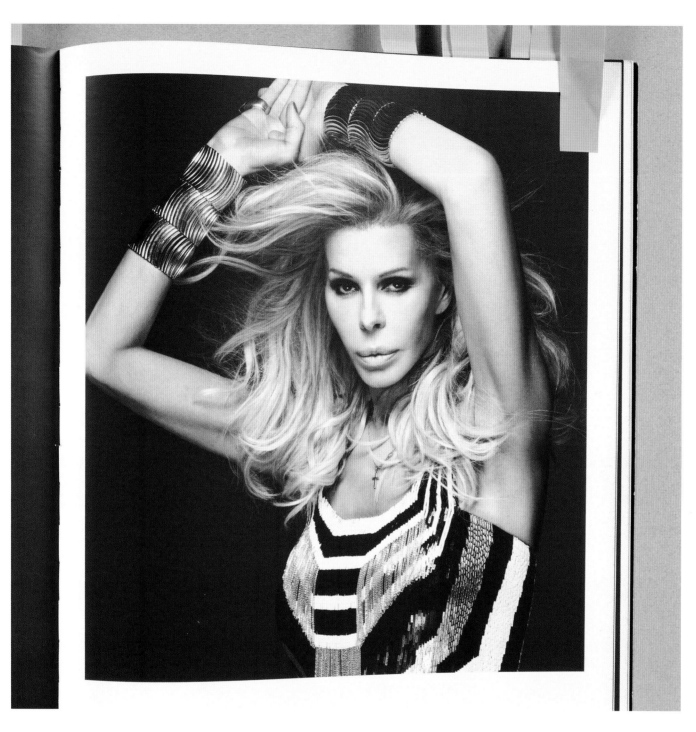

I don't consider myself a woman, cuz I don't know what that is.
I consider myself Lady Chablis and that is who I am.
With the term drag queen, it irks me because I am not
a drag queen unless I am getting paid.

—
THE LADY CHABLIS in conversation with Miguel Figueroa
C★NDY Transversal 4th Issue, 2012

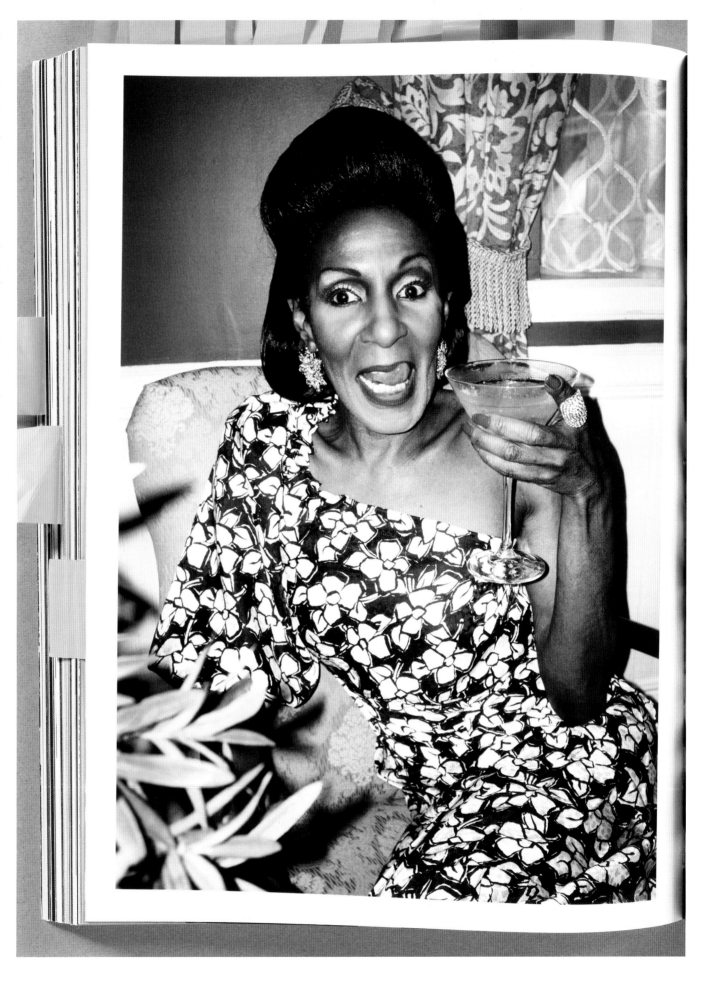

G★NDY Transversal 4th Issue, 2012. Page 266. The Lady Chablis photographed by Sofía Sánchez & Mauro Mongiello, styled by Samuel François.

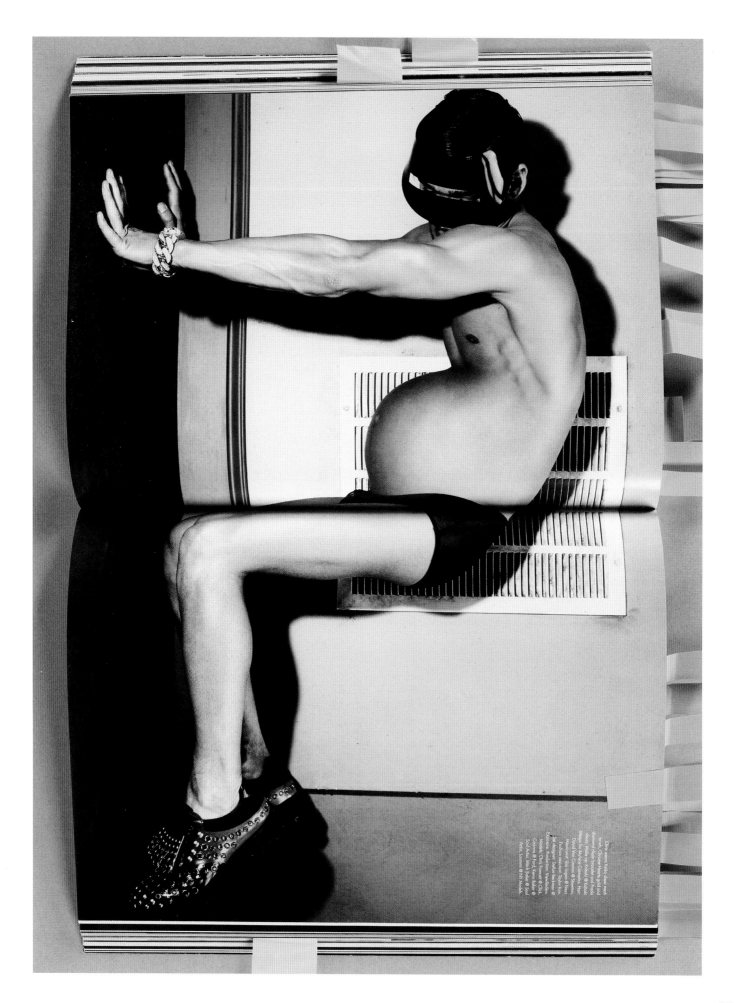

Chin wears Calvin Klein (total look), Chrome Hearty gold and diamond chain bracelets and Prada shoes. Make up: Colozzi @ Calvin Klein Cosmetics. Hair: David Von Cannon @ Streeters. Manicure: Elle Logan @ Mao. Fashion assistant: Taylor Kim @ Margaret Stefan Barbara @ Streeter Production. Photographer's assistants: Eric Powell @ CfA, Coralie @ Erik, Owen Bajo @ Saul Kane @ Erik. Models @ NY Models.

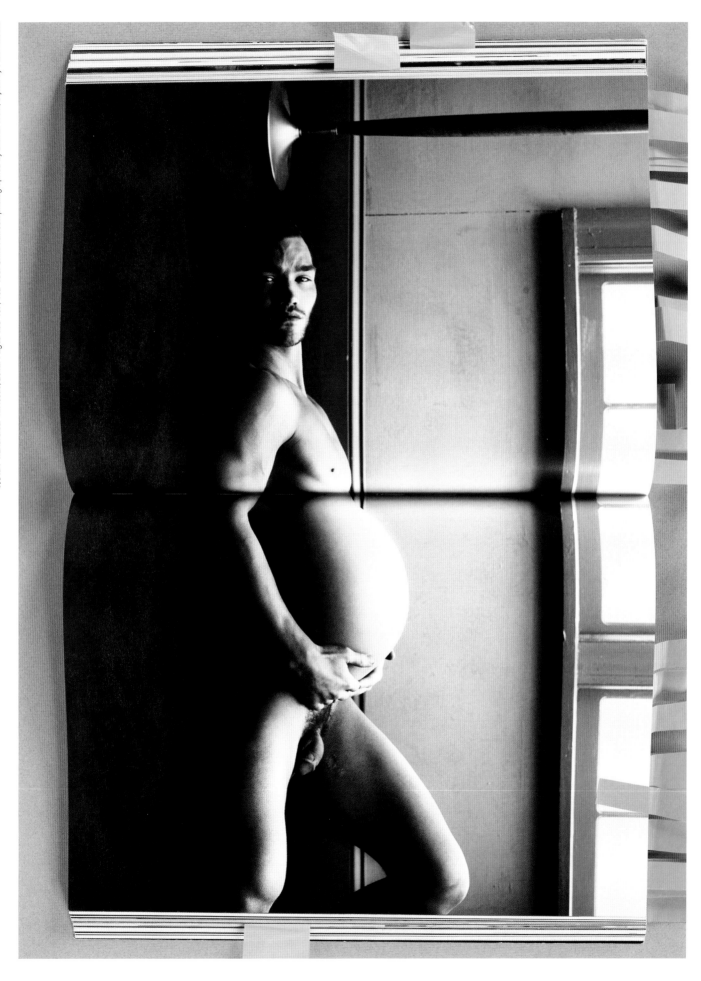

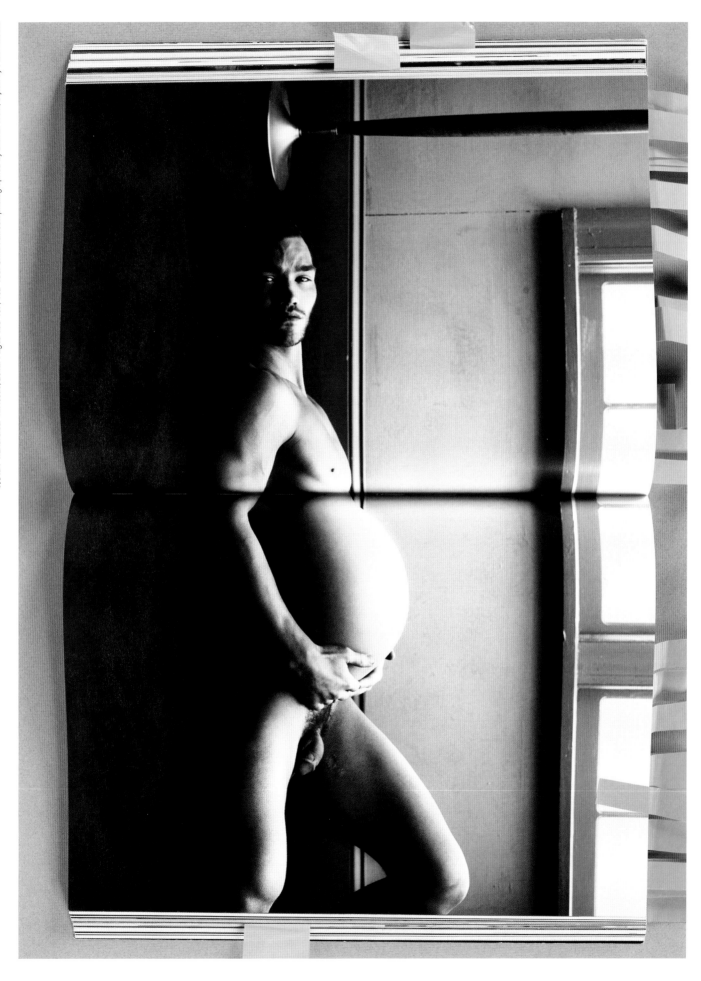

C✷NDY *Transversal* 4th Issue, 2012. Pages 186-187, 192-193. Chris Fawcett photographed by Steven Klein, styled by Patti Wilson.

CANDY Transversal/ 3rd Issue, 2011. Page 373. Valentijn de Hingh photographed by Bettina Rheims, styled by Jean Colonna. Valentijn de H. II, June 2011, Paris © Bettina Rheims, Courtesy Galerie Xippas.

VALENTIJN

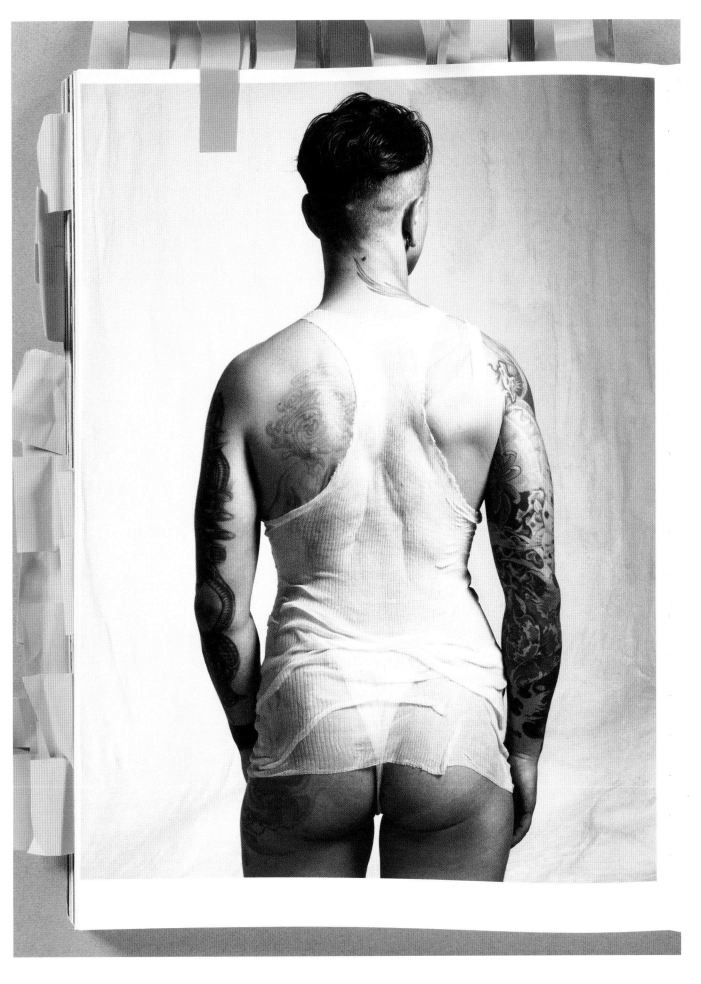

CANDY Transversal, 3rd Issue, 2011. Page 378. Eloy photographed by Bettina Rheims, styled by Jean Colonna. Eloy I. II, June 2011, Paris © Bettina Rheims, Courtesy Galerie Xippas.

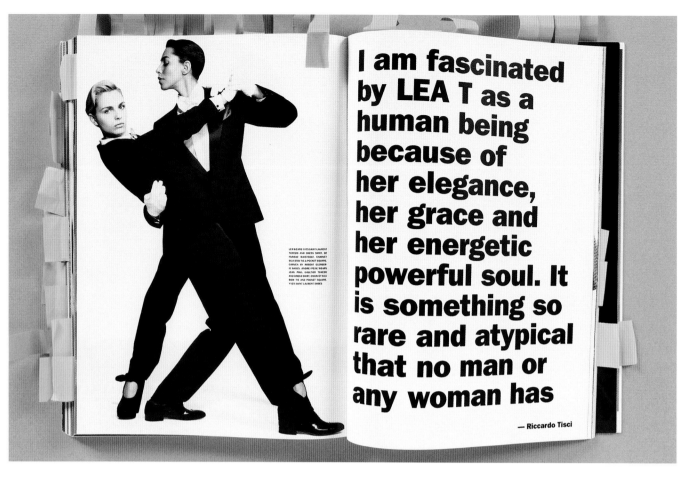

C★NDY Transversal 3rd Issue, 2011. Pages 320-321. Andreja Pejic and Lea T photographed by Andreas Larsson, styled by Michael Philouze. Quote by Riccardo Tisci.

LEA WEARS YVES SAINT LAURENT
TUXEDO AND DRESS SHIRT, DE
FURSAC WAISTCOAT. CHARVET
SILK BOW TIE & POCKET SQUARE,
CARVEN BY ROBERT CLERGERIE
H SHOES. ANDREJ PEJIC WEARS
JEAN PAUL GAULTIER TUXEDO
AND DRESS SHIRT, CHARVET SILK
BOW TIE AND POCKET SQUARE,
YVES SAINT LAURENT SHOES.

I am fascinated by LEA T as a human being because of her elegance, her grace and her energetic powerful soul. It is something so rare and atypical that no man or any woman has

— Riccardo Tisci

I basically grew up with and on the pages of *C★NDY*. The first issue
came out in 2009 when I was first starting my career as a gender-fluid model.
Back then there weren't many people representing either gender fluidity
or transness publicly. It was basically *C★NDY*, Lea T, and me. At the time
the majority of the fashion industry and media dismissed us as a niche
15-minute, gender-bending phenomenon that would stay contained
to a few editorials/runways. Today it has become one of the biggest
shifts in pop culture. *C★NDY*'s place in the history of the not so tragic
demise of gender norms is sealed! *C★NDY* and Luis Venegas
always serve the good T.

—
ANDREJA PEJIC
C★NDY Transversal 10th Issue, 2017

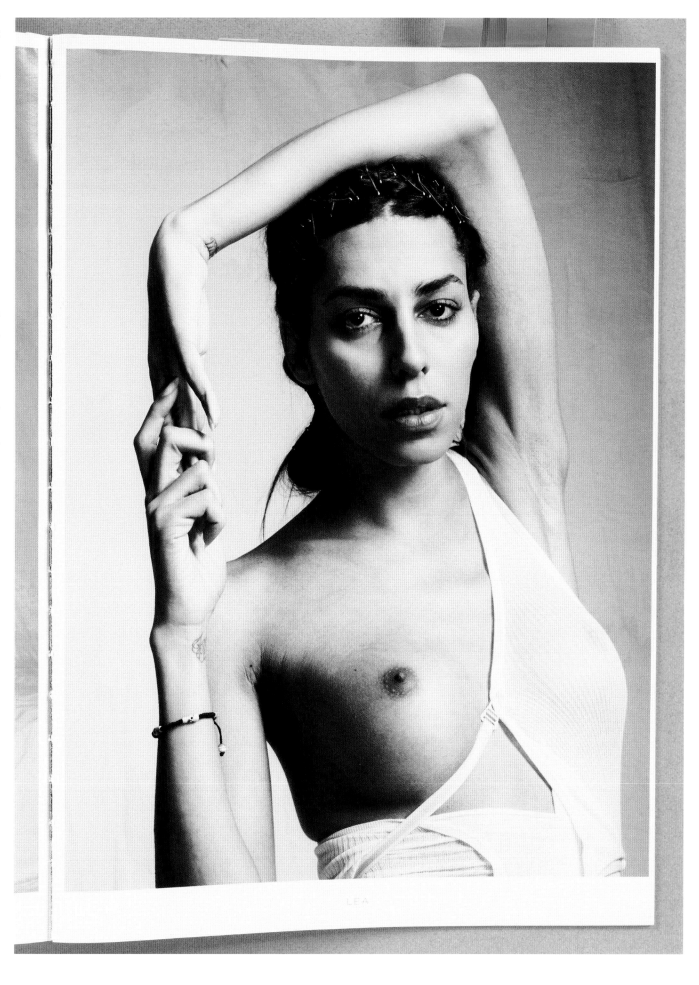

CANDY *Transversal*/ 3rd Issue, 2011. Page 371. Lea T photographed by Bettina Rheims, styled by Jean Colonna. Lea T, Juin 2011, Paris © Bettina Rheims, Courtesy Galerie Xippas.

LEA

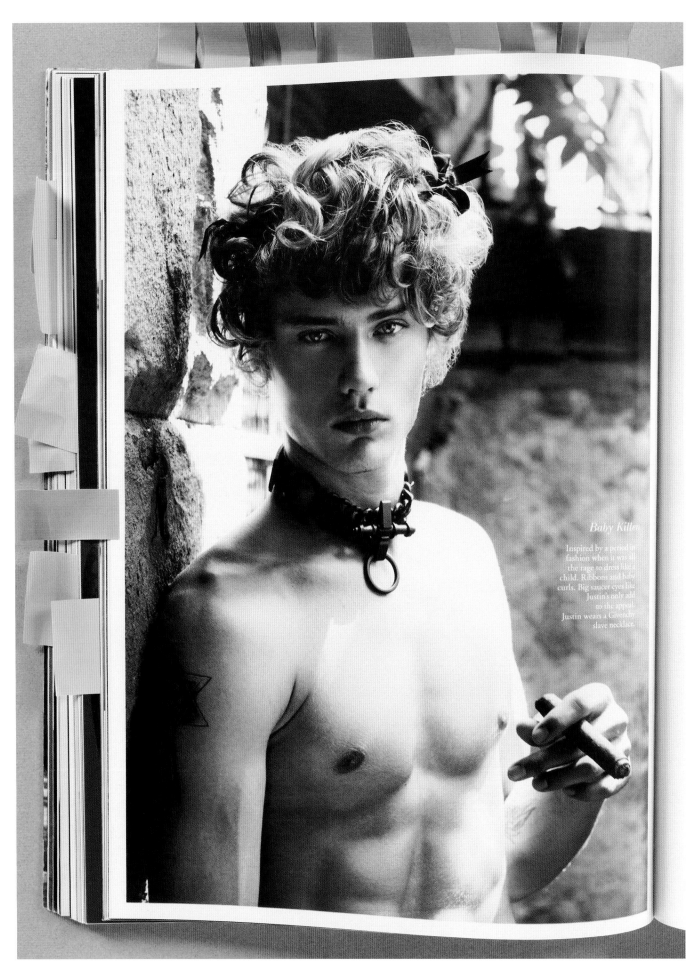

Baby Kitten

Inspired by a period in
fashion when it was all
the rage to dress like a
child. Ribbons and baby
curls. Big saucer eyes like
Justin's only add
to the appeal.
Justin wears a Givenchy
slave necklace.

G★NDY *Transversal* 3rd Issue, 2011. Page 166. Justin Barnhill photographed by Jack Pierson, styled by Jason Farrer.

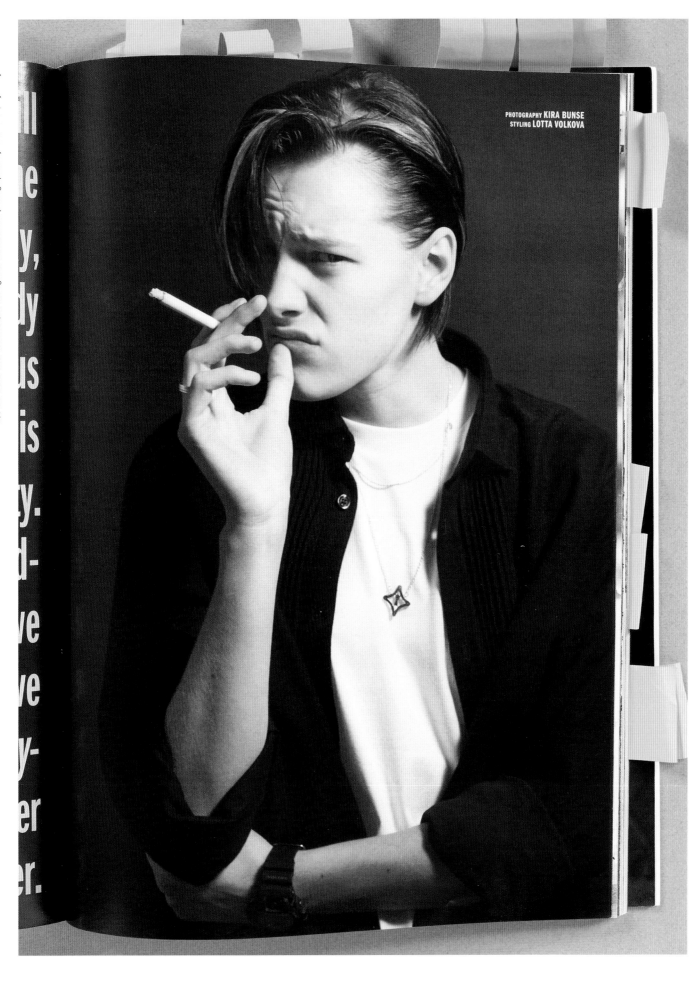

C★NDY *Transversal* 3rd Issue, 2011. Page 287. Erika Linder photographed by Kira Bunse, styled by Lotta Volkova.

PHOTOGRAPHY **KIRA BUNSE**
STYLING **LOTTA VOLKOVA**

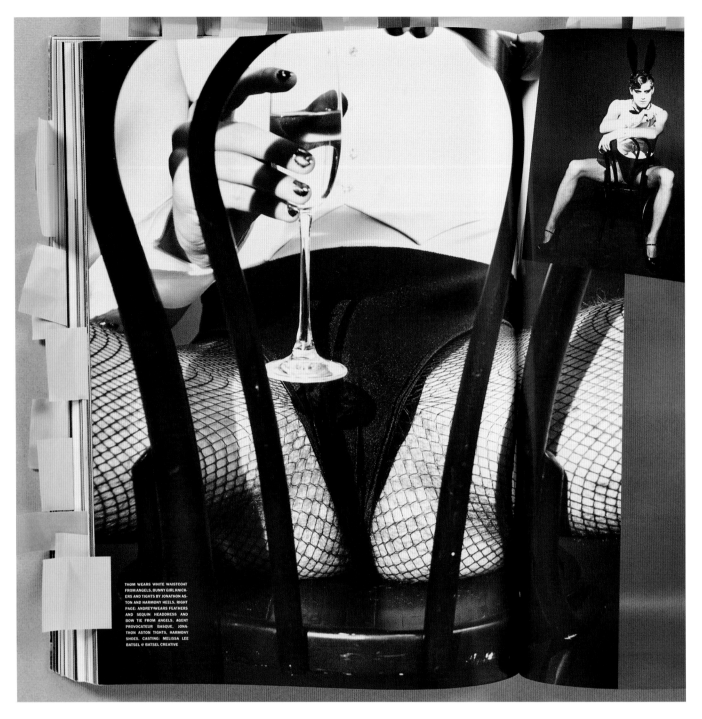

THOM WEARS WHITE WAISTCOAT FROM ANGELS, BUNNY GIRL KNICKERS AND TIGHTS BY JONATHON ASTON AND HARMONY HEELS. RIGHT PAGE: ANDREY WEARS FEATHERS AND SEQUIN HEADDRESS AND BOW TIE FROM ANGELS, AGENT PROVOCATEUR BASQUE, JONATHON ASTON TIGHTS, HARMONY SHOES. CASTING: MELISSA LEE BATSEL @ BATSEL CREATIVE

G★NDY Transversal 3rd Issue, 2011. Pages 220, 224-225. Playmates fashion story photographed by Mariano Vivanco, styled by Luke Day.

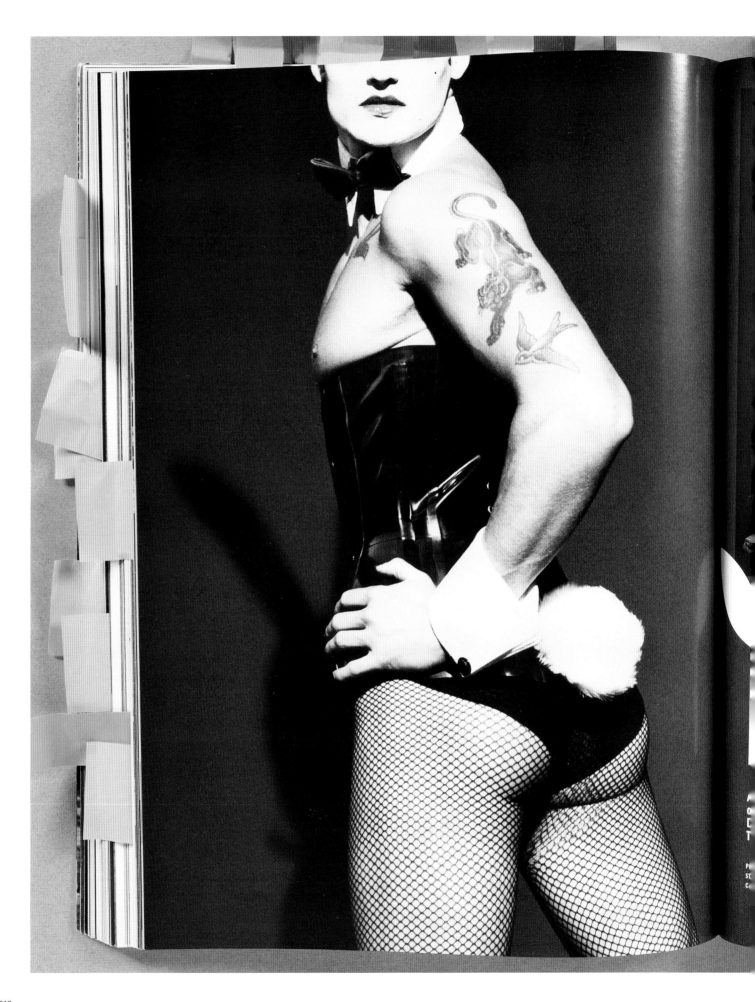

CANDY Transversal 3rd Issue, 2011. Page 221. *Playmates* fashion story photographed by Mariano Vivanco, styled by Luke Day.

PLAYMATES

As starting point for this section we decided to pay homage to the iconic *Playboy* bunnies, *Candy* style. We added a little bit of S&M perversion *à la* Helmut Berger in *The Damned*, and let's not forget the fabulous glam make up that would even make Dr. Frank-N-Furter very shy. And, most importantly, we picked the hunkiest and most exciting male models right now. *Voilà!* The cocktail is served. Aren't these the hottest bunnies you have ever seen?

PHOTOGRAPHY **MARIANO VIVANCO**
STYLING **LUKE DAY**
CREATIVE DIRECTION **GARY CARD**

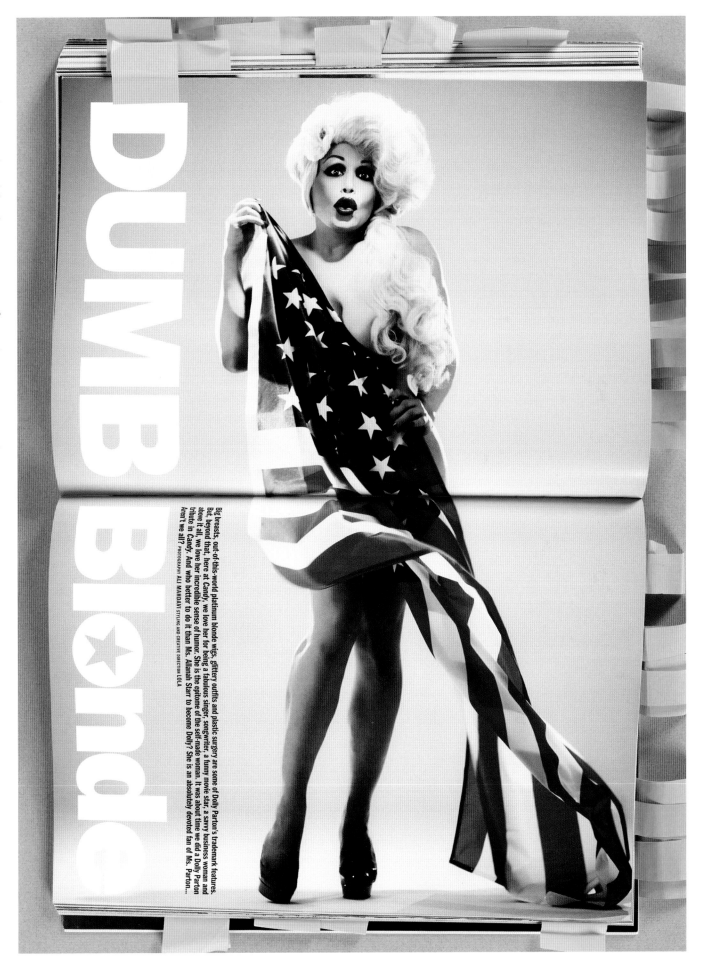

CANDY *Transversal* 3rd Issue, 2011. Pages 268-269. Allanah Starr photographed by Ali Mahdavi; styled by Laurent Mercier.

DUMB BLonde

Big breasts, out-of-this-world platinum blonde wigs, glittery outfits and plastic surgery are some of Dolly Parton's trademark features. But, beyond that, here at Candy, we love her for being a fabulous singer, songwriter, a funny movie star, a savvy business woman and above it all, we love her incredible sense of humor. She is the epitome of the self-made woman. It was about time we did a Dolly Parton tribute in Candy. And who better to do it than Ms. Allanah Starr to become Dolly? She is an absolutely devoted fan of Ms. Parton... Aren't we all? PHOTOGRAPHY ALI MAHDAVI STYLING AND CREATIVE DIRECTION LOLA

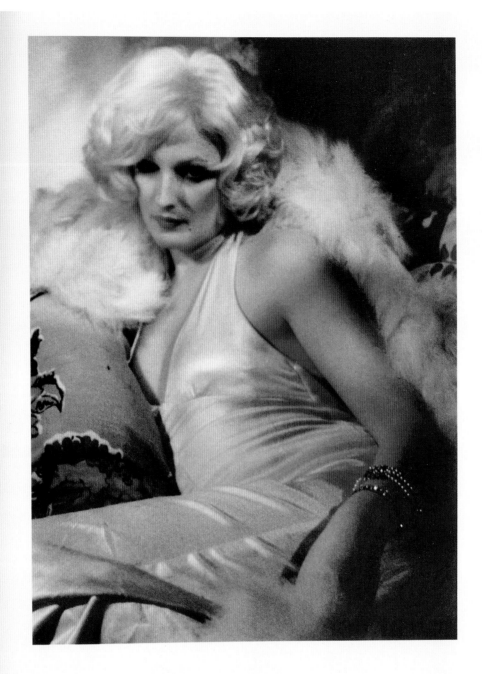

Candy Darling. New York, 1966. Photograph by Paul Jasmin.

C★NDY *Transversal* 10th Issue, 2017. Page 111. Candy Darling photographed by Paul Jasmin, NYC, 1966. RIGHT: C★NDY *Transversal* 3rd Issue, 2011. Andreja Pejic photographed by David Armstrong, styled by Christopher Niquet.

Honestly one of the best days i've had shooting ever. The stars in perfect alignment. Andrej i'd never met sad to say, I adored her. She somehow pitch perfectly channeled *C★NDY* channeling Kim Novak andMarilyn while too young to know who any of them really were. Kabuki,also as yet unseen by me was beyond magic transporting thoroughly enjoyed all of it. the subject and team comprised a legacy of drag reaching back beyond a half century, **MY DEAR.**

—
Private email sent by photographer DAVID ARMSTRONG
to Luis Venegas on August 5, 2011, after shooting Andreja Pejic

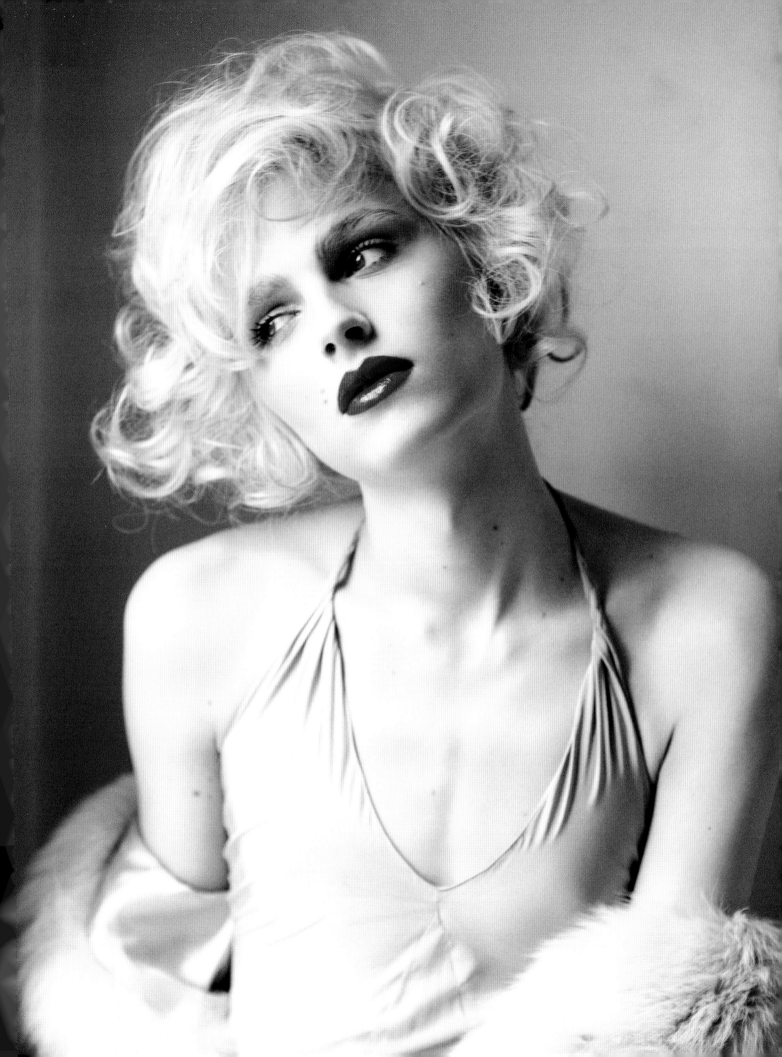

Iron Fist in Silk Glove

When I arrive at Luis Venegas's home, my notion that nothing happens by chance is reaffirmed. Luis lives just above what once was a party club called Yulia, where the legendary vedette Coccinelle performed in the late 70s when she still maintained her status as a trans icon, arriving from France and about to enter into decadence without return. Though Luis and Coccinelle were separated in space and time by ten feet and four decades, I cannot help telling him about it. Then I ask him my first question: How did you come up with the name C★NDY? He replied: "Whenever I start a project, I do it with the intention of having international visibility, so there was no room for a very Spanish name. I was looking for a universal word, very generic and easy. Candy is that kind of word, and, as the English speakers say, it's very catchy. It means 'treats' and is associated with something sweet and nice. It has an innocent side, but it's also sexy at the same time. And it also coincides with Candy Darling, who is one of the most emblematic figures in trans culture and culture in general. Candy is a fashion and style reference, which is also the foundation of the magazine."

When he mentions the Warholian star, I think of the fifth issue of C★NDY Transversal, where he published a recovered photo of her, one of the last taken, on her deathbed. "These images at the hospital are beautiful. One of those photos was used by Antony and the Johnsons for an album cover. Since then, I thought there had to be many more photos of that photo shoot. Peter Hujar, the photographer, had already died, but I contacted his estate and they provided me all those contact prints and discarded photos along with that magnificent photos of Jackie Curtis visiting her and even her finally resting in the coffin." We enter into a debate about the moral implications and immediately agree on how valuable the document is, which in view of the audience manages to give another dimension to the character, devoid of morbid curiosity.

When we were talking about death, we immediately turned to the of the death of Cristina "La Veneno," a timeless Spanish media star who had her very last photo shoot with C★NDY—only three weeks before her sudden death. I was involved in that feature, and so I am aware that Luis was about to self-censor and not publish her feature: "In all these years that I've been editing magazines, I had never seen myself in such a situation. The idea with her was to do a cover because I loved the character, the photos were lovely, and I also assumed that she would look forward to seeing herself on a cover. When I met her personally during those four hours doing the feature, I completely fell in love with Cristina. But the circumstances of her death were so mysterious… that I didn't want anybody to think that I was taking advantage of it."

We put death aside and moved on to life. I want to know how C★NDY Transversal was born. "There are three people to whom I spoke about C★NDY before anyone else. One was hairstylist Jimmy Paul; another one was Jefferson Hack, the founder of Dazed & Confused; and the last one, illustrator Jordi Labanda. Jordi told me that it would be an absolute success, and he went on with his arguments supporting his prediction, assuring that it was scientifically proven that whenever there is a trans person on television the audience increases." We cannot help smiling at Labanda's assertion, which proves impossible to fact-check, but that we believe blindly.

Luis recalls another one of the guidelines that had been set for the birth of C★NDY: "Although it was an independent product made from Spain, I always had an international vocation because I didn't want it to be a local product only. I have never done anything similar to a marketing plan to know how something will work, but right now it's already been ten years and twelve issues. It is also true that many times you jump into something when you are encouraged by people you trust and appreciate." It is at this point that the name of Laura Bailey, one of the main characters of C★NDY's eighth issue, comes up. "I truly appreciate and respect Laura. She has been collecting publications and show programs for her whole life. Much of her collection is at Yale University. At first, I told her that there were people who told me that maybe the stories would soon be over, that C★NDY would only last two or three issues, and she totally rejected that idea, assuring me that there was a big number of characters to talk about, in addition to all the stories that were still to come. And she was right." Luis says that a month after finishing one issue, new stories always begin to come up for the next C★NDY, like a snowball rolling by itself.

Looking back, Luis draws an accurate and positive conclusion: "The funny thing is that the magazine was born as a kind of Vogue, celebrating style and fashion from a transversal point of view. However, what is happening now is the opposite: more mainstream magazines are adopting all those codes that they had previously ignored and are now giving visibility to more transversal women and men. It's something that was meant to happen. I do not intend to say that it is because of C★NDY, but it is something that didn't happen before, and the truth is that I realized before it happened, although at that time I didn't think about it so much!"

Luis recognizes that in the early stages of C★NDY Transversal, when the magazine was just a sketch, not everyone around showed empathy for it. "There were people who thought that perhaps it would be something shabby and sordid…and I had a completely different vision. It was clear for me that I wanted to show the best of the best. The formula was to do something different and exciting, with the fashion world as the foundation. I just did what I would like to find in the newsstand."

I find it inevitable to ask Luis to define his creature in a few words, which he has been taking care of for a decade. "C★NDY is iron fist in silk glove." He later argues such an accurate description with the reasoning that the reader gets into unknown places in a nice way, always wrapped in a positive imagery.

As a great publisher, Luis's house is full of style and fashion magazines as well as a bookshelf that immediately draws the attention of any visitor. Observing his references, it fits perfectly with his ambition of endowing C★NDY Transversal with the elegance and dignity that are already present since the very first issue. "I didn't want it to be something of a minority and it was very clear for me that it had to be big. Even though C★NDY was an independent magazine—and still is—I was always clear that it had to have a very luxurious appearance, which was a fundamental factor for it to be taken seriously, along with that it's a limited edition, something that I love as a consumer. Whenever I do something, I try to carry it out in the best possible way, although I also think that the last issue I'm involved with at the time might be a farewell," he confesses in a mysterious way, while ensuring that he never keeps stories or features for the next time.

His level of commitment is so high that I want to know which is the phase of the work that he enjoys the most. "I have a great time during the entire process. I'm thrilled whenever a character or artist confirms their participation, but the part that I like the most is when I have all the material and I have to assemble the puzzle, making everything fit. That is to say, the editing—the step of deciding what I include, what I discard, the layout. Then, also during the promotion stage, I like verifying which are the contents that attract the most interest."

Luis is aware of another advantage of being his own boss—from the first to the last decision, everything falls on him: How many covers there will be? Who will appear inside? What photographer will be responsible for a feature? And even allowing himself to give space to what fascinates him the most, as he did on issue twelve with Joey Gabriel. "She is featured on that issue with an interview, her photos, and scrapbooks. I was aware that sixty pages is a large feature about someone who is not so well known, but I wanted to give her that space. Then it became one of the most celebrated stories by many readers."

He recognizes that, in these ten years, he has evolved in gender ideas, discovering nomenclatures that he was not aware of when the C★NDY Transversal adventure began. His generosity enables him to provide so much knowledge to the collaborators involved in the magazine. And he wishes to continue learning. He emphasizes his objective—which he refers to inspiration, entertainment, and information—using a phrase from Audrey Hepburn's movie Funny Face: "A magazine must have… blood and brains and pizzazz."

C★NDY is transversal in the whole meaning of the word. Its pages mix different generations, ranging from sixty-year-old Bond girl Caroline Cossey to drag queen Aquaria, a clear exponent of the millennial universe. It is fascinating to see such a cultural exchange when Germany makes its contribution with popstar Kim Petras while Spain shows the world the unique cabaret star Violeta la Burra. Such explosive melting pot has an explanation: "Although I didn't want it to be a local magazine, it is true that if I buy a magazine in The Netherlands, I like getting to know what's going on there. And if I buy Dazed & Confused, it always has that British touch. In C★NDY Transversal, there are collaborators from Brazil, Germany, India—the five continents, really. I find it appropriate that someone in Spain can discover who Octavia Saint Laurent is or see Paris is Burning; and, suddenly, an American discovers Carmen de Mairena. It is an exchange of references, and identification can arise in someone from any part of the world." Again, in my constant vindication that nothing happens by chance, I take the opportunity to tell Luis about the first transgender woman that appeared on Spanish television imitating Monroe: Her name name is Candy! Luis cannot hide his astonishment—and, I guess, his look for a potential story in his next issue.

In these ten years, Luis has had the opportunity to bring to his pages some of the stars who revolutionized the language of gender that are no longer among us, from Holly Woodland to Lindsay Kemp, and even novelist Jackie Collins, for whom we both profess admiration. "I still want to invite her sister, Joan Collins. In fact, I was about to have her, but when we were going to do the feature, Jackie died a few days before, which caused the cancellation of the plans."

In the C★NDY Transversal universe, there is room for muses very different from each other. "There are many of them and none in particular. Of course, we have Candy Darling, but of those who have collaborated, we also have Hari Nef, who is someone who can do theater but also advertise a new fragrance. And Tilda Swinton, with her ability for transformation. Luis recognizes that the covers with media stars—such as Lady Gaga, Marilyn Manson, or Miley Cyrus—served as an attraction to pull many readers in to discover C★NDY. "But it was James Franco's drag cover where repercussion was most noticeable. There are even people who believe that this was the first issue."

I put an end to my interview by proposing to him a trip in a time machine, where he could bring any star back from another dimension to the pages of C★NDY Transversal. Luis answers without hesitation: "I would have loved to have Coccinelle." Everything ends as it started because nothing happens by chance.

VALERIA VEGAS
Writer, journalist

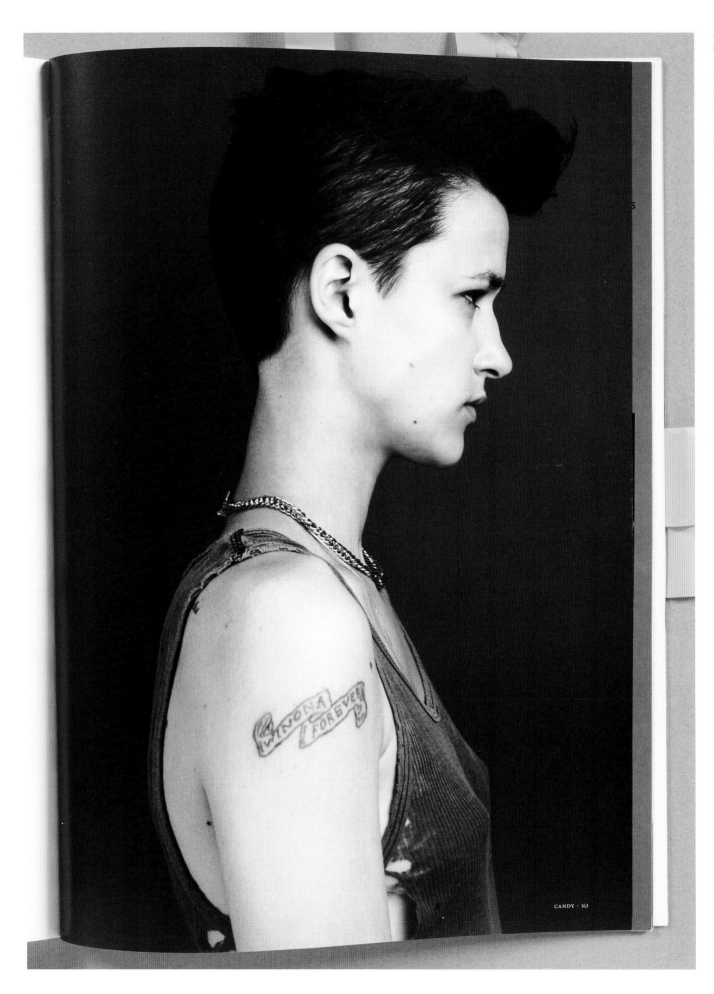

CANDY · 163

CANDY *Transversal*/ 1st Issue, 2009. Page 161. Agathe Mougin photographed by Kira Bunse, styled by Jos van Heel.

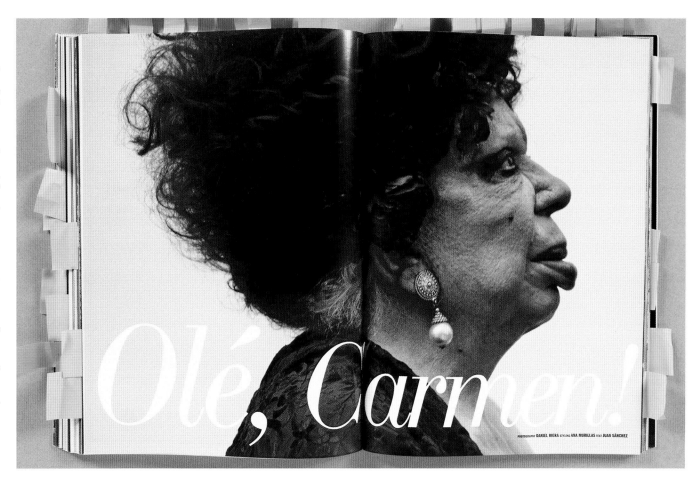

Olé, Carmen!

PHOTOGRAPHY **DANIEL RIERA** STYLING **ANA MURILLAS** TEXT **JUAN SÁNCHEZ**

CANDY Transversal 3rd Issue, 2011. Page 221. Pages 244-245. Carmen de Mairena photographed by Daniel Riera, styled by Ana Murillas.

Soy elegante, por detrás y por delante.

—
CARMEN DE MAIRENA in conversation with Juan Sánchez
C★NDY Transversal 3rd Issue, 2011

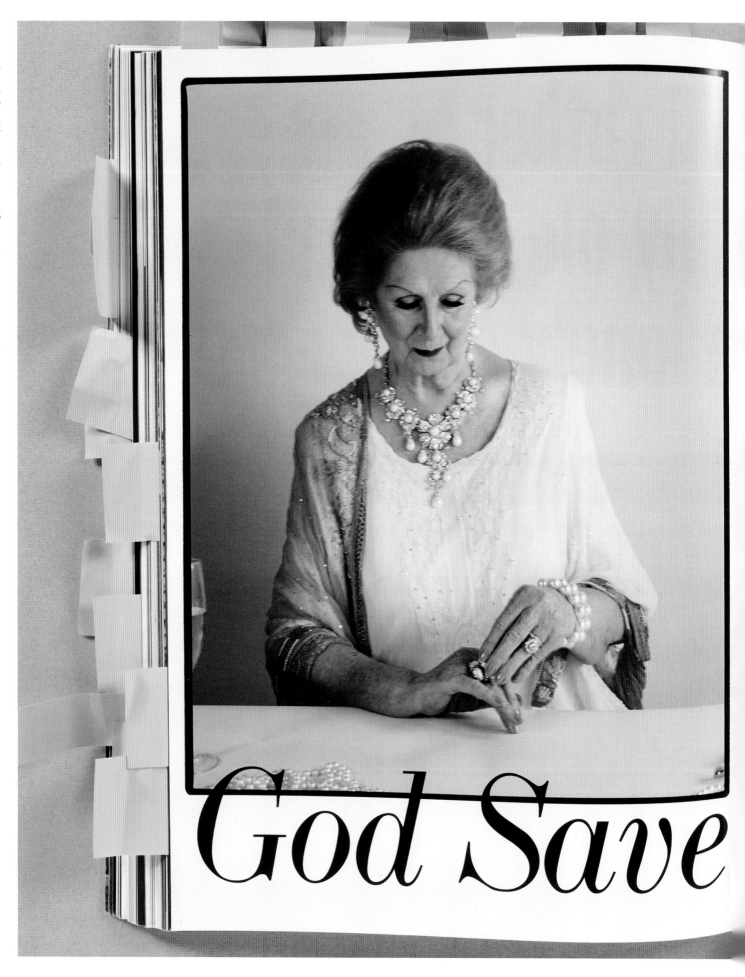

G★NDY Transversal 3rd Issue, 2011. Pages 238-239. April Ashley photographed by Tim Walker.

God Save

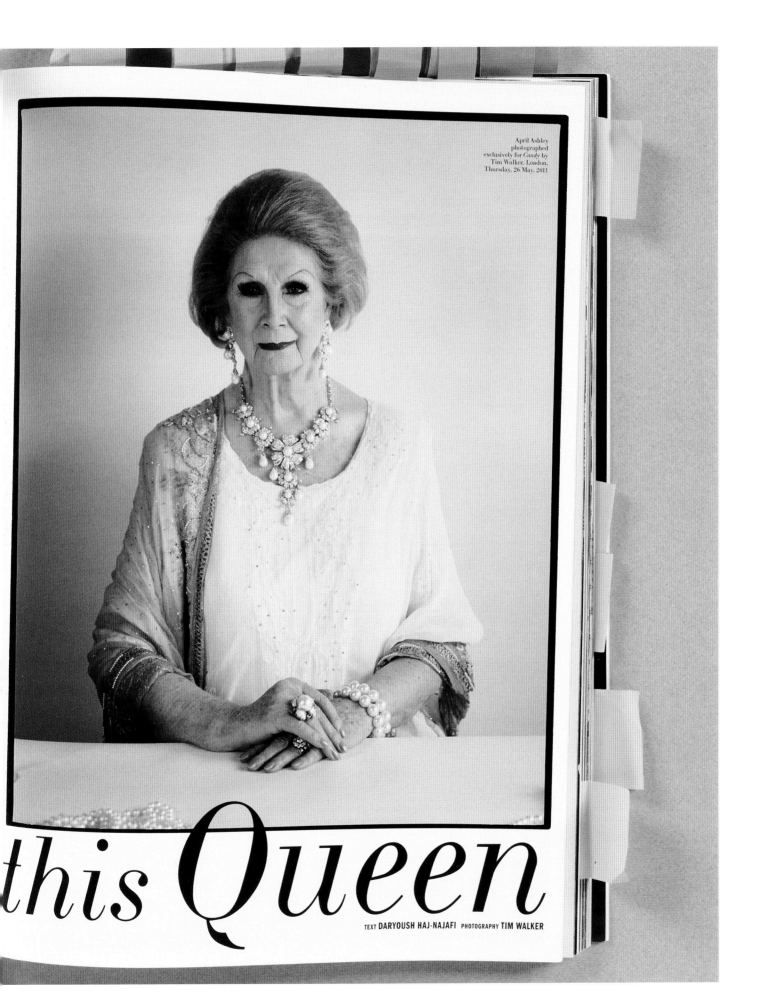

April Ashley photographed exclusively for *Candy* by Tim Walker. London, Thursday, 26 May, 2011

this Queen

TEXT DARYOUSH HAJ-NAJAFI PHOTOGRAPHY TIM WALKER

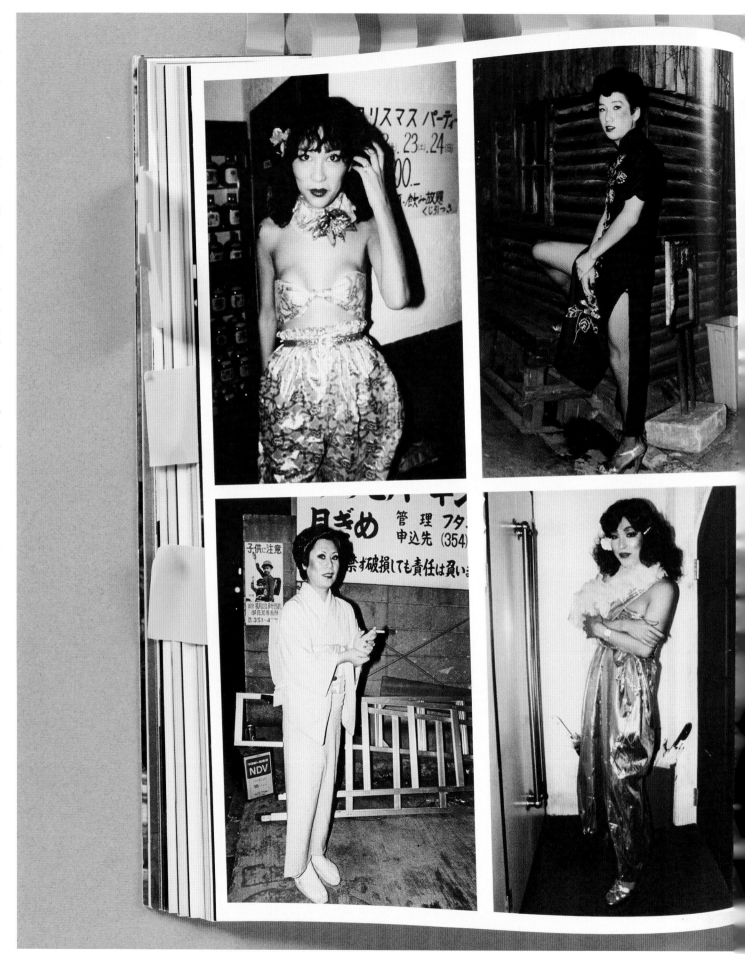

C★NDY Transversal 3rd Issue, 2011. Pages 118–119. Photographs by Hiroyasu Nakai; previously published by grafica in the book Gay In Shinjuku, 2008.

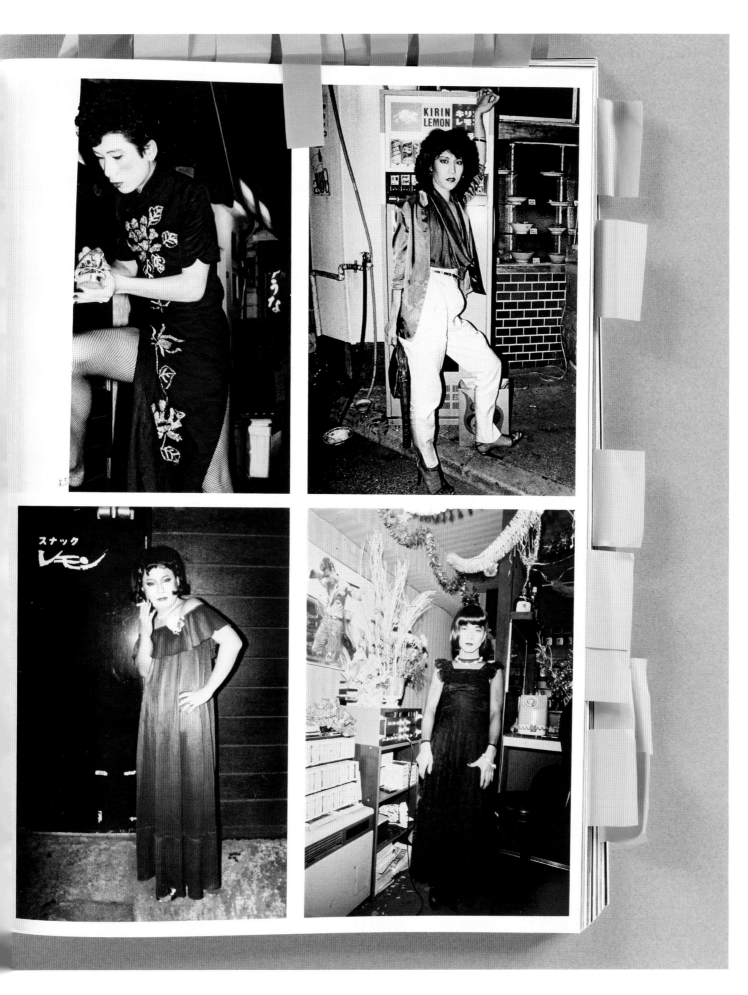

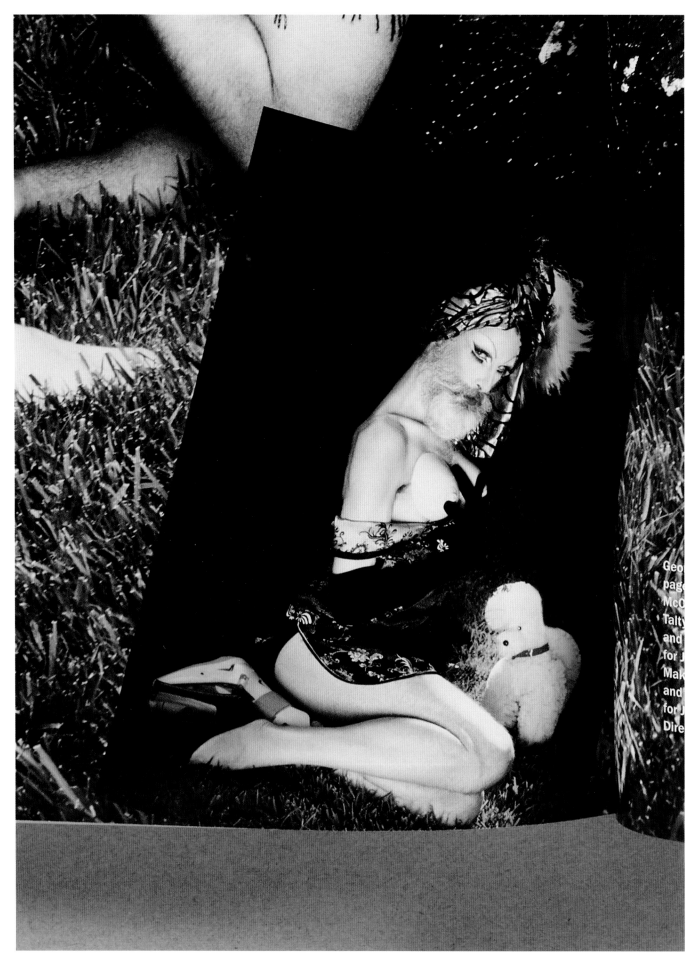

C★NDY *Transversal*/ 3rd Issue, 2011. Page 334 (Detail). Mathu Andersen photographed by Doug Inglish, styled by Christine Baker.

Geo
pag
McC
Talty
and
for J
Mak
and
for J
Dire

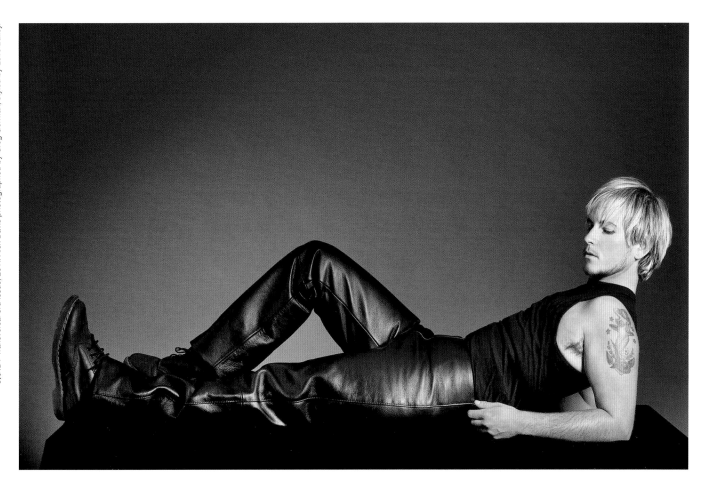

C★NDY *Transversal* 3rd Issue, 2011. Alex Davis photographed by Greg Gorman, styled by Love Bailey.

I just feel like a guy who had the strange experience of living as a woman and not understanding one minute of it. My girlfriend has taught me more about women than I ever imagined was understandable.

—
ALEX DAVIS in conversation with Amos Mac
C★NDY *Transversal* 3rd Issue, 2011

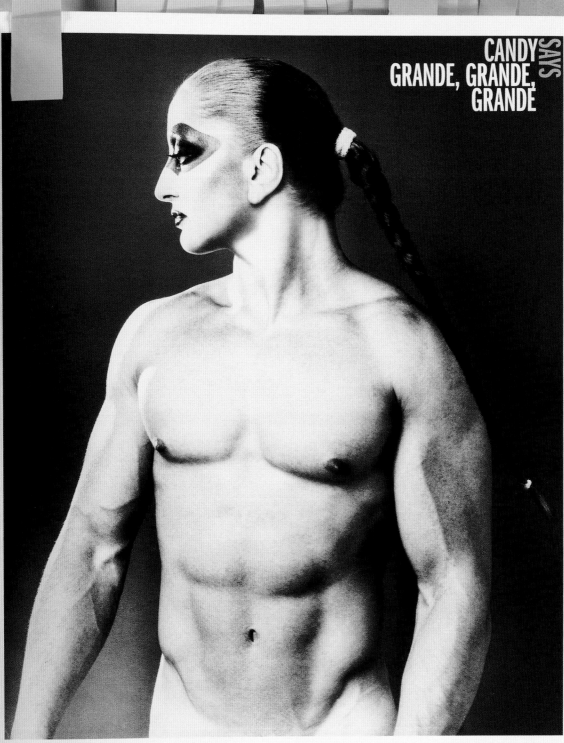

CANDY SAYS
GRANDE, GRANDE, GRANDE

Rane Supreme, 1987. Make-up: Stefano Anselmo

THE BEST ITALIAN POP SINGER EVER

MINA CREATED SOME OF THE MOST GROUNDBREAKING ALBUM COVERS ALONGSIDE PHOTOGRAPHER MAURO BALLETTI

PHOTOGRAPHY **MAURO BALLETTI** TEXT **RICCARDO SLAVIK**

C★NDY *Transversal* 3rd Issue, 2011. Page 87. Mina photographed by Mauro Balletti for her *Rane Supreme* record, 1987.

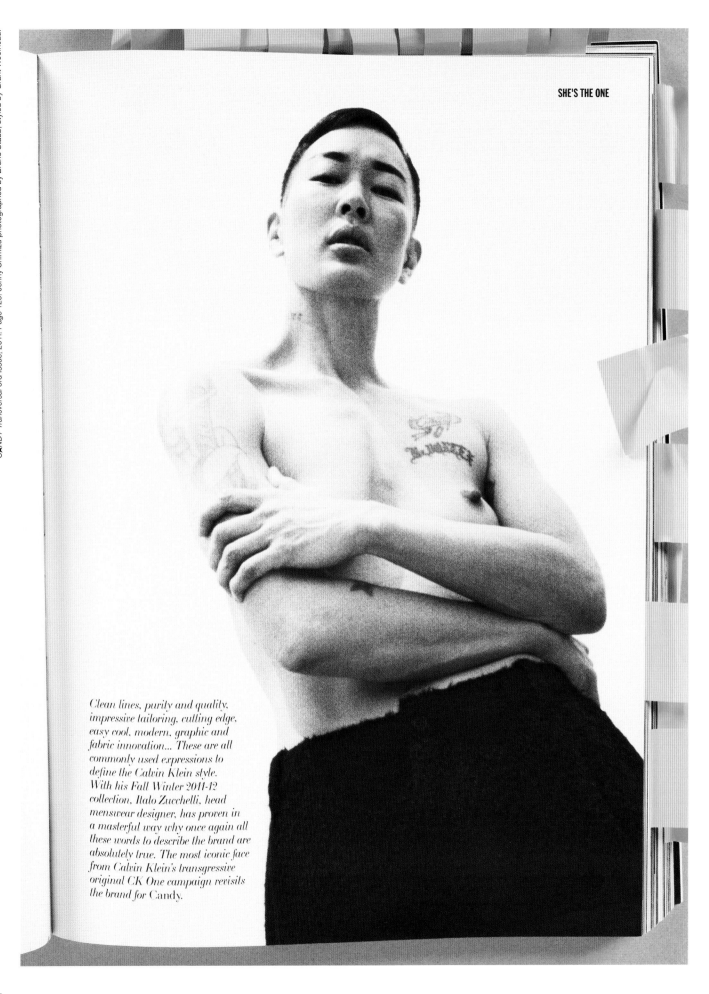

C★NDY *Transversal* 3rd Issue, 2011. Page 125. Jenny Shimizu photographed by Bruno Staub, styled by Grant Woolhead.

Clean lines, purity and quality, impressive tailoring, cutting edge, easy cool, modern, graphic and fabric innovation... These are all commonly used expressions to define the Calvin Klein style. With his Fall Winter 2011-12 collection, Italo Zucchelli, head menswear designer, has proven in a masterful way why once again all these words to describe the brand are absolutely true. The most iconic face from Calvin Klein's transgressive original CK One campaign revisits the brand for Candy.

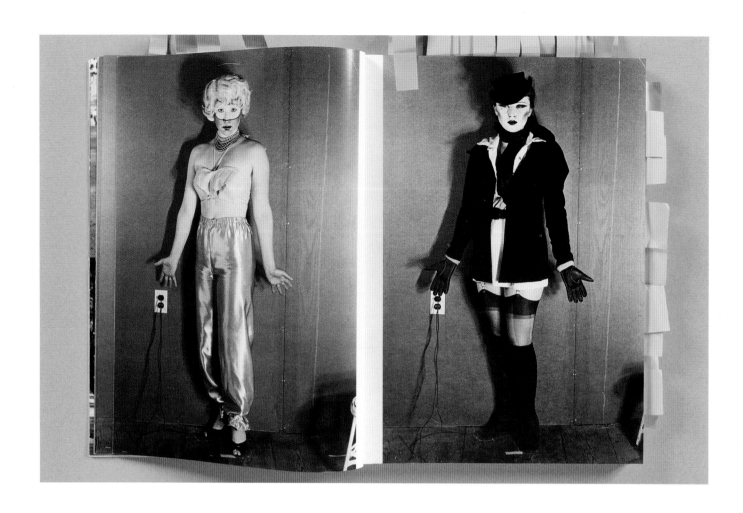

I'd never seen the magazine before Luis sent it to me. I think it's surprising that no one had done this kind of thing before, it's brilliant. Publishing this work in *C★NDY* was a perfect match since I'd been fond of it for many years but never knew what to do with it. It's so unlike anything else I've done, fantasy…

—
CINDY SHERMAN
C★NDY Transversal 3rd Issue, 2011

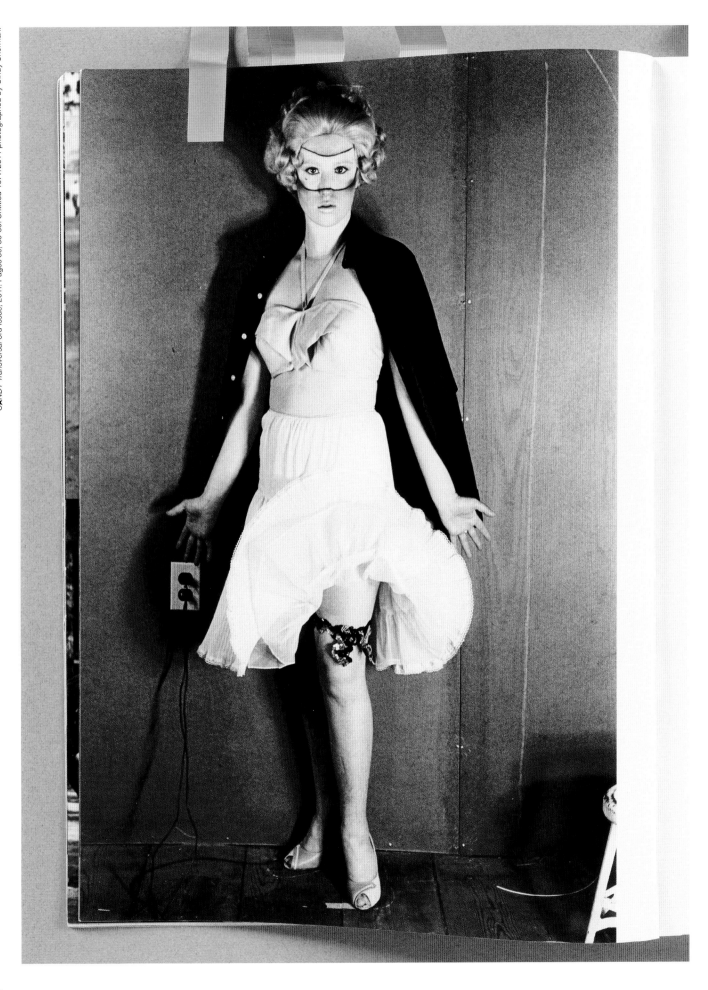

C★NDY *Transversal* 3rd Issue, 2011. Pages 30, 38-39. *Untitled* 1977/2011 photographed by Cindy Sherman.

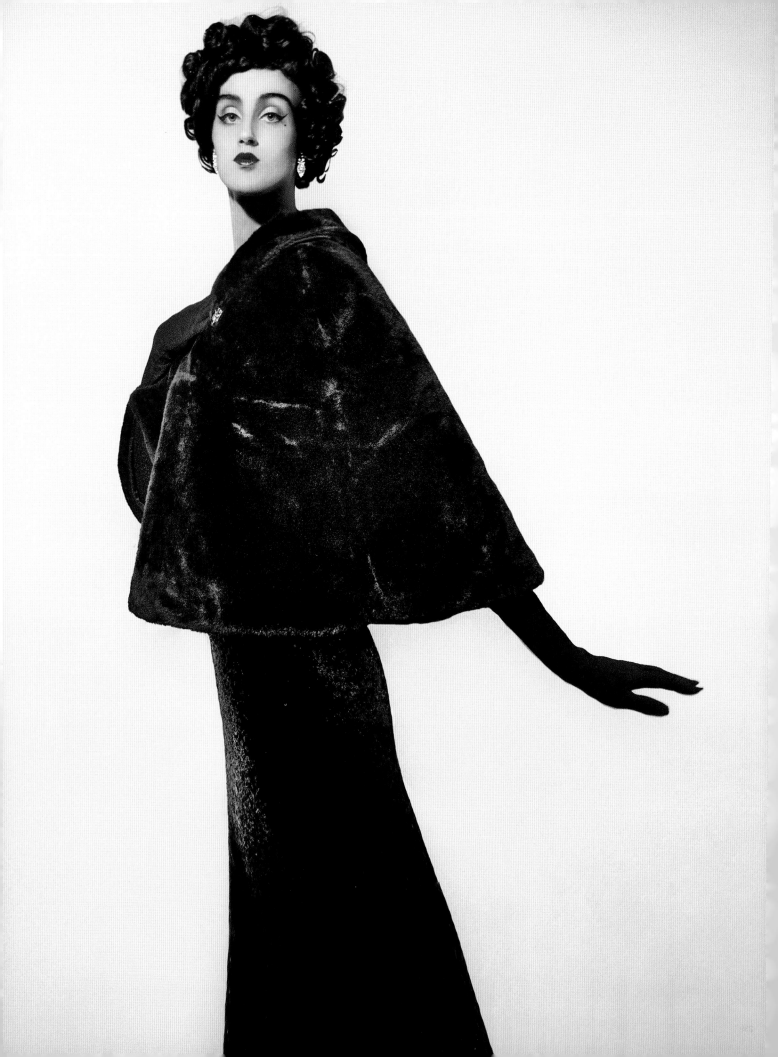

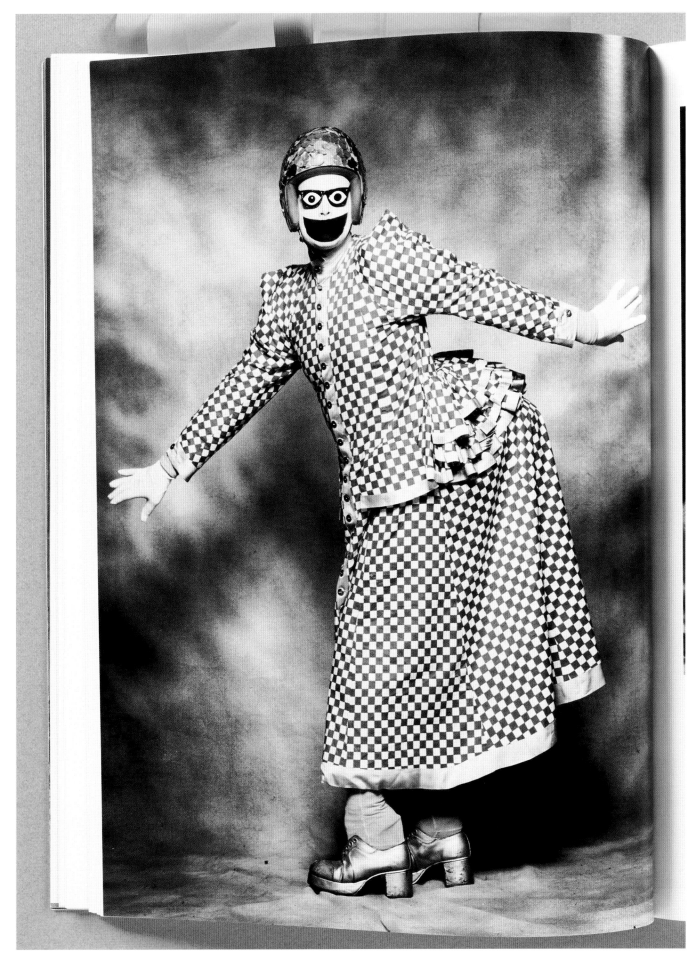

C✱NDY Transversal 7th Issue, 2014. Page 82. Leigh Bowery, Session I, Look 2, 1988, photographed by Fergus Greer. LEFT: Christopher Smith's self-portrait inspired by C✱NDY Transversal.

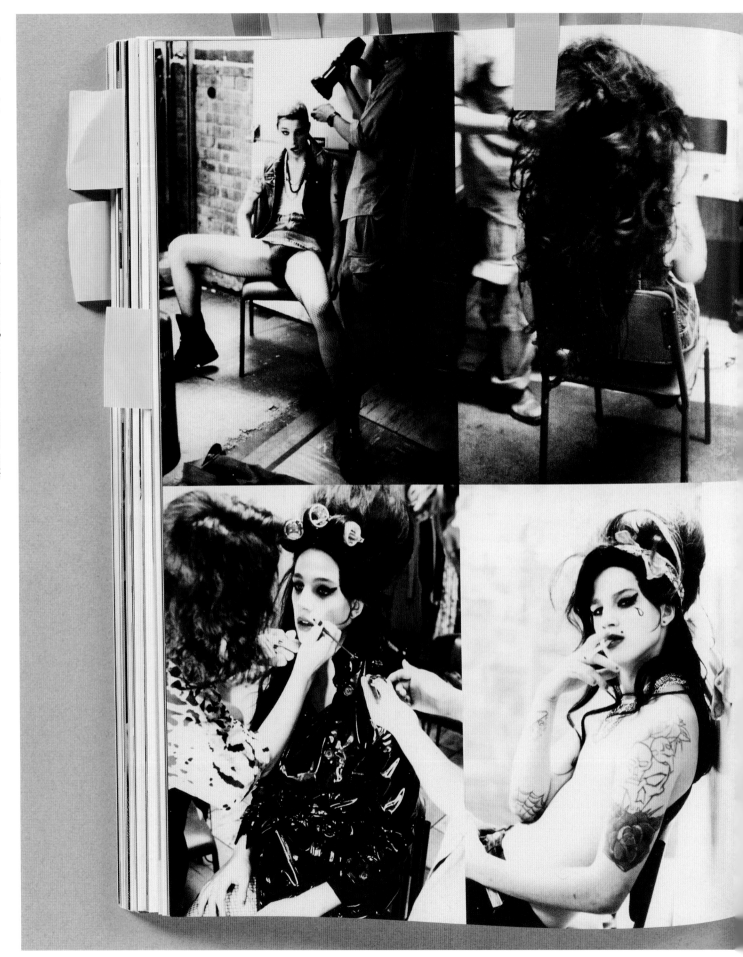

CANDY *Transversal* 2nd Issue, 2010. Pages 242-243. Ash Stymest photographed by Ellen von Unwerth, styled by Robbie Spencer.

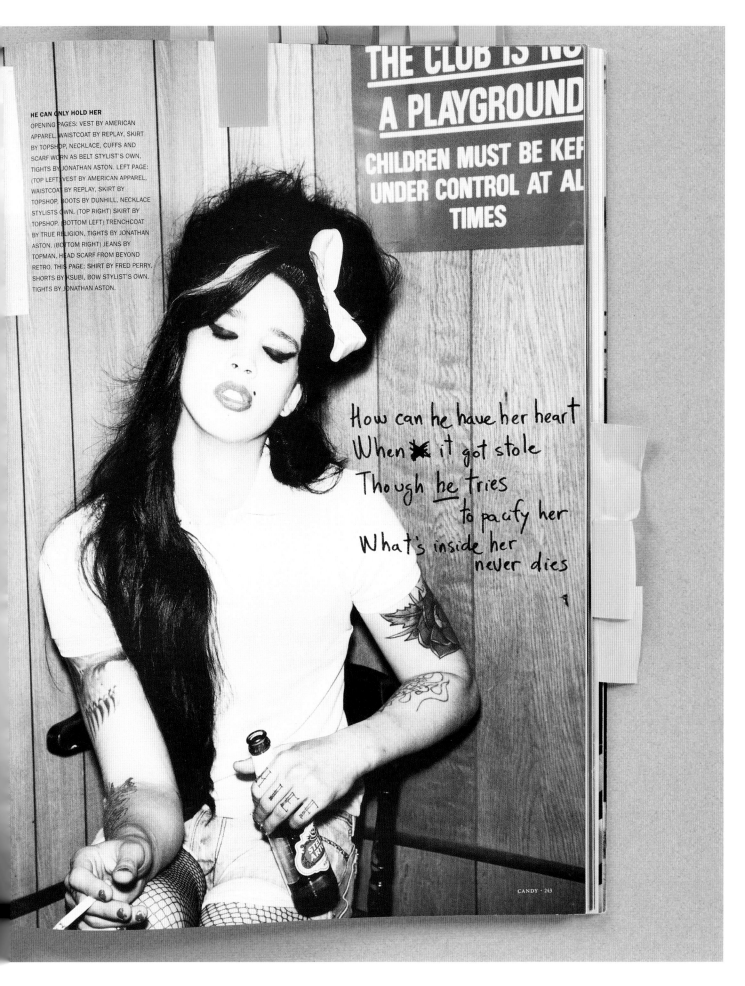

THE CLUB IS NO
A PLAYGROUND
CHILDREN MUST BE KEF
UNDER CONTROL AT AL
TIMES

How can he have her heart
When �direct it got stole
Though _he_ tries
 to pacify her
What's inside her
 never dies

CANDY · 243

241

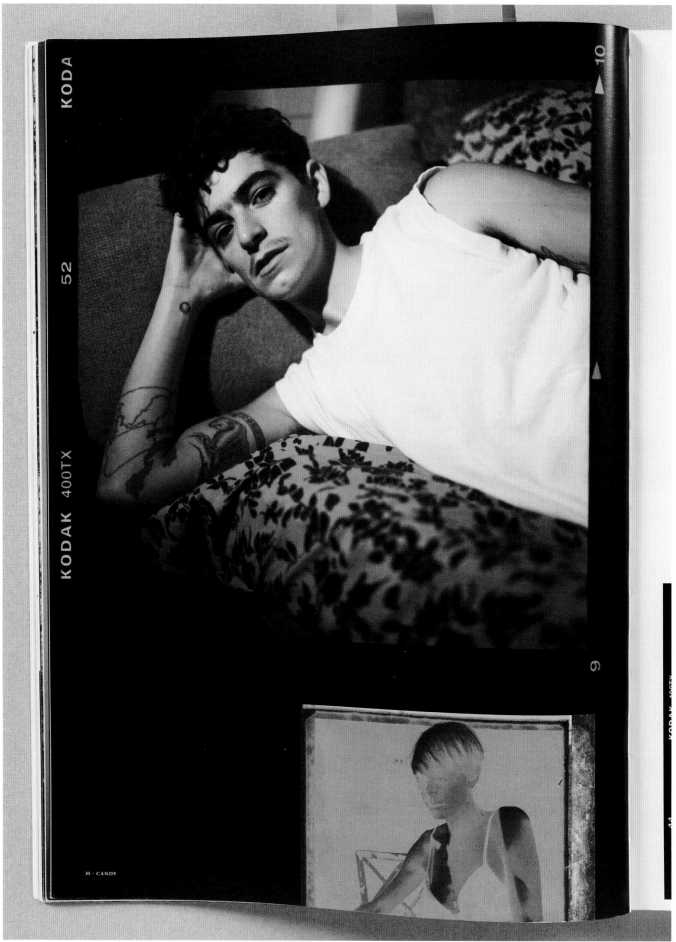

30 · CANDY

C★NDY Transversal 2nd Issue, 2010. Pages 178–179. Scout Rose photographed by Xevi Muntané, styled by Jay Massacret. Text by Amos Mac.

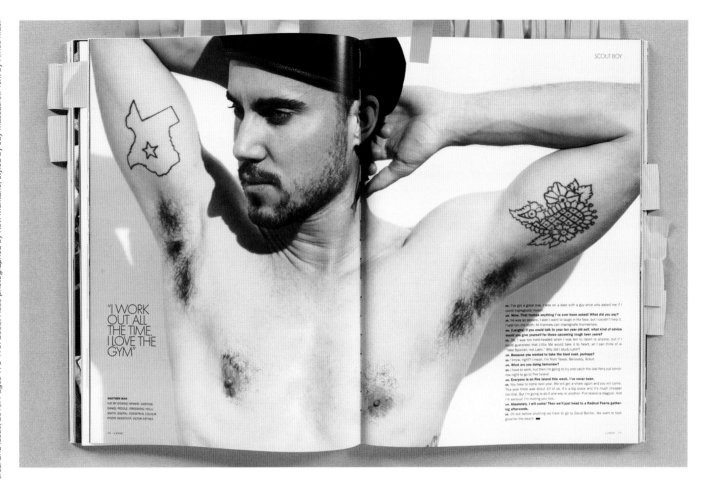

"I WORK OUT ALL THE TIME. I LOVE THE GYM"

When I first started transitioning, I was in this difficult but kind of wonderful play space where I hadn't yet figured out how I was most comfortable expressing myself gender wise. I used to wear sparkly belts and nail polish and swish a lot. And then over the years I slowly discovered that I feel most like myself when I look like a completely un-fabulous, boring dude.

—
SCOUT ROSE in conversation with Amos Mac
C★NDY Transversal 2nd Issue, 2010

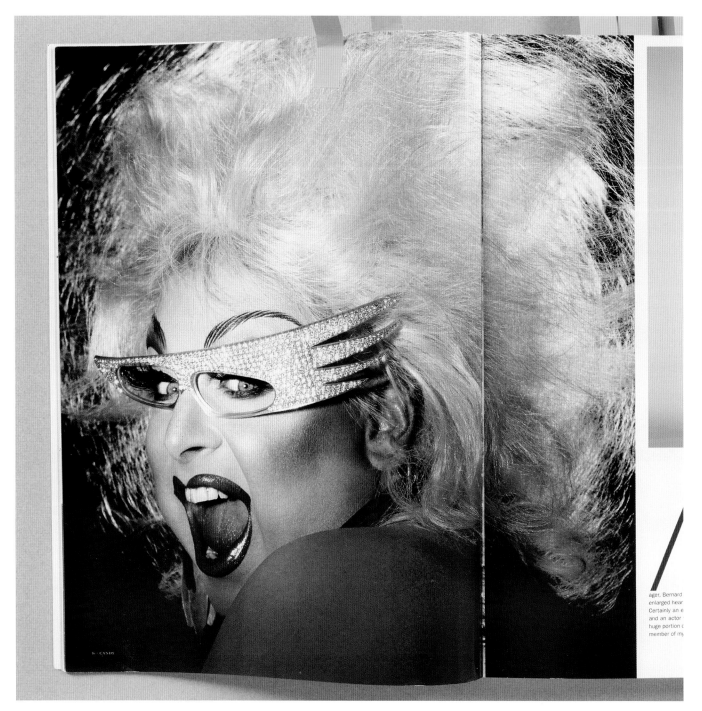

16 · CANDY

C★NDY *Transversal* 2nd Issue, 2010. Pages 16–17. Divine photographed by Greg Gorman, early 80s.

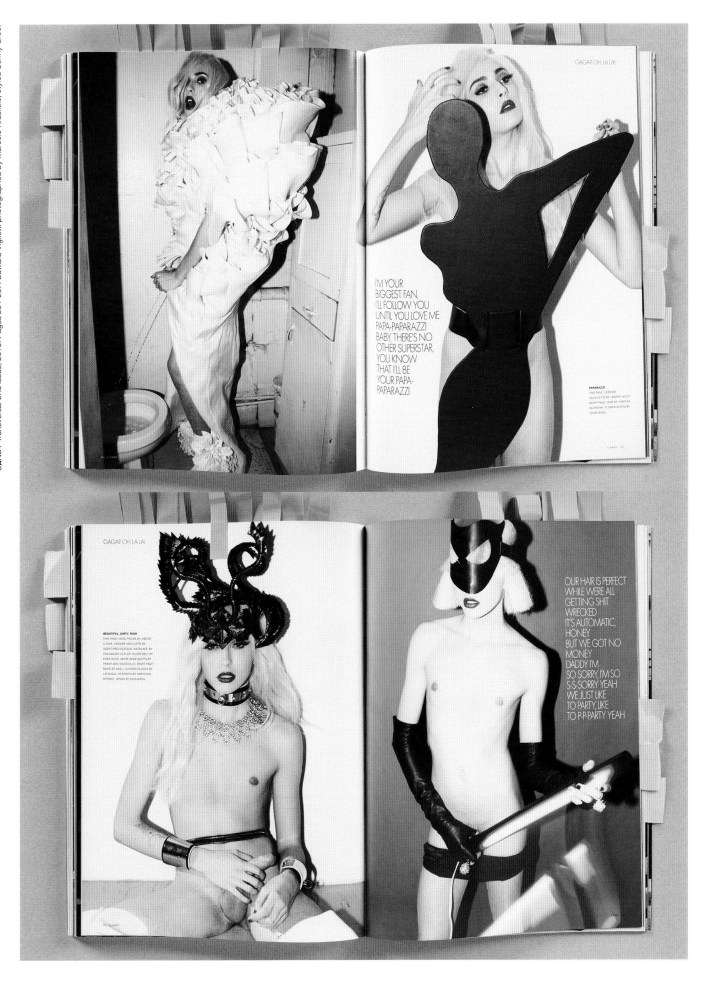

C★NDY *Transversal* 2nd Issue, 2010. Pages 264-267. Edward Vigiletti photographed by Marcelo Krasilcic, styled Sonny Groo.

GAGA? OH, LA LA!

I'M YOUR
BIGGEST FAN,
I'LL FOLLOW YOU
UNTIL YOU LOVE ME
PAPA-PAPARAZZI
BABY, THERE'S NO
OTHER SUPERSTAR,
YOU KNOW
THAT I'LL BE
YOUR PAPA-
PAPARAZZI

PAPARAZZI
THIS PAGE: LEATHER
SILHOUETTE BY JEREMY SCOTT.
RIGHT PAGE: COAT BY TIMOTHY
PLUMESKI. FLOWER BOOTS BY
THOM SOLO.

GAGA? OH, LA LA!

BEAUTIFUL, DIRTY, RICH
THIS PAGE: HEAD-PIECES BY OSCAR
O LYRA. CHOKER AND CUFFS BY
AGENT PROVOCATEUR. NECKLACE BY
CAVANNAUGH CUTLER. SILVER BELT BY
KARA ROSS. WHITE ANKE BOOTS BY
TRASH AND VAUDEVILLE. RIGHT PAGE
MASK BY AND I. LEATHER GLOVES BY
LACRASIA. HOTPANTS BY AMERICAN
APPAREL. RINGS BY BING BANG.

OUR HAIR IS PERFECT
WHILE WE'RE ALL
GETTING SHIT
WRECKED
IT'S AUTOMATIC,
HONEY
BUT WE GOT NO
MONEY
DADDY I'M
SO SORRY, I'M SO
S-S-SORRY YEAH
WE JUST LIKE
TO PARTY, LIKE
TO P-P-PARTY YEAH

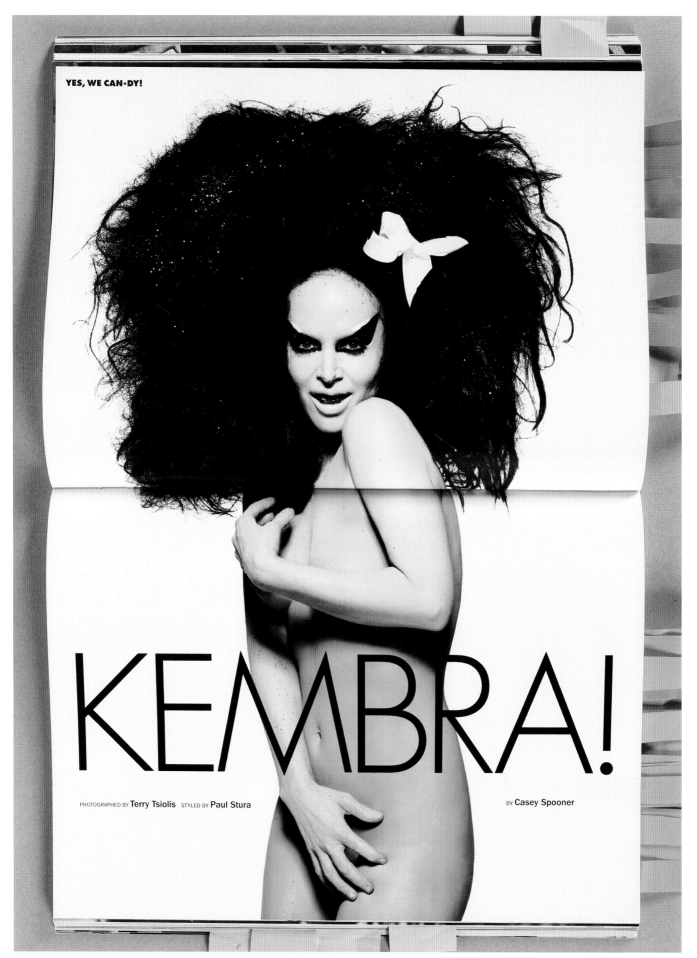

KEMBRA!

PHOTOGRAPHED BY **Terry Tsiolis** STYLED BY **Paul Stura**

BY **Casey Spooner**

C★NDY Transversal/ 2nd Issue, 2010. Pages 188-189. Kembra Pfahler photographed by Terry Tsiolis, styled by Paul Stura.

C★NDY Transversal 2nd Issue, 2010. Page 157. Amanda Lepore photographed by Jeremy Kost, styled by James Valeri.

AMANDA

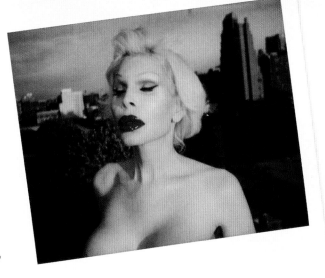

The BEAUTIFUL

BY Ladyfag NYC

I would love to inspire people the way that Marilyn Monroe inspired me. Hopefully someone that's troubled and made fun of can look at me and say, she did it, and I can too. Maybe give young transsexuals strength to know that it is possible to be yourself and not have to conform.

—
AMANDA LEPORE in conversation with Ladyfag
C★NDY Transversal 2nd Issue, 2010

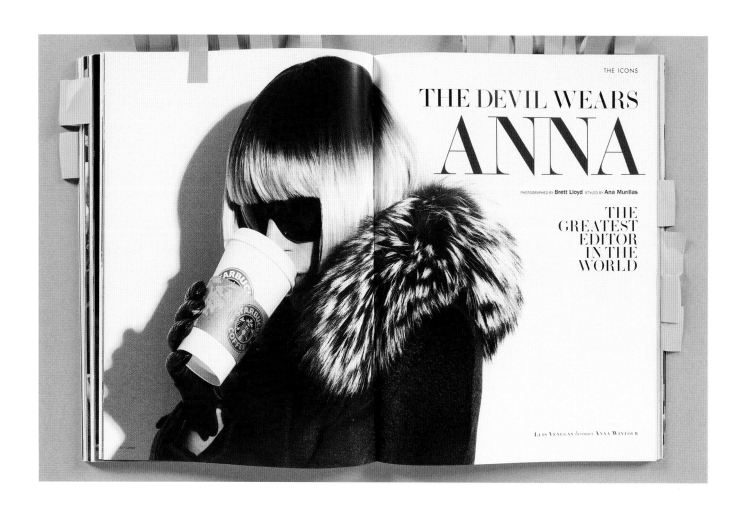

The first time I heard of C★NDY was the very first issue. I remember it being
something of a publishing event, something that felt —and still feels— very new.
And, in retrospect, very prescient. Today, trans rights are at the forefront of conversation,
for all the right and wrong reasons. C★NDY was the first publication
to really explore the idea —to champion and celebrate, without tokenism.

—
ALEXANDER FURY
C★NDY Transversal 12th Issue, 2019

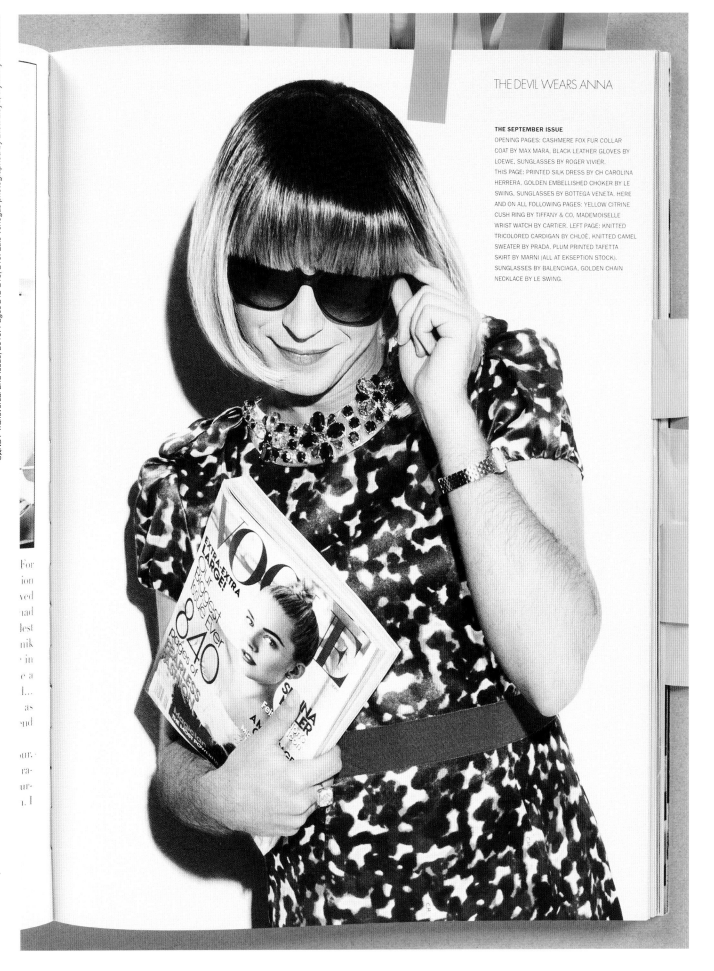

G★NDY *Transversal* 2nd Issue, 2010. Pages 212-213, 215. Luis Venegas photographed by Brett Lloyd, styled by Ana Murillas.

THE DEVIL WEARS ANNA

THE SEPTEMBER ISSUE
OPENING PAGES: CASHMERE FOX FUR COLLAR COAT BY MAX MARA, BLACK LEATHER GLOVES BY LOEWE, SUNGLASSES BY ROGER VIVIER. THIS PAGE: PRINTED SILK DRESS BY CH CAROLINA HERRERA, GOLDEN EMBELLISHED CHOKER BY LE SWING, SUNGLASSES BY BOTTEGA VENETA. HERE AND ON ALL FOLLOWING PAGES: YELLOW CITRINE CUSH RING BY TIFFANY & CO, MADEMOISELLE WRIST WATCH BY CARTIER. LEFT PAGE: KNITTED TRICOLORED CARDIGAN BY CHLOÉ, KNITTED CAMEL SWEATER BY PRADA. PLUM PRINTED TAFETTA SKIRT BY MARNI (ALL AT EKSEPTION STOCK). SUNGLASSES BY BALENCIAGA, GOLDEN CHAIN NECKLACE BY LE SWING.

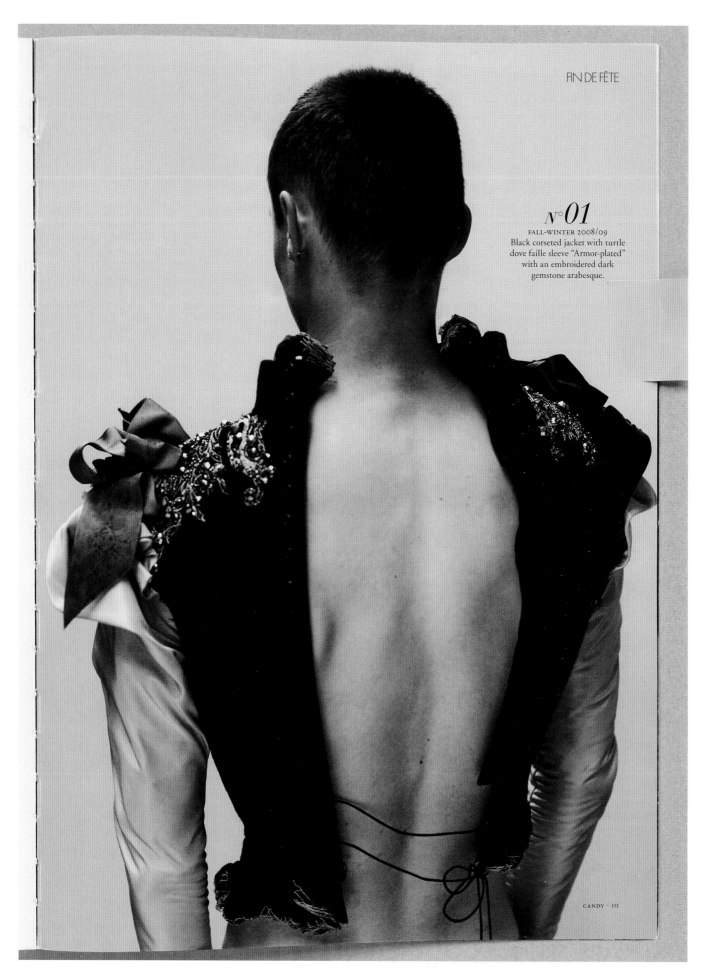

№*01*
FALL-WINTER 2008/09
Black corseted jacket with turtle
dove faille sleeve "Armor-plated"
with an embroidered dark
gemstone arabesque.

CANDY *Transversal* 2nd Issue, 2010. Page 193. *Fin De Fête* fashion story photographed by Karim Sadli, styled by Robbie Spencer.

CANDY · 193

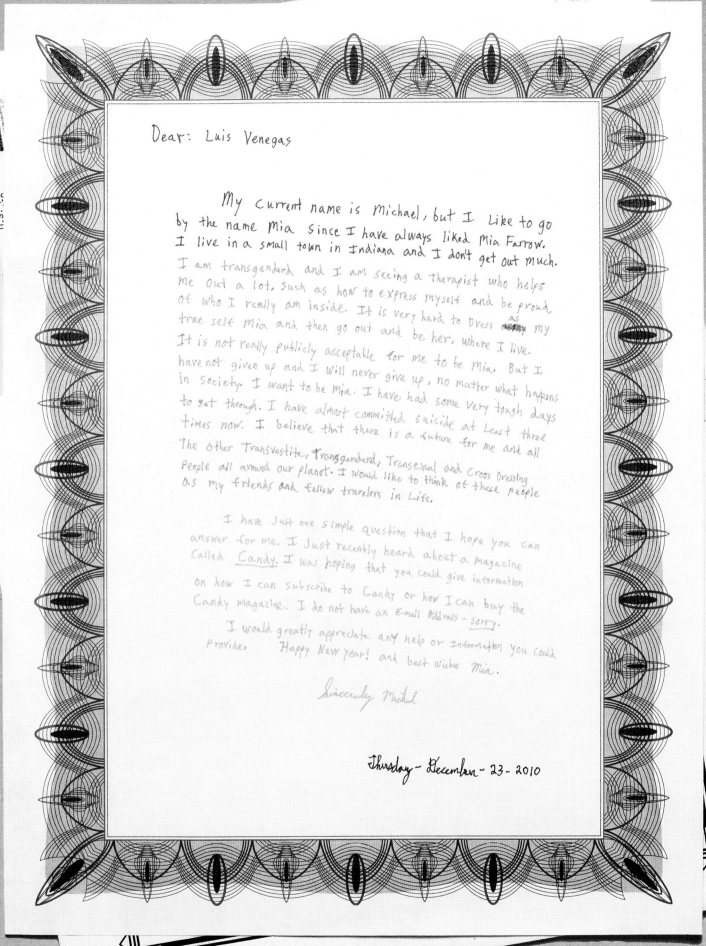

Dear: Luis Venegas

My current name is michael, but I Like to go
by the name Mia since I have always liked Mia Farrow.
I live in a small town in Indiana and I don't get out much.
I am transgenderd and I am seeing a therapist who helps
me out a lot. such as how to express myself and be proud
of who I really am inside. It is very hard to Dress ~~~~~ as my
true self mia and then go out and be her. where I live.
It is not really publicly acceptable for me to be Mia. But I
have not given up and I will never give up, no matter what happens
in society. I want to be mia. I have had some very tough days
to get through. I have almost committed suicide at least three
times now. I believe that there is a future for me and all
The other Transvestite, Transgenderd, Transexual and Cross Dressing
people all around our planet. I would like to think of these people
as my friends and fellow travelers in Life.

I have Just one simple question that I hope you can
answer for me. I Just recently heard about a magazine
called _Candy._ I was hoping that you could give information
on how I can subscribe to Candy or how I can buy the
Candy magazine. I do not have an E-mail Address - sorry.

I would greatly appreciate any help or Information you could
Provide. Happy New Year! and best Wishes Mia.

 Sincerely Michel

Thursday - December - 23 - 2010

CANDY *Transversal* 2nd Issue, 2010. Pages 204-205. Devohn Walker photographed by Daniel Riera.

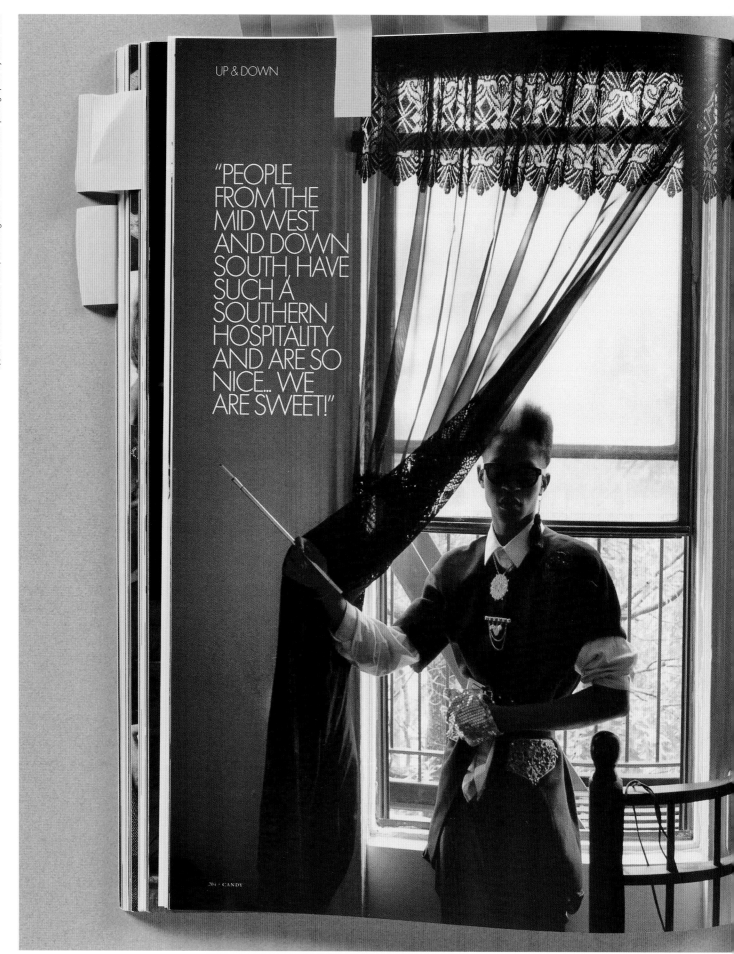

"PEOPLE FROM THE MID WEST AND DOWN SOUTH, HAVE SUCH A SOUTHERN HOSPITALITY AND ARE SO NICE... WE ARE SWEET!"

204 · CANDY

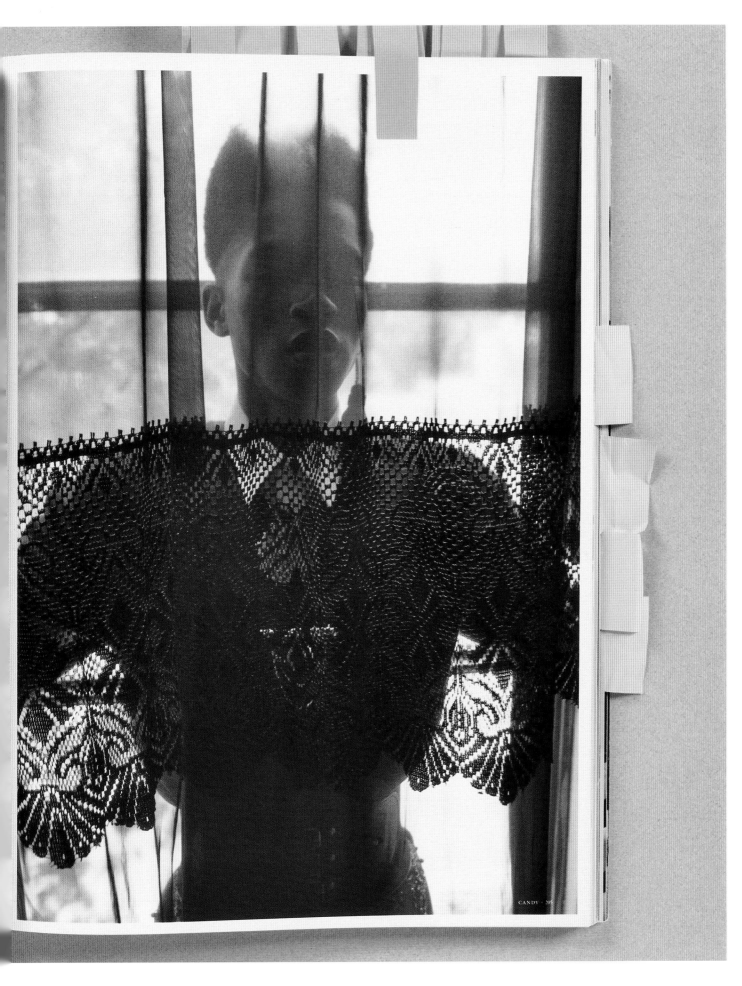

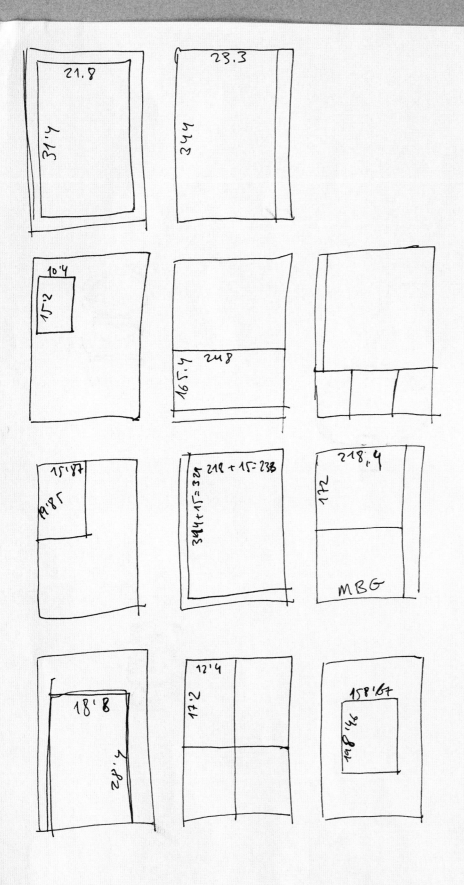

G★NDY *Transversal* 1st Issue, 2009. Pages 86-87, 92-93. Bianca Exotica photographed by Marcelo Krasilcic, styled by Antonio Frajado.

The best thing about Brazil is that I attract men. I've loved cock since I was 12, when I gave my cherry to a boy who stayed with me until I was 17. We were secret lovers because he already had a girlfriend. The last time I had sex? Last weekend. I left a party at Dudu Bertholini and I had sex with a handsome motoboy. He is a Corinthiano, a fan of the soccer team Corinthians, where Ronaldo shines.

I try to be as natural as possible, but I'm exotic by nature.

CHICA CHICA BOOM CHIC!

BIANCA EXOTICA
THE BRIGHTEST SMILE IN BRAZIL!

PHOTOGRAPHED BY **Marcelo Krasilcic** STYLED BY **Antonio Frajado**

LA CRAWFORD

TELL ME MORE, TELL ME MORE!
WAS IT LOVE AT FIRST SIGHT?
TELL ME MORE, TELL ME MORE!
DID SHE PUT UP A FIGHT?

FROM **GREASE**

130 · CANDY

CANDY Transversal 1st Issue, 2009. Pages 130-131. Cooper Cheatham and Crawford photographed by Daniel Riera, styled by Óscar Visitación.

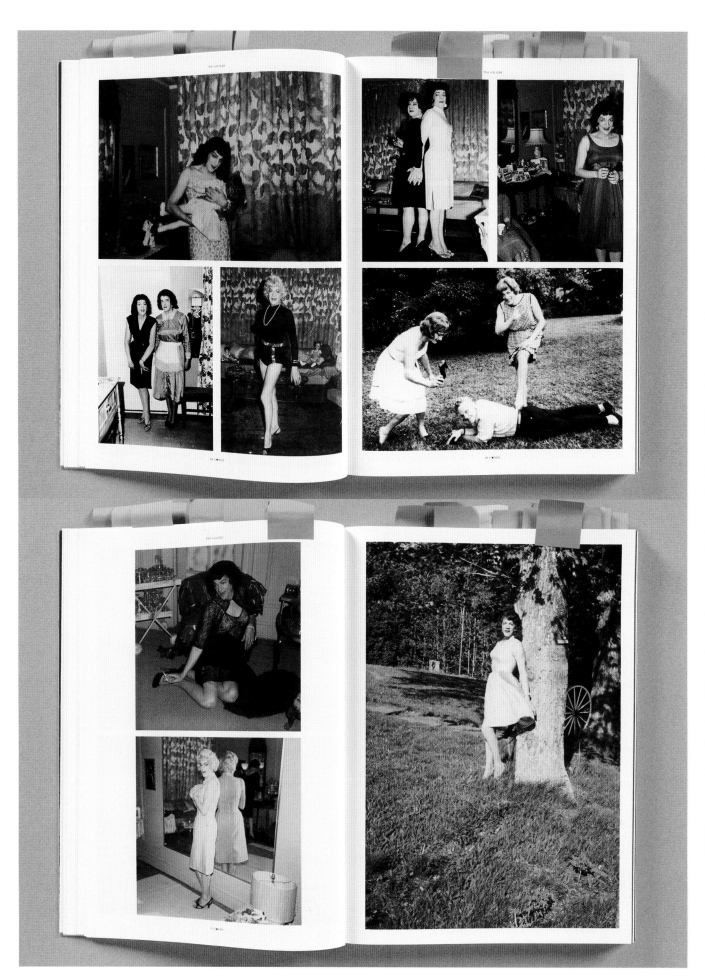

The rotated text on the right side:

C★NDY *Transversal* 7th Issue, 2014. Pages 68–71. Casa Susanna, New Jersey, early 60s. Courtesy of Cindy Sherman. RIGHT: Cole Mohr photographed by Brett Lloyd and styled by Kim Jones for C★NDY *Transversal* 1st Issue, 2009.

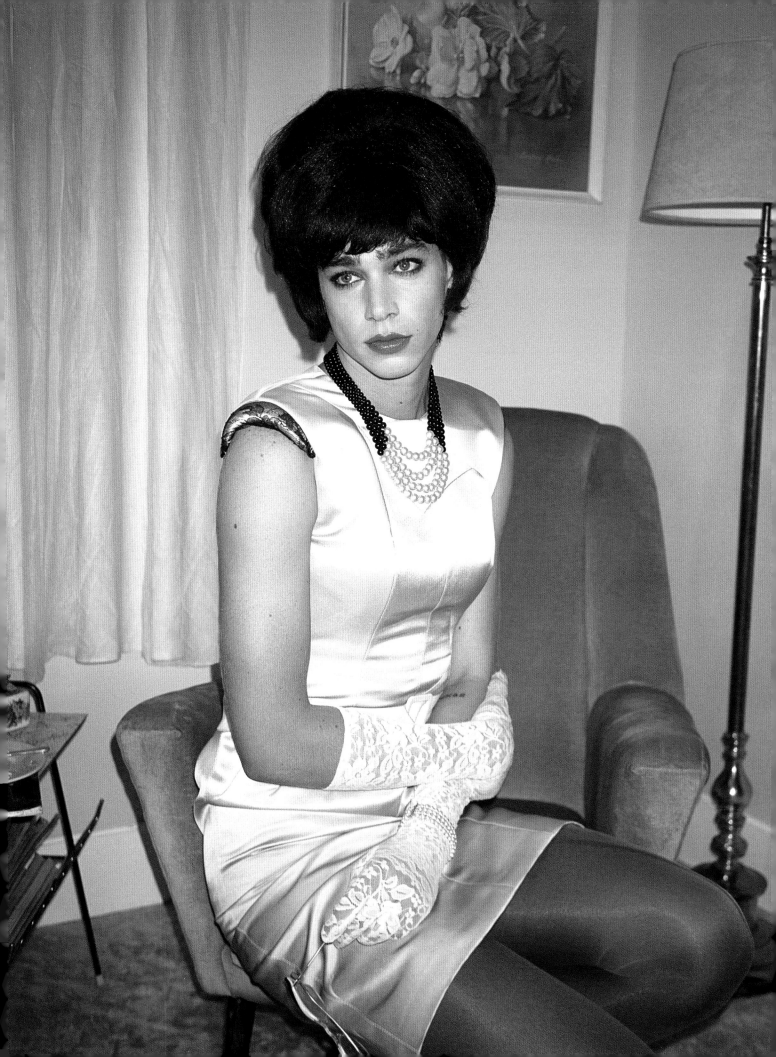

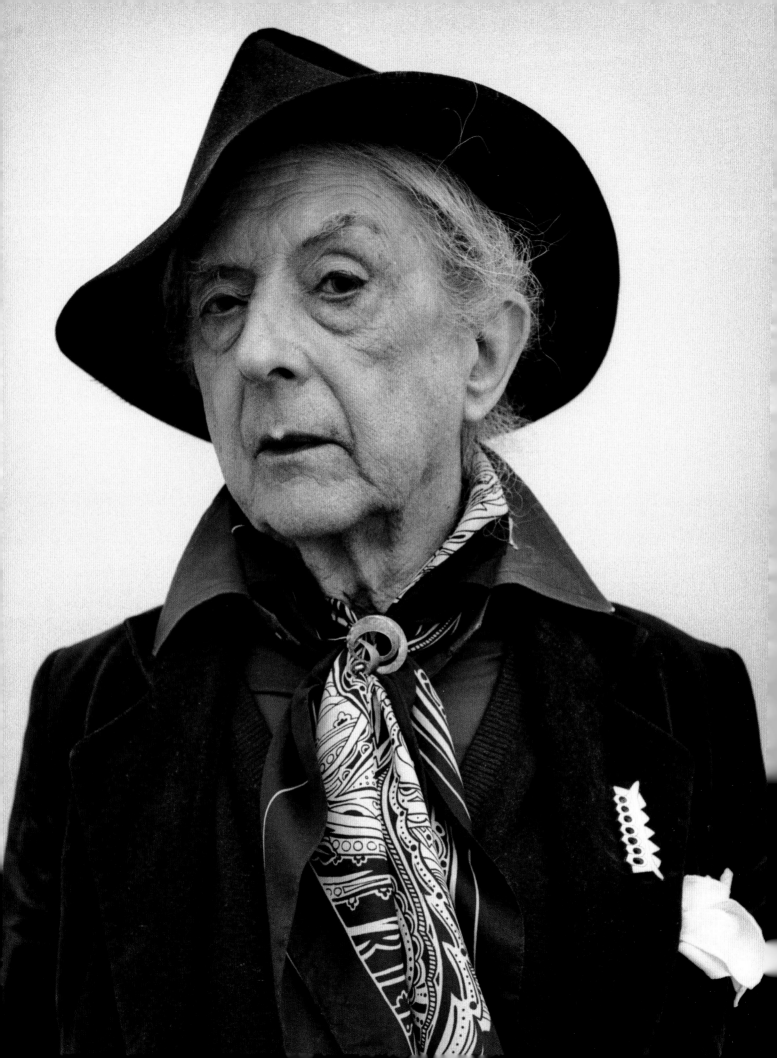

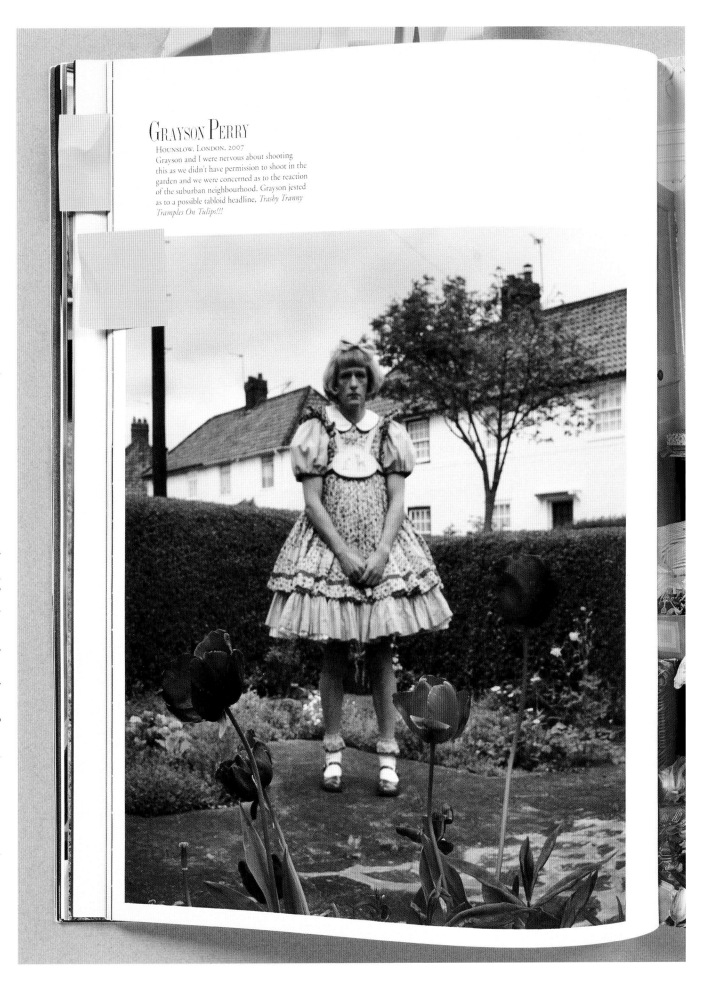

GRAYSON PERRY

HOUNSLOW, LONDON, 2007

Grayson and I were nervous about shooting this as we didn't have permission to shoot in the garden and we were concerned as to the reaction of the suburban neighbourhood. Grayson jested as to a possible tabloid headline, *Trashy Tranny Tramples On Tulips!!!*

G★NDY *Transversal* 1st Issue, 2009. Page 64. Grayson Perry as Claire photographed by Tim Walker, Hounslow, Middlesex, 2007. Quote by Tim Walker. LEFT: Unpublished photo of Quentin Crisp shot by Tim Walker, New York City, 1995.

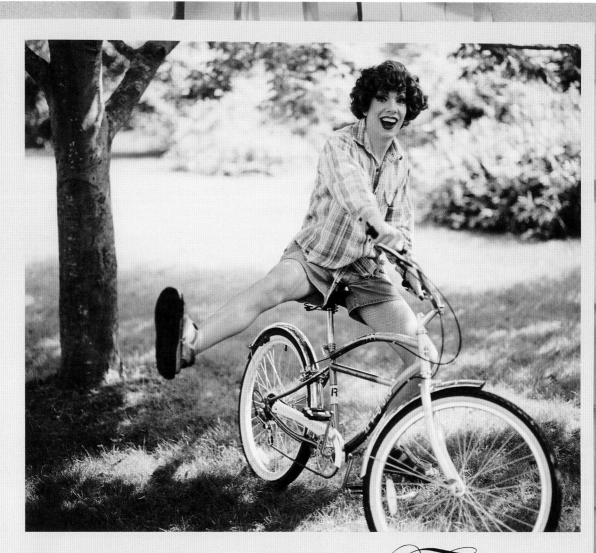

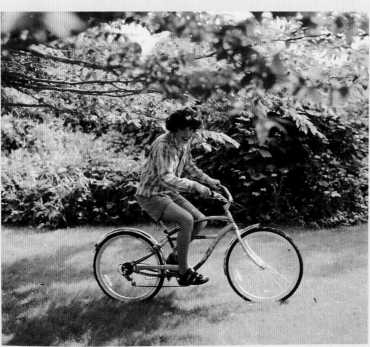

*T*HE NEXT TIME
I saw Lypsinka it was in the
character of Joan Crawford,
lip synching to her famous
interview for Pepsi from
the 1960s. We were at Paul
Morrisey's house in Montauk
that he once shared with Andy
Warhol. We all had so much
fun getting ready for the
performance, and I only wish
Lypsinka had stayed for the
summer.

CANDY · 31

CANDY *Transversal* 1st Issue, 2009. Page 31. Lypsinka photographed by Bruce Weber, styled by Joe McKenna, 2004. Quote by Bruce Weber.

CANDY *Transversal* 1st Issue, 2009. Page 35. Andre J photographed by Bruce Weber, styled by Joe McKenna, 2004.

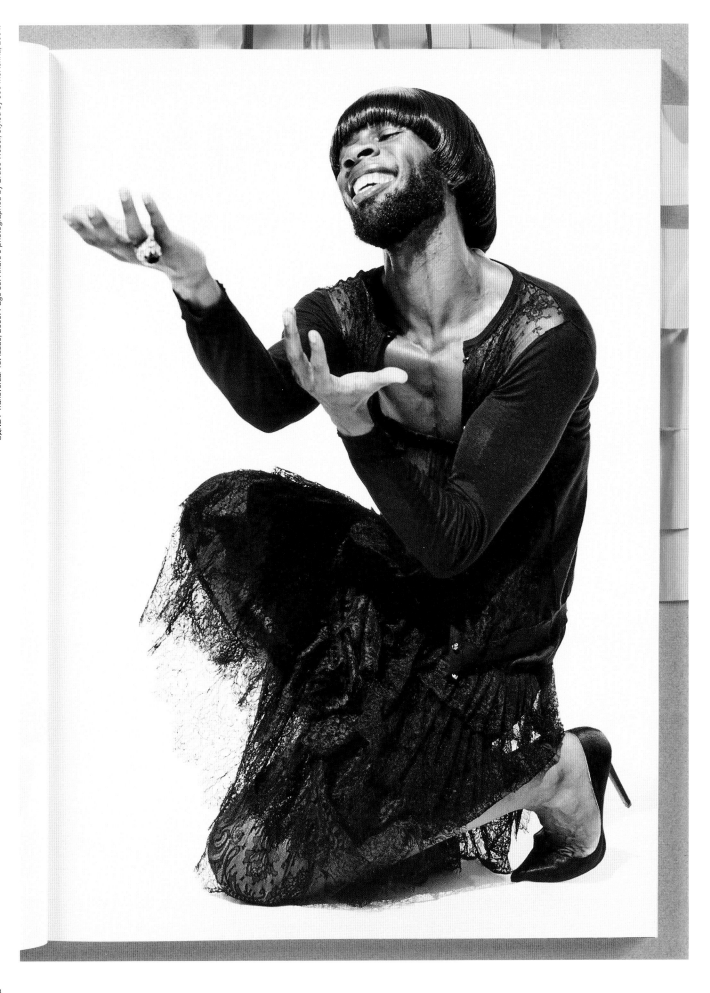

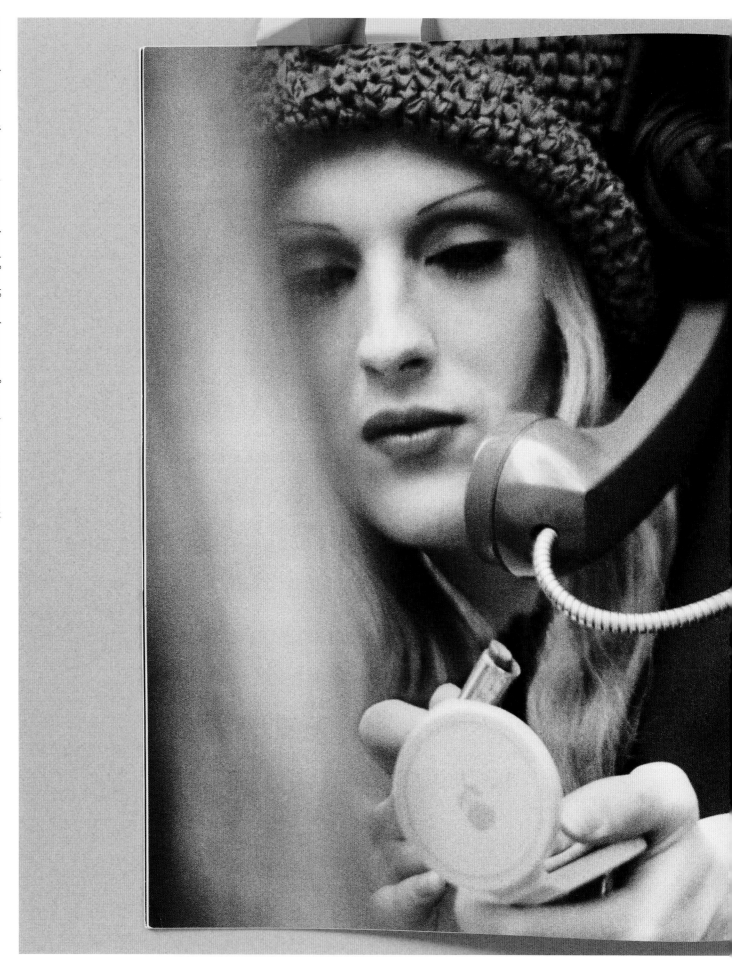

C★NDY Transversal 1st Issue, 2009. Pages 12-13. Candy Darling photographed by Bruce Weber, New York City, 1973. Quote by Bruce Weber.

CANDY DARLING was my friend. I took these pictures with my first camera, and afterwards Candy promised me I would be first on the list of preferred photographers. Candy had just worked with Richard Avedon and Cecil Beaton both, so it was wild for a young photographer like myself, just starting out, to be in that kind of company. But it was even wilder and more magical to be in Candy's company, because every construction worker and cabbie on the street would whistle when they first watched Candy walk by. And what could have been a more perfect name than Candy?

— *Bruce Weber* on

Candy Darling

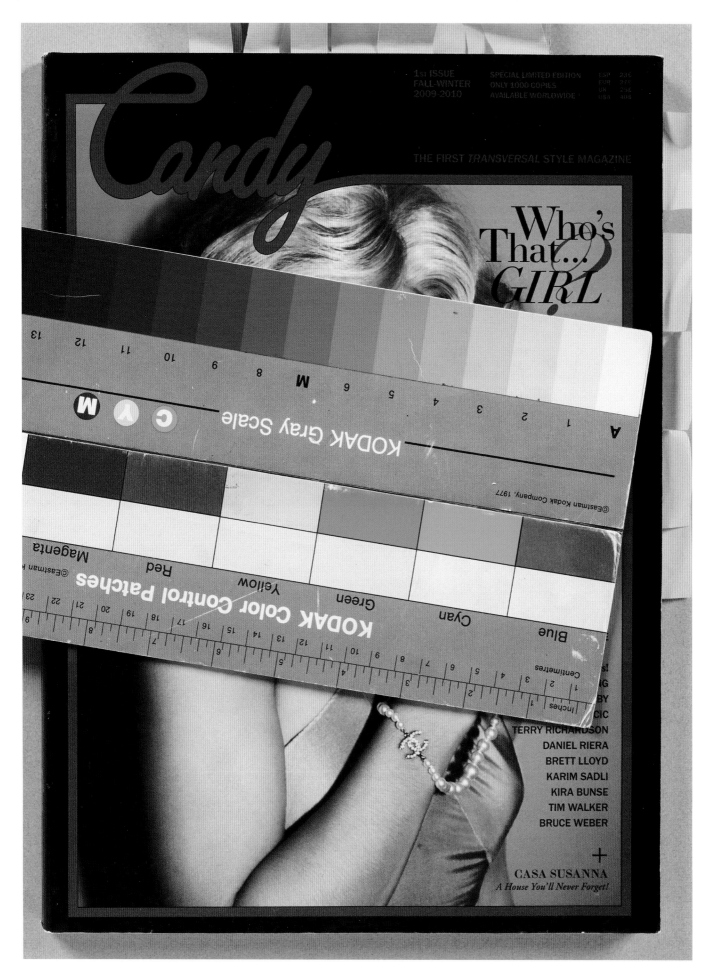

CANDY Transversal 1st Issue, 2009. Cover (Detail). Photographed by Brett Lloyd, styled by Kim Jones. RIGHT: Mel Odom's artwork inspired by the CANDY Transversal 1st Issue cover.

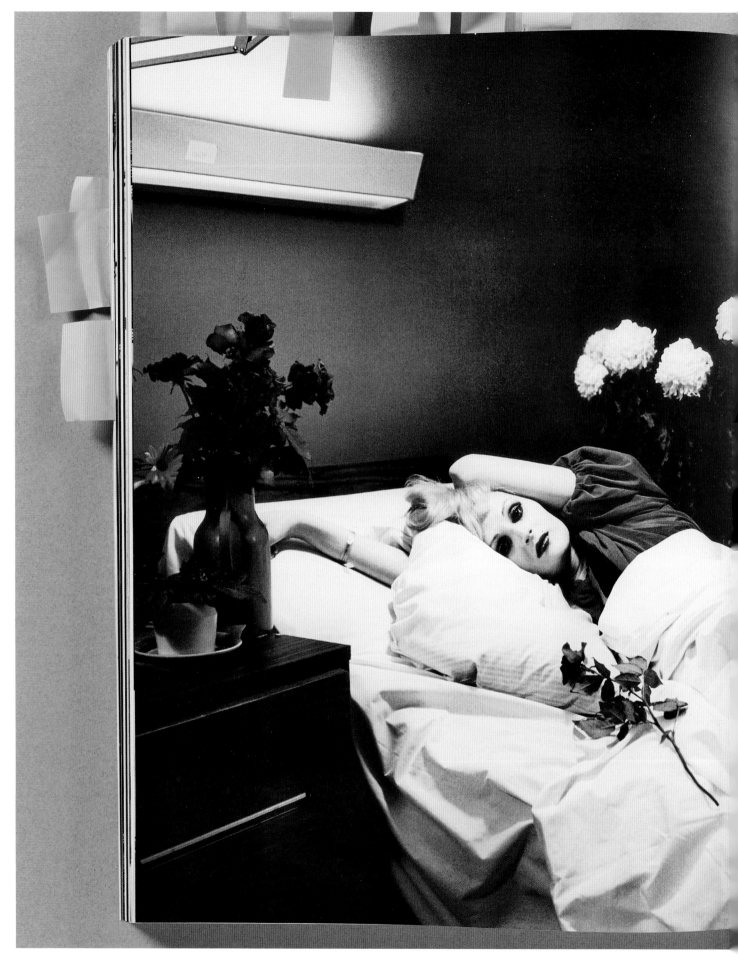

THE END

CANDY DARLING ON HER DEATHBED, 1974

CANDY IS HONORED TO PRESENT FOR THE
FIRST TIME THE COMPLETE SERIES AND
CONTACT SHEETS OF CANDY DARLING'S
PHOTOGRAPHIC SWAN SONG, SHOT JUST DAYS
PRIOR TO HER DEATH IN MARCH 21, 1974.
DEAR CANDY DARLING, YOU CONTINUE TO
INSPIRE US DAY AFTER DAY.
WE LOVE YOU.

———————— • ————————

PETER HUJAR
PHOTOGRAPHY

The True Love of Magazine Making

I remember first hearing about Luis Venegas in the early 2000s. At that time, he had just started publishing *Fanzine137*. There was a certain mythology surrounding this reclusive Spanish boy who lived in an apartment furnished only with fashion magazines, who would email requests to the world's greatest photographers and leading industry figures with the reputation of a first-rate letter writer. His messages, I remember being told by some of those photographers, simply "oozed charm." It is an editor-in-chief's stock-in-trade to be charming; take Graydon Carter's maxim for courting talent to the pages of *Vanity Fair* as a case in point: "the three F's" that Carter called his formula: flowers, faxes, and flattery. But what was Luis Venegas's secret? He had come out of seemingly nowhere, and yet he was pulling world-class contributors. I remember seeing issue three of *Fanzine137* in May 2006—the "Heartbeats Accelerating" issue, which was a beautiful book-sized magazine with contributions from Wim Wenders, Nick Knight, Wolfgang Tillmans, Roxanne Lowit, Walter Pfeiffer, Jean Paul Goude, and Richard Prince, and stories on unexpected queer icons like Nina Hagen and Slava Mogutin. It was hard to believe he did this all by himself, but it turned out it was all genuinely true.

Luis is a truly gifted magazine creator. He uses the word "fun" a lot whenever we get together to talk about why he loves magazines—and that's the sensation that all his magazines—*EY!* titles, *C★NDY Transversal*, and *The Printed Dog*—have evoked since he started *Fanzine137* around sixteen years ago. When he first imagined publishing *C★NDY*, we discussed his vision for celebrating "transversal creativity." Luis wanted to bring a fashion and lifestyle sensibility to representing the diversity of a new sexual revolution that was being inspired by an age-old one. He was looking to the future with an eye to the past, expanding the scope of inclusion for what he called "transversal"—a hybridization of trans from which we can extrapolate "to transition," "to transform," "to transgress," and the "universal"—a unity of difference, a commonality of otherness. It's a beautiful piece of language styling and wordplay that has allowed Luis to define his terms for *C★NDY* as a form of media manifesto: the world's first transversal style magazine.

Luis was inspired by the success of *Visionaire*, the artful, shape-shifting magazine conceived by Cecilia Dean, Stephen Gan, and James Kaliardos, which produced high-end, limited-edition issues. It was this aspirational, limited approach to publishing that led him to propose a "curated distribution" of only 1,500 copies of *C★NDY Transversal*. "They become objects of desire," I remember him telling me excitedly. He was so on point. What matters today in print media is not reach, but context, quality of the message, and impact of ideas, and *C★NDY*—within the richness of its stories and the ingenuity of its contributors—exemplifies that.

This book, a synthesis of ten years of adventures in the transversal, is a beautiful way to bring the limited-edition ethos of *C★NDY Transversal* to a broader audience. I am proud in some small way to have been an early supporter of *C★NDY*. I think Luis and I share a certain fascination with Andy Warhol's Factory, *Interview* magazine, and The Velvet Underground—when drag, queer culture, trans icons—like the magazine's namesake, Candy Darling—and otherness was pushed through Pop art as performance. This legitimized otherness in a way that was refused on television or in Hollywood movies, which repressed any expression of difference that challenged the conventional heteronormative stereotypes of late 1960s America.

Candy Darling appeared in several Warhol films, including *Flesh* and *Woman and Revolt*. In Richard Avedon's seminal image of the Factory—which inspired *Dazed & Confused*'s own sensibility for radical inclusion—we see Joe Dallesandro, Holly Woodlawn, Gerard Malanga, Warhol, and the entourage, some naked, clothes strewn on the floor, against a clinical, studio-white backdrop. Shot in 1969, Candy steals the image. She represents all of late 60s underground, libertarian, sexual freedoms with total insouciance. On *Transformer*, the album which debuted in 1972, Lou Reed again immortalized Candy in his song *Walk on the Wild Side*, and shortly after she was diagnosed with cancer. In 1974, at the age of 29, Candy was famously photographed by Peter Hujar on her deathbed. What an incredible cultural impact for such a short-lived career. And that same image was reproduced by Antony and the Johnsons for the cover of their second album, *I Am a Bird Now*. It's hauntingly beautiful—a tragic, melancholic, yet fiercely defiant representation of a performer, for whom the performance never stopped, for whom performance is, in many ways, larger than life itself. In Warhol's world, everyone was acting *all the time* and none more than his superstars like Candy Darling.

C★NDY Transversal magazine is an alternative stage for performance. Its actors—especially its cover stars—are always larger than life. Yet, its brilliance is in how it reveals a plurality of experience. There's a radical inclusivity that Luis conjures in his editing of *C★NDY* that makes it a truly genre-defying magazine. It's this genuine spirit of "fun" as Luis always reaffirms; positivity, togetherness, empathy, freedom, self-expression, liberation, and joy in otherness that allows *C★NDY* to transcends its niche, to be a universal beacon of love, a lighthouse of new possibilities, a spirit angel representing, as Maggie Nelson might say, "the many gendered mothers" of our hearts. It's Luis's true love of magazine-making that makes *C★NDY* so sweet.

JEFFERSON HACK
Creative visionary, *Dazed Media* co-founder

Illustrated joke by Jordi Labanda, published under the pseudonym Quentin Prisc in C★NDY *Transversal* 3rd Issue, 2011.

I have something to tell you.

Muchas gracias to every single one of you, dear C★NDY friends who have contributed to C★NDY Transversal magazine during the last 11 years and also to this book: artists, photographers, models, talent, writers, editors, stylists, advertisers, copy editors, translators, family, etc… you all know who you are. C★NDY love to all of you.

LUIS VENEGAS

First published in the United States of America in 2020
by Rizzoli International Publications, Inc.
300 Park Avenue South
New York, NY 10010
www.rizzoliusa.com

Copyright © 2020 Luis Venegas
www.byluisvenegas.com
Foreword: Jefferson Hack

Publisher: Charles Miers
Editorial Direction: Martynka Wawrzyniak
Design: www.setanta.es
Still Photography: Biel Capllonch
Production Manager: Kaija Markoe
Managing Editor: Lynn Scrabis

Dust Jacket: Bryce Anderson photographed by Michael Bailey-Gates, styled by Djuna Bel. C★NDY Transversal 12th Issue, 2019.

2020 2021 2022 2023/ 10 9 8 7 6 5 4 3 2 1

Distributed in the U.S. trade by Random House, New York

Printed in Italy

ISBN: 9780847865833

Library of Congress Control Number: 2019945680

Visit us online:
Facebook.com/RizzoliNewYork
Twitter: @Rizzoli_Books
Instagram.com/RizzoliBooks
Pinterest.com/RizzoliBooks
Youtube.com/user/RizzoliNY
Issuu.com/Rizzoli

FOLLOWING SPREAD: On the left, Kabuki's artwork inspired by C★NDY Transversal.